with a virtual catalogue

In Search of the Better' Ole

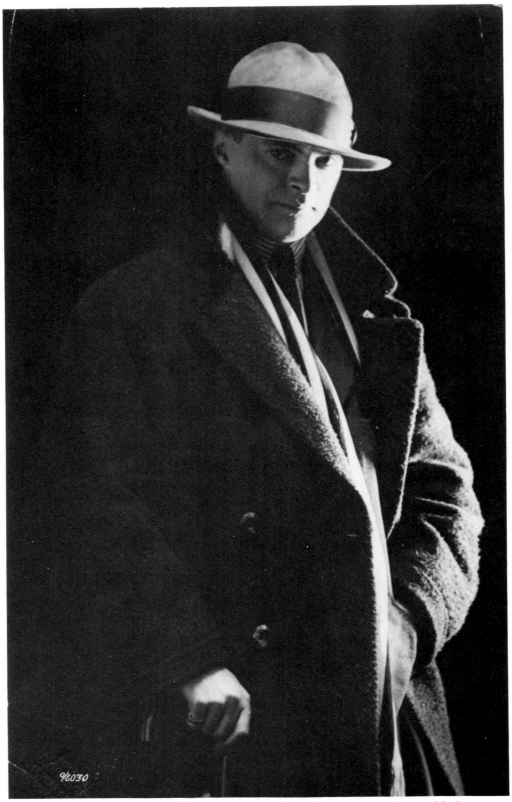

Bruce Bairnsfather, as he would like to be remembered. He is wearing his good-luck-omen, a snake's-head-ring.

In Search of the Better' Ole

THE LIFE THE WORKS AND THE COLLECTABLES OF
BRUCE
BAIRNSFATHER

BY TONIE AND VALMAI HOLT

MILESTONE PUBLICATIONS

To all Old Contempti-Bills.

"England owes Bruce Bairnsfather a good deal more than its leaders have yet recognised".

British Legion Journal, 1934

1985 © Tonie and Valmai Holt

Published by
Milestone Publications
62 Murray Road, Horndean
Portsmouth, Hants. PO8 9JL England

Design Brian Iles

Typeset by Inforum Ltd, Portsmouth

Printed and bound in Great Britain by
R. J. Acford, Industrial Estate, Chichester, Sussex

British Library Cataloguing in Publication Data
Holt, Tonie
 In search of the better ole: the life, works
 and collectables of Bruce Bairnsfather.
 1. Bairnsfather, Bruce
 I. Title II. Holt, Valmai
 741.5'942 PN6737.B3

ISBN 0-903852-65-9

Published in Canada by
Fitzhenry & Whiteside
195 Allstate Parkway
Markham
Ontario L3R 4T8

Other Books by Tonie and Valmai Holt

"*Picture Postcards of the Golden Age: A Collector's Guide*"
(1st Edition: McGibbon & Kee 1971. 2nd Edition: Postcard Pub. Co. 1978)

"*Till the Boys Come Home*: the Picture Postcards of the First World War"
(Macdonald & Jane's 1977)

"*The Best of Fragments from France by Capt. Bruce Bairnsfather*"
(1st Edition: Phin Pub. Co. 1978. 2nd Edition: Milestone Publications 1983)

"*Picture Postcard Artists: Landscapes, Animals and Characters*"
(Longmans 1984)

"*Stanley Gibbons Postcard Catalogue*"
(Stanley Gibbons Publications. 1st Edition: 1980. 2nd Edition: 1981. 3rd Edition: 1982. 4th Edition: 1984)

"*Holts' Battlefield Guide Books*"
 Ypres Salient (1st Edition: Leo Cooper 1982. 2nd Edition: T & V Holt 1984)
 Normandy–Overlord (Leo Cooper 1983)
 Market-Garden Corridor (Leo Cooper 1984)

In Preparation

"*More of Best of Fragments from France*"
(Milestone Publications)

"*Germany Awake!: the Rise of National Socialism Illustrated by the Contemporary Postcard*"
(Longmans)

"*Battlefield Guide to the Somme*"
(T & V Holt)

Contents

Acknowledgements

This book has taken a number of years to research, write and publish. The acknowledgements we make here refer to individuals and organisations with the titles and names appropriate to the time when their help or permission was given.

Sadly, some of Bruce Bairnsfather's contemporaries, who gave us such generous assistance, have since died.

We would like to thank the following people and organisations for their encouragement, help, information and, where appropriate, the loan of material and permission to quote from books, letters, obituaries, reports, reviews and other printed material and to reproduce letters, photographs, and memorabilia.

It is a long list – we found literally hundreds of people who remembered Bruce Bairnsfather and Old Bill with affection and gratitude and who were more than generous with their help. Nevertheless we are conscious that there may be some omissions, for which we humbly apologise.

THE FAMILY: first and foremost for their support and encouragement, but also for specific permission to reproduce from letters, sketches, information and other items so kindly provided, our sincere thanks:

Mrs Barbara Bairnsfather Littlejohn, Captain Bruce Bairnsfather's daughter; Mrs Joy Hoban, his niece; and Mrs Elspeth Cumming, Sir John Every, Mrs C.E.M. Handcock, Mr Frank Hawkins and Mr Harold Loyns.

NEWSPAPERS AND MAGAZINES: many of which published our appeals for information, which produced a flood of marvellous reminiscences, memorabilia and anecdotes:

Daily Express, London Evening News, Stratford Herald, Bucks Herald, Tony Arnold and *the East Kent Mercury, Birmingham Post, Berrows Malvern and Worcester Newspapers, Manchester Guardian, The Times, The New York Times, New Yorker, Daily Telegraph* with special thanks to Bernard Shrimsley, editor, and the *News of the World*; Keith McKenzie, Art Editor, Associated Newspapers, the Staff of the Archives and Libraries of the *Daily Mirror* and the *Daily Express* who helped us to locate many cuttings, and the *Illustrated London News* for all *Bystander* and *Tatler* references; *Kent Life* and Marian and Bill Evans for the loan of their Bairnsfather album.

LIBRARIES/MUSEUMS/ORGANISATIONS: The Hendon Reference Library for their continuing resourcefulness; the MOD Library; The Army Record Centre; the Central Library, RMA, Sandhurst; The Royal Hospital, Chelsea; The Royal Warwickshire Regiment Museum; The Public Record Office; The Imperial War Museum (especially our good friends Rose Coombes, Joseph Darracott and Terry Charman); The Royal British Legion (especially Ron Pennels, Wing Commander Pollington and Christopher Elliott who was their Assistant Press Officer); The MOTHS (especially Play Bill Harry Turner and Senior Old Bill of Great Britain, Paddy Padwick, whose recent death saddened us); The Birmingham Old Contemptibles (a marvellous group, whose memories of Bairnsfather meant more to us than any others); The Surrey Red Cross; The India Office; The British Museum; The Victoria and Albert Museum (especially the Theatre Museum); the BBC Programme Index (especially Miss Reed and Miss Varley); The Shakespeare Birthplace Trust (especially Mairi Macdonald); The Post Office Telephone Directories Section (especially Miss Partington); The Architects' Dept., The GLC; The Newspaper Library, Colindale; King Edward VI Grammar School, Stratford; Madame Tussaud's; Manny Curtis and the Cartoon-

ists' Club of Great Britain; Denis Gifford and ACE; Bill Wright and Bill's Amusement Alley for printing appeals for information in their magazines.

FIRMS: Abbot and Holder, art dealers; Bonhams; Christie's and Phillips the auctioneers; Ansell's brewers, Whitbreads' brewers; The Lambert Arms, Aston Rowant; Curtis Brown, literary agents, London; Royal Winton Potteries.

THE AMERICANS: The Chicago Historical Society; The Battery Book Shop, Nashville, and Mr and Mrs Reading Black's Book Search, Springfield, Virginia for finding out of print books; The US Army Military History Institute; The Dept. of the Air Force, Washington DC; The American Film Institute; The National Players Club, New York; Curtis Brown, New York; Miss Barbara Humphrys of the Washington Library of Congress Motion Picture Section and Jim Smart of their Music Dept. for arranging special showings for us of the Bairnsfather Vitaphone Film and Syd Chaplin's *The Better 'Ole*.

THE CANADIANS: Canadian Broadcasting Corporation; The Canadian High Commission and Canada House for arranging special showings for us of *Dreamland* and *Carry on, Sergeant!*; Our ever-helpful friends, Maggie and Richard of Admiral Stamp and Coin, Victoria, B.C; and perhaps our biggest thanks of all to D. John Turner, Archivist of the Canadian National Film Archives for finding and providing us with so much exceptional material about Trenton and *Carry on, Sergeant!* and the indefatigable Gordon Sparling whose personal memories were invaluable.

THE CARTOONISTS: Larry, Cummings, Garland, Chat, Hector Breeze, David Langdon, David Cuppleditch, Peter Brooke, John Jensen, and Illingworth for their versions of "The Better 'Ole", some of which we were able to reproduce here.

THE ACQUAINTANCES, ADMIRERS and FRIENDS of Captain Bairnsfather who either let us visit them or who corresponded with us and provided us with a wonderful store of anecdotes, facts, mementoes and reminiscences. We explained that we were anxious to portray a rounded, accurate picture of the man and his career. To help us to do this our sources gladly gave us information, but often asked that it should not be directly attributed to them. This confidence we have respected. Therefore, although all statements in this book shown in inverted commas are precise quotations, they are sometimes unattributed.

Mrs Jean Appleyard; Mrs Aubertin; Mr Tony Barker; Mrs Florence Bright; Mrs Bousfield; Major C. Bradbeer, M.C.; Mr Leonard Bull; Mr Dave Carter; Mr Bernard Channing; Mr Bert Cummings; Mrs Lilian Carrdus; Mrs Eileen Cook; Mr S. Cooper; Wing Commander Carroll; Mrs Daniels; Mrs Day; Mr Clinton Davis; Mr Barry Duncan; Mrs Lily Fordham; Mr Roger Freeman; Mr Dennis Flower; Mr Goodall; Mrs Olive Grinstead; Mr Eric Hain; Mr G.E. Healey; Mr T. Holte; Mrs Monica Hamilton; Mrs E. Henderson; Mr H. Howard; Mr Mick Harvey; Miss Clem Humphries; Mr E. Hyatt; Mrs Constance James; Mr Tom Jefferson; Mrs Vera Keen; Mrs Rhoda Kemp; Mr Bert Knight; Mrs Kedward; Mr Samuel Langfield; Mrs Jean Low; Mrs Ivy Ludlow; Mr Madders; Capt Machin, D.F.C.; Mr Percy McKeoch; Mrs Joyce Maltby; Prof. Laurence Martin; Mrs Ruby Matthews; Mr Alf Mutlow; Sir John Mills; Mrs Neale; Mrs Nicholas; Miss Queenie Pinder; Mr James Pearse; Mr Mowbray Pillans; Mrs Evelyn Phillips; Mrs Mary Pilcher; Mr John Pybus; Mrs Muriel Pushman; Dr & Mrs Richardson; Mr George Ratcliff; Mrs Elsie Rogers; Mrs E. Russell; Mr Russell; Mrs Amoret Scott; Mrs Margaret Spencer; Mr John Sandford; Mr R.C. Savage; Mr Robert Southall; Mr Ted Leigh-Spencer; Mrs D. Tapping; Mrs Turner; RSM G.A. Thornton, D.C.M., M.S.M.; Mr N. Tzimas; Cpl Walden; Mrs Gladys Whittaker; Mr J.S. Whyte; the Rev Lawrence Wray, and the many, many other kind people who added pieces to the jigsaw puzzle. A special word of thanks must go to Mark Warby who, since the age of 15, has been a diligent and enthusiastic researcher into BB's life and output, and who has made all his findings available to us.

SIAN and GARETH: Finally our thanks to our children for their forbearance and interest and for sharing their parents, and sometimes their bedrooms, with Bruce Bairnsfather and Bairnsfather memorabilia in many shapes and forms over the past ten years.

Foreword

We first came across Bruce Bairnsfather and his cartoons when we were researching the First World War more than a decade ago. His name cropped up with increasing frequency, particularly when we talked to individuals who had lived through those years. It wasn't from reading history books that we gathered information about him, but by talking to ordinary people – soldiers, civilians, mothers, wives – those that *knew* what it had been like to endure those frightful times. They remembered with astonishing clarity and emphasis how much Old Bill had meant to them, how he had kept their spirits up.

We came to realise that Bairnsfather's cartoons and, in particular, his brilliant characterisation of the British soldier as Old Bill, were an important factor in Allied morale during the Great War. Gradually we became fascinated by the man who had created this figure of humour and fortitude. To our surprise we discovered that there was far more to the Bairnsfather story than *Fragments from France*. There were films and stage plays, books and articles – by and about Bairnsfather and Old Bill. We realised that their career carried on between the two world wars and even during World War II.

During Bairnsfather's long and varied career, Old Bill was reproduced in pottery and brass, on scarves and as car mascots, on playing cards and postcards. Bairnsfather in his heyday was not only the most famous cartoonist in the world, responsible for *The Better 'Ole*, but he was also a lecturer of note and a music hall artiste.

We eventually learned that Bruce Bairnsfather was well-loved and admired by his contemporaries for his personal qualities as well as for his achievements. We found, too, that he had to endure many adversities – both family and financial in nature – in the course of his many years both in and out of the limelight.

We finally realised that both Old Bill and Bruce Bairnsfather had spent their lives in a continuing search for a personal Better 'Ole.

We grew to love our subject and to feel that his contribution to our nation has never been adequately acknowledged.

We hope that you will feel the same way.

Tonie & Valmai Holt
Sandwich 1985

Bruce Bairnsfather and Edmund Gwenn in the stage play of Old Bill MP, *said by some to have been sponsored by the British Secret Service and inspired by Winston Churchill.*

Chapter 1

Growing Up

(1873–1905)

Death came suddenly in India in the nineteenth century. When the Cheshire Regiment left Chester and sailed for Bombay in 1873, only a few of them would ever see England again. Although the Suez Canal, built in 1869, reduced the sea journey from months to weeks, some soldiers never even got to India. They died of sea sickness on the way.

Cholera, malaria, typhoid, rabies and bubonic plague waited to take their toll of those that did arrive. It was not unknown for a regiment to lose half its men through disease in a few days. It was commonplace to be talking to a man one morning and burying him the next.

Six years after the Chesters reached Bombay and continued inland to establish their Regimental Headquarters at Allahabad, Second Lieutenant Thomas Henry Bairnsfather, the most junior lieutenant in the regiment, arrived in India.

Thomas survived. So would his wife and two of their three children. One of these children was destined to become world famous, while the other would be disowned.

The Bairnsfather family was large and talented. Thomas was one of eleven children. Three of the five boys went into the Army, the fourth into the Royal Navy and the fifth into banking. Thomas's mother could trace her forbears to the Every line, whose baronetcy went back two hundred and fifty years. Thomas proved a keen soldier and a good one, and by March 1881, barely eighteen months after obtaining his Queen's Commission, he was promoted to full lieutenant and provisionally appointed to the Indian Staff Corps with the Bengal Infantry.

A young officer's life in India, apart from intermittent skirmishes on the frontier, was mainly devoted to keeping busy. Regiments, living in their own military areas known as cantonments, carried on a way of life that was simply an extension of public school. At the foundation of this life was the notion of duty. The

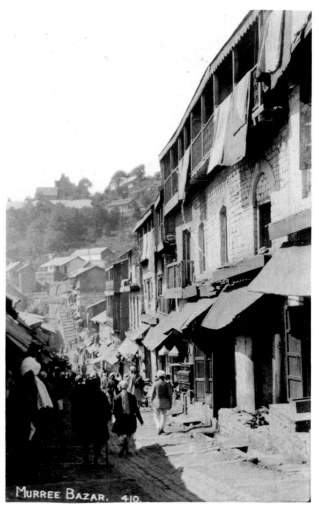

Murree Bazaar in the Indian hill town where Bairnsfather was born in 1887.

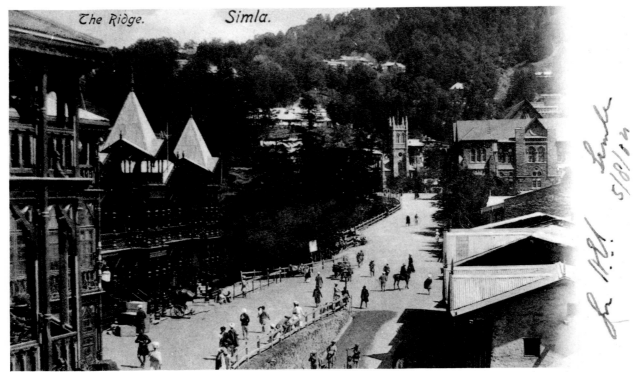

Simla, where both Rudyard Kipling and Major Thomas Bairnsfather played their parts in amateur dramatics.

British military did not doubt that they were a superior race and that their God-given task was to rule a subcontinent of inferiors. This situation was apparently accepted by the vast majority of Indians, towards whom the British officer maintained a good-humoured and tolerant attitude, much the same attitude he might have had towards juniors at school. But in this case school was replaced by the mess, where officers ate, played cards and dressed for dinner.

On 28 October 1886, while on leave in England, Thomas married Amelia Jane Eliza Every, with whom he shared a great-grandfather – Sir Edward Every, the eighth Baronet. Sir Edward's daughter, Frances, had begun the line which led to Thomas, while Sir Edward's son, Henry, had begun Amelia's branch of the family. Their backgrounds were similar, their outlook admirably suited to life in India. They were used to having servants and already familiar with the routine their lives subsequently followed. Life in married quarters was as ritually traditional in manners and customs as life in the mess.

The Army in India was stationed throughout the continent, with small units well forward on the mountainous north-east and north-west borders to counter the spasmodic activities of aggressive hill tribes. The mountains also served another purpose: refuge from the heat.

India's climate was as regulated as the British way of life there. Every year there was cold weather, hot weather and the rains. The hot weather, which lasted from mid-April to September, was so unbearable to the British that the Central Government emigrated to the hills each year, an 1100-mile journey by camel and elephant from Calcutta. It was in those hills, at an isolated station called Murree, thirty miles north of Rawalpindi on the borders of Kashmir in the lower Himalayas, that the Bairnsfathers' first child, Charles Bruce, was born on 9 July, 1887. Their accommodation was extremely primitive. The building was a small, corrugated iron roofed native structure, and Bruce's bathtub a galvanised iron horse bucket.

During the hot season the families all went to the hills. Husbands based down on the plains would take leave and join them for a few weeks. Transportation was by elephant, camel and bullock cart, with the wives and children lying or sitting in dandys, long box-like contraptions carried by four men. Movement around the hill stations was by horse. For the wives this was a means of getting away from the stifling inactivity of daily life. Amelia Jane Bairnsfather, or Janie as Thomas called her, loved riding.

There were servants for everything. The *dhobi* did the washing, the *chaprassi* ran messages and did general household chores, the bearer acted as valet,

the *punkah-wallah* worked the fans, the *mali* cared for the garden, the *mesalchee* cleaned the kitchen and the *khitmagar* waited at table. Most important of all was the *ayah*, who acted as maid and looked after the children. The Bairnsfathers' *ayah* spoke Hindustani, and this became Bruce's first language when he learned to talk.

The Bairnsfathers moved frequently as Thomas's job took him about the north-western frontier of the Punjab. They also moved to avoid disease. The rainy season was the time of greatest danger. Living conditions in the bamboo bungalows that served as married quarters became very difficult for a while. During the hot season the wood would shrink and warp the corrugated iron roofs, so that when the rains came the water poured in spreading disease, even in the hills. Eczema, prickly heat, *dhobi* itch and impetigo helped to make life additionally difficult.

Army Headquarters was established at Simla and in April each year Central Government trekked there for a five month stay. Simla was probably the most famous hill station of all, clinging to the sides of the lower Himalayas, 7,000 feet above sea level. The approach from the plains petered out to a single cart-track. Each year emigré families from the hot plains would be joined by senior officers of both civil and military authorities, their wives and children. Thus, for a few months, there was a conclave of the British middle classes established at Simla, waited upon hand and foot and with very little to do.

An artificial and time-consuming set of social behaviour patterns developed, involving much calling and visiting, formal dinners, riding, shooting and hunting, as well as an almost daily round of dance parties. Following the social calendar was sufficient to keep most people occupied but some needed to express their creative urges in a more positive fashion. The light clear air, the bright sun, the exotic, colourful gardens encouraged those who had the will, and ability, to paint.

Janie painted well. Her favourite subject was birds which she would execute in fine detail, often on silk. Her talent was a family trait. Her father, Colonel Edward Every Clayton, once Deputy Lieutenant of Derbyshire, was a skilled artist whose home was filled with his own paintings.

Thomas, descended from Colonel Edward Every Clayton's cousin, also inherited an artistic inclination, but his love was for music. At Simla, half a dozen productions of amateur theatricals were put on each year. Thomas produced a number of musical comedies, writing a good deal of the music himself. In 1904 Boosey and Co. was to publish one of his songs *The Braes o' Strathairlie*.

The Bairnsfathers were an unusual couple, not only because of their artistic talents, but also because

Painting of bird on silk by Mrs. Janie Bairnsfather.

they had a close relationship with Bruce. This was particularly true of Janie, and often she and Bruce would be alone with their Indian servants for weeks while Thomas was on duty in the plains. Most parents found it convenient to keep their children at servants'

THE

BRAES O' STRATHAIRLIE

Song

THE WORDS BY

MRS CRAIK

(AUTHOR OF "JOHN HALIFAX, GENTLEMAN")

The Music by

T. H. BAIRNSFATHER.

PRICE 2/- NET

BOOSEY & C̲o
295. REGENT STREET. LONDON. W.
AND
9. EAST SEVENTEENTH STREET. NEW YORK.
THIS SONG MAY BE SUNG IN PUBLIC WITHOUT FEE OR LICENSE.
THE PUBLIC PERFORMANCE OF ANY PARODIED VERSION HOWEVER IS STRICTLY PROHIBITED.
COPYRIGHT 1904 BY BOOSEY & C̲o

Cover page of "The Braes of Strathairlie" by Major Thomas Bairnsfather.

arms' length, but Tom and Janie shared, and communicated, their interests.

On 2 April, 1890, a second son was born, Malcolm Harvey. Thomas, now a Captain with the 29th Punjab Infantry, was no longer at Simla, but at another hill station called Dalhousie, further north on the Kashmiri border. Infant mortality, even among Europeans, was high in India, but hill stations, away from the press of humanity in the plains and cities, were generally safe from the epidemic diseases. Yet typhoid broke out in Dalhousie. Malcolm Harvey survived the typhoid but one month after his first birthday, on 16 May, 1891, died of meningitis and was buried the following day.

Meanwhile, Bruce was growing up, his Hindustani improving so that the *ayah's* rhymes and songs, her stories of demons and bogey men, were tuning his receptive imagination to the sights and sounds of India. As the family travelled about the hills, jungle and plains, impressions were stored away. Bruce saw the lazy brown rivers, the ruined temples, the blossoming flowers after heavy rain. Even then his eye for detail recorded images of snakes and butterflies, and the tricks of conjurors in the jostling bazaars. There

EARLY DAYS IN INDIA.

'I DIDN'T KNOW OF A BETTER 'OLE, SO COULDN'T GO TO IT.'

was a mystery to India, an amalgam of the *ayah's* tales and what he himself could touch and see.

The children of the British Raj were not allowed to stay in India for fear that the climate would "turn their brains". As soon as possible after the age of six, children were sent to England to school. But Janie didn't let Bruce go so early. She and Tom began his education themselves, further evidence of their attachment to him, but perhaps also a reflection of their meagre finances. For Janie the choice seemed to be between Tom and Bruce. Bruce had to go eventually, but should Janie accompany him or should she stay with her husband?

In the end, in 1895, when Bruce was coming up to his eighth year, they all went. It was to be Bruce's last journey across India. As they crossed the Punjab and skirted the vast Thar desert heading for the Indus valley and the port of Karachi, he experienced sounds and smells, and shimmering heat – impressions which would never leave him.

England seemed dark and dull. The Bairnsfathers travelled around visiting relatives, looking for someone who would take Bruce in for a while before he went on to school. Janie's brother, the Rector of Thornbury near Bromyard in Worcestershire, finally gave Bruce a home. Janie decided to go back to India with Tom.

Janie's brother took on the task of giving Bruce lessons, but for most of each day the boy was left alone. It was a strange quiet world. There were very few people about and no one who had anything in common with the young lad from India. They hadn't ridden on camels or elephants, heard the sounds of the jungle or jabbered away in Hindustani. In his isolation Bruce found his own amusements, frequently to the dismay of his uncle. He climbed trees, got muddy and smoked pipes secretly in the laurel bushes at the bottom of the garden. But more than anything, the loneliness of Thornbury made him draw.

As soon as his fingers could hold a pencil, Bruce had drawn pictures. Both Tom and Janie had drawn and painted and it was natural for them to encourage their son to do the same. Their pictures were representations of what they saw, rather than felt or imagined, and Bruce, while competent, seemed to have no particular talent. Now he was alone in England, far from the clear skies and wide open spaces of the Himalayas, far from his parents and, in particular, far from his mother. His mind, full of the bright images from his childhood, savoured the memories, and his frequent letters to his parents began to be illustrated with small sketches. Expressing his sense of loss, he relied upon his imagination, not to draw from life, but to draw about it. As he drew more often, the tension of separation eased, and soon he began to picture things around him. Bruce's drawings

were never directly taken from life but representations of his mental state. When milkmaids began to adorn the pages of his letters, Tom and Janie decided that it was time that Bruce went to school.

A son followed his father's footsteps. It was a natural assumption of the age. Living the life of the British Raj indoctrinated British children with an attitude which made them uncomfortable except amongst their fellows, so the choice of school was important. Tom and Janie chose Westward Ho! Kipling's school, the school sired by an even older establishment at which boys were groomed for Indian service – Haileybury.

USC Westward Ho! had been founded in 1874 by a group of retired Army officers in order to provide the type of public school education for their children they could not afford to pay for at the older established schools. Many of the earlier masters came from Haileybury, and the school set out with one major *raison d'être* – to get its boys into the Army through Sandhurst or Woolwich.

Janie missed Bruce terribly. He missed her too, but creativity assuaged his pain. In 1897, on 16 October, Janie bore her third and last son, Thomas Duncan. Janie would make sure he would never be sent far away to school.

When, the family came to England on leave the following year, they became convinced that the rising tide of their eldest son's artistic output had to be stemmed. This feeling was reinforced when relatives

EARLY DAYS IN INDIA

BAIRNSFATHER'S CAMELRY.

kept emphasising the child's need of discipline. Bruce was enrolled at Westward Ho! In May, Thomas took his son to meet R. T. Leakey, headmaster of the junior school. In regard to the lad's drawing ability he was quite specific. "Beat it out of him," he said. A month later, in June, canings began.

In the early days I found illustrating my career in the margin, most unlucky.

Bruce stayed at Westward Ho! for six years, the first two of which he spent in the junior school. There he was bullied, caned and had to fag for the senior boys. Much of the caning he brought on himself. He was mischevious by nature, and the contrast between the long isolation at Thornbury and the now constant close contact with other young excitable boys of like family background, brought an over-reaction.

Bruce devoted himself to avoiding work, despite the constant fear of reprisals from irate members of staff, who were free in their use of the malacca cane – a cane supplied by Hamptons, or Waring & Gillow. "On one occasion," recalled Mr Leakey later, "an exercise book was brought to me bearing on the cover 'Prep-work – Bairnsfather'. The contents told the tale of BB's excessive zeal during preparation – soldiers on every sheet, in every attitude." As a fitting punishment Bairnsfather was kept in the next half-holiday and told to spend two hours drawing soldiers instead of joining school games. The punishment only added fuel to the fire. The fact that he managed to

pass the entrance examination to the senior school was a great surprise to him, and a great relief to his parents. After his elevation to the senior school in 1900, the staff finally gave up in their efforts to educate him.

In 1899, Thomas had completed his Indian service as a cantonment magistrate at the big military camp at Umballah, 150 miles south of Lahore, and he was promoted to Major. Thomas, Janie and Duncan, whom they called Bumpy, came back to England and took a house near Bideford in order to be close to Bruce, yet another indication of their unusual attachment to their children.

Bruce continued to do badly at school. Although, like Kipling, he had been bullied in his early days, and had illustrated his letters home with small drawings of school life, evidence of a talent outside the military curriculum, unlike Kipling, Bruce did not gather around him a protective group of afficionados. He was an individual in a pack of individuals, assessing his teachers on a scale he called "their awe value". The lower the awe value the more he played around, digging holes with a pocket knife in desk tops to hide secret notes, throwing pen holders with their spiky iron nibs to stick in the classroom ceiling and finding grass snakes and slow worms on the hillside to produce during prep. Everyone, from the headmaster down, caned him. Even the prefects caned him for not liking rugby, and on one occasion he was caned just because in the preceeding week he had already had too many canings.

It was an increasingly worrying time for his parents. At the end of term his reports would be terrible: "Mathematics – bad; Chemistry – very bad, makes no attempt; French – poor." The criticism was unrelenting. The sad reaction of his father and mother to his results usually produced a short-lived determination while at home during the holidays to mend his ways, but this resolve never lasted once he returned to school. Playing with catapults was far more interesting.

But his individuality strengthened. A natural gift for caricature began to emerge. The diverting possibilities of pocket knives and pen nibs as alternatives to paying attention in class began to pall compared to the effects he could produce by illustrating his textbooks. In any class where the teacher had a low awe value, Bruce devoted his total effort to drawing comic pictures, in the margins of his textbooks. These drawings would pass from hand to hand around the class under cover of desk lids, their passage marked by giggles that led backwards to Bruce, a trail anyone could follow.

Soon Bruce's drawings became direct caricatures. Every blank surface served as a canvas for his observant pencil or crayon. Books, walls, blackboards and

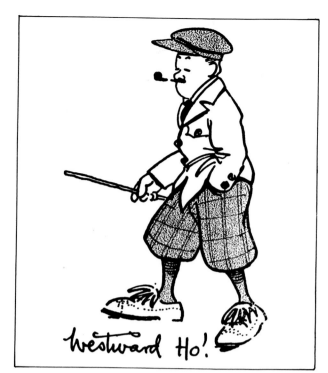

Westward Ho!

scraps of paper were all put to use. The more he drew, the more his admiring fellows encouraged him to draw, the less he worked. The caricatures increased in range, unwisely including one aggressive pupil who up-ended the artist into a clothes cupboard. But the staff were becoming aware that thumping Master Bruce on the head with a book, or the hand and bottom with a cane, was having no effect, and, strangely, they too were falling under the spell of his talent. Their final capitulation came when a staff member negotiated an exchange with the young artist – a nice clean textbook to replace the one that had just been "illustrated", as Bruce put it. The illustrated version was for circulation around the Staff Room.

In 1904 a new problem arose for Bruce's parents. General difficulties in staff and administration led to a decision that the school be moved to a more readily accessible and populated area. Should Bruce move with it? There seemed to be no point in his doing so. He had been there since 1898, and, apart from winning a school prize for drawing, had achieved only notoriety. The USC left Westward Ho! for Harpenden in May, the first in a series of moves and amalgamations which would eventually lead back to Haileybury.

Tom and Janie were still determined to educate Bruce and they decided to send him to a crammer where sufficient knowledge to pass the Army entrance examination could be forced into him. London crammers were far too expensive for their means, and

they finally settled for a Stratford-upon-Avon crammer called Trinity College. Once more they moved to be with him, renting half a large spa house at Bishopton. They would be there a long time.

Life at Stratford was a total contrast to that at Westward Ho! Trinity College was a rather grand title for a small school whose object was to get its students through examinations. Bruce himself observed that the general atmosphere of terror was missing and that "we were all much of the same age and did not have to slink about in fear of prefects and canings." The most startling difference, however, was in the extra-mural activities, and, in particular, visits to the theatre, where Bruce would sit enthralled, absorbing the atmosphere, remembering all the theatricals and parties of his childhood in India.

Nevertheless, his mind was set upon the Army. The cumulative effect of family tradition, six years spent at USC amongst boys whose common objective was a Service life, and a memorable holiday, during which he had seen the Seaforth Highlanders marching to church in full dress uniform, made him "burst to be a soldier". He wrote: "If only I could hurry up and get into the Army and look like that. Travel, romance, uniform, adventure. How I could swell around in front of my friends and relations." He attacked his studies – but only during weekdays.

Major Tom had arranged for Bruce to be a weekly boarder at Trinity College, probably because it saved a little money and also because both he and Janie felt able to add to their son's education at home. Duncan was now seven, and soon the problem of his schooling would be upon them. It was vital that Bruce be settled before then. The house that they had rented at Bishopton was divided in two, and the other half was rented to a Mr Czekacs, a Hungarian mathematician. By coincidence, Mr Czekacs had a great interest in birds, which complemented Janie's own fascination and encouraged her painting. He also played the banjo, a hobby which Bruce took up, so that the weekends at home were full of relaxations that rounded the corners of life that had been so sharp at USC.

Bruce had his own attic room where he could draw. Now, away from the introspective, narrow world of school, and subject to the warming influences of home, his artistic inclinations became more ambitious. He began to look around at the beautiful Warwickshire countryside, and to record his impressions in watercolour and in oil. They were new media to him and he didn't know how to use them. Learning of an evening art class at the newly-built Stratford Technical College, he persuaded his father to let him attend and very quickly became the star pupil. Mr Tom Holte, headmaster of the Art School, was quick to recognise Bruce's "special talent" and appreciated the great sense of humour the lad showed "in person

and pen''. Later, when he had achieved the fame that Mr Holte had forecast. Bairnsfather referred to him as "One of the Original Prophets".

Blossoming under Mr Holte's encouragement, Bruce's determination to pass the Army entrance examination gradually faded before his burgeoning artistic talent. It was only a small step to another outbreak of school cartooning and it soon happened – and even worse than before.

Bruce drew on the lavatory wall at Trinity. About twenty-five years later the lavatory was due to be pulled down. Mr Holte's son, with great perspicacity and thought for posterity, spotted those drawings and, immediately recognising them as the work of his father's prize pupil, photographed them. They clearly show characteristics of the world-famous codger who would appear ten years later.

Bruce, who was now known as the school's resident cartoonist, also began to sell his drawings to fellow students. Thus, at age seventeen, for half a crown here and seven and sixpence there, he made his first sales, and encouraged by these, he began to design and submit advertisements. Disappointment followed disappointment until one day a design for Players Navy Mixture was accepted, and his first cheque – two guineas – arrived. The future seemed assured. Bruce carried the cheque around for weeks, showing it to friends and anyone who would listen, until it was almost too tattered to cash.

His enthusiasms were being divided. The Army was still his objective but his energies were finding their own outlets and rarely in studies. The result of the

Photo taken in 1936 by Mr. T. Holte of Holte Photos Ltd., Stratford-on-Avon, of a Bairnsfather sketch on a lavatory wall of Trinity College, circa 1905.

examination, although anxiously awaited, was a foregone conclusion. He failed. "The only light in the darkness," he said, was "that I got nearly full marks in drawing." It is doubtful if Major Thomas or Janie saw that particular light.

Nevertheless, Bruce had a stubborn streak. Objectives were to be achieved, not compromised. His persistent determination to draw, despite school canings and parental disapproval, had been almost an unconscious expression of a natural talent. Now he demonstrated a development of that persistence, a conscious, calculated decision to try a different approach.

Entry to the commissioned ranks of the Army could be made in two ways. The first was through entrance to either Sandhurst or Woolwich. Well that was out; he had failed the exam. The second was by passing a much simpler examination followed by about eighteen months of basic training, finally leading to a full regular commission, a type of apprenticeship. Bruce tackled his father, who agreed to let him have a try, and then enlisted the help of Mr Czekacs to assist with the mathematics. Drawing was pushed to the side and he settled down to work. It was a decision on his part based on a compound of reasons. There was the objective itself that remained desirable, there was the evident disappointment of his parents to overcome, there was his own internal rejection of personal failure, and overall, there was a legacy from his youth in India – the Eastern concept of "saving face". It didn't look right to fail.

This time, in his eighteenth year, 1905, he passed.

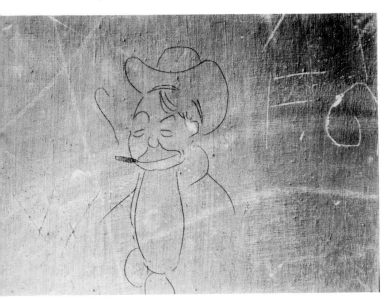

How many?

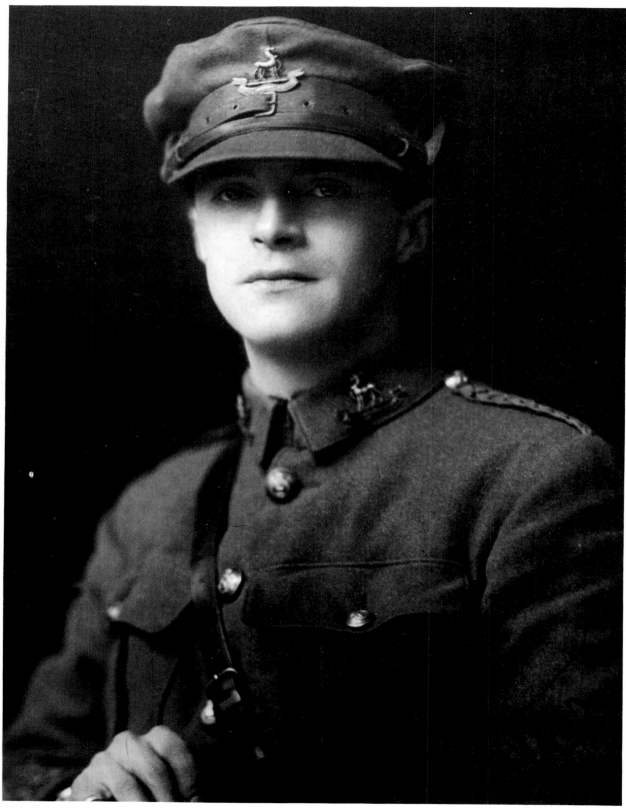

Bruce Bairnsfather in his militia uniform, circa 1908.

Chapter 2

Army, Art & Apprenticeship

(1905–1914)

Bruce joined the Third Militia Battalion of the Royal Warwicks, stationed at Budbrook Barracks, Warwick. Their ranks were full of what Bairnsfather in retrospect recognised as "a veritable herd of Old Bills, and those who weren't Old Bills were certainly 'Berts' and 'Alfs'. Living and drilling with them as I did I was unconsciously laying up a store of knowledge about them which was to aid me much when I started on my cartoons in the then un-dreamed of trenches".

The endless hours of drilling, bayonet exercises on cold, foggy mornings clutching an icy rifle, route marches, shooting practice in the butts, the training under canvas at Wedgenock – soon made Bruce realise that "if there was a Field Marshal's baton in my knapsack it was way down at the bottom, buried under a pile of sketches and notes". The only thing he found amusing was the elaborate uniform, which he referred to as a "costume".

Even transfer to a Regular Battalion of the Cheshire Regiment, his father's old regiment in Lichfield, and promotion to second lieutenant – "the lowest form of officer life" – only strengthened Bruce's opinion that he was "a military flop". He did, however, learn an invaluable lesson in junior officer survival – the importance of implicit trust in one's Sergeant Major and the magic words, "Carry on, Sergeant!"

The life, he moaned, "bored me to tears", and his sanity was only maintained by taking every opportunity to escape to Birmingham and haunt the lively music halls, such as the Hippodrome and the Empire. He was storing up knowledge that would stand him in good stead in later years although on the surface he was simply "having a jazzed up time" as part of a bright young set intent on getting as much experience of wine, women and song as they could.

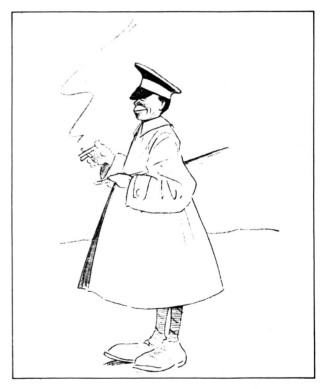

When the Regiment moved to Bordon, near Aldershot, and the safety valve of the Brummy music halls was no longer within Bruce's reach, the urge to give up the Army became irresistible. He became ill, and, given more time to reflect on his discontent, he decided to resign. He prevailed upon his parents to let him embark on an artistic career. It was 1907.

Only the Bairnsfathers' artistic talents can have given them enough sympathy and understanding to respond to Bruce's outrageous idea. Major Tom jour-

neyed to London to consult with a friend, "a distinguished member of the British Royal Academy", who gave him some sound advice. The friend said that if Bruce was determined to leave the Army he should be trained to "sell something, to eat".

Bruce was enrolled in the John Hassall School of Art near Olympia at Earl's Court with Charles Van Havermat as his instructor. At this time the equally-famous Dudley Hardy was Co-Principal, and H.M. Bateman had recently left the school to further his commercial career.

Major Tom had made the ideal choice. Hassall was to exert a profound influence on Bairnsfather, and indeed his own career had many parallels with that of his pupil. Later his daughter claimed that Old Bill was probably modelled on her father, as Hassall had a walrus moustache. There is quite a resemblance.

John Hassall had also failed the entrance exam to Sandhurst, but not once – twice! Like Bruce would

John Hassell, whose art school Bairnsfather attended and who was one of the claimants to be the original of Old Bill.

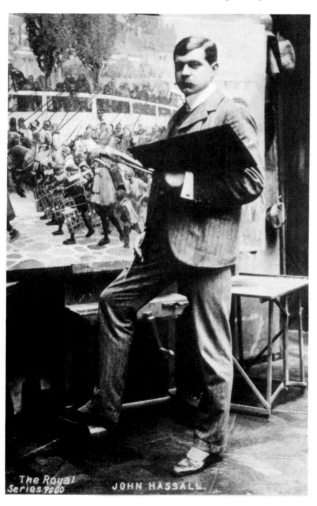

shortly do, he embarked on a career that had nothing to do with art – in his case, farming with his brother in Canada. Like Bruce, he continued to draw and sketch and won first, second and third prizes two successive years in the art exhibitions at the Canadian town of Winnipeg, Manitoba. Like Bruce, he went to school and even studied under Charles Van Havermat – at Professor Van Havermat senior's Academy in Antwerp. But perhaps the biggest similarity between the two was that both their careers took off dramatically through the patronage and promotion of a publisher. In Bairnsfather's case, the *Bystander* organisation was to see his potential and exploit it. For Hassall it was Messrs David Allen & Sons, the colour printers of theatrical posters and postcards, which made him famous.

David Allen sent out a circular letter asking a number of artists if they could produce posters. Hassall replied promptly, saying that he could, went to see them, and was hired on the spot as a result of a lightning sketch he did for the theatrical revue *The French Maid*. He worked for David Allen for seven years, producing hundreds of poster designs. Hassall, despite his varied abilities (he frequently exhibited at the Royal Institute of Painters in Watercolours, for instance), was always known as "the poster man". His humour shone through his drawings and he was once described as "the only man who could make cobblestones comic". Perhaps the one ability shared by both pupil and teacher which most contributed to their success was their power of observation.

Hassall, Dudley Hardy, Tom Browne, and Barribal (later to become Bairnsfather's friend) seemed like gods to the aspiring art student, and although he was obviously influenced by Hassall, it was Van Havermat who tutored him. Van Havermat had a diligent pupil. Bruce took a small room in Earl's Court. After working hard all day at the school, often the last pupil

About 10 years of this intensely absorbing study

to leave, Bruce would continue to work on his charcoal sketches back in his bare room. For relaxation, he haunted the music halls of West London. The Hammersmith Palace and Shepherd's Bush Empire provided a grounding for his own act yet to come. He observed humanity and stored his impressions – and worried about his future. After the gay, irresponsible but comradely Army life, Bruce often felt very lonely and depressed. As he came to realise later in his career, this frame of mind engendered some of his best and funniest work.

Van Havermat soon came to regard Bruce as his favourite pupil, and took a special interest in him, giving him individual lessons after school hours. He even did a portrait of Bruce in red chalk highlighted with white. As Bruce approached the end of his course, he asked his master's opinion of his future success. "You ought to be able to make £700 a year, but on the other hand, you might make nothing," was Van Havermat's equivocal pronouncement. It left Bruce dejected but determined.

Having studied at the Hassall school, it was natural that poster work should be Bruce's target. He met with little success and entered a period of profound gloom, with nothing but a collection of rejection slips to prove that he was working as an artist. He suffered the added responsibility of having to prove that his parents' generous decision to send him to art school was justified. After the months of what must have been expensive tuition to a family living on an Army pension, Bairnsfather was acutely embarrassed when well-meaning "friends" told his parents how sorry they were that they "couldn't do something with Bruce", or when relatives commented "Oh you know he draws; it's such a pity". Bruce weighed his burning desire to be an artist against his filial duty and, swallowing hard, took a job. At the time it seemed a terrible admittance of failure but despite a façade of irresponsibility he was (most untypically of his class and generation) extremely sensitive to his parents' feelings.

The most interesting opening that occurred in Stratford, the nearest town to the family home at Bishopton, was a job as an electrical apprentice with the firm of Spencer's, in Henley Street. The business was founded by Spenser Flower, brother of Mr Archibald Flower of the famous brewing family, well-known in the Stratford district.

Spenser Flower was a creative man. He invented the first double filament lamp which gave light bulbs twice the life. This invention was not well received by lamp manufacturers, and the idea was quashed. He also created the Dunlop tennis press and a design for an airship. But the Spencer business in Stratford that Bruce joined was perhaps the most original of all.

Spencer's sold "petrol gas" generators which could be used to provide lighting in homes and buildings. They also specialised in wiring premises for electricity.

At first, Bruce was a humble apprentice. Another Spencer employee, Mr William Piggott, went to live with the Bairnsfathers as a paying guest. It was a happy firm to work for, with a friendly relationship between workmen and their boss. Spenser Flower, Bruce and Jack Whakeley, also employed at Spencer's, bought a motor bike between them and they took turns to ride it.

At this time Bruce was living at home in Bishopton, in the Spa House. The Spa House had been built in 1837 as part of a development which aimed to take advantage of the current craze for health resorts by building a spa using the saline and sulphuric mineral spring at Bishopton. The complex originally consisted of the Spa House with a modern pump room and baths, and a hotel. It was opened with great hopes and ceremony to celebrate Princess Victoria's eighteenth birthday on 24 May. Lack of capital eventually led to its failure as a paying concern, and the whole project, which aimed to convert the open countryside of Bishopton into a thriving resort to rival Leamington or Droitwich, was finally abandoned. Renting out the spa as a private residence was a final attempt to make back a little of the lost money.

The senior Bairnsfathers became an established part of Bishopton social life, despite their modest means. Major Tom joined the local golf club and on Easter Monday, 5 April, 1907 took part in the medal play Kendall Cup Competition, coming fifth with a score of 93, handicap 10.

Mrs Bairnsfather pursued her favourite activity of horse riding. Her pride and joy was her saddle horse, a mare called Lorna Doone, which she rode side-saddle. Major Tom anxiously followed her progress as closely as possible by bicycle to see that she came to no harm with her fearless jumps. Mr Dial the groom/handyman, who lived with his wife in a cottage in the enormous stableyard, was in charge of a pony which drew the pony trap. Again, it was Mrs Bairnsfather who drove, and Major Tom who was her passenger on their shopping expeditions to Stratford to the butchers (who sometimes complained about unpaid bills) and the grocers. A monthly hamper arrived from Harrods to supplement the fare bought in local shops.

Mrs Bairnsfather, apart from the damage to the complexion that life in India always inflicted, was slim and handsome. She was, however, beginning to suffer from the rheumatism that was virtually to cripple her in later years and occasional expeditions were made to Leamington Spa to take the remedial sulphur baths. Janie would take the opportunity while in Leamington to visit the makers of her long

Bairnsfather's watercolour of Bishopton Gateway, circa 1910, given to Mr. W. Kedward.

riding habits, Sumner's of Clarendon Street. She went out riding every morning wearing a jaunty bowler after she had consulted with cook about the day's meals. Her pockets bulging with sugar lumps and carrots, she would bid good morning to Lorna Doone and the pony. When Major Tom went on his annual shooting holiday to Scotland she spent the days contentedly painting her delightful birds and bulrushes on silk, telling the servants she was not at home to callers.

Day-to-day life was simple and homely. The household consisted of Major and Mrs Bairnsfather, Bruce (whilst he was working with Spencer's), Duncan (apart from his period as a boarder at Oundle), William Piggott and the staff – Mr Dial the groom, Ethel Dykes the cook, and Rhoda Brooks the parlourmaid. During the day Major Tom spent a good deal of time in his study, composing music and work-

ing on family and charity concerts. At weekends Bruce spent hours in his studio at the top of the house, painting poster after poster and drawing charming watercolours of the countryside around his home. The family were prodigious letter writers. Every evening the parlourmaid collected the day's post from the hall table. The postman walked along the canal and blew a whistle as he neared the Spa. Then Rhoda would run out with the letters and pass them to him over the wall.

Economy was important, and family meals were modest. Breakfast and lunch were set out for the family to help themselves but dinner was always treated as more of an occasion. The family changed for dinner and Rhoda waited at table throughout the meal. First came the soup, in a large, egg-shaped silver tureen. Major Tom would serve the fish and carve the meat, sipping a Marsala or a whisky and the

Vesta Tilley, Dan Leno and George Robey, three of Bairnsfather's music hall idols.

meal always ended with fruit and nuts. Conversation was lively, with discussions on recently published books – the *Scarlet Pimpernel* being a unanimous favourite. Often the subject of Bruce's future was discussed and the standing family joke was that if he wanted to pursue his career as an artist, he would "have to marry money".

Duncan also caused some parental concern. He had enrolled at King Edward VI School in Stratford in the summer term of 1908, having previously been taught by his father at home. He is remembered by school friends as a mischievous boy, always in some sort of scrape. He ran up large bills at the school tuck shop, much to his mother's dismay, and generously distributed his largesse to friends. In 1910 it was decided that boarding at King Edward might help discipline him and counter-balance Janie's undoubted spoiling, but after a year he was moved to board at Oundle School, Peterborough. The fees were £25 p.a. for tuition and £60 p.a. boarding fee, perhaps too great a strain for the family budget, for in the autumn of 1914, Duncan, who was known at school as Tom, by his mother as Bumpy, and by most of his friends as Teddy (after his initials TD), was moved back to King Edward VI School for his sixth form year.

Each year the family went to Knocke-sur-Mer in Belgium for a holiday and while they were away Ethel and Rhoda had to spring clean the whole house. It was a happy household, the servants being extremely fond of their "Family" whom they regarded as "real gentry". Occasional social interchanges took place

with local "county" families, but dinner parties at Bishopton were not frequent.

At Christmas time, however, there were great celebrations. On Christmas night the family came into the kitchen, with large meat plates of raisins set alight with brandy, and the servants snatched the hot fruit from the dishes.

The family also put on an annual Christmas performance in the Great Bath Room of the Spa, which they converted into a concert hall for the villagers of Bishopton.

In 1909 this Christmas play was a splendid affair. Some fifty or sixty parents and children first sat down to tea, catered by Mrs Coles of Union Street. Over tea they read a large poster announcing that a concert and variety entertainment would be given in the Royal Spa Theatre. Moving into the converted Bath Room, they found a miniature stage erected on the main platform. From this the first part of the programme was played. It consisted of a puppet orchestra and performers (the music being provided by a gramophone concealed behind the puppet theatre). The programme ended with "The Family Grotto". Bruce, who had made the miniature stage and the puppets, pulled the strings, assisted by his father. Mr Czekacs played the gramophone. The second half of the show was a variety concert. Solos were performed by young Duncan Bairnsfather and Mr Paul Pym, a relative of Mrs Bairnsfather who often stayed with the family. Bruce and Mr Czekacs played the banjo and Major Tom accompanied on the piano. The entertainment, long remembered at Bishopton,

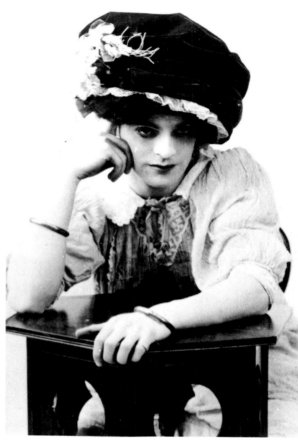

Two of the four photographs of Bruce Bairnsfather as Minnehaha and Nellie given to Rhoda Kemp circa 1910.

ended with Christmas presents all round.

Bruce called the miniature theatre "The Bishopton Empire" and constructed cardboard marionettes of his stage idols – George Robey, Vesta Tilley and Dan Leno.

Mrs Bairnsfather's contribution to these entertainments consisted of making the costumes. She was an accomplished needlewoman and especially enjoyed making clothes for Bruce. He was extremely handsome at this period with dark eyes and expressive hands, later remembered with enthusiastic affection after nearly seventy years by Rhoda Brooks (later Mrs Kemp) the parlourmaid at Bishopton. Bruce was described by Rhoda as "most beautiful looking". Rhoda found it hard to take her eyes off Master Bruce when she served at dinner. Once she was thrilled to be asked by Mrs Bairnsfather if she'd sit for the young artist. He had been having trouble getting the hands right in one of his pictures and his mother had remembered what well-shaped hands her parlourmaid had. When Bruce was satisfied with his work, Mrs Bairns-

father nudged him to say a proper thank-you to Rhoda for her help. He offered her a choice of four photographs. The enraptured Rhoda couldn't decide which to take – so Master Bruce gave her all of them.

One showed him in an Indian Princess costume (made by Mrs Bairnsfather who had trouble getting the beads) which came from a Bishopton production, "Extracts from Hiawatha". The family also put on scenes from *Chu Chin Chow* at another Christmas entertainment and a costume with a feathered hat was worn for one of Bruce's speciality songs – " 'You don't know Nellie like I do,' said the saucy little bird on Nellie's hat". Bruce took part in many amateur theatricals at this period, specialising in female impersonations and, to quote a school friend of Duncan's who frequently saw him perform, was "the Danny la Rue of Stratford". James Pearce, who often accompanied Bruce on the piano, remembers his clever portrayals of old women, as well as fashionable young girls. Bruce's many lady friends supplied most of his chic costumes and with the help of skilful

make-up he looked most convincingly female. Before one concert, already dressed, Bruce paid a visit to the lavatory where the outraged caretaker told him: "You must come out of this room miss, the rules are very strict here and ladies are not allowed in the gent's room." "Come and pull me out," was the masculine Bruce's retort.

Bruce sometimes put extempore jokes into his act, occasionally at his pianist's expense. One evening, as James played the introduction to his song, Bruce ran his fingers through the pianist's thick hair, commenting: "I must get this attended to, the moth's getting into it."

The concerts they did together were mainly for charity. The Earl of Gainsborough arranged two such charity performances during one day in Chipping Norton, and, between concerts, Bruce and James dined with the Earl.

Bruce arranged a series of concerts, painting the scenery and backdrops as well as performing in charity pantomimes at Compton Verney, the Warwickshire seat of Lord Willoughby de Broke. Sometimes Major Tom joined Bruce at the charity performances, either playing the piano, conducting or acting as "Chairman", for societies such as the National Deposit Friendly Society. In 1909 he did a turn in a concert at the Boy Scouts headquarters in Rother Street when, dressed as a country lad, he sang:

"Mary Ann she's after me
Full of love she seems to be.
My mother says it's plain to see
She wants me for her young man.
Father says if that be true,
Johnny lad faithful be,
For if there's one bigger fool than thee
It's Mary, Mary Ann."

Bruce varied his female impersonations with a red nose, baggy trousers and umbrella comedy act, working hard at his routine and make-up. As always, with everything he did, he took the trouble to do well, and on one particular occasion his professionalism paid dividends.

The Victorian novelist Marie Corelli had settled in Stratford after amassing a fortune from her melodramatic, highly moralistic books (*The Romance of Two Worlds, Barabbas, The Sorrows of Satan, Temporal Power*). Though incurring critical censure for her questionable taste and over-sentimentality, she cut a flamboyant and colourful figure on the Stratford social and cultural scene. Born Mary Mackay in 1885, she had adopted her pseudonym for an earlier career as a singer and pianist. She felt instant rapport with the handsome young artist she saw playing Ali Baba in a Stratford pantomime of *The Forty Thieves* (his own production) and determined to help launch Bruce on a music hall career. At this stage he really

wasn't ready. He most of all wanted to be a successful artist, and failing that, a competent highly-salaried engineer. But the impetuous Marie, convinced that she'd made a rare discovery, hauled him off to London to see her friend Sir Edward Moss, head of Moss Empires. Asked to audition, Bruce cried off in terror, asking if he could come back at "some later date when I feel more sure of myself". Ironically, some ten years later he was to tour Moss's theatres with his professional music hall act.

Bruce had already achieved one or two artistic successes since graduating from Hassall's school. His first sale was an advert for Player's tobacco. *The Geisha* and *San Toy* were playing at the time and he reflected the current vogue for chinoiserie by drawing a row of Chinamen, all smoking Player's cigarettes, with the words:

"For they smoke it in the West
Where it's reckoned quite the best
And you see they've introduced it into China."

He then sold an ad to Keene's Mustard. It showed a boy standing on a chair before a huge map of the world. The boy had dipped his finger in the mustard and smeared a broad line across the map. The caption read:

"One touch of mustard make the whole world Keene's."

Beecham's ads were his next success, showing "particularly athletic nymphs decorated with teeth, golf clubs and tennis racquets and positively bursting with health". But rejection slips were still more frequent than pay slips.

The influential Marie Corelli gave him a good lead when she introduced her protégé to Sir Thomas Lipton, the "Tea King". After an interview, again in London, he was asked to submit suggestions for posters. After many attempts, he was eventually successful with a drawing of a caddie driving a golf ball from the top of a packet of Lipton's Special. There was the typical Bairnsfather pun in the caption:

"Liptons make the best tea"

Bruce spent his fee many times over buying copies of the book by George Morrow on whose back cover his ad was printed. More Lipton's and Beecham's ads followed and Bruce saved as much of his fees and his salary from Spencer's as he could spare in order to buy tickets to the music hall and to make visits to Paris and Brussels to study French and Belgian masters. His greatest artistic success at this period came when he won a poster competition organised by the Sunbeam Opera Company, then on tour in Canada. The prize of £10 was won for his picture of Orpheus seated on the world, symbolising the company's tour.

At Spencer's he had progressed from the humble unsalaried position of wireman's assistant whose first assignment had been to help during the lighting of a

fruit warehouse at Evesham. This had mainly consisted of holding the foot of a ladder. His second job was the wiring of the old Memorial Theatre at Stratford and he'd enjoyed it. He loved the theatrical atmosphere, and the view of the peaceful Avon river. He helped to install the switchboard and then when the Shakespearean season began, he worked the switchboard for the princely sum of 30s. a week. He was also able to indulge his artistic side by designing two of the festival posters. When the season ended he was moved to Spenser Flower's other family business, Flower's brewery. Because he was "still learning" he again reverted to a non-salaried position. In addition to wiring, he learnt how to operate and maintain the dynamos and motors in the brewery's power house.

Bruce's first significant promotion was to wireman. He then progressed to inspector and finally to lighting engineer for the large country houses that provided Spencer's main clients. Gradually he became speciality salesman to the gentry, manning the firm's stand two successive years at the Industrial Exhibition at Olympia – periods which must have made him nostalgic for the nearby Hassall Art School.

When a sale was made, Bruce often moved in "en famille" with the household while he completed the installation. He usually won the admiration of his aristocratic clients with his after-work sketches. It irritated him intensely when they commented that he should give up installing electrical fittings to become an artist. His dedication to engineering was tenuous enough to waver every time he was encouraged to think he might make an artist, but he stuck to his guns, and amused himself by evolving some sophisticated psychological techniques to deal with the variety of potential client types. He enjoyed testing his powers of observation and ability to judge character, and employed a "Rich Lady Technique, another for Irate Colonel . . . Petulant Earl, Retired Contractor, Poor Lady and Rector", each with its own script. Bruce had thus worked out for himself techniques that salesmen are taught today. Like a budding politician, he soon discovered that sympathy for sickness or children melted the most difficult case. He was often able to sell to wives if he concentrated on the colour of the lampshades they could hang. His most trying jobs were as a roving troubleshooter, sent to diagnose and cure faults in defective plants. Then he had to beard irate clients, often titled, in their lairs, humbly introducing himself as "The man about the gas" or "The man about the electricity", or "The man about the lights".

Between his forays into the upper stratum of society, Bruce led the more mundane existence of a commercial traveller, staying in seedy hotels, hiring a bicycle at the station to visit country prospects, and taking every opportunity to pop into the local music

hall in his leisure time to follow his idols, such as Harry Lauder, Wilkie Bard and Harry Tate. He always had an affinity for the ordinary working man and he developed tremendous respect and affection for his fellow travellers. It may well have been during this period of working class existence that Bruce, a product of an aristocratic line, the British Raj and public school, did something quite alien to his background. He was tattooed – with a cobra on one arm and a butterfly on the other. The tattoos, which he never had removed, may well have given him a feeling of belonging, and solidarity, with his fellow artisans.

His work took him from "Holyhead to Thanet and from John o'Groats to Land's End." Back in Stratford, between sales trips, there were moments of light relief. His boss, Spenser Flower, married in 1911 and Bruce presented him, on behalf of the staff of Spencer's, with a silver bowl. Bruce had come to know and get on well with Mr Flower and did a series of twelve amusing adverts for Flower's Brewery which were used between 1918 and 1930. Mr Dennis Flower feels the "deliciously corny rhymes" (based on "The House That Jack Built") may well have been written by his father. But they are also typically BB, as he was an inveterate versifier in his early days.

To celebrate the Coronation of George V in 1911, Stratford illuminated the banks of the Avon and a river pageant, with prizes for the best illuminated floats, was staged. Bruce and his pals, Kedward and George Whakeley from Spencer's, built a fantastic fish of canvas, mounted on a punt, and lit precariously with naked candle light. The creation was over twenty feet long and eight feet wide and the intrepid designers sewed themselves into the canvas superstructure with packing thread.

Unfortunately, the weather seemed intent on damping their enthusiasm. From a steady downpour the rain developed into a virtual deluge, and the fish,

which originally bore more resemblance to a cod than the dolphin it was supposed to represent, collapsed entirely. Nevertheless, the Spencer's team won the third prize of £3 which offset the 19s. 6d. it cost to assemble their river monster. They fared better than a Mrs and Miss Bloom, whose representation of "A Midsummer Night's Dream" underwent a series of misfortunes as regards illuminations, the fairy lights one by one refusing to keep alight.

The river pageant, in particular the Bairnsfather fish, is still remembered with amusement by senior residents of Stratford-upon-Avon.

Life did have its harsher moments for Bruce at this period. Perhaps his most bitter disappointment, leading to ever deepening feelings of inadequacy and failure, occurred when he applied for a job as an artist. He had spotted it in the "Artists Wanted" columns of the *Daily Telegraph*. In reply he sent off some samples of his work and after a period of excruciating suspense, he was asked to attend for interview. His imagination ran riot and he had visions of heady success as he made his way to London. It went well too, until asked what he "would expect in the way of remuneration". He dared to whisper, "perhaps two pounds ten a week". No decision was made at the interview and Bruce was sent away to submit more sketches. Hope was still alive. Several suspenseful weeks later a large flat parcel arrived in the post and the covering letter started: "Dear Sir, We are frankly disappointed with your further designs . . ." Happily his mind was taken off this crushing blow to his aspirations by a new challenge.

In his capacity as diplomatic repairman to the gentry, Bairnsfather was despatched by Spencer's to sort out a malfunctioning machine in far off Newfoundland. Early in 1914, with his toolkit, he set sail from Liverpool on the *Mongolian*, sharing a cabin with a traveller in lace. For Bruce it was the first of many desperately seasick transatlantic crossings. He

was a fearful, and excruciatingly bad, sailor. Eventually, and almost to his surprise, Bruce arrived alive, if not well, at St John's and travelled on by train to Spruce Wood which he likened to the set of a Western film – with a décor of Indians and log cabins.

His client, Captain John O'Neil Power, owned, with his partner, a huge log cabin hostelry. BB was made very comfortable, and after his day's work on the recalcitrant lighting plant, filled his sketch book with local scenes and types. Power immediately recognised the embryonic spark of genius in his electrician's art work, much as former clients had done. But Power followed his praise by commissioning Bairnsfather to design a luggage label for the hostelry, and prophesied a successful future if Bruce would "chuck up engineering and . . . go in for art work". Later he was to remind Bruce of his advice.

Eventually the troublesome machine resumed working order, largely thanks to a strategically-placed piece of string, and the elated electrician beat a hasty retreat to St John's whilst it was still operational. Waiting there for a boat to take him home, he absorbed the local colour, observing and sketching.

Eventually he scrounged a berth on an ancient tramp cargo loaded with timber and bound for Liverpool. The old tub hit very heavy seas at first but they

soon calmed, and BB spent one of the most pleasant crossings of his life, making friends with the cook, who in exchange for sketches prepared the curries that Bruce still loved.

As the travelling salesman and electrician-cum-part-time-artist docked at Liverpool in a creaking cargo tramp, the cataclysmic event that was to bring him world-wide fame was exploding.

Advertisement by Bairnsfather for Flowers beer c. 1912 by courtesy of Mr. Dennis Flower.

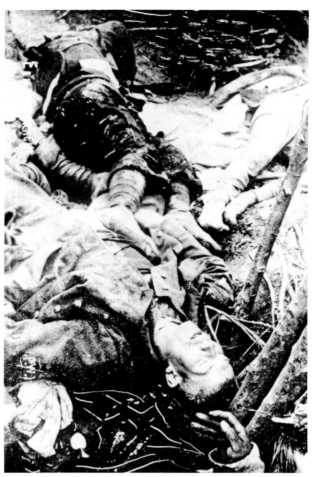

The reality of war on the Western Front that so horrified Bairnsfather.

Chapter 3

World War I Breaks Out: Genesis of a Career

(1914–1915)

Before Bruce Bairnsfather got back to Stratford two things happened. First, the string in Spruce Wood broke and, second, the Great War began.

This combination of circumstances was too much for Spencer's which wrote Bruce a letter which awaited his arrival at Bishopton. "Dear Sir," it began, "Owing to the outbreak of European War, your services are no longer required." He had no job and no money. His failure as an electrician was a severe blow to his morale, and, with that sense of patriotic duty which filled all Englishmen at that time, it was enough to make him do the very last thing in the world that he would have ever wished to do – rejoin the Army.

The war broke out while the country was enjoying August Bank Holiday, and it was entered into with a continuation of the high spirits that prevailed over those hot days in 1914. The struggle began as the nearest thing to a Holy War since the Crusades; its purpose to avenge Poor Little Belgium so cruelly invaded by the Kaiser's barbarians. Bands played, flags waved and women gave white feathers of cowardice to any man who didn't rush to join the long queues at the recruiting stations.

In order to gain the advantage of surprise, and following a plan devised by Count von Schlieffen in 1905, the Germans had invaded Belgium and then swung south to cross the French border towards Paris. Britain, bound by a treaty, which became known as the "scrap of paper", to defend Belgium, sent an expeditionary force to France to help halt the German tide. The invaders reached the outskirts of Paris. French reserves were rushed out by taxi to the fighting and side by side the British and the French stopped the advance.

The invasion had been rapid, taking just a few weeks, and now the Allies began to fight their way back north, so that by November 1914 the front line between the opposing forces ran roughly along the Belgian border. But the war was changing.

The Germans had immense superiority in fire power through their policy of employing large numbers of machine guns well forward, a tactic not matched by either British or French in the early days. This fire control over the battlefield, combined with the speed and surprise of their assault, had resulted in the highly fluid warfare of August, September and October. As the invaders were driven back north, so each side tried to go around the end of the opposing line and take the other side from the rear. Neither succeeded. The result was, that as the wet winter weather began, the two armies faced each other along a line that stretched from the North Sea to Switzerland.

The Belgians added to the strength of their line by flooding their land, so that movement became extremely difficult and in places impossible. Thus the opposing armies settled down to a static war, and to shelter from the leaden breath of machine guns they began to dig in. The line of trenches that criss-crossed Flanders in November 1914 was part of a pattern that would stretch a thousand miles.

The "Contemptible Little Army", as the Kaiser is said to have called the British Expeditionary Force, was a fine regular force. It had served its country to the limit and had been decimated in reward. Reinforcements were urgently needed. Reserve and militia battalions were hurriedly gathered together in England, given refresher training and sent to take the places of the thousands that had been killed or wounded.

When Bruce, out of a job, went to his old Regimental Headquarters at Warwick and offered his services, he was exactly what they were looking for. He was a trained soldier.

Within days he was in uniform again and back at Warwick, and on 12 September he was commissioned into the 3rd (Reserve) Battalion of the Royal Warwickshire Regiment.

Bruce's next move was to Albany Barracks, Newport, Isle of Wight, where he spent a restless month waiting to go across the Channel. He, like almost everyone else who had not yet experienced the war, felt that it might be all over by Christmas, and was impatient to get into it. His opportunity soon came. Early in November he was ordered to join the First Battalion of the Royal Warwickshire Regiment, then in trenches near Armentières, and was dispatched from Plymouth to Le Havre, with a party of one hundred men that he had to deliver to France.

The soldiers in France had few illusions about the war. They had seen too many comrades blown to pieces by shells, too many bodies lying across the strips of land between the trenches, too many limbless men wending their sad way back by stretcher to the ports, for them to believe in glamour. The new arrivals were not convinced of the horror, until they, too, suffered it at first-hand. They were excited, voluble and even happy, and the prospect of a glorious death only added to their determination to extract the most from life.

The reinforcement camp to which Bruce went was just outside Le Havre. He was there a week, and every evening he made his way to the Café Tortoni, where hurrying waiters, popping corks, blazing lights and mirrored walls set the stage for many last flings. "As we sat in the midst of that kaleidoscopic picture, formed of French, Belgian and English uniforms, intermingled with the varied and gaudy robes of the local nymphs, as we mused in the midst of dense clouds of tobacco smoke, we could not help reflecting that this might be the last time we should look on such scenes of revelry, and came to the conclusion that the only thing to do was to make the most of it while we had the chance. And by God, we did . . .," he wrote.

His instructions arrived to join his battalion, one of two Regular Warwickshire battalions then on the Western Front. His appointment was machine gun officer. The famous Warwickshires arrived in France just after the battle of Mons, and had taken part in the retreat, during which, to their dismay, their Commanding Officer, Lt.-Col. Elkington, had been cashiered. (In order to save the town of St. Quentin from destruction, he had been persuaded by the mayor to sign an agreement to surrender if the Germans attacked in force.) During the fighting there had been many casualties and many acts of bravery, one of which had won the D.S.O. for a badly-wounded subaltern, also in the First Battalion. His name was Bernard Law Montgomery, and he would one day become Britain's most famous soldier. He and Bruce were both born in 1887, and as they served in the same battalion (as did A.A. Milne, the author), they must have met in France. At the time, however, before either had gained fame, the meeting would

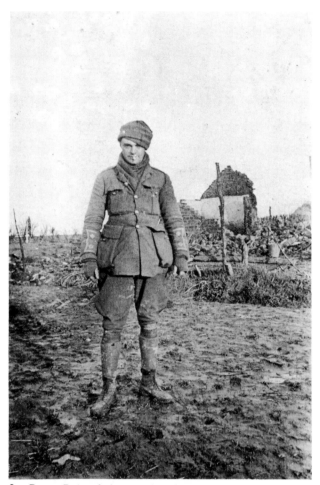

Lt. Bruce Bairnsfather, in the Plugstreet Wood area, 1914. Photo from Duncan Bairnsfather's photo album, courtesy of Marian Evans.

have been of little significance to them. Fifty years later, another opportunity to meet would arise, and one of them would reject it.

The journey to the front took two days by train, via Rouen and Boulogne, and the further north, the flatter, greyer and wetter everything seemed. The warm sparkle of the last week of anticipation quickly faded. Cold and hungry, Second Lieutenant Bairnsfather arrived at the end of the line. He had no idea where the regiment was. There was no one to meet him and to cap everything he found that he had broken his watch.

Moments after finding his own watch to be useless, he discovered another in full working order under the opposite seat. He took this as a sign. Either it meant he would be given time to live, or that his time was near. Fate decided the former.

Trench life was an existence whose realities only experience could fully communicate. Hundreds of

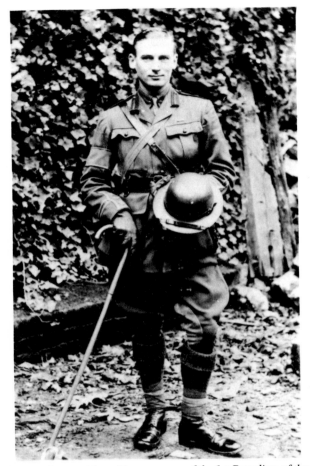

Captain Bernard Law Montgomery of the 1st Battalion of the Royal Warwickshire Regt.

men fought side by side in muddy ditches as high as their heads, frequently up to their waists in water. In front of them was barbed wire and the enemy trenches. Between the trenches lay the bodies of the slain, soon to be so numerous that they would form part of the trench walls. Everywhere rats fed on the dead. The clothes of the living were full of lice. The trenches had their own diseases: trench foot, where feet swelled to balloon-like size through constant immersion in water; trench mouth; trench fever; trench almost anything. Add to this the constant stutter of the machine gun and the frequent artillery barrages with the appalling devastation of town and village that they wrought, and the whole becomes a picture of such fearfulness that it is astonishing that the armies did not refuse to fight.

Later in the war large numbers of French, German and Russians did mutiny and collectively refused to fight. Not so the British. Why not? There are plenty of obvious easy answers such as "The French were reacting against poor generalship", "the Germans thought that their cause was already lost", "the Russians were revolting against the Czarist régime", but they are answers to "why did the mutinies occur?" and not "why didn't the British mutiny?" They had done so in India, after all.

Part of the answer lies with Bruce, who joined his battalion in the trenches near Armentières in November 1914. His job was to take charge of the Maxim machine gun section and this entailed a great deal of moving around at night, as his guns were distributed amongst the different companies. He described this nightly journey as follows: "Finally, after two hours visiting, floundering, bullet dodging, and star shell shirking, accompanied by a liberal allowance of 'narrow squeaks', I got back to my own trench; and tobogganing down where I erroneously think the clay steps are, I at last reach my dug-out, and, entering on all fours, crouch amongst the damp tobacco leaves and straw and light a cigarette."

Trench life was a great shock to Bairnsfather and he concealed his true feelings, as many officers did, under a puerile, public school approach to the war. It became a team game in which ritual patterns soon developed, so that preoccupation with routine dulled overt sensitivity to the horror all around. Those who had been in the war from the very start had grown up with the gradually deteriorating conditions and had almost become used to them. Bairnsfather went straight in without acclimatisation and the effect on him was so profound that even when he had the opportunity to get away to a rear area he seldom took it. Getting back into the game would be too painful.

Christmas 1914 saw a lull in the "game", and Bairnsfather took part in one of the most extraordinary episodes of the Great War, an episode that might have brought him a court martial. It started on Christmas Eve. He tells the story himself.

"The day had been entirely free from shelling, and somehow we all felt that the Boches, too, wanted to be quiet. There was a kind of invisible, intangible feeling extending across the frozen swamp between the two lines, which said 'This is Christmas Eve for both of us – *something* in common.'

About 10 p.m. I made my exit from the convivial dug-out on the left of our line and walked back to my own lair. On arriving at my own bit of trench I found several of the men standing about, and all very cheerful. There was a good bit of singing and talking going on, jokes and jibes on our curious Christmas Eve, as contrasted with any former one, were thick in the air. One of my men turned to me and said: 'You can 'ear 'em quite plain, sir!'

'Hear what?' I inquired.

'The Germans over there, sir; you can 'ear 'em singin' and playin' on a band or somethin'.'

I listened; – away out across the field, among the

dark shadows beyond, I could hear the murmur of voices, and an occasional burst of some unintelligible song would come floating out on the frosty air. The singing seemed to be loudest and most distinct a bit to our right. I popped into my dug-out and found the platoon commander. 'Do you hear the Boches kicking up that racket over there?' I said. 'Yes,' he replied: 'they've been at it some time!' 'Come on,' said I, 'let's go along the trench to the hedge there on the right – that's the nearest point to them, over there.'

So we stumbled along our now hard, frosted ditch, and scrambling up on to the bank above, strode across the field to our next bit of trench on the right. Everyone was listening. An improvised Boche band was playing a precarious version of 'Deutschland, Deutschland, über Alles,' at the conclusion of which, some of our mouth-organ experts retaliated with snatches of ragtime songs and imitations of the German tune. Suddenly we heard a confused shouting from the other side. We all stopped to listen. The shout came again. A voice in the darkness shouted in English, with a strong German accent, 'Come over here!' A ripple of mirth swept along our trench, followed by a rude outburst of mouth organs and laughter. Presently, in a lull, one of our sergeants repeated the request, 'Come over here!'

'You come half-way – I come half-way,' floated out of the darkness.

'Come on, then!' shouted the sergeant. 'I'm coming along the hedge!'

'Ah! but there are two of you,' came back the voice from the other side.

Well, anyway, after much suspicious shouting and jocular derision from both sides, our sergeant went along the hedge which ran at right-angles to the two lines of trenches. He was quickly out of sight; but, as we all listened in breathless silence, we soon heard a spasmodic conversation taking place out there in the darkness.

Presently, the sergeant returned. He had with him a few German cigars and cigarettes which he had exchanged for a couple of Maconochie's and a tin of Capstan, which he had taken with him. The seance was over, but it had given just the requisite touch to our Christmas Eve – something a little human and out of the ordinary routine.

After months of vindictive sniping and shelling, this little episode came as an invigorating tonic, and a welcome relief to the daily monotony of antagonism. It did not lessen our ardour or determination; but just put a little human punctuation mark in our lives of cold and humid hate. Just on the right day too – Christmas Eve! But, as a curious episode, this was nothing in comparison to our experience on the

Lt. Bairnsfather on his way to the Christmas Truce, Christmas 1914. St. Yvon.

following day.

On Christmas morning I awoke very early, and emerged from my dug-out into the trench. It was a perfect day. A beautiful, cloudless blue sky. The ground hard and white, fading off towards the wood in a thin low-lying mist. It was such a day as is invariably depicted by artists on Christmas cards – the ideal Christmas Day of fiction.

Walking about the trench a little later, discussing the curious affair of the night before, we suddenly became aware of the fact that we were seeing a lot of evidence of Germans. Heads were bobbing about and showing over their parapet in a most reckless way, and, as we looked, this phenomenon became more and more pronounced.

A complete Boche figure suddenly appeared on the parapet, and looked about itself. This complaint became infectious. It didn't take 'Our Bert' long to be up on the skyline (it is one long grind to ever keep him off it). This was the signal for more

Boche anatomy to be disclosed, and this was replied to by all our Alf's and Bill's, until, in less time than it takes to tell, half a dozen or so of each of the belligerents were outside their trenches and were advancing towards each other in no-man's land.

A strange sight, truly!

I clambered up and over our parapet, and moved out across the field to look. Clad in the muddy suit of khaki and wearing a sheepskin coat and Balaclava helmet, I joined the throng about half-way across to the German trenches.

It all felt most curious: here were these sausage-eating wretches, who had elected to start this infernal European fracas, and in so doing had brought us all into the same muddy pickle as themselves.

This was my first real sight of them at close quarters. Here they were – the actual, practical soldiers of the German army. There was not an atom of hate on either side that day; and yet, on our side, not for a moment was the will to war and the will to beat them relaxed. It was just like the interval between the rounds in a friendly boxing match. The difference in type between our men and theirs was very marked. There was no contrasting the spirit of the two parties. Our men, in their scratch costumes of dirty, muddy khaki, with their various assorted head-dresses of woollen helmets, mufflers and battered hats, were a light-hearted, open humorous collection as opposed to the sombre demeanour and stolid appearance of the Huns in their grey-green faded uniforms, top boots, and pork-pie hats.

The shortest effect I can give of the impression I had was that our men, superior, broadminded, more frank, and lovable beings, were regarding these faded, unimaginative products of perverted culture as a set of objectionable but amusing lunatics whose heads had got to be eventually smacked.

'Look at that one over there, Bill' our Bert would say, as he pointed out some particularly curious member of the party.

I strolled about amongst them all, and sucked in as many impressions as I could. Two or three of the Boches seemed to be particularly interested in me, and after they had walked round me once or twice with sullen curiosity stamped on their faces, one came up and said 'Offizier?' I nodded my head, which means 'Yes' in most languages, and, besides, I can't talk German.

These devils, I could see, all wanted to be friendly; but none of them possessed the open, frank geniality of our men. However, everyone was talking and laughing, and souvenir hunting.

I spotted a German officer, some sort of lieutenant I should think, and being a bit of a collector, I intimated to him that I had taken a fancy to some of his buttons.

We both said things to each other which neither understood, and agreed to do a swap. I brought out my wire clippers and with a few deft snips, removed a couple of his buttons and put them in my pocket. I then gave him two of mine in exchange.

Whilst this was going on a babbling of guttural ejaculations emanating from one of the laager-schifters, told me that some idea had occurred to someone.

Suddenly, one of the Boches ran back to his trench and presently reappeared with a large camera. I posed in a mixed group for several photographs, and have ever since wished I had fixed up some arrangement for getting a copy. No doubt framed editions of this photograph are reposing on some Hun mantelpieces, showing clearly and unmistakably to admiring strafers how a group of perfidious English surrendered unconditionally on Christmas Day to the brave Deutschers.

The Christmas Truce. A Memory of Christmas 1914.

Slowly the meeting began to disperse; a sort of feeling that the authorities on both sides were not very enthusiastic about this fraternizing seemed to creep across the gathering. We parted, but there was a distinct and friendly understanding that Christmas Day would be left to finish in tranquillity. The last I saw of this little affair was a vision of one of my machine gunners, who was a bit of an amateur hairdresser in civil life, cutting the unnaturally long hair of a docile Boche, who was patiently kneeling on the ground whilst the automatic clippers crept up the back of his neck."

The Commander of the BEF, General Sir John French, heard about the Christmas Truce, as it became known, and although in retrospect his attitude mellowed, at the time he reacted firmly: "I issued immediate orders to prevent any recurrence of such conduct and called the local commanders to strict account . . ." Bairnsfather, who had been promoted to full Lieutenant just seven days before, was, in view of what happened to Lieutenant-Colonel Elkington, very fortunate to avoid censure.

By his second month in the trenches, Bairnsfather had formed a close attachment to the soldiers of the Warwickshire Regiment under his command. As they were regulars and locally recruited they mostly hailed from the part of England with which he was so familiar, the Midlands. Unlike the red-tabbed Staff Officers some way behind the lines, some of whom never saw the front, the junior Infantry Regimental Officer suffered almost all of the privations of his men. Perhaps for the first time, the young middle class gentlemen and the working class soldiers met on equal terms under a common danger. Bairnsfather found in his men all the qualities which had so endeared him to the working classes of the Midlands and with whom he shared his love of music hall. His concern for his section helped him to forget the hideous reality around him. He began to consider how best to control his scattered force, and decided to place himself at a central position. As luck would have it there was an ideal spot. Immediately behind their trench lines was the small village of St Yvon and Bairnsfather, with another subaltern called Hudson, took over one of the battered cottages.

They used the cottage each time they came up for their four or five days in the front line. On every visit they improved it slightly, barricading the walls with corrugated iron and rubble, draping sacks across the many gaps made by shells and enlarging and extending the cellar. Movement had to be by night, or just before dawn, because the enemy artillery severely punished any movement in the village area by day. In this enforced idleness Bairnsfather's urge to draw returned. He began to do cartoons on small pieces of paper which very quickly became popular with the

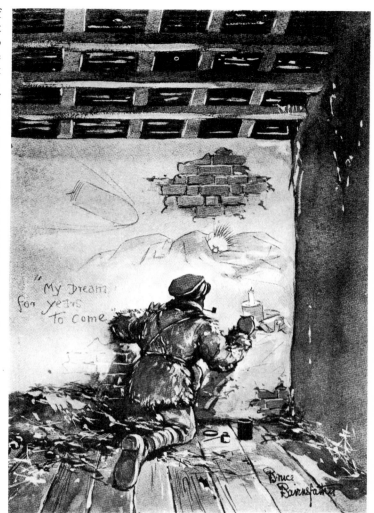

The Birth of Fragments . . .

Pin up by Raphael Kirchner.

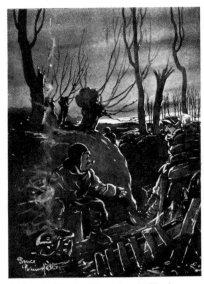

*"Chuck Us the Biscuits, Bill, the
fire wants mendin"* –
A Fragment from France.

"Where Did That One Go To?" –
The first Fragment from France.

"They've Evidently Seen Me" –
A Fragment from France.

soldiers, who pinned them up in the trenches. The
laughter they inspired acted in the same way upon
Bairnsfather as the laughter at Westward Ho! and the
laughter at Trinity College. It made him draw more
cartoons. He liked being liked. Soon he was drawing
on everything – scraps, ration boxes and the walls of
the cottage. He was up to his old tricks again and the
soldiers loved it. So too did the Regimental officers.
The cartoons were a tonic, a safety valve for the
growing tensions of trench warfare and were exactly
what they needed. In the Warwickshire trenches,
alongside the pictures of Raphael Kirchner's scant-
ily clad ladies, Bruce Bairnsfather's cartoons were
being pinned up.

Bairnsfather himself, once he began drawing
again, found the game of war easier to play, as if his
own internal conflicts gained relief by his creative
activity. He even tried his hand at sniping, which
Julian Grenfell, just a mile or so away with the Royal
Dragoons, called "the greatest sport". Eventually
Grenfell recklessly showed himself over the top of his
trench and was shot and killed. Bairnsfather was
luckier, although he, too, took chances. His Com-
pany Sergeant, Sergeant A.E. Rea recalled: "My
greatest headaches were caused by his tendencies to
climb up on parapets to 'see what he could see' when
some of us were heart-in-mouth that a German sniper
might pick him off."

On one occasion Bruce found himself a spot in the
rafters of a ruined farmhouse overlooking the Ger-
man lines, climbed up at night and sat on a beam
waiting for daylight. At last he saw a target, the small

circular cloth hat of a German soldier. Carefully he
raised his rifle, took aim and fired. The hat dis-
appeared. As he was about to reload, a shell crashed
into the courtyard, then a second dropped on the
farmhouse to the left and "without waiting for any
more I just slithered down off that beam, grabbed my
rifle and dashing out across the yard back into the
ditch beyond, started hastily scrambling along to-
wards the end of one of our trenches. As I went I
heard four more shells crash into that farm". That
experience led directly to one of his later cartoons,
the one entitled "They've evidently seen me".

During this short period beginning in January 1915
Bairnsfather found and stored the spark of his crea-
tive genius. He vented the disappointments and frus-
trations of his past artistic failures on drawing comic
figures of German soliders; he played to his enthu-
siastic British audience by picturing them too, using
their jokes and their expressions. He drew exactly
what he saw, heard and remembered, he captured
those moments when, in the midst of war, the forces
of habit or practicality govern events and not the
forces of darkness. His joke, "Chuck us the biscuits
Bill, the fire wants mendin'," hardly needs a picture.
Through his cartoons his companions could see them-
selves, and the absurdities of the lives they were
leading; they could, for a brief moment, stand aside
from the war, and laugh.

It was in the cottage at St Yvon that the catalytic
event took place that was to make Bairnsfather
famous.

Bruce and some others were in the cottage when

the Germans began to shell the village with their heavy guns, and knowing how all artillerymen, friend or foe, like to aim at buildings, they decided to take refuge in a nearby ditch until the strafe was over. Finally they considered it safe to venture out and returned to their battered quarters. Hardly had they got inside when a heavy shell landed nearby, and almost to a man they rushed to the broken doorway and exclaimed "Where did that one go?" Bairnsfather made a quick pencil sketch on the spot. Later, when they left the line for their rest period, he made a finished wash drawing and entitled it "Where did that one go to?' . . . It was an immediate success amongst the officers and men of the battalion. A fellow sub-altern suggested that Bairnsfather send it up to a paper for publication. A copy of *The Bystander* was lying around and its size and shape suited the size and shape of the drawing, so for that most simple of reasons he sent his picture to that magazine. He then forgot about it, and over the next few weeks the routine of "In and out of the Trenches" continued. Although it was not yet evident, the strain of trench life was beginning to have its effect on Bairnsfather.

It was a moment of surprise and joy when a letter arrived from *The Bystander* accepting his drawing and enclosing a cheque. He immediately sent off another cartoon entitled "They've evidently seen me", based on his sniping experience, and that drawing, with the first one accepted by *The Bystander*, began the long line of cartoons that later became known as *Fragments from France*. Within the regiment and brigade Bruce's name was becoming familiar to all. His humour was a salve on the irritations of war. It kept up everyone's spirits, it helped morale. The colonel of the regiment asked him to decorate the walls of Regimental Headquarters and his scribbles on pieces of paper were passed from hand to hand along the trenches.

Shortly afterwards he was granted seven days leave, and complete with shell case souvenirs and a small pair of clogs which he had found in the ruined cottage in St Yvon, he went home to Bishopton, to, as he described it, "the leafy calm of Warwickshire". He suffered a strange reaction.

The way of life of officers and men in the trenches did not allow pretence. With the evidence of sudden death all around, men soon learned whom to respect, whom to trust, who was genuine and who was false. Sergeant A.E. Rea, Bairnsfather's company sergeant, gave this opinion of his officer. "His care for all of us was only matched by his lack of care for his own welfare, and we shall ever gratefully recall a most distinguished officer and a true gentleman". Relationships were formed quickly and directly, and strengthened daily, because the co-operative effort to defeat the enemy influenced every action.

At Bishopton, Bairnsfather was unable to communicate to anyone just what the war was like. He was not alone in that. Many soldiers, indeed most soldiers, had the same experience whenever they came home. But Bairnsfather missed the protective blanket of undemanding comradeship and began to shiver.

Without the pressure of responsibility or the need to maintain his own image of himself, Bairnsfather had a nervous reaction. The local doctor advised him to extend his leave. At first he accepted the idea. but then on impulse, without waiting for orders, he set off back to France. The taste for adventure that had sprung from his early days in India, and the need for routine within the security of which he could exercise his small personal freedoms inspired his flight. It was further evidence of approaching exhaustion.

The battalion moved its positions slightly, going further north to Douve at the base of the Messines Ridge. The days were long, dark, dismal and eternally wet. The ground was a morass of mud into which men could sink without trace. Bairnsfather began to notice signs of tiredness. During his nightly tour of his gun sections he would develop a strong urge to lie down in the mud and go to sleep. The temporary anasthaesia of sleep was something he longed for. It shut out the enveloping aura of destruction that was integral to life at the front.

The battalion was taken out of the line for a ten-day rest period, just in time to avoid Bairnsfather breaking down, and in that period of rest at Outtersteene, not far from Bailleul, he found himself billeted in a French farmhouse with the transport officer and their two soldier servants. In his thoroughly depressed state, the warmth and hospitality of the occupants of the cottage, Suzette Charlet-Flaw and her friends Berthe and Marthe went straight to his heart. It was a time he would never forget. Those ten days, he said, "were an oasis in a six months' desert" and there were

other bright spots too. A letter of acceptance for "They've evidently seen me" arrived from *The Bystander*, Colonel Loveband of the Dublin Fusiliers asked him to draw some "colonel pictures" on his billet walls and one officers' mess commissioned him to draw six pictures at twenty francs each.

Then the weather improved. On 17 March, 1915 the war diary of the 1st Battalion, Royal Warwickshires Regiment recorded; "It was reported that boring machines had been heard on the German lines probably mining our trench. This was later discovered to be a bullfrog which was heralding the approach of spring." The good weather provoked "a rash of sketching", as Bairnsfather put it, and his work continued to be in great demand throughout the Brigade. His own colonel wanted the walls of the new battalion HQ decorated, the Brigade Commander asked for a drawing, and at Divisional Headquarters they had half a dozen of his pictures. Of course there was a clamour for the cartoons in the trenches. Within eighteen months the morale-boosting effect of what Bairnsfather was able to put on to wall or paper would be acknowledged by France, Italy and America, yet his own country would never reward him.

In the middle of April 1915, the battalion was moved to Ypres, the small Belgian town that formed a salient into German-held territory. Ypres had been a beautiful place with two particularly magnificent buildings – the Cloth Hall and the Cathedral, built about 1300. Now the town was becoming a pile of rubble, the constant German shelling gradually reducing every building to a ruin. As the Warwickshires approached the town, the battered Cloth Hall was set ablaze and Bairnsfather watched it burn, the yellow and blue flames leaping high into the sky. It was the beginning of the Second Battle of Ypres.

At 1700 hours on 22 April, the Germans used poison gas for the first time in war. About five miles north of Ypres they released clouds of chlorine, a thick yellow fog which rolled slowly across to the Allied trenches. The effect was dramatic and a complete surprise. The French colonial troops who bore the brunt of the attack, coughed, choked, retched, died – and those who were left, ran. Within hours there was a wide gap in the Allied defences. The Germans were as surprised by their success as the Allies were by the introduction of gas warfare and were unprepared to follow up their advantage. Two days later on 24 April, the Germans repeated their attack, this time in the area of Langemarck and Passchendaele, to the north-east of Ypres, hoping to burst through to the town.

Only the outstanding bravery of the Canadian and British soldiers in the face of appalling casualties prevented the German attack from succeeding in breaking through to Ypres. The Warwickshires were marched into the battle in the early hours of 24 April, encountering a vicious assault of machine gun and artillery fire, and then in the area of Wieltje, two miles north-east of Ypres, where their casualties were heaviest, the war claimed Bairnsfather: ". . . . I heard a colossal rushing swish in the air and then didn't hear the resultant crash . . . All seemed dull and foggy, a sort of silence worse than all the shelling surrounded me. I lay in a filthy stagnant ditch covered with mud and slime from head to foot. I suddenly started to tremble all over. I couldn't grasp where I was. I lay and trembled . . . I shook all over and had to lie still, with tears pouring down my face."

His nerves had gone at last. The weeks of horror now engulfed him. A shell explosion had thrown him in the air and damaged his hearing, so that he was completely disorientated, and without the support of his physical senses to steady his mind, all control went.

He was shell-shocked, but unlike many of his fellows, Bruce still had plenty of time to come. In that one day the Warwickshires lost five hundred other ranks and seventeen officers killed, wounded or missing.

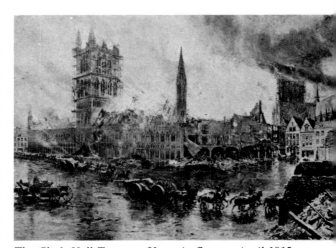

The Cloth Hall Tower at Ypres in flames, April 1915.

Chapter 4

The Birth of Old Bill &
'The Better'Ole'

(1915–1916)

Crisis and success seem inseparable companions in Bairnsfather's life. "Compensation", Emerson would have probably called it, a philosophy that, in part, Bruce himself subscribed to. He once described his own beliefs as "a mixture of The Sermon on the Mount, Kipling's *If*, Omar Khayyam and Astronomy". The compensation for his injury at Wieltje came very quickly.

His condition was rapidly diagnosed as "shell shock" with suspected damage to his left ear, and within forty-eight hours he was in hospital in Boulogne en route to England. While he was still in France, a fellow casualty, reading the name "Bairnsfather" on the chart of the foot of Bruce's bed, said "Are you the feller who drew this?" and handed him a copy of *The Bystander* for January 1915. There was his drawing "Where did that one go to?" with an accompanying explanation:

"A Sketch From the Front

A reproduction of a sketch sent home to us from the Front by an officer of the 1st Royal Warwicks. "I have drawn it", he writes, "as well as I can under somewhat difficult circumstances, and, I may say, from first hand impressions."

Those first-hand impressions brought him very close to total collapse. Early in May he was sent back to the 4th London General Hospital at King's College, Denmark Hill, and his mother came to visit him every day. Her love and devotion in that critical period probably did more than anything else to restore his self control, and from then on he called her his "Mascot Mother".

The acceptance of his second drawing, "They've evidently seen me", the fruit of his sniping expedition, and its publication in *The Bystander* of 21 April, added to the impetus of his recovery once he was well enough to be shown the magazine. However, since he was paid only £2 for each drawing it did not occur to

him that any permanent and profitable arrangement might be possible between himself and *The Bystander*. Apart from physical exhaustion, and the disorientating effects of the damage to his ear, his imagination was continually beset by horrifying images of vicious hand-to-hand fighting in engulfing mud and barbed wire. The memories allowed him only fitful rest.

After some weeks the urge to draw returned and his mind was full of images ready to tumble down his fingers to the waiting page. Janie brought in paper and paints and the hospital agreed that "drawing" would be therapeutic. Yet Bruce did not consider it worthwhile to submit any more for publication – until one day, when a representative of *The Bystander* called. The magazine had apparently received floods of complimentary letters about the two drawings they had published and even requests to buy the originals. Would Lieutenant Bairnsfather agree to do a weekly drawing for £4 a week?

"Well I'm damned," Bruce exclaimed to Janie after the representative left. "Fancy them wanting some more drawings." It had come as a complete surprise to him and he was excited and enthusiastic. A few days later, no doubt aided in recovery by *The Bystander* commission, he was back at Bishopton, and by the end of May was working on the drawings that were to make him famous. All of his picture work in the war period was a personal statement made without contrivance. He unloaded his burden of horror on to his audience in the guise of humour. "What it really feels like" was published on 2 June, 1915 and expiated the intense dreams that had plagued his early days of convalescence. Two weeks later "That sixteen inch sensation" safely encapsulated his own injury.

"What It Really Feels Like". A Fragment from France.

"That 16 inch Sensation". A Fragment from France.

He had about a month at home. His brother Duncan was back at the Edward VI School Stratford, after three years at Oundle. Major Tom and Janie were well-known, established figures in the community. Thus, in the loving familiar calm of Warwickshire, he improved very quickly. Relatives visited frequently to see how he was, and his pride in his *Bystander* commission was intense. Yet the family never complimented him upon his work. "Quite the artist aren't we?" commented one elderly Every-Clayton aunt, a condescending remark that he still remembered in his seventieth year. The family could accept artists, painters, serious exponents of art, but not cartoonists. Even Bruce, who preferred the company and styles of a more humble circle of companions than most young men of his background, could not entirely accept himself as a "cartoonist". He rarely referred to his work as "cartoons". He would say "pictures" or "drawings". It was the thousands of people who laughed at them that called them cartoons.

Just like in the old days at Spencer's, Bruce was soon visiting his favourite music halls and sitting smoking in his favourite pubs, watching the working people he admired so much. He was well-known in his regular places, and enjoyed the attention of small numbers of local people, sketching on any surface offered to him. It couldn't go on for ever, as the barmaid at the Crown Hotel in Warwick pointed out to him at the end of July. "I see you're a captain," she said and showed him the list of promotions in the paper. Soon after, the Medical Board in Birmingham pronounced him fit for light duties and posted him to the Royal Warwickshire Depot in the Isle of Wight.

The depot had changed since his first visit there in 1914 en route to France. Albany Barracks had expanded, taking over part of the prison buildings, and additional red brick huts had sprung up to replace the bell tents. There was less a sense of adventure to the place and more an atmosphere of permanence. He found it depressing and once again, as he had whilst on leave, wished to be back at the front. Yet the posting was to complete the genesis of the character around whom almost everything else he ever created would focus – Old Bill.

The main function of the depot was to train recruits to replace the casualties suffered by the regiment, and to rehabilitate as many of the wounded as possible until they, too, were fit enough to return to the front. Captain Bairnsfather was given command of a company of two hundred men who were all on light duties. They were "old soldiers" who had already fought in France.

There is a collective character shared by men who have experienced intense comradeship such as that of the trenches of World War I. They affect clannish ways of speech and behaviour which seem to parallel the ways of the outside world without participating in it. The more of them there are together, the more they play their common role, the more they exaggerate their favoured characteristics, and the less they feel obliged to obey the petty rules of society.

Bruce had command of two hundred such men. He trained them, disciplined them, paid them and cared for them. They were mostly from the Midlands, the characters he admired as civilians but now bestowed with the trademarks won by their common experience of war. They did just enough work to avoid trouble with authority, were just clean enough, not quite insubordinate. They fretted at all the regular restrictions of barrack life, conspired to frustrate authority – and Bruce, who had served with them in the mud and blood of Flanders, knew and understood. "I love those old work-evading, tricky, self-contained slackers – old soldiers", he said. "They are the cutest set of rogues imaginable, yet with it all there is such a humorous, childlike simplicity. They can size up their officers better than any Sherlock Holmes. I'll guarantee that an 'old soldier' will know to a nicety how dirty he can keep his buttons without being hauled up by his new officer, after doing one parade under him. An 'old soldier' will pinch a tunic from a man in another company because he has pawned his own, and come on parade with it, entirely to deceive you, temporarily. If you were lying wounded in the middle of a barrage, that same man would come and pull you out."

And good "old Bill" belongs to these lovable humorists.

Many senior officers could not comprehend such an assessment. There was a gulf of misunderstanding between those who had served in the trenches and those who knew only the life at headquarters. Montgomery later wrote that many staff officers in the First War never saw the front line conditions in which their soldiers fought. Such people regarded Bairnsfather's characters as misplaced, false, and not true representations of the British soldier. Perhaps that attitude lay behind the refusal of the establishment in later years to acknowledge the debt the country owed to Bairnsfather. Yet even Monty ignored Bruce: there is

One of the first named portraits of Old Bill.

not a single reference to his famous fellow officer of the Warwickshires in the Field Marshal's memoirs.

That company of two hundred Old Contemptibles impressed their collective image upon Bairnsfather and upon the years of observation of Midlands working men that had gone before. In his drawings a composite character began to appear. "Who's that soldier you keep putting in your pictures?" a fellow officer asked Bruce. "Which one?" replied the artist. "That one", said the enquirer, pointing to a figure in a balaclava helmet and with a walrus moustache. "Oh", said Bairnsfather, without thinking,

"That's Old Bill"

It was the beginning of a lifelong partnership.

Bruce's physical health was steadily improving. His prankish schoolboy approach to life began to re-emerge and he went off on weekend leave to the mainland as often as he was permitted and, sometimes, when he wasn't. He was an extraordinary mixture. At heart he was shy and reserved, yet when sure of his ground he loved to hold the attention of

those around him. He was a loner, yet sought the company of others. The experiences and memories of those months of war were depressing his spirit, but at times these feelings could be released in a stream of creative artistry. The tension and compression of his spirit was the spring of his creative genius.

After two months light duty in the Isle of Wight he was posted again. This time it was to Salisbury Plain, to the headquarters of the 34th Division at Sutton Veney, and he entered into his new appointment with enthusiasm. He was the divisional machine gun officer, responsible for training the machine gun officers and sections of the whole division. He was certainly well qualified for the task, having spent six months in the trenches in command of his own machine gun section, and he took great pains to see that, as far as possible, all those he instructed were made aware of what it would really be like at the front. The men were young and fresh, the burgeoning products of Kitchener's Army, volunteers, anxious to get to battle. Bairnsfather caught their mood, and seeing them as charges in his care, prepared them for what he knew lay ahead of them.

"I took a group out daily into the country round about . . . and used to try, by means of sketches and word pictures, to give my machine gunners as real a vision as possible of the front and what it means; but it's very, very hard – nearly impossible – to convey the correct idea."

There was frequently considerable tension, even feelings of hatred, between the staff officers with their safe, "cushy", jobs at headquarters and those officers and men who served in the trenches. Bairnsfather felt that tension and yet his criticism is not that the staff were "incompetent swines responsible for thousands of unnecessary deaths" as Sassoon inferred, but simply that they did not share the same dangers as the men at the front. Indeed, Bairnsfather never revealed that loss of life in war, his or anyone else's, was something that unduly disturbed him. That may have been due to his martial background, the indoctrination at Westward Ho! or simply his overconcern with "Nature". But the destruction of the environment profoundly upset him. Thus, on Salisbury Plain, where there was no visible destruction, he was able to enter into the game of war with gusto.

It was a make-believe period. Each day he had an ideal audience for whom he was the centre of attention. When he had enough of training he could dismiss the men. The evenings were for relaxation trips to Warminster to see the latest Charlie Chaplin film, or time spent extracting from his detailed sketch books the idea for his next *Bystander* drawing.

At Sutton Veney, in October 1915, he drew the picture that was to become his most famous, whose

A chaplain to the Forces
that would have been welcome

title became part of the English language, and that in many eyes still is the most lasting cartoon of all time.

The cartoon was entitled "One of our minor wars", and it showed two soldiers in a muddy shell hole, the air above them filled with exploding shells. One soldier looks disgruntled and the other is saying: "Well if you knows of a better 'ole, go to it".

The Bystander used the drawing in its Christmas issue of 24 November, 1915. It had a sensational effect. The magazine sold out completely. Soldiers in the trenches and the public back at home roared with laughter.

This time the public could identify themselves with the two soldiers. They too knew the human situation that the "better 'ole" represented. This statement from the trenches described a condition as old as the human race – discontent – and a challenge to confront it. It was the greener-grass proverb in khaki. The cartoon's caption became a popular catch word. "Well if you knows a better 'ole . . ." fitted family arguments as well as international wrangling and the swelling tide of autograph books that had reached Bruce via *The Bystander* now became a torrent.

The Bystander seized upon the country's enthusiasm and early in 1916 published a collection of forty-one of Bairnsfather's weekly drawings in booklet form. They called it *Fragments from France*, a title no doubt dreamed up by Bruce who loved puns and alliterations – he talked of "shattered châteaux" and "bullets and billets". *Fragments* had as its cover "The Better 'Ole" in full colour as well as a black and white version inside. It sold out. It was reprinted and sold out again. *Fragments* was reprinted nine more times and sold over one quarter of a million copies, a staggering quantity in 1916. *The Bystander* knew that it had a winner and played up to it. In the introduction to *Fragments* the editor said, referring to Captain Bairnsfather: "Without the war, he might never have put pencil to paper for publication." It made a good storyline, but was untrue. Since his days at the John Hassall art school, Bruce had longed to draw for a living. This petty exploitation of the idea that the

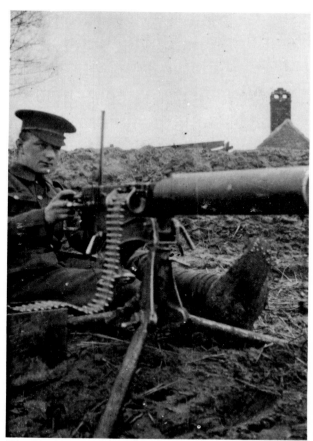

The Maxim gun. Bairnsfather was responsible for training machine gun officers. This photo may well have been taken by him in the Plugstreet area in 1914. From his brother's album, courtesy of Marian Evans.

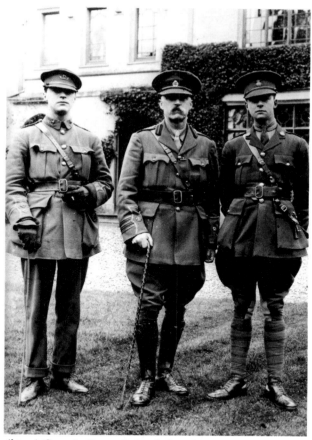

(l to r) Captain Bruce Bairnsfather, Major Thomas Bairnsfather, Officer Cadet Duncan Bairnsfather. By kind permission of the Trustees and Guardians of Shakespeare's Birthplace, Stratford-upon-Avon.

war had created an artist was to influence critical appreciation of his work for the rest of his life. Later editors would try to correct the impression created by that first introduction, but to no avail. The damage was done at the beginning and it was permanent.

Early in 1916 the 34th Division set out for France. Bruce watched them go, marching to the station accompanied by their bands, the Scottish regiments reminding him of that holiday when he had watched the Seaforths parading for church. He was proud of them but, to his disappointment, he was not to go with them.

He returned to the Isle of Wight for a few weeks, now well enough to take part in camp variety sketches which he called "soldiers gaffs". Usually they were of the "red nose and give us a song" variety and he enjoyed doing them. He was now a celebrity. In November 1915 and January 1916 *The Bystander* had published his picture, and he was easily recognised.

Before he was posted back to France, he took a works company to Aldershot and based himself at the nearby Queens Hotel at Farnborough, smoking large numbers of Gold Flake cigarettes, being "lured by a whisky and soda" as he put it, and signing innumerable autograph books. This only lasted for a week or two, and then his posting card arrived. He was to go to France as staff captain (special reserve) Fourth Army Railheads at Montrelet in the Albert/Doullens sector. The idea of being a staff captain didn't appeal to him, partly because he didn't know what the job entailed and partly because he felt himself to be a regimental officer. Nevertheless, he didn't worry about it too much.

"All I cared about was the fact that I was going out. It's a curious feeling, this wanting to go back. Nobody could possibly want to go back to life in the trenches or to participate in an offensive, if one looks at it from that point of view alone. But it's because all your pals are out there at the front, and all the people who really matter are at the front; that's why you long to be one of them, and in with them, in the big job on hand. The satisfaction of

The most famous cartoon ever published. "Well if you knows of a better 'ole, go to it". A Fragment from France. *The original, photo courtesy of the Victoria and Albert Museum.*

Mrs. Janie Bairnsfather and her two soldier sons. Bishopston Spa, 1916. By kind permission of the Trustees and Guardians of Shakespeare's Birthplace, Stratford-upon-Avon.

feeling that you are in the real, live, and most important part of the war, is very great. The feeling that you amongst all the gang who have the nasty part to do, and that you are accepted by them as one of the throng, is enormous.

But people must never be misled into thinking that just being 'out in France' is sufficient to produce this feeling of satisfaction. Oh dear no! You must have been either in the Infantry or the Flying Corps. Infantry is the thing. You can take your hat off to anyone in any infantry battalion anywhere at the front, to a distance of not more than two miles from the firing line. You can then be certain that you have saluted men who have gone to the hub of the show. Those are the chaps to be amongst."

This longing for the comradeship of the trenches was shared by all those that had known it, and led to the formation of many organisations after the war whose object was to recapture the ideal of "all for one and one for all". Many years later one of these world-wide organisations adopted Old Bill as its symbol. That was the Memorable Order of Tin Hats, the MOTHS (whose history is described in the "Post-Mortem" chapter).

By now, early 1916, Old Bill had emerged as a character in Bairnsfather's drawings. He had actually been present from the beginning, but not named. The third drawing published on the cover of *The Bystander*, 15 September, 1915 was entitled "When the 'ell is it going to be strawberry". It certainly shows Old Bill, although he can be identified only in retrospect. But Bruce himself was not back amongst his beloved Old Bills. He was back in the rear areas, assistant to the Administrative Commandant of the area between Doullens and Amiens. Their joint responsibility was the maintenance of discipline in all communications and this meant a great deal of travelling behind the lines, passing through many areas which had been cruelly devastated by the war.

About this time Duncan pulled himself together and passed into the Royal Military College Sandhurst as a cadet on 18 January, 1916. Bruce was fast becoming a national celebrity, although his parents were not too enthusiastic about the reasons for his success. Nevertheless, his drawings gained some stature in their eyes when an exhibition of his originals was put on in May at The Graphic Gallery in the Strand. Offers for the originals came from all quarters and

"the Better 'Ole" went to an unnamed general in the War Office.

The Bystander followed the success of *Fragments* and issued *More Fragments from France* with an eye to the future. In the first *Fragments* they had offered six colour prints of selected cartoons at one shilling each. In *More Fragments* they offered another six:

"*Fragments from France* may now be had in the following styles and prices:

De Luxe Edition

A selection of favourite *Fragments* specially printed suitable for framing. 32 pictures in handsome cover 5/6 post free

Shilling Edition

No. 1 Series. 300,000 copies already sold. The popular edition for the boys in the trenches, in hospital or in camp 1/3 post free

Postcards – Series 1

Sets of 6 different *Fragments* beautifully produced in photogravure

Coloured Reproductions

Nos. 1 and 12 now ready. Please send for list."

The commercial exploitation of Bairnsfather's work began. Bairnsfather was totally naive. The excitement of his success blinded him to the need to get a fair return for his efforts. *The Bystander* increased his weekly fee to £20, but often he would do two or three drawings for the same money. Some of his cartoons had previously appeared in *Pearson's Magazine* in 1915, perhaps commissioned directly by *Pearson's*, but from 1916 onward the *Bystander* organisation had almost total control over his picture output.

Bairnsfather was quite without malice, as his drawings clearly demonstrate, displaying a sense of fun rather than anger. He was easy meat for the businessmen and entrepreneurs who saw the potential of his work. He had no agent or financial adviser. In later life he complained about his treatment but, typically, made light of it.

While his fame was mounting in England, Bruce was enjoying his new job in France. His full timetable involved inspecting the different railheads in the sector, the type of activity and adventure which delighted him. At the same time he was saddened and moved by the widespread destruction of the countryside and these contrasting emotions kept his creative spring fully wound. He began to make notes for a book of his wartime experiences, probably in response to outside prompting. On top of all this effort he continued to fill sketch books and to send off a finished drawing to *The Bystander* every two or three days. Tension inevitably took its toll and by July he was back in hospital suffering from exhaustion and with a huge and painful carbuncle on the back of his neck.

At hospital in Rouen, he had a small private cubicle in what had once been a monk's cell. Although physically low, he retained the schoolboy's need to react to attention, and being a celebrity he attracted a lot of it. In his own words: "Thanks to an inherent juvenile spirit, I can permanently camouflage a lot of

Packet of the first series of Fragments *to be reproduced by* The Bystander *as postcards.*

Memories of Rouen

troubles, come up to the surface and drink in the joys of life.

"Under the soothing influences of kind-hearted nurses, aided by succulent substantial assets such as chicken and occasional champagne, I slowly recuperated in my cubicle, and in a few days began to look back on past events and ache for pencils, paints and paper. I got these and dived off into a volume of scribbles, sketches and jokes on a host of topics which ironically amused me. If ever that monk goes back to that cubicle of his, he's going to find a fine mess on the walls. I perpetrated a series of most worldly drawings on the sides of his ethereal cell."

The nurses brought their autograph books to Bruce and often he had to lock himself away from distractions for a whole day to complete a new *Fragment from France*. Apart from his fame, itself a source of attraction for the nurses, he was an exceptionally handsome man with the deeply appealing brown eyes that Rhoda Kemp had so admired in Bishopton. A year later that small cubicle and the nurses' autograph books were still being proudly pointed out and shown

to patients and visitors. By coincidence, an injured Royal Fusiliers officer, Clinton Davies, who later played in one of Bairnsfather's stage productions, was put in the room in 1917. "The nurses showed me their autograph books with Bairnsfather's signature and usually with a little drawing of Old Bill saying 'Ullo', 'Cheerio' or 'Strewth'," he remembered. "There was a mirror on the wall of the cubicle and sticking out behind it, drawn on the plaster, was a woman's shapely leg wearing a high-heeled shoe. It was a bit like a dancer's leg in a high kick and you could see it naked right up to the thigh. Of course I

went over to the wall and looked behind the mirror as the artist obviously meant me to do. There was nothing there except "Honi Soit Qui Mal y Pense" and it was signed "B".

Despite obvious moments of light-heartedness Bairnsfather was camouflaging a lot of troubles and the Medical Board at Rouen ordered him back to England. He returned on the *Asturias* which was loaded with wounded from the Battle of the Somme. Bruce called the Somme "that great and glorious conflict", still making that strange distinction between the destruction of life in a noble cause and the devastation of nature.

His destination was King's College, Denmark Hill, Camberwell, the same hospital where he had gone after his Ypres episode. There he was formally classified as not fit for active service in France, confirmed as a Staff Captain in the Special Reserve and sent home to Bishopton to get better.

He used his time to astonishing effect.

The title page of Bullets and Billets, *1916.*

Chapter 5

Officer Cartoonist in Great Demand

(1916–1917)

Bruce had been back at Bishopton only a short time before he was persuaded to go to a garden fête at Kineton House, at Kineton, near Stratford, where Lady Willoughby de Broke was raising funds for a Red Cross hospital. Before the war he had frequently organised theatrical performances at the de Broke's country seat at Compton Verney, painting the drops and acting. At the fête, in ten minutes of lightning sketching on 7 August, 1916, he earned £85 for the Red Cross by selling his drawings to the highest bidder. It must have given him a shock to realise that in ten minutes he had earned what *The Bystander* paid him in a whole month.

Bruce had briefly touched success and security several times before, only to find that they had eluded his grasp. Here he was earning almost £10 a minute: past experience suggested that it wouldn't last.

But Bruce wasn't just drawing. He was also writing a book called *Bullets and Billets* from the notes he had begun in France.

His publishers were Grant Richards of London. Perhaps they, too, saw the potential for profit with Bairnsfather and approached him directly. It is a possibility that his *Bystander* contract prevented him from doing a "picture book" with any other publisher and thus he was forced into prose.

In addition he was also writing for the stage, a further natural development of his talents. His own enthusiasm for the music hall meant that it was only a small step to translate his drawn characters into theatrical reality. At small gatherings he would act out the situations depicted by his drawings, once again revelling in the admiring attentions of a captive audience. Perhaps at Bishopton, perhaps in London, someone saw Bruce do his act and judged it good enough for a professional production. However it came about, in mid-1916 he was working with the writer Basil Macdonald Hastings on a short scene for a revue called *Flying Colours* at the London Hippodrome, a revue

put on by Albert de Courville.

Albert Pierre de Courville was one of the first people to introduce spectacular revues to London, and during the First World War his productions became famous. These revues were extraordinarily varied with scenes ranging from comedy, through dance pieces and musical interludes to dramatic excerpts. When the leading promoter of London revues was persuaded to put Bruce's work on to the London stage, it was a positive and significant recognition of the popularity of his cartoons.

By the time that Bruce worked with Macdonald Hastings on the sketch for Albert de Courville's review, Old Bill was the pivotal character in his work. It was not a conscious decision on Bairnsfather's part, it just happened. Old Bill was not based upon any individual, despite the many claims to the contrary that would arise ever after. Old Bill's face can be seen in the drawings Bairnsfather did on the walls at Stratford Technical College after he left Westward Ho! although a claim by the Junior School Headmaster of Westward Ho! that he was the original Old Bill pre-dated even those.

The truth is that Old Bill just evolved. Bruce put it this way: "I was drawing him for a year without knowing it. Some people have the impression that there actually was an Old Bill, and that I used him as a model. That is quite untrue. There were thousands of Old Bills."

The characters in the *Flying Colours* revue, scene six out of a total of nine scenes (in the majority of which "Little Titch" and Gabrielle Ray were the stars), were Bill, Bert and 'Arry. The scene was called "Bairnsfatherland or The Johnson 'Ole" and lasted about five minutes. Three soldiers are chatting in a trench to the background of gunfire. They are visited by an officer, "a bleedin' good feller," says Bill. They pretend not to be "A" Company when sandbags arrive to be filled but change their minds raucously

The *"Bairnsfatherland" section of the* Flying Colours *programme.*

Advertisement by Bairnsfather for Flying Colours.

John Humphries, the first stage Old Bill.

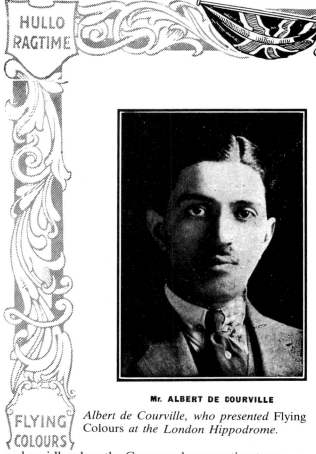

Mr. ALBERT DE COURVILLE

Albert de Courville, who presented Flying Colours *at the London Hippodrome.*

and rapidly when the Company's rum ration turns up. The item is simply a series of interpreted cartoons, beginning with "When the 'ell is it going to be strawberry", and short snatches of song. It opened at the Hippodrome in the second week of September and was an immediate success. Edgar Wallace interviewed Bairnsfather just before the revue went on. One critic rated his piece, with another sketch: "By far the best features of *Flying Colours*, the new review . . . the Bairnsfather episode is as good as the Bairnsfather pictures. It is written with discretion and produced and acted with skill." Columbia Records recorded the show, including "Bairnsfatherland", on a 78 rpm wax record.

Old Bill was played by John Humphries, and he played him again in another revue, *See Saw*, shortly afterwards. Authority was not pleased. There were questions in the House. Generals, particularly the chair-borne variety, complained about Bairnsfather's image of the British soldier, soon "the Thunderer" would raise its voice against his "degraded" images.

Doubtless Bruce's parents felt that "author and playwright" was a more acceptable career for their son. But he was still a soldier.

The cover of the programme for Flying Colours *at the London Hippodrome, 1916.*

"The Eternal Question . . . When the 'ell is it going to be strawberry?" A Fragment from France.

On 16 August, 1916 Bruce's brother, Duncan, left the Royal Military College Sandhurst and was commissioned into the Royal Warwickshire Regiment. Now Major Tom had two soldier sons and both in France! Duncan for the first time and Bruce for the third.

The war was not going well for the Allies. When it had started in August 1914 the popular opinion was that, "it will all be over by Christmas". Now, two years later, the enemy still occupied large parts of France and Belgium, and Russia was faltering. The stream of volunteers in Britain dried up in 1915 as the appalling numbers of killed and wounded became known. Conscription was introduced. The winter of 1915–16 had been disastrous. There was the carnage at Loos, leading to the dismissal of Sir John French in December, the costly failure of the Dardanelles Expedition, the increasing sinking of Allied ships at sea by German U-boats, and the collapse of the Asquith government following the accusations that the British Forces in France were short of ammunition. In June, Britain's revered war leader, Lord Kitchener, was drowned when his ship, HMS *Hampshire*, struck a mine and sank on the way to Russia. In July came the

almost unbelievable casualties in the Somme offensive. The first day of the battle was the blackest day in the history of the British Army. Over 60,000 men were killed and wounded. The Irish rose in armed rebellion at Easter and food prices in Britain had almost doubled since 1914 – and there were increasing shortages of staple commodities foreshadowing desperate times in 1917. In France there were cruel battles around Verdun: German offensives that were to last for months.

In this bleak environment, in the blackest days of the war, Bairnsfather made the country laugh. They laughed at home and in the trenches, and found a remedy for the depression that was overtaking the French, the Rumanians and the Germans. The fact that the British were able to rally, to respond to the cry "we'll see this thing through to the end" owed much to Bairnsfather. Ordinary people, soldiers, regimental officers knew this and showed it by buying Bruce's cartoons in their tens of thousands, waiting anxiously for each new *Fragment*. But the Army staff could not accept this apparent failure or the comparative inadequacy of carefully planned official propaganda campaigns – often because some of the cartoons poked gentle fun at *them!*

"Old Bill" had by now emerged as an identifiable character, together with his companions, Bert and Alf. They coped with everything the enemy, their NCO's, their officers or The Staff could throw at them. People loved their honest roguery and their apparent ability to carry on their own lives despite the efforts of enemy or authority to challenge them. Bill, Bert and Alf were the soldiers of reality, scruffy and comfortable. That wasn't the image that the authorities had of their soldiers. It wasn't the image that most senior officers welcomed in their headquarters, well behind the lines. The Blimps soon began to carp at Bairnsfather's work.

The French establishment, unlike the British, had no social or cultural barrier to acknowledging the role Old Bill and his companions played in morale. At the end of 1916, as the holocaust that raged around Verdun subsided, the French requested that Captain Bairnsfather be loaned to them, to create for France what he had created for his own country – higher morale through laughter. The War Office agreed, and in the one solitary act of recognition that it or any other branch of British officialdom would ever concede, appointed Captain Bruce Bairnsfather as "Officer Cartoonist" in the Intelligence Department. To Bruce it was an ecstatic occasion: formal acceptance as an artist at last. Presumably the request by the French Intelligence Department forced the War Office's hand, or perhaps there was an officer who had served in the trenches and who knew how right the drawings were. In any event, Bruce was told to

Bairnsfather's representation of the Staff Officer (which was also the Front Line view) may have been one of the reasons why the Staff and their political peers refused him formal recognition,

continue to draw his *Fragments* on behalf of the war effort.

His official job in France was the first in a series of lonely tasks involving a great deal of travelling. He was sent to a small seaside town called Coxyde-les-Bains, not far from Ostend and from the moment he arrived was treated by the French as a celebrity. Based at the headquarters, which displayed his cartoons on every available wall, he was conducted around the trenches day after day. It proved to be a great strain, for not only was he once again surrounded by the destruction of war but he was unable to converse at length with his companions, and at the end of each tiring day's tour he had to sit alone to complete his notebooks. Nevertheless, he was greatly impressed by the humanity of the French Headquarter Mess, where "that frigid atmosphere which some of our headquarters can and do assume is entirely lacking . . . a second lieutenant, when at some 'off duty' period, say at dinner, can talk with his General and be answered and talked to by his General like two human beings who have respect for each other's knowledge, each in his own sphere. You will frequently find with us that, under similar circumstances, a gloomy unintellectual silence is maintained".

The French asked permission to reproduce Bairnsfather's drawings in their official "Bulletin des Armées" and he continued his tour of their lines. In November Cassell published *A Temporary Gentleman in France* by Captain A.J. Dawson, a descriptive writer in the Intelligence Department whom Bruce had met in France. Bruce drew the coloured cover. Almost at the same time Hodder & Stoughton published another Dawson book on behalf of *The Bystander*. It was called *Somme Battle Stories* and included eight drawings by Bairnsfather, none of which feature Old Bill. Only one, or at the most two, of these pictures appears elsewhere in a different guise at a later stage, a fate which was to befall many of the *Fragments*.

In December Vivian Carter, editor of *The Bystander*, published his own book *Bairnsfather, A Few Fragments From His Life* (Hodder & Stoughton). Starting with a frontispiece photograph of the Captain, it traced his development from India to early 1916, including picture extracts from Bairnsfather's notebooks and letters. Its underlying purpose was to present a case for Bairnsfather's recognition as a true artist, the beginning of an attempt to repair the damage triggered by that phrase, "without the war he might never had put pencil to paper for publication" in the foreword to *Fragments*.

In the same month, Bruce's own book *Bullets and Billets* was published by Grant Richards. He dedicated it: "To my old pals, Bill, Bert and Alf, who have sat in the mud with me." There is no mention of *The Bystander*. In over 300 pages of text and 18 full-page illustrations, as well as occasional vignettes, he recounts his adventures from his first landing in France to his return to England after his wounding at Ypres. Had he written it under another name it might have fared even better than it did. However, despite pointing out that Captain Bairnsfather was a better artist than author the *Daily Express* liked parts of it: "Captain Bairnsfather gives a delightful account of the meeting of German and British soldiers in No Man's Land on Christmas Day 1914," and on 7 December, one *Times* reviewer also approved. "This chronicle of the start from England; life in the trenches, the real thing; home on leave and the knockout, is full of humour, and good humour, and vivid writing". Praise indeed for a mere cartoonist, but heavy guns were brought to bear on 21 December, in the *Literary Supplement* ". . . we regret unfeignedly that when the Empire laughs we must remain dumb . . . we know a battalion where a soldier such as Captain Bairnsfather takes as his type would be most summarily dealt with. Nothing so quickly lowers morale as

slovenliness, and nothing is more difficult to check than the gradual degeneration due to trench life; and yet here we have an Army officer who invariably depicts his men (to whom his book is dedicated) as the very type which the Army is anxious to suppress. Bairnsfather's Alf and Bert are disgusting because they are too horrible. It is not with Captain Bairnsfather's humour that we quarrel, for his situations are invariably amusing. It is because he standardises – almost idealises – a degraded type of face.'' The reviewer goes on to turn his attention to Vivian Carter's brief biography ''. . . an elaborate life of the artist by a friend, a life not so remarkably varied as to deserve such a reward – if we may call it so?'' These sour grapes represented the views of a large part of one per cent of the country – ''the Establishment.'' Not all the points made, however, were untrue. Bill and the others were scruffy, but then it was virtually impossible to be otherwise when fighting a trench war – perhaps the reviewer had never been to the front. This formal statement of the general establishment view provides a clue as to why Bairnsfather was never given any official reward for his undeniably significant contribution to the war effort.

Bairnsfather himself was the ideal Boys Own Paper type of Englishman. If only the reviewer had taken the trouble to meet him. He was quiet, self effacing and intensely loyal. Clem Humphries, the actor John Humphries' daughter, remembered an instance of Bairnsfather's loyalty, when during the rehearsals for *Flying Colours* her father refused to deliver lines that he judged ''too risqué''. ''He never cracked a dirty joke. He refused to be vulgar. When de Courville asked him to do a sketch measuring a fat woman, he considered it to be vulgar and said so. De Courville got up, walked out and engaged someone else. And then Bairnsfather came and saw this other man rehearsing. 'Oh no,' he said, 'if Humphries doesn't play the part, my sketch doesn't go in'.'' De Courville capitulated.

Whatever the official view of his work in England, the French had no doubt about its value and were not ashamed to show their appreciation. When the time came to leave Coxyde, Bruce was given a farewell dinner by Prince Alexander of Teck who lived at nearby La Panne and was the British representative with the King of the Belgians. Then he set off for Verdun. There he was welcomed and conducted around that devastated symbol of French pride by General Mangin himself, the architect of the final victory at Verdun.

The pace of work, the loneliness of his travelling existence, gave Bairnsfather no time to consider what return he was getting for his efforts. Since he had begun drawing for *The Bystander* he had never missed a deadline, producing two or three drawings a

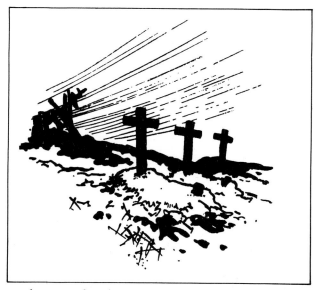

week, every drawing requiring two days to complete. In addition, he had worked with Dawson on his books, written his own *Bullets & Billets*, co-operated with Macdonald Hastings on ''Bairnsfatherland'' and following the success of that, was, early in 1917, back in England working both on the finished versions of his French drawings and a new piece for the André Charlot revue *See Saw* at the Comedy, for which Ivor Novello did the music and Arthur Eliot wrote with others. *The Times* was kind to it when it opened early in March 1917: ''A new and amusing episode of trench life. 'Where did that one go to' by Captain Bruce Bairnsfather . . . shows some of the characters which Captain Bairnsfather has made so familiar, including Mr John Humphries as Old Bill, Mr Hugh Wright as Bert and Mr Billy Daniels as Alf and fills a very welcome place in the entertainment.'' The success of his theatrical pieces and a suggestion by André Charlot gave Bruce the impetus to attempt a full length play, for now he was stretching out towards his first love – the theatre. There was no thought of financial self-preservation in his mind, he was still giving without thinking of taking. He was still the lad up from the country.

1917 was to be an even more intense period than 1916. That momentous year would see Bairnsfather's work transformed into a hit London stage show, books in both France and England as well as films, while the sales of *Fragments* would approach two million. The stage show was to be called *The Better 'Ole* and he had just completed the script in collaboration with Arthur Eliot, whom he had met at the Comedy during *See Saw*, when the Italian Army officially requested that he tour the Italian Front and make some drawings. He was enthusiastic about the idea, and, leaving the London base which he had

"Perils of War – And of Popularity". From Fragments from
All the Fronts. *No. Six.*

established at the Langham Hotel, he set off for Italy
– via Paris.

Bruce made many visits to Paris, both before the
war and during it. Usually they were very brief, since
Paris was often a stop *en route* elsewhere, and his visit
this time was of the twenty-four hour variety. Just
what he did in those few hours is difficult to say.
Maybe that sense of freedom that came across all
Englishmen of Bruce's type once they were across the
Channel, led him to step outside himself and to go
"jazzing it up" as he had done in his Yeomanry days.
Perhaps he made love to some demi-mondaine. In his
book, *Carry on Sergeant* written ten years later where
he comes closest to expressing his true feelings, he
talks of sitting in the lounge at the Folies and of being
approached by a "highly decorated face. 'Non ce soir,
Mademoiselle', you found yourself saying", he
wrote. Then he goes on: "But it must not be thought
that all this tinkle, brass and scent should be con-
demned. The myriad of women of slender allegiance
played a big part in the war. We did not all have
splendid loyal wives or loyal sweethearts. The Great

*"19 . . .?" This cartoon was considered by Charles Dana
Gibson to be the most brilliant thing that Bairnsfather ever
did. From* Fragments from All the Fronts.

War, ranging from a mile behind the front line trenches, back to the Pacific Coast of America and to the uttermost fringes of Australia offered every conceivable sex story known to man. Loyalty, infidelity and promiscuity, all had their places in the war." This could well have been a retrospective justification of a naughty time in Paris.

His Italian destination was the road and rail junction town of Udine, close to the Austro-Hungarian border and he billeted there at the British Military Mission. The Italian objective in the fighting against the Austrians was the port of Trieste, and the opposing armies faced each other along a line that ran due north from the Gulf of Trieste following the line of the River Isonzo through the Alps to Caporetto. Bruce was immediately struck by the difference between the western and Italian fronts. It would have been difficult not to comment upon it. In his book, *From Mud to Mufti*, he said: "But what a different landscape to fight in from our front. Instead of the sticky mass of sloppy sand-bags along the edge of a narrow canal, which constitute the normal trench on the western front, these men had nothing but rocks and sand to deal with . . . so you can imagine what making trenches was like." The warm weather suited him and he enjoyed staying at Udine as a base and going back and forward towards the front and seeing, as he put it, "the mountainous difficulties lying between the Italians and the capture of Trieste". Thus the days there were a rest from the earlier intensive weeks that, as yet unknown to him, were beginning to tax his health again. But it was the war which he had come to see and for that he had to continue on to the mountains.

Once again the importance attached to his work by an ally was made clear. The guide for Bruce's look at the fighting in the Alps was the Duke of Milan and the first part of the journey forward was made in the Duke's car and provided much material for later cartoons about Italian driving and hairpin bends. "Now and again," said Bruce, "we would nearly collide with an Italian staff car which was doing its usual ninety miles an hour round impossible corners." Eventually they could go no further by car and transferred to mules, and then the journey continued on foot until at last they reached the forward positions of the Alpini, the Italian Alpine troops.

Bairnsfather developed considerable admiration for the soldiers whom he met. They lived in appalling discomfort, in boiling heat during the day and bitter cold at night on mountainsides that offered no cover. Their isolation from their own forces in the plains was such that wherever he went Bruce was questioned for hours about what was happening in the war. A cartoon that he later drew on this theme was said by the artist Charles Dana Gibson, then Head of the Amer-

Charles B. Cochran, who produced The Better 'Ole *at the Oxford Theatre, 1917.*

ican Division of Pictorial Publicity and later owner and editor of *Life* magazine, to be "the most brilliant thing Bairnsfather ever did".

Its caption was "19 ?".

On 6 April, 1917, America would declare war on Germany and soon, like France and Italy before her, that mighty country would also seek the help of the same lone Englishman.

Meanwhile, General Cadorna, the Italian Chief of Staff whose headquarters was at Udine, voiced his approval of Bruce's drawings, and in England Arthur Eliot was doing the rounds of theatrical managers, carrying the *Better 'Ole* script.

Practically everyone in London, including de Courville and Charlot, refused it – except C.B. Cochran that is. Cochran liked the script. "This thing cannot fail," he told himself, "And if it does it will be my fault." Armed with his conviction he took over the management of The Oxford Theatre, which was suffering from bad times, and determined to put *The Better 'Ole* on there. "I saw big money or entire fiasco in *The Better 'Ole*," he said.

It was big money. But not for Bruce.

Chapter 6

Recognition on Stage & in Films

(1917–1918)

In 1917 Bruce Bairnsfather was a celebrity. It was natural that the rapidly-developing world of cinema should seek him out.

Public showings of moving pictures had only begun at the turn of the century, and the structure of these performances owed much to the music hall. Very often film shows would be incorporated into an evening of theatrical entertainment and it became a regular practice as the war continued to show scenes from the front. De Courville introduced short films into *Flying Colours* when it was playing at the London Hippodrome. In such a young, vibrant and obviously exploitable field, there was great competition amongst cinema impresarios for the newest thing. Animated cartoons using a sequence of drawings to give the impression of motion were extremely popular, and it was only a small step to capturing on film well-known artists drawing and sketching.

In May 1917, Film Booking Offices, a film renting and distribution company, announced its intention to produce twelve Bairnsfather cartoons, each one to be a 1000 feet "single reeler film lasting about fifteen minutes". Bruce was not required to draw cartoons himself. Another artist was engaged to copy the drawings, the audience seeing only the hand creating the picture. *The Bystander* gained most of the financial benefit, perhaps all of it, since it held the copyright on the published cartoons.

The Star announced the venture on 19 May: "One by one the world's leading cartoonists have succumbed to the all conquering cinema . . . now comes the interesting announcement that Captain Bruce Bairnsfather has been prevailed upon to lend his genius to the act of the cinema cartoon . . . he gave the world a new type of humour at a time when there was little to be seen but a dreary wilderness of ruin and gloom. He showed us at home the lighthearted spirit which made our 'contemptible little Army' perhaps one of the greatest forces in the present war." The film was shown to a selected audience later in May at the West-End Cinema and was an immediate success.

Within a month the second series of cartoons was produced and shown. *The Times* commented: ". . . as the moving hand of the artist sketched with rapidity, the evolution of the scene in which the characters played their droll parts was watched with keen interest and the result was received with hearty laughter."

Public distribution of the films began in July and Film Booking Offices announced plans to display over one hundred cartoons in all. Meanwhile the real artist continued to make money for other people, appearing at fund-raising events and sketching pictures on the spot for auction. He even found time to draw a special picture to acknowledge the magnificent feat of the Canadians capturing Vimy Ridge, a German bastion that had defied the French for over a year. The picture, showing a Canadian soldier standing on the Ridge, was auctioned on stage on 11 May, at His Majesty's Theatre, during a special Canadian matinée revue in aid of St Dunstan's Hostel for Blind Soldiers and Sailors. In the audience were Queen Alexandra, Princess Victoria and the Princess Royal, and they saw Bairnsfather's drawing sold, with one by the famous Dutch artist Louis Raemakers. The Raemakers picture fetched 4 guineas. The Bairnsfather picture fetched 225 guineas, a telling assessment of Bairnsfather's popularity.

Simultaneously, from 7 May to 11 August at the annual Royal Academy Exhibition, a watercolour portrait of the Captain was on display – Exhibit Number 840. The portrait was by William H. Barribal, an artist whom Bairnsfather had long admired and with whom he was to become very friendly.

Bairnsfather was almost unavoidable. In April two more Dawson books were published, by Hodder & Stoughton. The first *Back to Blighty* was published

for *The Bystander* in the same format as the previous *Somme Battle Stories* and had eight inserted glossy drawings by the artist. *For France*, the second, carried no such *Bystander* acknowledgement and was larger and of better quality. In Paris Bairnsfather's internationality was evidenced by the publication of *Chez nos alliés britanniques* by Fernand-Laurent which included *Dessins de Bairnsfather*. In America, too, interest in his work was accelerating.

The backcloth to all of this activity was a continuous treadmill of work as Bairnsfather translated his Italian notebooks into finished pictures, and an increasing uneasiness about the play *The Better 'Ole*, now in final rehearsals. Bruce's uneasiness was shared by almost everyone associated with the production and the play came within a breath of cancellation. At the very beginning, even the script found few supporters. Arthur Eliot, with a member of *The Bystander* staff, Mr McFarland, who acted as Bruce's business manager in return for 20 per cent of the artist's earnings, toted the script around London while Bruce was in Italy, and could not drum up any interest, even from André Charlot and de Courville, both of whom had seen positive evidence of the popularity of Bairnsfather's shorter pieces. However, at Easter the script reached C.B. Cochran who took it away to read while on holiday. "The night before Good Friday I read *The Better 'Ole* and my wife asked me what was making me laugh so much. I read it to her. She laughed as I had done, and sometimes our laughter came through tears. I put the book down and said, 'I shall do this play, but it's a question of getting the right theatre. I should like the Oxford Music Hall. That is a theatre with an atmosphere redolent of 'Old Bill' and beer. The two must go together' ."

By contrast, Cochran's long time stage director, Frank Collins, was emphatic in his opinion of the script ". . . piffle, a schoolboy of fourteen could write a better play than that".

Cochran didn't disagree. "Technically speaking *The Better 'Ole* was about as crude a play as ever gained the distinction of a West End production. It was lacking in construction, and the story was not only puerile, but dropped out half-way through the play." However, Cochran had a sense of timing, and he realised how disaffected the population had become with the increasing hardships of life at home and the empty rhetoric of government propaganda. He knew the play had the stuff of success: ". . . three hundred of the best jokes enacted during the war ran through the play, and also there were the Bairnsfather types, 'Old Bill', 'Bert' and 'Alf' who stood for the optimistic philosophy of 'Tommy' in the tremendous conflict . . . it was the exact psychological moment for a war play without false heroics."

Although Cochran admitted that John Humphries

would have been the best choice as Old Bill, he engaged one of the country's leading actors to play the part because his "London name" would help to swell audiences. The actor was Arthur Bourchier, and he was taken on at £100 per week with a guaranteed engagement of six weeks. It was the longest contract in the whole cast. Herman Darewski, who had worked on *Flying Colours*, both produced the music and wrote several numbers for *The Better 'Ole* and even he, at first optimistic, began to doubt the validity of the play as opening night approached. Bairnsfather spent as much time as he could at rehearsals. "Never was I associated with a more modest genius," said Cochran, but even that genius was so worried about Bourchier's interpretation of Old Bill that he practically lived with Bourchier, supplying him with drawings, and explanations of the character. On the day of the dress rehearsal Bairnsfather told Cochran: "You have made a mistake in engaging Bourchier." Cochran assured him that all would be well and they both with Darewski and Arthur Eliot, went on to the rehearsal. It was terrible. "Just about the most miserable evening of my life", is how Bruce described it. Darewski wanted to close the show immediately, but Cochran remained firm. "I had . . . a glimpse of the play as I had visualised it when I read it," he said.

Cochran was a showman. He had placed advance publicity in the popular newspapers and magazines for several weeks before opening and had engaged

Arthur Bourchier, who played Old Bill at the Oxford, showing his natural physical qualities for the part.

CHARLES B. COCHRAN'S Production
By BRUCE BAIRNSFATHER
and ARTHUR ELIOT

Bruce Bairnsfather

EMPIRE, KINGSTON

Advertisement by Bairnsfather for a touring company of The Better 'Ole.

Mademoiselle Edmée Dormeuil, a popular and attractive English-speaking French actress, as the female lead. He placed sandbags all around the foyer of the theatre to give an atmosphere of the front and made up the box office to look like a dug-out. On the opening night, 4 August, 1917, the audience, already familiar with the Bairnsfather cartoons, were treated to an atmosphere of the trenches from the moment they entered the theatre. Darewski's band played the popular soldier songs, such as *Tipperary*, and in a typical stroke Cochran arranged for lantern slides of the *Fragments* cartoons to be shown. The inexperienced lantern operator put several slides in upside down which only intensified the good humour of the audience, who from the moment they caught sight of Old Bill's walrus moustache roared with laughter.

Bairnsfather, so sure that the play would be a disaster, had sent for his mother to come and join him to keep him company, and leant heavily for a few days on Gold Flakes and whisky and soda. On opening night he had arranged two seats at the very back of the

stalls so that he and his mother could remain hidden, and escape easily at the end. In the event it caused a small problem.

When the final "Splinter" came to an end, the audience shouted for the authors. Captain Eliot was quickly produced but Bruce could not be found. The *Daily Express* reported, ". . . suddenly a figure in khaki was seen to be climbing over the conductor's shoulder, and with a spring landed over the footlights on the stage. It was Captain Bairnsfather who almost fell into Old Bill's arms as he turned to smile at the laughing and cheering audience". That first night in London was the beginning of a two and a half year sequence during which a dozen companies would tour the world – in Australia, India, Canada, Africa, America and the United Kingdom – playing the show, and the first of 817 performances at that one theatre.

The story was very simple and built around Old Bill. It was an amalgam of Bairnsfather's personal experience and hence in turn his *Fragments* cartoons, consisting of two "Explosions", "Seven Splinters" and "A Gas Attack".

The first Splinter depicted a soldier's gaff "somewhere in France", exactly the sort of amateur theatrical in which Bruce so much enjoyed taking part while he was in the Isle of Wight. Splinter Two, in the "Café des Oiseaux", "nearer the Front", arose out of memories of the Café Tortoni at Le Havre where Bruce had "made the most of it" before going into the trenches in 1914. Splinter Three was in "Billets", "just behind the Front". In this scene Victoria, the French girl played by Edmée Dormeuil, made her appearance. Victoria and the other girls were directly modelled on Suzette Charlet-Flaw and her companions, with whom he was billeted early in 1915 – the "oasis in a six months' desert". So the story went on, even including a Captain Milne, perhaps an unconscious memory of his fellow officer A.A. Milne from the 1st Battalion Royal Warwickshire Regiment who would later find such fame with his children's stories.

A dramatic element is introduced when Old Bill discovers the plans of a German spy. In attempting to foil the enemy, Old Bill is almost executed himself, but is saved at the last moment by Victoria and awarded the Légion d'honneur, returning in triumph to his wife Maggie and to his pub, "The Better 'Ole".

The play was an outstanding success, though oddly the newspapers never really acknowledged its full impact on the audience, who frequently stood and cheered when each two hour performance finished. The stage magazine *Play Pictorial*, however, devoted a complete issue to it and Max Pemberton in *The Weekly Dispatch* called it, "A real war play at last . . . it is a success beyond expectation. Nightly you may see Guardsmen laughing and little milliners' assis-

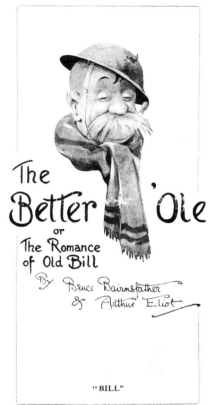

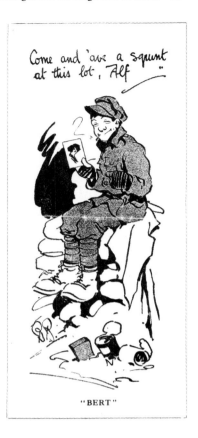

The programme for The Better 'Ole *play*.

tants weeping and hear the cheers of the men in khaki *who know*. Mother and son, the son who fought, sit side by side and hold hands. And he tells her proudly, 'It was just like that out there'. Yes, it was and is just like that out there, and no surer tribute could be paid.'' Pemberton forecast that it would have ''prodigious success in America and the far lands''. He was right.

The receipts at The Oxford were exciting. Before Cochran took over the theatre and put on *The Better 'Ole*, the theatre rarely did big business. One hundred pounds a week would have been big takings. In its first week, *The Better 'Ole* took £2753.15s and by the fourth week it topped £3000. Taking into account the earnings of the touring companies, it is possible to believe Bairnsfather's later assertion that while Cochran eventually made £100,000 profit from the play, the author made only £2000.

While all this was going on, *See Saw* still ran at the Comedy. Indeed, one critic on the morning after the first night of *The Better 'Ole*, suggested that Bourchier should go and see John Humphries' performance as Old Bill in order to learn how to do it properly. Cochran and Bairnsfather continually had

to remonstrate with Bourchier who tried to play the part for laughs, thus losing much of the honest integrity that lay behind the character. But Old Bill was a national figure – a world character now, everyone's property. In August, the fourth volume of *Fragments from France* was published, bringing the total printing to an astonishing 1,725,000 copies. The Midlands pottery firm of Grimwades began to issue pottery pieces carrying reproductions of the *Fragments* cartoons. The pottery, in the shape of everything from shaving mugs to flower pots, was cheap and plentiful. The transfers, each produced from a separate lithographic stone on which was copied the Bairnsfather cartoon, were produced in sheet form by the Chromo Transfer & Potters Supply Company Limited of Stoke-on-Trent, but without acknowledgement to *The Bystander*. Chromo Transfer did state that the ''sketches'' were copyright, but did not say to whom.

It is likely that the Tallis House-*Bystander* organisation got some financial return on the venture, since it was holding the reins on the hottest commercial property of the war – Bruce Bairnsfather – and it would not have been well disposed to pirate exploitation of his talents. Grimwades was the prime, if not

Lt. A.A. Milne, 1st Bn the Royal Warwickshire Regt.

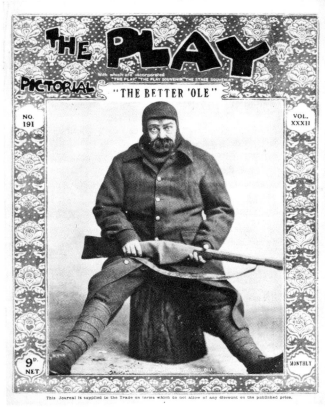

The cover of the Play Pictorial *magazine devoted to* The Better 'Ole *in 1917.*

only, users of the Chromo Transfer cartoons which were exact copies of Bairnsfather drawings, but other potteries including Carlton and Wilkinson produced a variety of pieces and continued to do so for a decade. However, *The Bystander* by now had moved into new areas for profit, and was marketing a series of playing cards produced by Chas. Goodall & Sons bearing reproduced *Fragments* cartoons, as well as introducing a monthly series of six postcards. On top of everything, Bairnsfather continued to produce his weekly drawings for *The Bystander*, *Bullets and Billets* had a limited edition printing of one hundred copies for special sale, sheet music from *The Better 'Ole* was selling apace and Bruce co-operated with Arthur Eliot to write another sketch called " 'Ullo" for a new revue, *Any Old Thing*, due to open at The London Pavilion in December. The situation was almost one of overkill. The public loved Old Bill, but the excessive exposure of the character by natural commercial pressure may have been another factor in

the lack of official British recognition of his contribution to the war effort. Bairnsfather finally admitted that he couldn't cope, and wrote to Cochran saying that he had been approached by too many people to write plays, sketches and film scenarios, that he wished to state publicly that he would not undertake any more dramatic work until he had something new to say. It was a sensible acceptance of a need to reduce an overwhelming pace of work, but would he ever have anything new to say? There wasn't time to find out, for before the year was out once again an ally demanded his presence.

The American propaganda department wanted Bruce to go to France to capture the spirit of the United States troops who were beginning to arrive on the Continent, to do what he had so far done for the British, French and Italians – relieve the tension of war through laughter. It was an opportunity that excited him, partly because his earlier trips for the French and Italians had been particularly exhausting due to the difficulty of communication, and partly because his sense of adventure was sharpened by the idea of working amongst kith and kin from three thousand miles away.

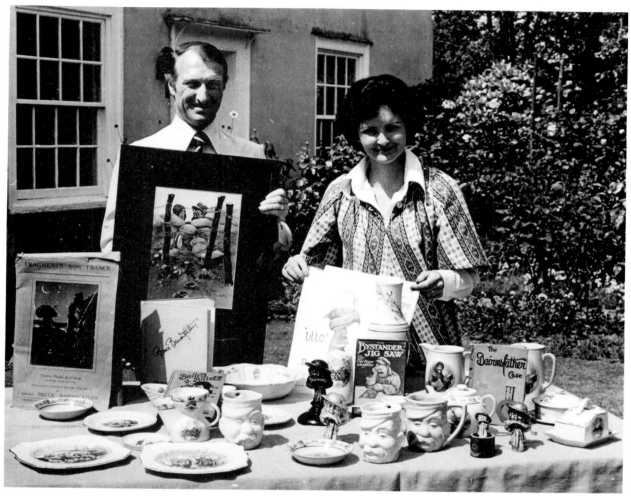

The authors, with a selection of Grimwades Bairnsfatherware pottery pieces and other BB memorabilia.

Transfers used by Grimwades for their Bairnsfatherware.

He left for France early in 1918, just as the claims to be the original Old Bill began, led by his old Headmaster from Westward Ho! Mr R.T. Leakey, who wrote to the *Graphic* on 17 December, "I do not know whether I may claim the honour of being the prototype of Old Bill, but . . .?". It was acknowledgement by a teacher, of the status of his one-time pupil. Acknowledgement was made in a different fashion at Neufchateau in Alsace Lorraine by the American army when Bruce arrived there in January.

The division Bruce was to visit was based at Neufchateau and the Commander, General Clarence Edwards, had a collection of Bairnsfather's cartoons. The general immediately invited Bruce to dinner and personally supervised the arrangements for the tours of the front line, insisting that one of his ADCs accompany the artist. It was a timely break for Bairnsfather who, looking around at the cheerful freshness and strength of the American soldiers, told himself, "I shall be all right here".

The enthusiasm of the men to "get into the war" aroused him, and their cowboy hats added an element of theatre which allowed him to relax and enjoy himself. Everything he saw seemed larger than life, even the food. "What a terror the American soldier is for eggs. I saw a plate containing a dozen fried eggs, and found on enquiry that they were all for one man."

The Americans were the most friendly people he had ever known, their touch-paper reaction to humour making him determined to visit their home country. At the same time he assessed their military strength as a war winning factor, "I knew Germany hadn't a chance," he said. While he dismissed the German chances of survival, he still admired them for their determination and efficiency.

"The Man Who Came 3,000 miles".

With his notebooks full of sketches he set out to return to England and by extraordinary coincidence bumped into his brother on the quay at Boulogne. On 30 March, 1917, just seven months after leaving

"My Brother . . ."

Sandhurst, Duncan had been appointed as an ADC to Lieutenant General Sir Richard Haking prompting Bruce to draw one of the few cartoons in which he depicted real people. The likeness is splendid. Duncan was obviously doing well in the Army and the ADC appointment with its red tabs would have attracted the admiration he had sought through excessive generosity at school. He continued to do well, and by the time the war ended had served on the Western and Italian Fronts, receiving both a mention in dispatches and the award Chevalier of the Crown of Italy.

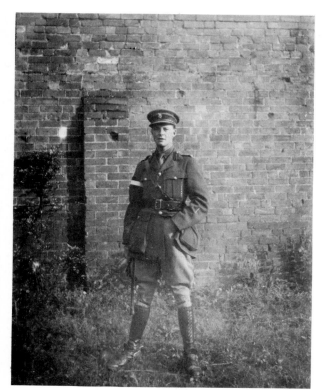

A.D.C. – Lt. Duncan Bairnsfather.

Officer Cartoonist – Capt. Bruce Bairnsfather.

Dear Sirs

Sorry about cheque. The Lloyds Bank (nearly opposite Selfridges I think) is the one that is authorized to change my cheques.

Try it there or if not any use I will write and I have had no difficulty before at that Bank near Selfridges Oxford St.

Yrs truly

Bruce Bairnsfather

Capt

Letter from Capt. Bairnsfather to the Manager of the Langham Hotel.

Photographs from Duncan Bairnsfather's album, courtesy of Marian Evans.

The meeting between the brothers was brief. Bruce had been fond of Duncan, ten years his junior, when the latter was a child, and often drew for him. But the considerable age gap between them and the different directions their lives took, meant they saw little of each other even as children. At the time the family were worrying about Bruce in his teens wanting to be an artist, young Duncan was the family favourite. Duncan remained the favourite, even when Bruce became successful, because his career was traditional and recognisable. Nevertheless, Bruce remembered the meeting with pleasure, "I . . . had the good fortune to run into my young brother . . . He is one of those people of whom ladies say, 'He has got on so well, you know'. He is a Staff Captain. You know what I mean. A red hat, two strawberry marks on the collar of his coat, highly nuggeted topboots, spurs and shorts. He condescended to lean against a counter in the Hotel Folkestone and have a cocktail with me . . . He's a good lad my brother". Bruce would be proven wrong about that.

Bairnsfather's visit to the American forces had attracted considerable attention in the Press at home and in America. On his return he was once again caught up on an increasing round of charity appearances and lectures, his drawings appearing on an immense range of things from collecting boxes for Queen Alexandra's Field Force Fund – "Do you know of a Better 'Ole than this for your money?" – to pottery, china, film and paper, and individual drawings such as the one he did for the programme for the opening of the Chevrons Club in February 1918. The club was for petty officers of the Navy and NCO's of the Army, and Bruce's drawing showed an NCO, and underneath carried the phrase, "Carry On Sergeant". It was the phrase that he said enabled him to deal with whatever difficulties he experienced while in the Army. It was also the phrase that later would demand two years of his life and bring about a disaster.

The Better 'Ole at The Oxford continued to play to packed houses. Seeing its success, de Courville wrote a solicitor's letter to Bairnsfather, claiming that under an earlier contract *The Better 'Ole* should have been offered to him and not to Cochran. There was talk of a court injunction to stop the play. Luckily, however, the script had been submitted to de Courville who must have rejected it without reading it. Mr McFarland, of *The Bystander*, had had the foresight to get de Courville's refusal in writing, so the trouble blew over. However, the episode gave Bruce good reason to consider just what financial return he was getting out of the play. He was certainly not rich as a result.

During the last year or so he had lived at The Langham Hotel, and was very popular with all the staff – from the cashier, Lily Johnson (doing what was normally a man's job for the duration) to the Manager, Mr Roberts. Room No. 364 was Bairnsfather's regular room and at that time the room keys had large substantial brass tags. Mr Roberts was delighted when Bruce presented him with a sketch of Old Bill holding the large key to 364 and saying, "If you knows of a better 'ole, go to it". He was not so delighted when one of his favourite client's cheques was refused by the bank. Bruce also had a studio at 7 St Pauls Studios, Barons Court where he did his work. It was expensive to maintain and the bills at The Langham were a drain. One of his cheques bounced and the hotel cashier tackled him about it. He wrote back apologising, and suggested that the hotel should try to cash the cheque again – and that if that didn't work he would write another one. Whatever the reason for the difficulty, he was beginning to be more conscious of money, the money that others were making from his ideas and his labour.

Now *The Better 'Ole* was about to be filmed, Cochran was negotiating for the stage show to go to America and the Australian Government wanted him to go Down Under to raise morale. He was back at the treadmill.

Chapter 7

The First Trip to America

(1918)

The art of the cartoonist was in great demand, both for documentary purposes, and as animation for the fast-developing cinema business. It is thus a significant measure of Bairnsfather's international standing that in this highly competitive climate the well-known French artist Francisque Poulbot was described in the British Press as "the French Bairnsfather". Charles Cochran had the same opinion: "The Poulbot drawings of children playing at soldiers were to France in 1918 what the Bairnsfather cartoons were to England."

Cochran obtained the London rights for a Poulbot play which was then being presented in Paris, "Les Gosses dans les Ruines" (The Kiddies in the Ruins) and arranged for the artist to come to England to design the scenery. On the boat train back to London, Cochran met Brigadier General Cannot whose brother he had known under the stage name of Chamberlain and whose nephew was the comedian Jack Cannot. General Cannot, a fluent French speaker, was doing liaison work with the French army, and, on hearing about Cochran's interest in the Poulbot play, agreed to translate it so that it could be incorporated into Bairnsfather's *Better 'Ole*.

The piece was introduced at the Oxford on the afternoon of 27 June, 1918 to an invited audience, when, as Cochran put it, he would ". . . by courtesy of the authors of *The Better 'Ole*, Captain Bruce Bairnsfather and Captain Arthur Eliot, introduce into *The Better 'Ole* as a new episode, 'the Kiddies in the Ruins' ".

Bairnsfather would probably have been flattered by the inclusion of Poulbot's work in the play, but despite his retiring and modest inclinations, even he was becoming aware that he was himself a celebrity, and may well have spoken up for a share of any additional income. The critics liked the combination. One called it "A Noble War Play" and noted that "Miss Sybil Thorndike, as the wife who escapes from her persecutor, gives eloquent expression to the author's burningly indignant lines". It was Sybil Thorndike's first part on the West End stage.

At the beginning of 1918, Thomas Welsh, the general manager of Gaumont Pictures, and George Pearson, one of its successful writer/producers, left in order to set up their own production company, Welsh-Pearson. The first two motion pictures that they made in their Craven Park Studios were Bairnsfather's *Better 'Ole* and Poulbot's *Kiddies in the Ruins*.

The film was a seven-reeler. Old Bill was played by Charles Rock, Arthur Cleave was Bert and Hugh Wright was Alf. The extent of American interest was clearly indicated when Paul H. Cromelin took out American copyright on 16 May, a good six weeks ahead of the British release on 1 July, although oddly enough Cochran had much more difficulty in finding an American producer willing to take on the stage play.

"I offered the American rights first," he said, "to my old friend William A. Brady, but he declined them. The script passed from one manager's office to another but was turned down. George M. Cohan did not 'give it a chance'." Eventually when Cochran had virtually decided to produce the play at his own risk, he was approached with an offer by Charles Coburn. They agreed terms.

Bairnsfather expressed little interest in the possibility of the Americans taking *The Better 'Ole*. "I did not think that the American public would appreciate the point of view or the humour," he remembered many years later, but it is more likely that his lack of interest sprang from the fact that his income from such a production would be little or nothing.

During 1918 Bruce continued to draw for *The Bystander*, working from his Barons Court studio, and to appear at charity functions for good causes. In June at a Surrey Red Cross sale run by the Duchess of

SPLINTER 3.

"BILLETS." *Just Behind the Front.*

A Tommy	Harry Danby
Victoire Peggie Foster
Bert Tom Woottwell
Alf	Sinclair Cotter
Old Bill ...	Arthur Bourchier
Officer of the Woman } Workers' Corps }	Hilda Denton
The Colonel	Frank Adair

Trio... ... " Carrying On "
ARTHUR BOURCHIER, TOM WOOTTWELL, SINCLAIR COTTER

Song ... " The Irish Girls " ... HILDA DENTON

"S'truth"

INTERVAL.

EXPLOSION II.

SPLINTER 4. " THE WAY IN."

Old Bill	Arthur Bourchier
Bert Tom Woottwell
Alf	Sinclair Cotter

Tommies.

Trio ... " We Wish We Were in Blighty "
ARTHUR BOURCHIER, TOM WOOTTWELL, SINCLAIR COTTER.

From the Original Drawing by Poulbot.

" Run to mother, and tell her I'm a prisoner of war, with the milk can."

Remember Belgium

In Splinter 4 will be introduced :—

OLD BILL'S TALE :

" THE KIDDIES IN THE RUINS."

Adapted from the French of PAUL GSELL and POULBOT by Brigadier - General J. E. CANNOT, C.M.G., D.S.O.

Scene .

A Village in the Somme on the morning of May, 1917.

Maurice Regnard		FREDERICK ROSS
Père Honoré (the Village Mayor)		KEITH SHEPHERD
Père Martin	Old Men of the Village	HERBERT H. YOUNG
Père Fortuné		HARRY DANBY
Père Mathieu		FRANK ADAIR
Corporal Jules Lelong		DAVID CLARKSON
Trooper Henri Laval		C. LILLFORD DELPH
Trooper Emile Marchand	...	FREDERICK BAKER
Trooper Francois Boucher	...	A. WAY
Francoise Regnard		SYBIL THORNDIKE
Nini Regnard	Her Children	MONICA MORGAN
Jeannot Regnard		FERNAND MERTENS
Amele (" Melie ") (Her Adopted Child)		
		VIOLETTE KEMPLEN
Mère Leroi	Women of the Village	FLORENCE WOOD
Julie Laroche		GLADYS FFOLLIOTT
Leonie Lebeau		RUBY KERTHEEN
Caroline Paillard		THERESE NORDBLOM
Jacques Loiseau	Children of the Village	HUGO CHARPENTIER
Pierre Laroche		KATIE SNOW
Louisette Laroche		ELLA LOWES
Henriette Paillard		JULIA BELAS
Alphonse Paillard		ALBERT LOCK
Alfred Lebeau		FRANK WORTH
Armand Lebeau		BEN WENDY
Noel Lebeau		SYDNEY PINNER
Lucile Lebeau		JILL SANDERS
A Soldier (Cyclist)		VICTOR ROBSON

The Scene executed by SACKMAN, from the model of POULBOT.

Costumes designed by POULBOT.

Children trained by ITALIA CONTI.

Staged by FRANK COLLINS.

The Better 'Ole *programme showing new Poulbot episode, Sybil Thorndike's first appearance on the West End stage.*

Sutherland at Guildford, Countess Onslow paid 100 guineas for one of his cartoons. Which one is not certain, but exactly sixty years later Surrey Red Cross once again used a Bairnsfather drawing – this time as a button badge – to raise money. The drawing "Old Bills made like new" may very well have been a copy of the one purchased by the Countess. It was certainly issued as a postcard in 1918.

Bruce also suffered from the mistaken identities and gossip that fame brings. Many papers, including the *Evening News* and the *Daily Express*, carried one

such story on 26 and 27 July. The *Express* said: "A London chauffeur Arthur Turner, who was fined £2 at Camberley yesterday for illegally using petrol, told magistrates he had taken Captain Bairnsfather and a lady from London to Camberley on a joy ride. The chairman said it was 'a bad 'ole this time'."

Bruce wrote immediately to the *Evening News* ". . . I see I was up for 'Joy Riding' at Camberley . . . I don't know what year is referred to but I haven't been to Camberley since 1915. Either someone has taken in the APM (Assistant Provost Marshal, who

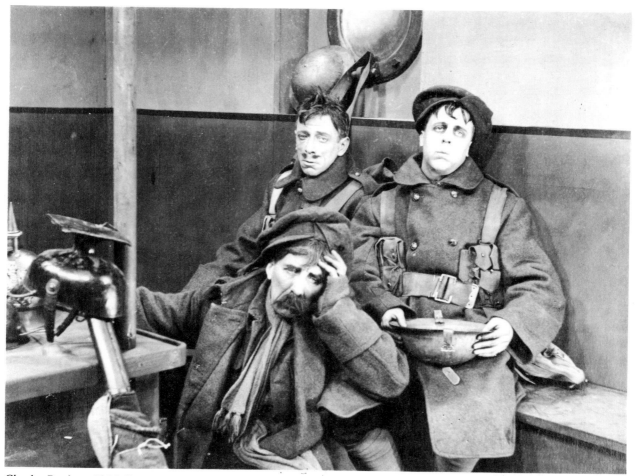

Charles Rock as Old Bill, Arthur Cleave as Bert and Hugh E. Wright as Alf in the Welsh Pearson film of The Better 'Ole, *1918.*

apparently stopped the offending car) or your correspondent was misinformed: as it is I get all the blame and no joy ride". It was a good natured riposte and was accompanied by a typical Bairnsfather sketch showing an officer and a lady in a speeding car.

However, things didn't stop there and Bruce found it necessary to write to the *Daily Express* on 1 August – this time without a drawing. "Owing to the inundation of letters and wires from which I am suffering in reference to my fictitious 'joy ride', I shall be glad if you will allow me to explain that I had 'nothing to do with the case'. I was confined to my room at the time of the charge, and the news of my dare-devil escapade came to me by the evening papers as I lay in bed . . . The whole story is either a careless mistake on somebody's part or a hoax and it has put me to a great deal of annoyance."

He obviously felt upset at the letters he was getting, which no doubt were critical of his supposed behaviour. The newspaper reports had damaged his public image and he placed much value on keeping up a good appearance. He was also unwell. The intensive work schedule which he maintained was partly to blame. Another reason was the legacy of that shell at Wieltje. His hearing had not totally recovered, and apart from the physical injury, shell shock had dampened his previously resilient personality. The explosion that had ended his war wreaked a permanent change in his life, limiting his extrovert phases to shorter and shorter periods as time went on.

It is also probable that there was a further tension hidden in the joy ride story. When the matter was finally cleared up in August the APM himself made a statement which included the phrase ". . . the officer in the car recently stopped . . . was not Captain Bairnsfather the artist . . ." Could it then have been another Captain Bairnsfather? Duncan, maybe? Many years later the Bairnsfather family came to believe that Duncan did at times impersonate his famous brother, and Duncan's personality, which

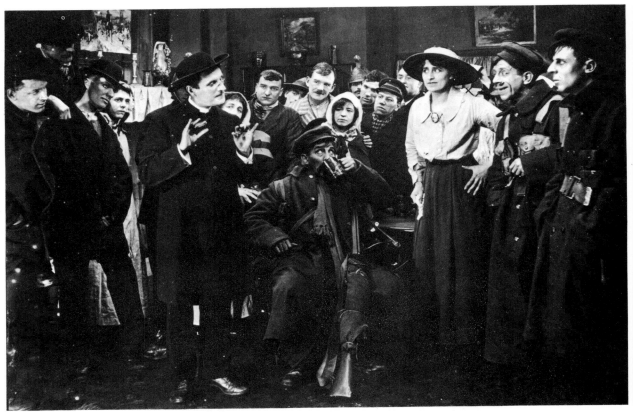

The whole cast of The Better 'Ole *1918 film.*

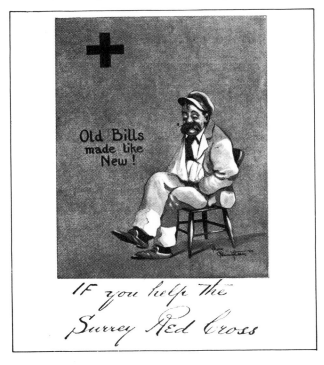

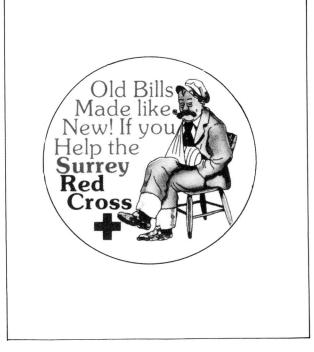

Postcard sold to raise funds for the Surrey Red Cross, 1918. *The same design used as a badge in 1979, for the same cause.*

tended to the opportune, was of the sort that would not see much objection to such a pretence if it gained him an advantage. Such a thing would, however, upset Bruce a great deal.

His fame did have its pleasant benefits nevertheless. Following in the footsteps of the French, Italian and American authorities, the Australians had already asked if they could have him too. Unlike the other armies, they didn't want him to go to the front line, but to visit Australia itself. In the company of Hugh MacIntosh, an Australian businessman who had initiated the idea of his visit, he travelled to Liverpool. There they stayed at the Adelphi Hotel, while waiting to embark on the White Star Liner *Adriatic* en route to Australia via New York. They were there for two or three days due to a shortage of coal for the ship's engines and visited the Argyle Theatre at Birkenhead where George Graves, the well-known comedian, was topping the bill. When Bruce visited Graves in his dressing room it was the first of several visits he was to make to that room. The later visits would be when he was himself appearing on stage and the dressing room would be his.

The time at the hotel was pleasant. Graves was staying there and so were Seymour Hicks and Ellaline Terriss who he was to get to know even better later

on. There was also yet another Provost Marshal around, one Lieutenant H.S. Truin of the Scots Guards. Bruce was still an "officer cartoonist" despite the widespread commercialisation of his work, and thus subject to military scrutiny. Military law, having failed to get him for "joy riding" tried again, and twenty years later Lieutenant Truin wrote to the *Evening Standard* and recalled the incident: "It is autumn 1918. I am Deputy Provost Marshal, Liverpool area.

"I see in the French restaurant of the Adelphi Hotel an officer. He is dark, clean shaven. He wears no Sam Browne belt. He wears black socks with brown shoes!

"I shudder slightly. I point out that by his conduct he is acting in a manner prejudicial to our winning the war.

"I ask his name. I have him again. He has not signed our register at the Provost Marshal's Office.

"Next morning he comes to sign and expiates his crimes by drawing in the register a full page portrait of 'Old Bill' saying 'Blimy! 'Ere comes a blinking Provvo Marshal!' "

Seymour Hicks, the actor-producer, whose path was to cross with Bairnsfather's on several occasions.

"C'est la Guerre". A Fragment from France. *Bairnsfather was an excruciatingly bad sailor.*

It was a happier outcome than from his last association with a "Provvo Marshal" and doubtless Old Bill would have approved of the black socks.

Bruce wasn't a good sailor, and Seymour Hicks sent him off with a special remedy for sea sickness while MacIntosh kept him occupied during the passage by daily Turkish baths and sessions in the swimming pool. Thus the crossing, helped by good weather, passed smoothly. It was just as well, for his welcome to New York was as tumultuous as only the Americans can make it. Short of a ticker tape parade, he might have been a visiting Head of State.

On 30 September, 1918 the *Adriatic* steamed up the Hudson River and docked in New York. It was the first of many visits Bairnsfather would make. The minute he stepped on to the gangway to go ashore he was asked to sign a copy of *Fragments* and from then on he was besieged by reporters, autograph hunters, sightseers, well wishers and those who wanted to ask him to dinner.

MacIntosh drove him to the Astor Hotel on Times Square, a trip that Bairnsfather enjoyed. "Everything I saw was strange and full of interest," he said, and when they arrived at the Astor, not only did the crowd increase, but he also had the telephone to contend with, as well as letters and messages delivered by hand.

The two travellers had about a week to spend in New York before continuing the journey to Australia. Bruce tried to please everyone. He spoke to crowds on the street during the daytime and in the evenings, attended dinners as guest speaker. He even found time to visit the Ziegfield Follies to see W.C. Fields and to meet Irving Berlin. All the while the newspapers wanted his views on the war and on the American troops in Europe. On the day he landed he told *The New York Times*: "They are all a splendid lot of fellows, who make themselves at home in France as if they were in their own country. I never saw a finer or more courageous lot of men. America should indeed be proud of the army she has sent abroad. My best days in the war have been spent with the American soldiers."

The Americans matched his enthusiasm with their own, and within three days of his arrival persuaded him to address the government-sponsored Division of Pictorial Publicity, a part of the propaganda organisation known as the Federal Committee on Public Information. The Divisional Head was Charles Dana Gibson, President of the Society of Illustrators and the highest paid illustrator of the day. Gibson introduced Bairnsfather to the meeting which was held at the Salmagundi Club on Fifth Avenue. Amongst the many famous artists present were James Montgomery Flagg and Howard Chandler Christy. Gibson understood the value of Bairnsfather's work and came straight to the point. "You can't lick a man who laughs while he is fighting," he said, "and through the gloom of war has come the gleam of Bairnsfather's wit as evidence of the spirit that moves the British Army." The meeting gave Bruce a thunderous reception. He was overwhelmed by the open-heartedness of the Americans, who showed no reserve in expressing their appreciation of his work. James Montgomery Flagg took him to the great hall of Grand Central Station and made a pencil portrait of him before a huge audience. Five thousand people turned up at the New York Hippodrome to hear him speak and the Literary Digest described him as both "The War Lord of Laughter" and "The Hogarth of the Trenches". The description used more than any other, to describe Old Bill, or Bairnsfather, or the composite figure that they were to become for many people, was "the man who won the war". It was a typically generous American phrase, but yet, were a poll to have been taken amongst the front line forces of the British, American, Italian and French fighting soldiers, it is certain that they would have overwhelmingly agreed. In March 1979, sixty-one years later, Driver W.T. Jarrett of the 15th Brigade Royal Artillery, an Old Contemptible who had gone to France in August 1914, gave this opinion of Bairnsfather. "He cheered us up no end," he said. "No one in this world ever did more to bring comfort or humour to our depressed state of mind."

Coburn's version of *The Better 'Ole* play was due to open at Greenwich Village on Saturday 19 October and Charles Coburn called on Bruce at the Astor and invited him to the dress rehearsal. "It was a bit of a mess," in Bairnsfather's opinion, and when he sat in his seat on the opening night he once again kept well back in the audience. The theatre was full, and the two-hour performance an outstanding success, as much of a surprise to Bruce as had been the Oxford version. *The New York Times* was overwhelmingly enthusiastic in its review the following Monday, ". . . if one may judge by the quality of the performance and the gales of laughter which swept through the little audience, it is destined to move uptown and repeat on Broadway, the success it has already scored in London". The review concluded: "In brief, *The Better 'Ole* is . . . the real thing, which sweeps an audience off its feet by the sheer force of sincerity. Sooner or later, everyone will see it . . ." The reviewer was right about its success for it would play all over America. He was also right about Bairnsfather's sincerity being a vital element in the success of his work. Since all his work, whether on stage, in books or on film, was derived directly from his cartoons, their sincerity shone through. That sincerity was in turn based upon Bairnsfather's personal experiences in the trenches. In October 1918 it had been three and

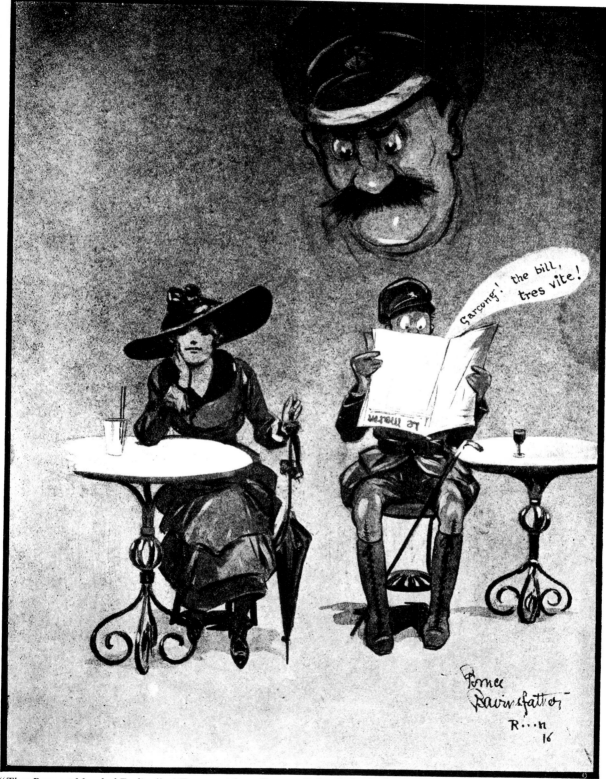

"That Provost Marshal Feeling". A Fragment from France. *Bairnsfather had several clashes with "Provvos" during his Army career.*

a half years since he had served as a combatant officer in France. During that time he had tapped the memories of his six months in France and in the absence of fresh personal experiences to spur his genius he relied upon Old Bill and his friends Bert and Alf. There were already signs of repetition in his *Fragments* drawings, permutations on the same basic ideas. Everyone wanted him to "do Old Bill" but he was too easily persuaded, and no doubt found he needed the certain approval his famous character would win him. Change was difficult for him but an event was coming that would require him to change.

That event was the Armistice.

Through the fortnight that he had been in New York he had been suffering from bad earache in his damaged left ear, aggravated by swimming on the *Adriatic*. When he nearly lost his hearing in that ear, he went to a specialist who eased the pain by releasing the water which had become trapped behind the ear drum. The specialist also told him that he was overworked and run down. He advised Bruce to give up the Australian Tour and go home. Bruce didn't argue. Within a few days he set sail on the troopship *Ordana*, taking American soldiers to France.

He stayed in his cabin for four consecutive days and then his irrepressible spirit responded to the youthful vigour of the soldiers on board. In the second week of the voyage he drew a picture for a "gaff" held on the ship. It was auctioned for £100 on behalf of a seaman's orphanage. Before the ship reached the Mersey he was completing the final chapters of his next book *From Mud to Mufti*. As he came into Liverpool the air was full of rumour of an armistice. He noted for his new book, the coincidence that he had arrived in Liverpool from North America just as the war was beginning, and here he was arriving again as it was ending. He did not see it as an omen, but perhaps it was.

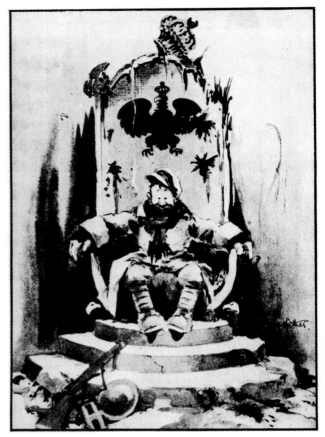

"Ullo". Bairnsfather's reaction to the news of the Armistice on 11.11.1918. In a Fragment from France, *Old Bill sits on the throne of his namesake, Kaiser Bill.*

Chapter 8

Editor & Lord of the Manor

(1918–1921)

Bairnsfather had arrived back in Liverpool in 1914 to discover he was out of a job. This blessing in disguise forced him into early enlistment, so that as part of that immortal band, the Old Contemptibles, he gained the indelible experience which led to his world-wide success. Returning in 1918, he was probably more dismayed at the number of jobs that awaited him.

The Armistice celebrations over, he continued working on *From Mud to Mufti* and his contributions to *The Bystander*. The December issue incorporated an Old Bill in the cover design. It was a small but curious irony that the magazine used the swastika, then merely regarded as a symbol of good luck, as a decoration between paragraphs. Bairnsfather, ahead of his time, was to become aware of the dangers of this sign. But in 1918 the influenza that was sweeping the world, and which was to claim more victims than the war itself, was a more immediate problem.

Bairnsfather's double page centre spread in this Christmas edition was of a contemplative nature. The coloured picture showed Old Bill, in civvies again, sitting in his own armchair against a backcloth of his wartime, balaclava-clad self. The slogan "Peace on Earth, Goodwill towards Men" is written above his head and the caption is "Once Upon a Time".

The London Theatre article in this festive issue reviewed *Scandal* at the Strand. Arthur Bourchier was in the cast and an illustration of the play's characters shows Mary Robson approaching Bourchier with the words, "I hardly know you. What ever have you done". The artist Harris's aside is "Evidently misses the Old Bill moustache". Although *The Better 'Ole* was still on tour, the famous star preferred to stay in the West End.

The special two-shilling *Bystander Annual* also came out at the same time, and the magazine's most successful artist was commissioned to do the full colour cover. It showed two of our American allies

huddling near a glowing brazier in icy surroundings with the caption: "Say Pete, why ain't we sent over in car loads, frozen, instead of this cold storage out here." The face of the seated Doughboy is the characteristic high cheek-boned and slightly hooknosed craggy face that Bairnsfather always gave his American soldiers. Perhaps he had a favourite Red Indian model: certainly it is a very different type of face from the stodgy features of Old Bill, Bert and Alf that *The Times* correspondent found so degrading.

The annual carried an advertisement for "the famous F.C.G. Toby Jug scenes of Prominent Personages of the Great War" designed by Sir F. Carruthers Gould, which includes President Wilson, Marshal Foch, Lloyd George, Haig, Beatty, Jellicoe, French and Joffre. The ad introduced a new line, "Captain Bruce Bairnsfather's study of 'Old Bill'. Depicted in Staffordshire porcelain in the form of a jug, painted by hand in natural colours at the Royal

Old Bill in Wilkinson's Royal Staffordshire porcelain: the coloured and plain white versions.

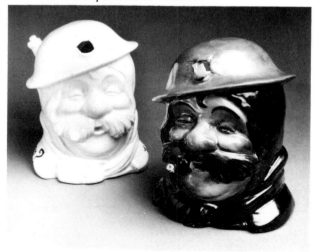

The cover of the Bystander Annual *for 1918. The magazine had as its comic theme, "If Germany Had Won".*

Staffordshire Potteries, Burslem. Each mug bears the autograph of Captain Bairnsfather. Height 5 ins. Price 10/6 each". It was a most appealing piece, and a few uncoloured versions also appeared. The distribution of these limited edition items was "controlled exclusively by Soane & Smith Ltd., 462 Oxford Street. London W.1." Today they are extremely rare.

The magazine took as its theme "If Germany had won". Bairnsfather's two full-page cartoons had the joint heading "Autres Temps. Outrés Bills" with an editorial note, "The French is Old Bill's". One showed Old Bill in Hun uniform, complete with *Pickelhaube*, and bore the caption: "Cannon Fodder, No. 199689, Old Billerich." The other showed him reading a German phrase book, commenting: "Yer know yer wants to 'ave 'oopin cough to pronounce this stuff." Most cartoons in *The Bystander* were still "Passed by Censor". Will Owen, Bert Thomas, Harold Earnshaw, W. Heath Robinson and G.E. Studdy were other famous artists who contributed to this bumper issue.

Reports at this time that a new play by Captain Bruce Bairnsfather, Captain Arthur Eliot and Herman Darewski, entitled "The Way out, or His Temp. Sec. Loot" would be produced by Cochran at the Oxford Theatre after the run of *The Better 'Ole*, led to nothing. It is highly possible that Bairnsfather simply ran out of time, or that the script did not come up to scratch.

There were certainly several other theatrical projects in the pipeline. An announcement was made that a new sketch by Bairnsfather and Eliot called *Souvenirs* was to be introduced into Ernest C. Rolls revue *Laughing Eyes*. It was described as "a sort of epilogue to *The Better 'Ole*, showing Old Bill in 'civvies' grappling with the problems of life without a war". Bairnsfather painted special scenery for the sketch, but if it was staged it made no impact, for no reports of it were published.

Rolls hoped to stage "the two new Old Bills appearing in London contemporaneously". The second was a full length piece "by far the best work the two Mons men (Bairnsfather and Eliot) have written". It was to have been a musical play with songs by Darewski showing "the Walrus in home life after the war with his wife and children". Rolls expected to "make a surprise engagement for the part of Old Bill".

The projects were as abortive as "His Temp. Sec. Loot" and Bairnsfather must have wasted many hours. Eliot had something of a reputation in the theatre. He had been responsible for the highly successful revue *See Saw* (with its one Bairnsfather sketch) in 1916 and also wrote some of the catchy songs for *The Better 'Ole*. He and Bairnsfather had much in common as real fighting soldiers, as Eliot had

served as a lieutenant with Kitchener's Horse in the Boer War and with the Indian Division in France in 1914. He had, like Bruce, come out of active service to work in the theatre. During their collaboration on *The Better 'Ole*, they worked in Eliot's Hampstead home, where they "sat and smoked and talked for hours together". They worked well together, sparking ideas and comedy situations off each other, but in retrospect Bruce felt that he had contributed the major part – "the situation, lines and gags", while he attributed to Eliot "the tailoring". This mild criticism was the beginning of a trait that would grow, marring Bruce's otherwise open and trusting nature: an ever-increasing tendency to suspect others of stealing his ideas, or of taking credit for his creation. Although Bruce found Eliot, "a genial and hospitable man with a roguish humour and excellent to work with", at the time of *The Better 'Ole*, the string of failures they collaborated on undoubtedly soured their relationship. Later, on 14 July, 1919 a strange little paragraph was to appear in *The Times*, under the heading "Captain Bairnfather". It read, 'Messrs. W.H. Champness and Co., Solicitors write: "With reference to the mention in the reports of the inquest on Mrs Atherton of the name of their client, Captain Bruce Bairnsfather as a collaborator with Captain Eliot, we desire to state on behalf of Captain Bairnsfather that his collaboration with Captain Eliot ceased some time ago." '

The reference was to the sensational suicide of Arthur Eliot's wife. Eliot, who tried his hand at many things in his time – including working as manager of Cochran's 1913 circus at Olympia – was an undischarged bankrupt, who had been through the bankruptcy courts three times. He was a widower with three grown-up step-children when on 26 April, 1919 he was married for the third time, to a smart, wealthy divorcée, Mrs Mabel Louisa Atherton. The marriage got off to a bad start. Mrs Atherton (as she continued to be known even after her marriage) claimed that she found her new husband in bed with his 24-year-old step-daughter only a few days after the wedding. She also accused Eliot of keeping a young lady from Murray's Night Club. He countered by accusing her of sending him anonymous threatening letters and left his new bride. On Tuesday, 8 July, after an interview with Arthur's brother when she tried to persuade him to make Arthur come back to her, Mrs Atherton shot herself. The inquest, with all its scandalous implications, was reported at great length in all the newspapers the following Saturday. In some of the accounts Arthur Eliot was described as having collaborated with Bairnsfather, and although the verdict was "suicide while of an unsound mind", the whole business was so unsavoury that Bruce felt compelled to dissociate himself from his former col-

league. Ironically he, too, would be involved with divorce, infidelity and bankruptcy and receive similar exposure by the media before his career was finished.

Despite these setbacks on the theatrical front in Britain during 1918, progress was more positive in America. On 18 January, 1919 Charles Coburn copyrighted *The Better 'Ole* in the U.S.A. and went into rehearsals. January 1919 also marked the beginning of a series of lectures in Britain – an accomplishment that Bruce was to develop to a high degree of proficiency over the years, drawing on his hours spent in music halls to add "business" and excitement to his presentation. He used lantern slides and sketched on a blackboard, entitling his talk "Old Bill and Me". The tour took him to twenty major towns in England and Scotland and began at The Queen's Hall in London on 29 January. Sir Ian Hamilton, who had already been loud in his praise of Bairnsfather's value in morale-raising (one of the few "establishment" personalities to do so) presided. He described Captain Bairnsfather as "a great asset . . . the man who had relieved the strain of war, who had drawn a smile from sadness itself by his skill in poking fun at tragedy. We might still need him to cheer us". He added that Bruce was "the man who made the Empire laugh in its darkest hour".

The talk was well-received. It was a simple, sincere description of Bairnsfather's career to date, from his enlistment to Old Bill's emergence and fame. The story was still new to many in his audience, and he was still fresh in telling it. He "kept the audience in roars of laughter" proving "that his humour was not exhausted when the pencil is out of his hand".

The admiring audience could not have known that their hero was nearly paralysed with stagefright at the beginning of the talk or that Captain Bairnsfather felt it was only the breaks he managed to get during the slide show that enabled him to reach "the end of the show without having to give in".

The lecture tour that followed this terrifying yet successful debut was exhausting. Bruce was conscious of his inexperience as a lecturer and felt that people were coming to see him "as a freak . . . between the rubber-skinned man and the long-necked Burmese women at a circus". The ladies in his audience found him far from a freak, as their fan letters showed. They wrote, "I think you are the nicest man in existence. I really am in love with you – quite". "Fairy Maggie" writes to "darling Bairnsfather" with an invitation to see her every day, complete with her schedule showing free afternoons or evenings. "Gypsy" and "Julie" and a host of others wrote with a variety of propositions.

But Bairnsfather avoided any entanglements and for him the highlight of the tour was meeting his boyhood idol, his fellow graduate of Westward Ho!

SUCCESS

Rudyard Kipling. Kipling was in the audience at Bath and asked to see Bruce after the show. Bairnsfather was delighted at the great man's comment – "bloody good".

Of course, the lecture tour had been organised by *The Bystander*. After four years of dealing with this reluctant celebrity, the editors and publishers knew his failings. Reports that Bairnsfather was getting bored with work, and even more so with the socialising that inevitably followed, filtered back to Tallis House. Everywhere he went, people were anxious to talk to him, to buy him a drink, to invite him to dinner – this man who had helped them through the dangerous and dreary days. The prospect appalled him, for though he loved people, he liked to meet them on his terms, preferably unrecognised, man to man in the local pub. In anticipation of possible problems one of *The Bystander's* publishers rushed up to Scotland to see Bairnsfather through the last lap. The Scottish part of the tour was due to visit Glasgow, Aberdeen and Edinburgh, going on to end in Sunderland.

The budding lecturer behaved himself in Glasgow, Aberdeen and Edinburgh and his publisher judged it safe to leave him to finish the tour alone. He saw Bairnsfather into the slow train to Sunderland and returned to London. It was a bad move. Bairnsfather sat in his carriage and through the windows saw "a long, low smart Pullman car train, complete with dining saloons, draw in on the opposite platform . . . I could see inviting neat white tables with silk shaded lamps, and above the carriages on a long board, the magic and alluring words 'King's Cross' ". It was altogether too much for him and grabbing his suitcase, he dashed on to the London train in the nick of time.

He arrived back in London thinking he had undergone his last ordeal by lecture, but almost immediately he received a very tempting offer from "the most

important lecture tour manager in America". The tour would include bookings in all the most prestigious places. Bruce's sense of adventure and his almost insatiable curiosity for seeing "how the other half lived" conquered his natural loathing for the task. If he had known how many more such tours it was to lead to, he might have thought twice about the decision.

The tour opened in Philadelphia in the spring of 1919 after Bruce had an extremely bad crossing that delayed his arrival in Pennsylvania. Feeling distinctly queasy, he was rushed to his first engagement at the Opera House, arriving an hour late. Despite his condition, he was dragged afterwards to a midnight supper party at the local hotel, and put through the "celebrity ritual" that he so intensely hated. He was a very bad guest of honour at heart, disliking empty small talk and unable (or unwilling) to dance. Yet such was his character, that, rather than offend his host or hostess, he would try to give the impression that he was enjoying himself.

On this first major lecture tour of America he was given red carpet treatment, staying at The Ritz, when he appeared at New York's Carnegie Hall and the Brooklyn Academy of Music. From San Francisco to Toronto his path was smoothed, his tickets bought, his luggage seen to, his hotels booked by a representative of the Lecture Bureau – a contrast to many of the later, gruelling tours he undertook alone.

Bairnsfather came to understand and love the American people. He admired their willingness to learn new experiences and gain new information, which made them such marvellous lecture audiences. This first tour, with its official receptions, lionising hospitality and Press interviews, made him realise that, once his novelty value had worn off, he would have to offer something more substantial to be welcomed a second time. Such was his dedication, that he worked hard to gain that second invitation – and succeeded so well that he was asked again and again.

"The Bairnsfather Vogue" was still so strong at this time that many misconceptions as to his wealth existed in the general public's mind. The fever of speculation was spreading in America too, and a wild report on 4 February, 1919 in the *Daily Express* from J.W.T. Mason, their American correspondent, had made extravagant estimates of the earning potential of *The Better 'Ole*.

De Wolf Hopper, the famous American comedian, had just been engaged to play Old Bill in Chicago. His was the fifth company to open simultaneously in major United States and Canadian cities. The other Old Bills were equally well-known names: Charles Coburn in New York, Macklyn Arbuckle, James K. Hackett and Edmund Gurney. Companies perform-

ing Bruce's work were also touring Britain, India and Australia. He was, literally, a world-wide success.

No wonder his critics, knowing the success of the London production, estimated that the receipts for the season would be between £300,000 and £400,000, that Coburn would become a millionaire in dollars and that Bairnsfather's percentage, "will probably make him financially independent . . . Fortune is now assured . . . *The Better 'Ole* is regarded as the finest demonstration of the essential similarity between British and American points of view on life ever seen in the United States. This accounts for the unprecedented popularity of the play".

The truth was to be very different, but certainly the play started by doing well in the States. The Welsh-Pearson film of *The Better 'Ole* was also showing in New York. *The New York Times* felt that the silent picture would suffer by comparison with the lively Coburn stage version currently playing at the Cort Theatre, and that the characterisation and atmosphere were weaker. Praise was, however, given to the performances of Charles Rock, Arthur Cleave and Hugh E. Wright as Bill, Bert and Alf. As a whole the picture bore "the unmistakable stamp of Captain Bairnsfather's human humour".

An exhibition of Bairnsfather's paintings was showing at the Greatorex Galleries in Grafton Street in February, reminding the public that he was first and foremost an artist. The exhibits were mostly the drawings that appeared in the later *Fragments from France*, and included one or two serious pictures, like, "Bert, it's our officer". In a long critique, Sir Claude Phillips gives Bairnsfather full marks for appeal, and says that, "in his beginnings little more than an amateur, [he] has proved himself irresistible. He has come, he has been seen, he has conquered". Old Bill is likened to "the creations of Dickens" with something "that recalls those of Rudyard Kipling", even a "Caliban become kind and neighbourly". A hint of censure creeps in however, "we should be sorry if this strange creature . . . were accepted as a true though exaggerated type of the British soldier during this, the greatest of all wars. There were many like him, no doubt, . . . for all that, we should be sorry to believe that what the artist shows is more than one aspect, and that the least important, if not the least characteristic of the British soldier".

As for his draughtsmanship – "We cannot admire it for itself", said Sir Claude, but admitted that "it is sufficiently straightforward, sufficiently vivacious to express his spontaneous facetiousness, his pantomimic farce". These are perceptive comments, for Bairnsfather's long love affair with broad music hall jokes and his own participation in amateur pantomime gave many of the *Fragments* their framework and atmosphere. Sir Claude's summary contained

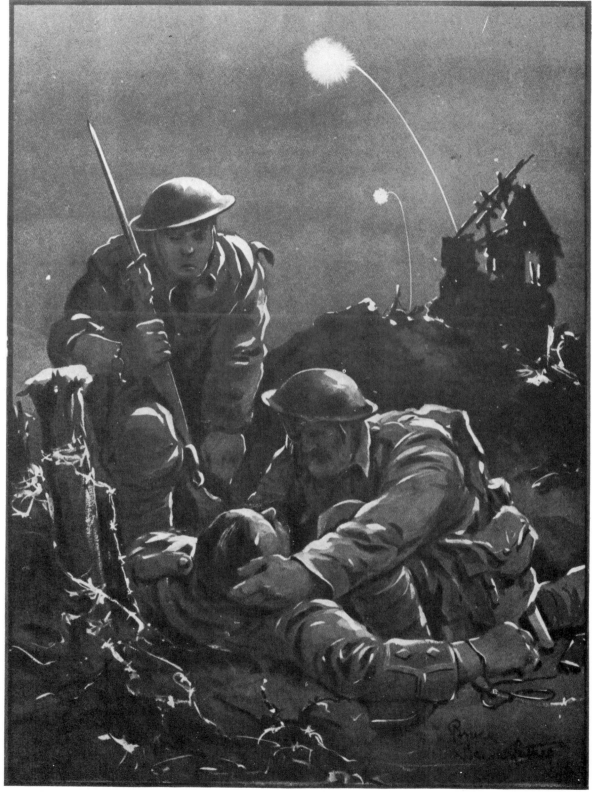

"The Raid. 'Bert! It's our Officer!' " An unusually serious "Fragment" and a sincere expression of the feeling of mutual affection between Tommy and his junior officers.

some more prophetic remarks: "Captain Bairnsfather is hardly at his best when he strives to escape from the limits established by his great success, and the desire of the public (after the British fashion) to have more and more of what they have made their own."

The public forced Bairnsfather to stay within those confines for most of his long career, only escaping them to try and prove that he had ability as a serious artist when, because his popularity had waned, there was no admiring public to clamour for the same old thing.

But in 1919 he was adored and admired. His incredible popularity gave him great influence and, as had happened before, charities were quick to prevail upon his good nature, knowing that his name would attract funds to their cause. On 18 June, the *Daily Express* published a new "Victory Loan" version of "The Better 'Ole" with the caption: "The original of this cartoon by Captain Bairnsfather is offered to the highest bidder among *Daily Express* readers. The proceeds will be invested in Victory Loan, and the certificate will be returned to the Treasury for cancellation. No bid received after first post on Monday next will be entertained. The original sketch measures 18½×14½ inches."

For the past few months, Bairnsfather had been working on one of his biggest and most time-consuming projects. It was yet another *Bystander* creation, a magazine of Bairnsfather's very own. He entered into a five-year contract to edit the magazine (called, not unexpectedly, *Fragments*) and to produce sketches at the princely sum of £3,000 p.a.

The first issue came out on Wednesday 16 July, 1919. It was a weekly magazine, selling for twopence, printed in black and white on poor quality paper, a contrast to its glossy, two-colour, ninepenny cousin *The Bystander*. It was deliberately aimed at a down-market ex-Serviceman's readership. "We don't want no high-falutin stuff in FRAGMENTS', says Maggie (Old Bill's wife) in her "Letter" in September 1919. Bill says it's a pal's paper for pals the world over."

In fact it was a curious mixture of Bairnsfather schoolboy humour, social comment, chit-chat and gossip, with some excellent contributions from top-class writers and artists. The brunt of the copy was obviously to be borne by Bruce. He did the cover, a major full page cartoon each week, a letter page, the illustrations for several of the regular features, full page articles on a variety of topics in most issues, "letters" to Bill, or Maggie as appropriate, "their" replies and competitions. He threw himself wholeheartedly into the role of caring editor, and was not afraid to redress injustices. Profiteering, inflated prices of basic household commodities such as milk and butter, unemployment, rent restriction, the Irish

question, Bolshevism, prohibition, industrial discontent, strikes, waste – were all subjects taken on by the editor. Winston Churchill buying a Ford car; Tubby Clayton writing a book about Talbot House (the soldier's rest house in Poperinghe near Ypres, visited by Bairnsfather when he was serving in the Ypres Salient); the monkey gland youth treatment fad; memories of the efficacy of the rum ration before going over the top: these were some of the topics commented upon by Old Bill or the Captain. As the people's champion, Bairnsfather was supreme. Considering his rigidly conventional family background, he had an extraordinary ability to communicate with, and understand, the problems of the working classes, and showed a total lack of fear in flouting the expected establishment view. He would have made a marvellous journalist today. The sincere, caring message was loudly received, and circulation of the magazine boomed: 500,000 copies weekly on 20 September, 6,000,000 sold by 27 September, 7,000,000 sold by 4 October.

A regular format soon developed. One distinguishing feature was the weekly theme – 23 July "Peace", 30 July "Bank Holiday", 6 August "Prince of Wales", 13 August "Lucky Number", 20 August "Naval", 27 August "Dogs", 3 September "Children", 10 September "Strikes" 27 September "Goose", 4 October "Animals", 11 October "Unlucky". Regular columns became established – Old Bill's letter; "French Frags" – gossip from France about chorus girls' wages and where to buy *Fragments* in Paris; "Sky scrapings" – gossip from New York about Pussyfoot (the U.S. nickname for William E. Johnson, famous Revenue Officer) and prohibition; "Trunk Calls" – conversations with political leaders on contentious subjects of the day, from divorce to the price of whisky; "In reply to yours" – Bairnsfather answers readers' letters – "Sports Spasms" – with football, boxing and racing gossip; "Film Flickers"; London theatre gossip and star profiles; jokes and comments from Old Bill; "Betty's Column" – an illustrated poem describing the dotty adventures of a debutante; household hints and homely chat; "Mud Memories", reminiscences of wartime experiences – and short stories and articles on a variety of topics close to working class hearts.

The whole magazine was lifted by the quality of the illustrations. Not only did Bairnsfather sprinkle it liberally with his own drawings, but original and distinctive artists such as Victor Hicks, who illustrated the theatre page, and the "Betty" page as well as doing other "fillers", Edward Wighill who did the regular serious political cartoon, and W. D. Ford who did the sporting caricatures, were weekly contributors. A.K. McDonald, and Bruce's old friend Barribal, drew some of the "glamour" pictures.

The Old Bill Doubles Competition. Fragments *magazine, 20 August 1919.*

It was a lively, human publication, with an endearing air of amateurishness about it. The readers loved it, and it found its way all over the world – especially where soldiers (like Bert and Alf) were still serving, as in the Rhine Army of Occupation.

Competitions abounded. The one that attracted the most attention was the "Old Bills Doubles Competition". First announced on 20 August, it promised the winner £5 a week for a year – a total of £260 – for putting himself at the disposal of the Captain at Tallis House, *The Bystander* headquarters, for twelve months. Bairnsfather was laying up trouble ahead for himself. More than enough walrus-moustachioed, out-of-work ex-Servicemen were passing themselves off as the original model of Old Bill as it was, cadging drinks and sponging in general. The Doubles Competition laid him open to claims from all over the country. But it was good for circulation; Old Bill was such an eminently imitable character. The beetroot nose and walrus moustache, the sparse hair and rotund figure were all easy to emulate and the competition attracted many entries. Old Bill had already been brought to life in countless Peace Pageants around the country – usually winning the prize for sentimental reasons alone.

The winner was announced in the 11 October edition. He was Samuel Birkenshaw of 123 Eldon Street, Oldham, Lancashire, an ex-policeman and, of course, with a "a fine record as a soldier". The job the Captain had in mind for Mr Birkenshaw to earn his £5 a week was to appear as Old Bill in public "especially attending big football matches". The "lot of fine stunts in view for Bill" that the Captain had up his sleeve either attracted little publicity or didn't materialise. For this is the last heard of Samuel Birkenshaw in the magazine.

Football competitions followed the Doubles competition, as well as various prizes for household hints, colouring and poetry. "Maggie" gave away prints of the picture showing Old Bill kneeling before the newly-erected Cenotaph, entitled "His Pals". This was reproduced as a postcard and prints were advertised through the magazine.

The competitions that Bruce himself would most have enjoyed were the Pun Competitions. The first one was announced on 6 December, with a first prize of £100, second prize £25 and third of £15. The advice given to entrants was that the best pun was the worst one!

Judging the Old Bill Doubles Competition. Fragments *magazine, 11 October 1919.*

The Cenotaph picture which sold as a print through Fragments *magazine.*

Bruce Bairnsfather, shortly after the Great War. His "velvet eyes" and "beautiful hands" made a great impression on all the women he met. The thinning hair was soon to be hidden by an almost permanent cap or trilby.

Bairnsfather also wrote several personal and revealing articles on topics such as "How to be a successful playwright", "How to become an artist". They were autobiographical in content and often reproduced ideas and passages from previous writings – from *The Bairnsfather Case* and *Bullets and Billets*. He was able to give free rein to his anxieties, irritations, hobby-horses and foibles.

The £3,000 *Bystander* contract gave Bairnsfather a new sense of financial security. Ever since his drawings had started to earn him money in 1915, he had been saving hard, obviously thinking that the flow might stop at any minute. His first extravagance was to buy the Old Spa house at Bishopton for his parents. Now he could see his income assured for the foreseeable future, his thoughts once more turned to property.

In all his writings, Bairnsfather was extremely reticent about his private life. Even from the enquiring Press he managed to keep his personal affairs an absolute secret. He was an extremely attractive man, with velvet eyes that matched his velvet voice. Women found him appealing and vied to entertain him, but no hint of a liaison appeared in the newspapers or magazines. Yet it must have been in 1919 that he met his future wife, his companion for the rest of his life. Thoughts of settling down, even of marriage, led him to consider acquiring a suitable residence. Bruce looked for a country property in keeping with his new status as "International Personality, Playwright, Artist and Star".

He had a studio at Bishopton, and used it as often as his commitments permitted, enjoying his mother's cosseting and the relaxing Warwickshire atmosphere. But more and more between the extensive tours he was forced to make, he found himself living and working in his London studio. He longed for a place of his own where he could relax and create.

The area he chose was the lovely Buckinghamshire countryside around Aylesbury – within easy reach by rail or car of London, near Tallis House and his main source of income. A well-established Aylesbury estate agent was charged with finding him the right sort of residence. He went "severely and painfully historic" in his choice, yearning for Tudor beams, drawbridges and moats. At last, a suitable "gem" came up.

It was an estate owned by a Colonel Goodall, comprising an Elizabethan house and 250 acres of ground. The house was known as Waldridge Manor and it was in a state of total disrepair. Bruce fell in love with it on sight and bought it for the enormous sum of £7,000. The expenditure didn't stop there. It would take a year and several thousand pounds more to make Waldridge habitable.

The house had belonged at one time to Sir Richard

The new Lord of Waldridge Manor.

Ingoldsby whose mother was Oliver Cromwell's daughter, Elizabeth. Cromwell was reputed to have stayed at Waldridge with his niece, training his troops in a nearby field. Sir Richard was notorious for being the man who signed Charles I's death warrant, later asserting that he was forced to add his signature. When Cromwell's cause was lost, Sir Richard joined the supporters of the exiled Charles II and, of all Charles I's regicides, was the only one to obtain a free pardon from Charles II, even being awarded the Order of the Bath.

This duplicity and resourcefulness appealed to Waldridge's new owner, who was thrilled when, during the restoration of the manor house, a pair of pistols was discovered. They had been sealed in one of the big Tudor chimneys which had attracted Bairnsfather from his first sight of Waldridge. The pistols were pronounced to be of the Stuart period by "an archeologist", adding to the delight of the Captain.

The house dated from the early seventeenth century, the large central stack of chimneys built in the shape of the letter "H" being one of its outstanding features. The original building was half timber, filled

with herringbone brickwork, but parts of the house were refronted later in the century with a thin brick skin and stone mullioning plus transomed windows – the perfect house for a Lord of the Manor.

Waldridge needed a new staircase, new lighting, heating and water systems, with a boiler pump and radiators for central heating, a bathroom, a new kitchen, complete replastering, new floorboards, new supporting beams, some new windows and a damp course. It needed antique furniture to suit its style and age, curtaining and pewter ornaments.

To pay for reconstruction Bruce sold off two hundred acres of the land in small packets, fifty acres here, fifty acres there, netting him £6,000. The repairs cost £5,000, not counting the furnishings, enormous sums for 1920.

Bruce bought a Sunbeam car – the first he had ever owned – which soon clocked up a good deal of mileage between London and Waldridge. Eventually he persuaded Major Tom and Janie to leave the Bishopton home he had so recently bought for them and move to a pleasant house named White Cliff in the Hollow Way, Whiteleaf, Princes Risborough. Bruce then used his parents' new home as a base from which to supervise the work on nearby Waldridge.

As always, the senior Bairnsfathers soon settled in to make themselves useful and respected members of their new community. Major Tom joined Whiteleaf Golf Club, becoming Captain in 1923–4. He also became a member of Princes Risborough Amateur Operatic Society, soon rising to the position of conductor. On one occasion, never to be forgotten by fellow members, the conductor brought along his famous son, Bruce. The society was deciding upon its next production and after much discussion the popular operetta "Dorothy" was chosen. Bruce must have been in particularly skittish mood, for he is mostly remembered for his flirtations with the young lady members of the society – behaviour which earned him a rebuke from his father.

In October Bairnsfather's second book of personal

London : Grant Richards Ltd

The title page of From Mud to Mufti, *1919.*

experiences, *From Mud to Mufti*, was published. It continued the story of Bairnsfather's progress from where *Bullets and Billets* left off. *The Times Literary Supplement*, following its tradition of lukewarm, if not hostile, feelings towards Bairnsfather's work, said: "Another instalment of the same kind of thing as the public is familiar with in Captain Bairnsfather's series of *Fragments from France* and *Bullets and Billets . . .* There is the same kind of amusement to be got out of the letter press and there are the same caricatures of the British soldier."

The book included a picture of Old Bill scrutinising with suspicion a miniature model of himself, saying: "I'll bet that . . . Bairnsfather is at the bottom of this." The little Old Bill doll four and a half inches high with its velvet face, felt balaclava, hands and wire-reinforced feet, walrus moustache and woollen muffler, was one of the most popular representations of Old Bill produced – and had a multitude of uses. In the second issue of *Fragments* on 23 July, the theatrical page featured an interview with Lee White, popular star of the Alhambra and the Ambassador's, who had originated in America's southern states. Lee was "the first woman to impersonate Old Bill. Asked

The Old Bill Fraternity membership card, designed by Bairnsfather.

The Bairnsfather-designed Old Bill Fraternity enrolment form, signed by the Duchess of York (now the Queen Mother).

The OLD BILL Fraternity

ENROLMENT FORM

I consent to become a member of The Old Bill Fraternity and undertake to purchase from St. Dunstan's, goods made by war-blinded men to the minimum value of 5 - (plus cost of delivery) annually. To pay an initial membership fee of 6d. and in the event of my having to resign, to provide a substitute member. In fulfilling these conditions it is my desire to show appreciation for the sacrifice made by the Nation's war-blinded, and I will assist by interesting others in the objects of the Old Bill Fraternity.

"PUT IT
THERE ➡
MATE"

M H.R.H. The Duchess of York
145 Piccadilly

Please state title or whether Mr., Mrs., or Miss.

why, Lee replies, 'Why, he is so full of sympathy. What woman can resist sympathy. That's why Old Bill is the most beloved of English soldiers. That's the Bairnsfather touch – sympathy. His world isn't Shoreditch or Mayfair – it's the heart'', and the expressive hands pointed to an Old Bill doll. 'That's my mascot . . . Bill brought me all my luck'.'' Another popular star of the day, Beatrice Lillie, threw the Old Bill dolls into the audience during a Charlot revue. The Red Cross had also used the doll as a fund-raiser during the war. Victor Hicks included the doll in his amusing picture "Mass meeting of prominent members of the mascot movement" in the "Lucky" number of *Fragments* on 13 August, a picture which included the swastika. The doll was a favourite with children. Many of those wartime children still prize their Old Bills today, and one present-day owner recalls: "I still have and treasure my Old Bill doll that I was given at the age of five, sixty years ago. He was sitting on top of the Christmas tree and it

A miscellany of mascots, notably the Old Bill doll, in Fragments *magazine, 13 August 1919.*

was a case of love at first sight. My beloved Old Bill has always gone everywhere with me. He has been up the Yangtse to Chungking and home through what was then French Indo-China and of course he always came down to the shelter with me during the last war.'' Perhaps the most interesting use recorded of an Old Bill doll was when the Prince of Wales presented one to the clown Whimsical Walker, in appreciation of his performance in a London circus just after the war. The Prince was an official member of the "Old Bill Fraternity", founded to assist blinded soldiers treated at St. Dunstan's. The Prince's sister-in-law, the Duchess of York (now the Queen Mother) was the first lady member of the Fraternity. Bairnsfather designed the enrolment form, the membership card and an Old Bill collecting box.

If the Prince of Wales was a Bairnsfather fan, the admiration was mutual. The 6 August issue of *Fragments* was devoted to the popular and handsome Edward on the occasion of his visit to Canada. It included a poem which started, "Oh Prince, resplendent in your regal youth. We wish you fortune in your voyaging, that is no vain and foolish wandering, but one of search for beauty, peace and truth". It was written by the extraordinary William Dowsing, born a gypsy, brought up in a workhouse, and who had written the War Sonnets to accompany Raemakers' biting anti-German cartoons.

As this first peacetime year of Bairnsfather's fame drew to a close, he was invited as a principal guest at the Peace Commemoration of the Blackfriars Club on 26 November at the Café Monico, Piccadilly. Louis Raemakers had been invited, but he had been forbidden by his doctor to leave his home in the South

That first cheque!

of France, and Bruce nobly stepped into the breach. His talk on how he had drawn the first *Fragments from France* raised some laughs – especially when he described his reaction to his first cheque (for three guineas). He didn't know whether to frame it or cash it, and in the end spent "£2.19s.6d in getting copies of the paper and giving them to friends".

The days of three guinea cheques seemed far away now, but to keep the sizeable fees rolling in Bruce had to keep working at a breakneck pace. No sooner was Christmas over than he was off again to the States, in the illustrious company of fellow lecturer Sir Oliver Lodge, on the Red Star Liner *Lapland*, leaving Southampton on 5 January.

The strain of the previous months of overwork, followed by the sailing he still found hard to tolerate, took its toll almost as soon as he landed. After his lecture in Washington on 22 January, Bruce collapsed

Bronze car mascot of Old Bill. Brass and nickel plated versions also exist.

"from nervous trouble" and was taken to hospital.

Bairnsfather didn't attempt to continue with his tour once discharged from hospital. In February he sailed back on the *Adriatic*, but was not allowed to rest during the voyage. At a charity concert an updated version of "The Better 'Ole" was auctioned for £125. He stopped off in Paris for a few days, to have a recuperative browse round the Montmartre pavement cafés he loved but so rarely had the chance to enjoy.

Back at home his name and cartoons were as popular as ever. Grimwades, the Staffordshire pottery firm which made the Bairnsfather ware during the war, was still producing a large range of items. But now the legend printed on the base had changed, from the green sign saying, "Made by the Girls of Staffordshire during the winter of 1917 when the boys were in the trenches fighting for liberty and civilisation", to "A Souvenir of the Great War, commenced August 4th 1914, Armistice November 11th 1918, Peace signed June 28th 1919", followed by, "Bairnsfather ware", with an Old Bill head – all printed in brown. The range now included whole dinner services and tea sets, complete with teapot and teapot stand, milk jug and sugar bowls, and some items in a finer china.

Another item bearing his name was to prove one of the most popular marketing ventures reproducing Old Bill ever produced. The 8 May edition of *Fragments* advertised the 'Old Bill' motor mascot in

Bairnsfather's own car sports the Old Bill mascot outside Princes Risborough railway station.

bronze, price 2½ guineas, the most popular one in the market". It was made by the famous speciality model and mascot manufacturers, Louis Lejeune of Great Portland Street, London. As well as the bronze model, Lejeune produced versions in brass, in nickel and in chromium plate. Bairnsfather mounted an Old Bill on his own car. Private S. Cooper, a fellow Old Contemptible, recalls how, when his sister Olive was working as cook for the Captain in his town house at this time, he and Olive would sometimes be given a "run round" by James, the chauffeur and handyman. The mascot was recognised by theatre crowds in the West End and saluted by the police – "a thrill in those days". A few weeks later Bairnsfather would regret this easily identified car in a brush with the law.

The month that the Old Bill car mascot was advertised in *Fragments*, an event occurred that few people can have imagined at the time to have any bearing on the life of Captain Bruce Bairnsfather. On 3 May the Hon. Mrs Cecilia Agnes Scott was granted a divorce from her husband, the Hon. Michael Scott O.B.E., fifth son of the third Earl of Eldon, holder of the Order of the Black Star of France and the Military Order of Aviz of Portugal. The grounds were his adultery, coupled with desertion of the petitioner, "by reason of his failure to comply with a decree for restitution of conjugal rights, dated 14 October, 1919". Cecilia Bruton and Michael Scott had married at St James Church, Melbourne, Australia on 6 March, 1907, and there was a daughter, Heather, born on 6 January, 1908. Mrs Scott had custody of Heather. At this stage there was no breath of a link between the newly-divorced Mrs Scott and Captain Bairnsfather. His working life continued at his normal pace in a variety of directions.

Fragments was still attracting high quality contributors such as George Holland, W. Heath Robinson (in a series called "Leaves from a Boy Scout's Diary") and Arthur Ferrier. Ridgewell contributed a new comic strip, "The Adventures of Plum and Apple". The brilliant comic artist George Belcher even drew several covers.

The Rev G.A. Studdert Kennedy, the First World War padre who had become popular and famous as "Woodbine Willie", dispenser of cigarettes and comforting philosophy in the trenches, was a regular contributor during 1920. On 17 January a series of stories about "Percy of Pont Street" started, with illustrations by the fine comic artist Will Owen. "Percy" was an ex-officer, who for lack of a more gentlemanly or suitable offer of employment after the war, started a coffee stall in Covent Garden. Percy was the focal point for a variety of adventure tales in which he acted as arbiter, expert and local philosopher. The series continued for twelve episodes. In the final story, "Percy" goes to work for a millionaire,

marries an aristocratic young lady and passes on the stall to his wartime superior officer, Major Archibald Stanways, down on his luck. The story was written by W.A. Darlington who became one of the most respected and best-loved theatre critics in Fleet Street, writing for the *Daily Telegraph* as its regular drama correspondent from 1920–1968. Darlington was also a prolific author and by a strange series of coincidences one of his works was to upset Bairnsfather, who by now was quick to suspect others of stealing his ideas.

In April 1917, Darlington, a Territorial Officer in the Northumberlands, was shot through the lung by a German bullet and spent "four blessed months of convalescense with nothing to do but write my head off". During those months in hospital he started writing a series of comic sketches around the central character of a soldier who had a "magic button" – freely admitting that he owed no small debt to the Arabian Nights for the idea. He called his hero Alf – being a modern sounding name with similarities to the original Aladdin, and as his own name was Bill, called one of his subsidiary characters after himself.

The sketches were accepted and published in 1917 by the *Passing Show*, a popular magazine. Darlington had called them "Alf and his Wonderful Button" in respect for his source, but the editor of the magazine suggested the snappier title of "Alf's Button". They were an instant success. In 1918 Darlington expanded the idea into a novel which was published by Herbert Jenkins in 1919. It sold 250,000 copies and in 1920 was made into a silent film starring Leslie Henson. By now, of course, the over-sensitive Bairnsfather had noticed the chance combination of the names "Alf" and "Bill" in what was an outstanding success. His jealousy would become even greater as "Alf's Button" continued that success in another medium.

By another quirk of fate, the last episode of "Percy of Pont Street" appeared on the left-hand page of *Fragments*, and on the right-hand side was a review of the revival of *The Better 'Ole* at the Oxford.

Soon after *The Better 'Ole's* second run at the Oxford, Bairnsfather in his Sunbeam, with the give-away mascot of Old Bill on the bonnet, was caught for speeding on 29 June. He was driving up Constitution Hill, Green Park, and a zealous police sergeant recorded his speed over a measured furlong at 27 m.p.h. The case came up on 16 August at Bow Street Station and it was reported that when a constable signalled to the defendant to stop "he slowed down and then accelerated and drove off at a great speed". W.H. Champness, the lawyer who was to be kept busy by his client over a number of years, said in the defence that "Captain Bairnsfather did not observe the constable and had no knowledge whatever of the incident". It didn't wash, and "the defendant

was fined 10s for exceeding the speed limit and £5 for failing to stop".

Soon after the hearing, Bairnsfather's bright young brother, Duncan, got married. He was then serving in Kashmir as the ADC to Major General Sir George Barrow and his bride was Miss Eleanor Hardy Tipping, eldest daughter of Mr and Mrs Llewelyn Tipping of the Islamia College, Peshawar. The wedding, reported in the Civil and Military Gazette as "very pretty", took place at St Mary's Church, Gulmarg, on Tuesday 24 August. The reception was held at Nedon's Hotel and after cutting the cake with her husband's sword the bride changed from her dress of "white crêpe de chine with a gracefully draped skirt, the folds on the bodice showing glimpses of Old Brussels lace over flesh pink georgette" into her going-away gown of "reseda chartreuse" and left with her new husband "amid the usual shower of confetti for Tangmarg, en route for the river where the honeymoon is to be spent". It was a fairy-tale wedding and the bridegroom had what promised to be a brilliant career ahead.

Bruce, the unconventional son, also had matrimony on his mind. Waldridge Manor, bought with "that primitive and prevalent desire to make a beautiful home for my wife", was coming along well. Under the heading "It's a far far better 'ole", *The Bystander* of 29 September printed a two-page feature on Waldridge. Bruce posed for publicity photographs in "The New Old World Garden" where "six months ago rough meadowland ran to within a few feet of the house". The Cromwellian connection was reported with the verdict that: "The restoration is a really wonderful piece of work and the house – miles from anywhere – makes a well-secluded home for the famous artist."

The "famous artist" was still contributing to *The Bystander* as well as editing *Fragments* and the issue contained one of his full page cartoons. The *Graphic*, also in the *Bystander* group, was another paper for which he regularly drew and wrote.

His major cartoon in the following week's *Fragments* followed the marriage theme, and perhaps reflects his ambivalent feelings towards the subject – feeling a strong natural instinct to "build a nest", but fearing it might cramp his artistic freedom.

On 21 October *The Times Literary Supplement* carried a review of an extraordinary little book called *The Bairnsfather Case: as tried before Mr Justice Busby. Defence by Bruce Bairnsfather. Prosecution by W.A. Mutch.* It described it as "telling in a lighthearted way how Bairnsfather started as an artist, the obstacles to success he encountered, and the personal qualities which most helped in winning his reputation. Not surprisingly, the *Graphic* gave the book a glowing review, reproducing several of the amusing

Wedding of Duncan Bairnsfather and Miss Eleanor Hardy Tipping at Gulmarg, 24 August 1920. From Duncan's album, courtesy of Marian Evans.

original sketches with which it is liberally peppered. L.G. Redmond-Howard, the reviewer, found the "very novelty in the art of collaboration is admirably suited to illustrate his philosophy and for this reason the book has a far higher value than the mere collection of genial jokes and drawings and criticisms of which it is composed". Mutch was on the editorial staff of *The Bystander* and his chapters were in a highly adulatory strain.

Bairnsfather was still not spending much time at Waldridge. In November, when Mrs Scott's divorce was made absolute on the 15th, he was on another 10,000 mile lecture tour of the U.S.A. On 24 December he sailed from New York on the White Star *Baltic* to return to England to an event that would change the whole pattern of his life and career.

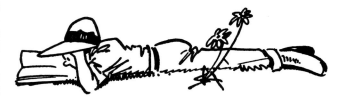

Chapter 9

Husband, Playwright & Entrepreneur

(1921–1927)

On 15 January, 1921 at "The Register Office in the District of London City" the marriage was quietly solemnised between Charles Bruce Bairnsfather (described as a bachelor, occupation artist, of Tallis House, Whitefriars) and Cecilia Agnes Scott, formerly Bruton (described as formerly the wife of Hon. Michael Scott, O.B.E., from whom she obtained a divorce). The ages of the bride and bridegroom were given as 34 and 33 respectively, and the witnesses were Angela Ashbury (the bride's sister) and W.H. Champness (the bridegroom's solicitor). Divorce was still considered as somewhat of a social stigma in 1920, and the wedding had been deliberately kept quiet and low key. The event was not even reported in the newspapers until ten days after it had taken place, and pictures of it were not supplied to the Press. No doubt the marriage of one of Britain's most eligible bachelors would have caused great consternation amongst his many female admirers. His choice was an Australian divorcée who, by all accounts, looked far older than her husband (despite the one-year age difference stated on the marriage certificate). Little is known of their courtship, other than they met "at a party in London". Cecilia, or "Ceal" as she was known, had worked at Grosvenor Square Hospital during the war. She had been born and brought up in Sydney, where her Irish-born father, William, and Gloucestershire mother, Mary Markby, had emigrated. She had a brother, John, who died young, and three sisters – Claire, who remained in Australia, Helen, who moved to the U.S.A. and wrote for the stage under the name "Helen Jerome" and Angela, whose married name was Ashley. It was Angela, who also lived in London, who was the witness at Bruce and Ceal's marriage. They called her "Bunny".

Ceal was a contradictory, complex personality. She was, or had been, a very handsome woman, with eyes that vied with Bruce's for beauty and depth. She had style, elegance, and a powerful charm, that she could

The Hon. Mrs. Michael Scott.

turn off and on, strong enough to overcome the hardest heart. Her marriage to the aristocratic Michael Scott on 6 March, 1907 had given her a taste for the better things of life, and even after her divorce she kept in close and affectionate touch with her sister-in-law, Lady Margaret Hamilton Russell. Marriage to the country's most popular, famous and successful personality appeared to offer Ceal a continuation of the life to which she had become accustomed, and which she enjoyed to the full.

By now the impressive estate with its Manor House at Waldridge in Buckinghamshire had been restored to comfortable elegance and the couple also took a smart town house in John Street, off the Strand. The number of staff fluctuated over the next three years, but basically at John Street they had Olive the cook, a lady's maid and a valet/chauffeur/handyman.

The latter, Anderson, was chosen out of thirty-two applicants. Jobs were scarce and there was hot competition for the few good posts suitable for untrained ex-Servicemen. The Captain and his lady were considered good employers, "a different breed to the new rich who moved into the West End after the war". The Captain's first move on employing Anderson (an ex-Royal Marine who had been a footman and butler since the war) was to give him £5 to "send telegrams to all the other applicants". He was a kind and considerate master, and both he and Ceal were remembered by the staff in those poverty-stricken times for trusting them completely, leaving their valuables on their dressing tables when they returned home after an evening out for their servants to put away. Employment with the Bairnsfathers at that time meant an interesting life – meetings with famous people such as C.B. Cochran and Billy Bennett, the current West End Old Bill.

They spent most weekends at Waldridge. The household was a young and happy one as far as the staff were concerned. Again it fluctuated, but mainly consisted of two young local girls, Dorothy and Emily Hopcraft, who looked after the mistress and generally cleaned and ran the house, and Edith Jones who did the cooking and helped with the housework. She was the daughter of the ticket collector at Princes Risborough, Waldridge's nearest railway station. Jones was an ex-soldier and enjoyed chatting with the Captain on the odd occasions when he decided to go up to London by train rather than in his Sunbeam automobile. It was during one of their friendly conversational exchanges that Jones suggested his daughter as cook. The three girls were joined by Bert Cummings as handyman (he also acted as part-time chauffeur when Anderson, or Brown who followed him, didn't bring the master and mistress from London) and several members of the Ludlow family. Jenny Ludlow and her mother worked from time to time in the house and her father and brother in the garden.

For most of these local villagers, the time spent at Waldridge was the happiest period of their lives; the Bairnsfathers were often absent and for long periods they had the house to themselves. They were allowed to have friends to stay overnight and had plenty of time for fun and games – riding their bicycles, taking photographs of each other in the grounds, having glorious pillow fights throughout the rambling house. Heather, Ceal's daughter by her first marriage, now in her early teens, was often allowed to stay there by herself. She was a pleasant-natured, likeable girl, starved of attention and company and she eagerly joined in the sport with the cheery young staff.

However, the other side of Ceal's personality – the reverse of her sweetness, her charm – soon manifested itself. Shortly after the marriage, her new husband and her staff realised that she had an unfortunate dependence upon alcohol and that when she gave into it she was subject to tantrums and outbursts of temper of an extremely violent nature.

The happy young staff, brought up frugally and abstemiously in the tiny villages surrounding Waldridge were amazed at her capacity for alcohol – "from stout to champagne to claret"; at her disregard for valuables – the nearest object at hand would be hurled and smashed to smithereens in her rages; and at the colour of her language. Dorothy, the eldest of the girls in the household, was increasingly called upon to put her mistress, unsteady of gait and slurred in speech, to bed. Ceal made impossible demands upon them all – ordering Cummings to drive her to Princes Risborough station to catch a train that left in three minutes' time – for example. Cummings did his best to oblige and noted that, after a hair-raising drive through the narrow winding country lanes with his foot flat down on the accelerator, his mistress – although in a heap on the floor at the back – was "stone cold sober" when they arrived at the station.

Bruce must soon have had misgivings about his choice of partner. His work load was as demanding as ever, and it was extremely difficult to maintain his creativity in the uncongenial atmosphere that so often prevailed at home. For not only was Ceal subject to her unfortunate bouts of drinking and temper, but she also led Bruce, the reticent, shunner of society, into a hard-drinking, extravagantly socialising local "fast" set. At the centre of the gay whirl were the Barribals – "Barri" and Babs. Barribal, whose portrait of Bruce had been exhibited in 1917 at the Royal Academy Summer Exhibition, had long been one of Bruce's artistic idols. He was a highly successful commercial artist, contributing to a range of magazines (including Bairnsfather's *Fragments*) designing playing cards, postcards and posters for a variety of

Babs and "Barri" Barribal, part of the "Aston Rowant Set".

products. His glamorous girls, drawn from many models (whom he photographed and then painted from his own photographs) all had a strangely similar look – especially around the mouth. They all resem-

The Lambert Arms: painting by Bruce Bairnsfather of the centre of the "Aston Rowant Set" in the early Twenties.

bled his wife, Babs, who was intensely jealous, and who all too often vented her wrath on pictures that it had taken the long-suffering Barri days to paint. Other members of the set noticed that Babs and Ceal were soon very friendly, spending much time in each other's company. The Barribals lived at The White House at Aston Rowant, near an inn called The Lambert Arms. The host at The Lambert Arms was a Mr Browning, but the great attraction of the inn, which became the scene of many wild parties, was his family of four beautiful daughters. Bruce did a charming watercolour of The Lambert Arms for Browning which still hangs there. At one time it also proudly boasted a fine collection of Bairnsfather cartoons.

Another couple in the Aston Rowant set were the theatrical builder, John Pinder, and his wife, Eva. Many of the high living crowd were potential clients for Pinder and he was obliged to keep in with them to get commissions. This certainly paid off as far as Bruce was concerned, for Pinder redesigned and helped Bruce convert the barn at Waldridge into a studio-cum-theatre. It was a big task, and when the

large furnace that had been in the centre had to be moved, John Pinder called in his elder brother, Harry, who was also a builder for the brewers, Barclay Perkins. When the conversion was completed, both brothers and their wives were invited to the grand opening party on 29 October, 1921. Harry Pinder was considerably older than his brother Jack (as John Pinder was known), and virtually a teetotaller. He and his wife were appalled at the amount of liquor consumed at this and other parties thrown by the "set" and by their generally disorganised, pleasure-seeking lives. They noted that many of the titled and celebrity guests were more than a little merry even before they arrived and Harry firmly refused a future invitation to stay the weekend at Waldridge.

The function that marked the opening of the theatre-barn to quote Bruce's hastily hand-written notes, given to each guest on the back of a postcard of "They've evidently seen me", consisted of "8–9.15 Dancing. 9.30 Waldridge Hippodrome, 10-? Dancing . . . Asprin?" The choice of postcard was particularly apt for the Pinders. During the war Harry had manned a machine gun on top of the G.P.O. building in London. He was also responsible for building the tallest chimney at that time in the capital, on a brewery that he had built for Barclay Perkins. During the excavations for foundations of that building he had been perspicacious enough to recognise the site of the Globe Theatre. When Bruce asked him if he wasn't nervous during his machine gun duties with bombs and shells liable to land around him, Harry had jokingly said, no, as he could always dive into his chimney for shelter – whereupon Bruce re-drew the *Fragment*. "They've evidently seen me" for him.

The highlight of the evening was the "Waldridge

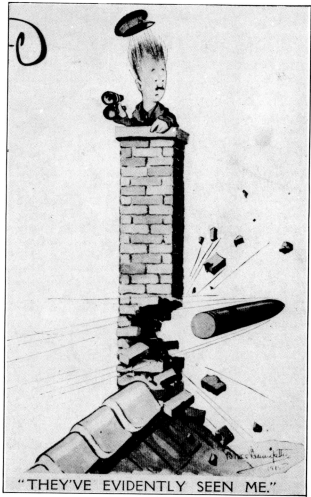

"THEY'VE EVIDENTLY SEEN ME."

Invitations to the opening of the Waldridge Hippodrome. 29 October 1921.

The Waldridge Hippodrome, Bairnsfather's miniature theatre at Waldridge Manor.

Hippodrome" event. As at Bishopton, Bruce had constructed a fully working scale model of an operational theatre, complete in every tiny detail. Cummings had helped him with the lighting, installing over 170 little lights. The puppet show was a great success with the gay, distinguished guests, but Bruce used the miniature in a much more practical way afterwards, working out the sets and characters for his next stage production.

Bruce had always hated parties but, as usual, he strove to please and gave every impression of throwing himself into the gay life for Ceal's sake. From time to time it all became too much to bear and he would withdraw into himself in sober periods of solitary reticence. The staff all sympathised with their quiet and gentle master, and often wondered how he managed to work. Apart from the Barribals and Ceal's sister, Bunny, there rarely were guests between the extravagant parties, mainly because Ceal was not often capable of entertaining. Although they now lived within fifteen minutes of Waldridge, Major Tom and Janie never visited their son and daughter-in-law. They would have hardly regarded Ceal as a suitable wife for Bruce. In the quieter and calmer periods he enjoyed playing the part of country squire, wandering through the peaceful grounds, soaking in the beautiful scenery, calculating how he could make his fortune from egg farming. The week was shared between the work for his magazine, frequent visits to Tallis House, his regular contributions to the *Graphic* (usually done at Waldridge and finished at the last possible moment and rushed to Princes Risborough station by Cummings to catch the London train) and work on a new theatrical production. For the *Graphic* he was drawing a demanding daily strip cartoon – "The New Adventures of Old Bill" as well as a wordy weekly "chat" column with a sketch or two thrown in about his life in the country. During the week, or when required for magazine, theatrical and other commitments, Bruce and Ceal lived in their apartment in the elegant town house in John Street.

Bairnsfather's career was still moving strongly in several directions, despite the demands made by his new marriage and hectic social life. In contrast, his younger brother, whose career had, at the time of his marriage the previous year, promised such a brilliant future, had somehow come to grief.

Certainly Duncan had always been in scrapes as a

schoolboy, but Bruce had been a naughty pupil too, and yet emerged from his school days with an honest and sincere personality that impressed all who met him. Duncan, on the other hand, had spent much more time with his parents, and there is little doubt that he had been spoiled. His wartime career had been exemplary. He had even been mentioned in dispatches by General Plumer – who, coincidentally, was popular with Tommy for his supposed resemblance to Old Bill – for "gallant and distinguished service in the field during operations on the 18th April 1918". He had also received "an official notification of the high appreciation of HM the King of his services rendered on that occasion". It is probable that Bruce, the non-conformist soldier, envied Duncan and felt that he, like his brother, should have been at least mentioned in dispatches. Sadly, the colonel who had observed Bruce rescuing a wounded Canadian comrade under heavy fire at St Jean, was himself killed before he could make his report. Nevertheless Bruce admired his dashing ADC brother, and it must have come as a great shock to him (and an even severer one to Major Tom and Janie) when because of a scandal, Duncan resigned his commission on 8 October, 1921. There is little doubt that the "resignation" was far from voluntary. Its circumstances are now shrouded in mystery. Many Army records were lost through bombs and fire during the Second World War and scandals were deliberately suppressed by families of the standing and background of the Bairnsfathers. There are hints of fiddling mess funds, gambling, drink and womanising, but no precise facts survive. Whatever the cause, Duncan and his wife were moved into the Whiteleaf area, near his parents and Bruce. There his daughter, Joy, was born before the year of 1921 was out. He soon developed a reputation locally as something of a ne'er-do-well. His childhood nickname of Bumpy came into general use again and it is said today in Monks Risborough that most of his time was spent sponging on his famous brother and cashing in on his name. In July of 1922 Bruce was so exasperated by Duncan's repeated attempts to take advantage of him that he was forced to publish the following disclaimer in the national Press: "Captain Bruce Bairnsfather asks the *Daily Express* to state that he has no connection with a concert party with which the name of Mr T.D. Bairnsfather is associated, or with any enterprise in which his own name does not appear."

The favourite younger son, whose wartime Army career had been such a textbook success, never recovered from his mysterious *faux pas*. His marriage was dissolved and Major Tom and Janie took his little daughter, Joy, and brought her up with a devotion that she would always cherish. Joy never saw her father after the age of five, when he emigrated to

Edmund Gwenn, who played the lead in Old Bill M.P. *and who went on to further fame in films.*

Australia. To the family it was as if he had never existed – he was simply erased from all but their private thoughts. Janie had promised Joy's mother never to discuss Duncan with the child, but the sensitive little girl knew that in her grandmother's eyes her father could never really do anything wrong and that packages were quietly put together and sent overseas to him. All the family can say about Duncan from this time onward is that it is thought that he emigrated to Australia, worked for a Sydney radio station, married again and died during the Second World War.

Bruce, however, was working hard at the time on a new play. He had, with the ever-mounting expenses of Waldridge and the high cost of the lavish life he and Ceal were leading, become more money conscious. Remembering the vast sum made by Cochran from the stage version of *The Better 'Ole* and that his own meagre profit had to be halved with Arthur Eliot, Bairnsfather decided to write his script single-handed, and to put the play on himself.

As the theme of the play, Bairnsfather decided that Old Bill should reappear in civvy street, making at some stage a gesture of thanks and recognition to his fallen comrades. Working the idea out physically with models in the "Waldridge Hippodrome" Bairnsfather developed a scene where the Cenotaph appeared to Old Bill in a vision. Gradually the setting of a coal mine emerged, with Old Bill, Bert and Alf as miners. As always, Bairnsfather needed real experience in order to create. He visited a mine at Nuneaton, going down the pit, visiting the coal face, talking to miners. Suddenly the half joking advice that Winston Churchill had given Bruce, when they had lunched together in 1917, came back – "Make Old Bill go to Parliament".

He decided to call the play *Old Bill MP*. It would follow Old Bill's progress from the mine, through industrial strifes and discontent, to Westminster. Bairnsfather submitted the outline to Golding Bright, the theatrical agent, who in turn passed the idea on to Seymour Hicks, whom Bairnsfather had not seen since the meeting in the Adelphi Hotel, Liverpool, in 1918 – just before he set off on his first trip to America.

Hicks agreed to collaborate with Bairnsfather on the play, and so great was Bruce's pleasure that this famous actor/producer should choose to work with him, that all his good intentions about not putting himself in the position where he would have to share out a large proportion of any profits were soon forgotten.

The great actor was touring at the time, and Bairnsfather had to follow him from theatre to theatre or to his London home during his breaks to work on the script. They got on well, and when Bruce was elected to membership of the exclusive Garrick Club in April, Hicks was seconder to his proposal by H.V. Higgins.

The play carried an intensely patriotic message. Indeed members of the cast were convinced that it even had official backing as authorised government propaganda, through which Admiral Sir Reginald Hall could combat rising Bolshevism and labour unrest. A syndicate was formed (called the "O.B. Syndicate") to finance the venture and Admiral Hall was indeed part of it. Affectionately known as "Blinker" as he had a tic in one eye, Admiral Hall had gained tremendous fame during the First World War as the head of Naval Intelligence, especially in regard to his connection with the notorious "Zimmerman Telegram". This announced Germany's intention to engage in unrestricted submarine warfare, a policy which was instrumental in bringing America into the war. His association with *Old Bill MP* was, therefore, automatically construed by the cast and some of the more discerning public as confirmation of the fact that the Secret Service was behind the production. Running true to form, Bairnsfather himself invested heavily in the syndicate.

They had great difficulty in finding a suitable West End theatre for what had developed into a huge and spectacular production, with an enormous cast. Eventually the Golders Green Hippodrome, long considered as a propitious venue for a pre-London try-out, became available. Edmund Gwenn, an established West End actor (who was to achieve even greater fame in films) was engaged to play Old Bill. Rehearsals were soon under way, Bairnsfather designing and painting the scenery and working on the costumes and make up as well. Seymour Hicks got good advance publicity for the play and made great purchase out of the fact that the captain would play "himself" in the show. Of Bairnsfather the papers reported that:

"Before the War he was in great demand in his native County of Warwickshire, and though he specialised in low comedy 'dame' parts, he often took male characters".

The propaganda aspects of the play were also well-reported:

"The band of the Scots Guards will be seen at Buckingham Palace, and the main motive of the play is the search by Bill for a common meeting ground of the masses and the ruling classes for an adjustment of all the present-day grievances which he feels are the direct outcome of the majority of people having forgotten what the War was fought for . . . The piece is full of comedy, with a big, basic, serious idea. In it will be employed a company of a hundred, including the principals and small parts, and it is called a 'show' so it may not be judged as a play pure and simple. It contains not only drama and comedy, but singing and dancing and we hope it will be an entirely novel form of entertainment."

It was a lot of promise to fulfil. What is beyond question is that it gave employment to a great many actors and would-be actors who would otherwise have been on the dole!

The "show" opened on Easter Monday, 17 April, a date which clashed with Sir Harry Lauder's appearance at the Prince's. It was "greeted with roars of laughter and salvoes of applause", and reviews voted it as "spectacularly imposing. The acting is vigorous, especially that of Mr Edmund Gwenn as Old Bill, a part perfectly performed on the lines of thrustful comedy-melodrama. Captain Bairnsfather appears as himself in a studio scene. He is entitled to more respect as an author than as an actor". Bairnsfather's part consisted of playing himself as the artist, sketching in his studio a portrait of Old Bill which comes to life in the shape of Edmund Gwenn. The two then

discuss the state of the country, the ingratitude and forgetfulness shown to those who gave their lives in the war.

For Bairnsfather was still emotionally involved with the war, and he was horrified when Field Marshal Sir Henry Wilson was assassinated by two IRA terrorists as he was returning to his Eaton Place home on 22 June, 1922. Bairnsfather drew a striking picture for the *Daily Express* on 27 June, showing the murdered field marshal dying at the foot of the Cenotaph, with a British Tommy reverently placing a wreath with the message, "From the 'Unknown' to the 'Greatest' ".

When the engagement at Golders Green finished, a West End theatre still hadn't been found. There was nothing else to do but to go on tour – an expensive decision with such a huge production. Portsmouth, Birmingham, and many other cities were on the circuit as well as London suburbs such as Hammersmith, but there was no profit for the syndicate. Cash began to run out. Then a recent event that had seemed like a set-back proved to be a blessing.

Bairnsfather's £3,000 per year contract with *The Bystander* – his main, regular source of income, was terminated. It was a desperately worrying blow at first. The group had been sold out, the *Graphic* having steadily run down hill since the war, and *The Bystander's* format having been greatly altered. There was no place for Bruce any more and he agreed on a cash settlement of £1,000 on termination of his contract.

When *Old Bill MP* was playing in Newcastle-on-

Back page of the programme for Old Bill M.P. *at the Lyceum, 1922.*

OLD BILL ᴬᵀ ᵀᴴᴱ LYCEUM

Funny 'ow they never can leave a feller's past alone

LYCEUM OLD Bill M.P

THE MAN WHO WON THE WAR

Tyne, the financial secretary of the OB syndicate rushed up north to inform Bairnsfather that cash was fast running out, and the members felt it advisable to cancel the one remaining engagement at the Palace, Manchester.

Typically, Bairnsfather decided "to save the ship and back my luck". Ceal was despatched to Waldridge, where he had strangely stored the "pile of crisp bank notes" that represented his payment from *The Bystander* "in a large antique iron chest". She returned nervously to Manchester where the show had opened, with the £1,000 cash in her handbag. The show was reprieved, but there was still no London theatre available as they neared the end of the two-week run. In a dramatic phone call on the last Friday, Seymour Hicks saved the day. He had managed to get the Lyceum.

The play opened there on 12 July. It was the first production in this famous theatre for five months. The theatre had closed after the run of the pantomime "Cinderella" finished on 18 February because of the financial squabbles of the Melville brothers, Walter and Frederick, which had ended in the courts with a compulsory closure order. The closure had put 250 people out of work and cost the brothers £500 a week. Happily their differences were ironed out and the theatre was able to reopen just in time to save *Old Bill MP*.

The Melvilles performed an emotional reconciliation on stage after the opening night, which added to the critics' opinions that ". . . there probably never was a more astonishing first night . . . It was the strangest mixture of hard boiled melodrama, boisterous fun, thick sentimentality and patriotism with a punch". Seymour Hicks had led the Melville brothers to the footlights and joined their hands. He then made a speech, as did Fred Melville, Edmund Gwenn and Captain Bairnsfather, who made a remarkable tribute to Ceal, saying that for two years he had been aided and inspired in the task solely by his wife. It was the first public manifestation of the almost unbelievable loyalty he was to show towards her, through thick and thin, over the next thirty-eight years.

The play was confidently expected to run "for the life-time of the actors". In fact it ran at the Lyceum for 159 performances, ending symbolically on 11 November.

Clinton Davis, the actor who had occupied the same bed after Bairnsfather in the hospital at Rouen in 1916, took over the role of one of the Bolshevik extremists and his future father-in-law, Alec Johnstone, played the other. He played the role complete with monocle and moustache and recalls that he was "a decent cad". He doubled as Reichner, a German MP with the one line, "Shorter hours and higher wages – that's my platform", spoken with a German

accent. The cast, which included future stars such as Johnny Danvers and Brian Ahearne, conscious that the play was "dripping with propaganda and patriotism" played it tongue in cheek. But it went down superbly with the less demanding audiences of 1922, who cheered the heroes ("You may take my life, you may take my honour, but you can't take my Victoria Cross") and booed the villains. Edmund Gwenn played Old Bill in traditional comic style – complete with curled up dickie and red nose – to the delight of the audience.

Mr Davis got £7 a week at the Lyceum, but dropped to £5 when he went on tour with one of the two companies which travelled simultaneously for about six months. Johnny Danvers, who had played the Mayor at the Lyceum, took over from Edmund Gwenn as Old Bill in one touring company, and the Bairnsfather scene was cut out. The fifty or so "supers" (or "extras") got 2s. 6d per night and the company played all the Number One Theatres in the Moss Empire Group. In Glasgow the audience joined in when the opening lines of "the Red Flag" were sung by the villains intent on blowing up the mine, and insisted on singing four full verses – so much for the "anti-red" message of the show!

While *Old Bill MP* was still playing at the Lyceum, the author/actor was approached with yet another proposition – to do a variety act. The prospect terrified him as much as the thought of lecturing had done. Positively refusing to make his debut at the daunting Coliseum, he agreed to appear at the Victoria Palace, topping the bill at £110 per week. A whole new career thereby started for this versatile, paradoxical artist. He was always torn between the desire to conquer new fields, to make people laugh in different ways, and an uncontrollable terror of public appearances. Whatever his private fears and torments, he came over as the warm, sincere person he was. His fifteen-minute act was a resounding success, benefiting from his early love affair with the music hall, his study of professionals such as George Robey and Vesta Tilley and his experience in front of an audience, both in his recent lecture tour and his run at the Lyceum.

He was booked for a twenty-two-week tour of Moss and Stoll theatres. After playing the Victoria Palace on 22 November with his, "Old Bill and Me", act, he went on to the Coliseum that he had so dreaded. During his engagement there, Ceal gave birth to a daughter on Boxing Day. The newspapers, predictably, made great play on the "Bairn's father" pun – a joke that Bruce would have enjoyed, and several, in their enthusiasm to report the birth as being a special Christmas present to Bruce, put the event as having taken place on the 25th, not the 26th of December. A nanny was added to the household at John Street and the baby was christened Barbara,

"The Bairn's Father" Barbara makes her appearance on Boxing Day 1922. The Press decided that Christmas Day was a more exciting birthday.

(known to family and friends as "Barbie") at the fashionable St Martin-in-the-Fields.

The delighted father had to dash off on tour again, still surprised at himself for actually performing on so many of the hallowed stages upon which he had seen his boyhood idols play, and bewildered by the whole success of it all. Fame he found to be ". . . distressing in my case, for I am by nature happiest in obscurity".

As well as performing on stage he was continuing to draw and write for a variety of publications. The *Sunday Express* published a Bairnsfather cartoon and article to mark the publication of *Sir Douglas Haig's Command*, a book which raised the then controversial question, "Was it the genius of Foch or the brilliant tactics of Haig that won the war?" Many soldiers would have disputed both claims, and in his article, Bairnsfather allows Old Bill to suggest that a truer picture of the war would be given by a rank and file book of reminiscences, rather than by those which appeared in the rash of printed versions by commanding officers. It was a device that he would employ many times in the future: to use Old Bill to express his own strongly-held personal opinions – opinions that it would not be considered seemly for Captain Bairnsfather to voice.

Old Bill was still as much a part of him as ever, so far as the public was concerned, and look-alikes were still trying to cash in on their resemblance to this universally loved character. Bairnsfather's idea of an Old Bill Double competition was still rebounding on him. On 30 December his hard-working solicitor, Champness, wrote to the *Daily Mail* on behalf of his client, who "has been subjected to considerable in-

THE TRUE OLD BILL

OF THE BATTLEFIELDS,

Who since the War has tramped thousands of miles
with his famous Dog.

ALBERT EDWARD FRICKER,

(known as "Old Bill, the Battery
barber,") 47030. Royal Field Artillery,
presents this postcard of himself,

In Immortal Memory

of the gallant comrades who perished by
his side on the battlefields of Flanders,
France, Salonica and the Balkans.

Serving on sea and land from 1914 to
1919, he was in the battles of

1915. Loos; Bois Grenier.

1916. Bully Grenay; The Somme;
Salonica.

1917. The Balkans.

1918-19. Woolwich Arsenal.

Gassed, blown-up, shot in head, frost
bitten, maimed for life.

As a youth, Trumpeter of Artillery,
Guard of Honour, Bristol 1887 Jubilee.

*Were they not " a wall unto you,
both by day and by night."*

*Albert Edward Fricker. One of the many claimants to be
"The True Old Bill" who distributed his card at the opening
of the Menin Gate.*

*Another famous Old Bill pretender: Sydney Frank Godley,
who won the second Victoria Cross of the war.*

convenience and some comment by reason of a man
who describes himself as the original 'Old Bill' . . .
The man in question is in the habit of obtaining
money by sale in the streets of a pamphlet and by
reference to himself as the original, 'Old Bill', which
leads to the inference that our client has made use of
him and is now giving him no assistance". The letter
ends by reconfirming that Old Bill was purely a
figment of his creator's imagination.

The man in question may well have been Albert
Edward Fricker, who sold postcards of himself and
his "famous dog". He claimed to be "the True Old
Bill of the Battlefields" and the back of his postcards
listed his wartime record and wounds – "gassed,
blown-up, shot in the head, frost bitten, maimed for
life". Sadly, many gallant ex-Servicemen were re-
duced to this type of begging to survive. Perhaps the
best known ex-Serviceman who would later claim to
be the original of Old Bill was Private Sydney Frank
Godley. Godley won the second Victoria Cross of the
Great War for his action in holding the bridge over
the Mons Canal at Nimy in August 1914. After the

Plumer mentioned T.D. Bairnsfather in Despatches and he was widely considered to resemble Old Bill.

war, the famous VC often donned Old Bill kit. It was to raise money for the Royal British Legion Poppy Appeal, however – not to scrounge.

As the new year of 1923 opened, Bairnsfather was still on tour and contributing to a number of publications. Somehow he had found time to revisit the battlefields of the Western Front and a series of "Old Bill Looks Back" articles appeared in the strange little *Pictorial Magazine* "the only two penny magazine with one shilling magazine features". At this stage after the war, the great rebuilding task was nowhere near complete, and round the town of Albert on the Somme there still lay miles of barbed wire and enough fuse tops to satisfy any souvenir collector. Old Bill and the Captain had no difficulty, in the still bleak and ruined landscape, in recreating the mixed feelings of fear and comradeship, the atmosphere that shone so sincerely through all the *Fragments from France*, and that made them the outstanding success they were. In fact Bruce took Ceal with him to show her the scenes of the birthplace of his unexpected and phenomenal fame.

Old Bill was at work back at home too, and in the *Daily Express* of 24 January a picture of his car mascot effigy appeared on a London General Omnibus Co's B43 bus, which had seen active service during the Great War. The mascot was presented to the LGOC by "a metal worker" and it is highly likely that he made his own pirate models from one of the

authentic originals. That bus is now in the Imperial War Museum, still bearing the shiny brass Old Bill mascot.

Everything that Bairnsfather did at this time made news, and the fact that he was fined £2 at Bow Street Police Court on 11 April for "allowing his motor car to stand for an hour in Charing Cross Road on 12 March and failing to produce his driving licence" was duly reported. The captain appeared in a better light in May, when the prestige magazine *Ideal Home* did a seven-page illustrated feature on "Lower Waldridge Manor, the residence of Capt. Bruce Bairnsfather – A Time-Honoured Relic". The history of the manor is traced back to the Domesday Book, and the Cromwellian connections described in detail. Compliments were paid to the careful way in which Bairnsfather, with his architect Guy Pemberton, had restored Waldridge so that "it appears today most happily in tune with the Elizabethan nature of the building. At the same time it possesses a hot and cold water supply, and electric light and radiators". The sepia pictures show the house from the exterior and interior including the dining room and drawing room with their well chosen period furniture and ornaments. Also clearly visible are the antique pistols that Bruce discovered in one of the chimney stacks and on the same mantelpiece a variety of souvenirs from the Great War, an Old Bill doll, originals by BB himself and, on the drawing room wall, a picture by his friend, Barribal. The drawing room is furnished in Chinese Chippendale style "with distinctive yellow and black chequered cushions in a slightly cluttered, but nevertheless pleasing fashion".

Unfortunately the Bairnsfathers were able to make less and less use of Waldridge. Film offers in the region of £5,000 for the rights to his work had come from the States from the Ideal Film Company, and rival bids were being made for the U.S. stage production by a firm called Lewis and Gordon. The situation became extremely fraught and complicated between the OB syndicate and the two rival bidders. The outcome was a half-hearted stage production by Lewis and Gordon that flopped in Canada and never reached New York. As all hopes of a film version were now lost, Bairnsfather offered to write a completely new film story for Ideal Films. The offer was accepted, and work began on the story to be called *Old Bill Through the Ages* at Elstree. Syd Walker, the well-known comedian, starred as Old Bill.

When work was well under way on the film, Bairnsfather's solicitor, W.H. Champness, was required yet again, to write to the papers on behalf of his client. The subject this time was a film version of an Anatole France novel called *Crainquebille* which had been ineptly translated as "Ole Bill of Paris" by the English distributors. One of the actors in the film

The interior of Waldridge Manor, as featured in Ideal Home *magazine, May 1923. The artist in his studio.*

bore so striking a resemblance to Captain Bairnsfather's Old Bill that "many members of the public, noticing the title and picture will undoubtedly associate these with our client's work. As Captain Bairnsfather has already arranged for the production of a film called *Old Bill Through the Ages* which is almost ready, and as Anatole France's work (which has nothing to do whatosever with Old Bill) should be strong enough in itself without borrowing the name of Captain Bairnsfather's creation, we have on his behalf made a courteous request to the producers of the *Crainquebille* film, in order to avoid confusion, to use some other title than that adapted from our client's work. This they have declined to do".

Indeed reviews on Sunday, 19 August, pointed out the likely confusion between the two titles and the *Sunday Express* film critic commented: "One must congratulate the genius who translated *Crainquebille* as Ole Bill. His feat recalls the linguist who translated 'pas demi' as 'not 'arf'."

Other engagements took Bairnsfather's mind off the problem. As his music hall tour drew to a successful close, Bairnsfather was engaged at a salary of $750 (then about £150) per week to do the same act on the American stage. The British tour finished with repeat engagements at the Victoria Palace and the Coliseum where it had started, then Bruce and Ceal sailed off to America for his first variety tour overseas.

It was a daunting task! American vaudeville audiences were very different from their British counterparts, often being far less demonstrative and vocal. Bairnsfather arrived amidst a blaze of publicity – reporters and photographers and special lunches to welcome him. A seasoned vaudeville performer, Bert Levy, was detailed to show him the ropes, and before his opening at the "make or break New York Palace", Bairnsfather had a try-out at the suburban Washington Heights Coliseum. He was a bag of nerves and had a passive reception. Coming off stage convinced that he was a complete flop, Bairnsfather was astounded to be told by the manager: "You went over well . . . They're always tough like that here on Monday afternoon. We call this 'The Bootleggers' Matinée'."

Going on to the Orpheum at Brooklyn he gained more confidence and two weeks later opened at the famous Palace, in a bill topped by Elsie Janis, and was thrilled to be told that her friend, Lord Birkenhead, considered him "one of the best acts in the show".

During the long grind that followed, he worked Los

Angeles, Rochester, Syracuse and up into Canada. He was flattered by Professor Stephen Leacock's praise and enjoyed a bootleg drink at his home. He worked with Sophie Tucker and Wee Georgie Wood, McIntyre and Heath, the blackface comedians, the trapeze artist Lilian Lietzel, and the strongman Brietbart, (whose large white horse accidentally kicked him in the jaw during his act) with many other stars who Bairnsfather enjoyed watching as much as playing with.

Christmas was spent in Kansas City and celebrated with a memorable on-stage party for the cast after the show. Then it was on to St Louis and to Chicago. The Chicago show was crucial. His performance there would decide whether he would continue through western Canada and down the Pacific Coast. Chicago audiences were notoriously hard to please and when Bairnsfather saw he was in second spot, he protested violently to the manager. He was hardly reassured to be told that there was a "considerable anti-British crowd in Chicago", but he managed to get moved to the marginally more favourable spot of third, and, much to his own surprise, and with some help from Sophie Tucker, he "got away fine".

The option to extend the tour was taken up and on he went – first to Winnipeg, where he and Ceal managed to find time to socialise with the Coburns who were playing there. Bairnsfather could not easily tolerate the cold, and was pleased to move on from a freezing Winnipeg to Calgary, through the Rockies and down the Pacific Coast to San Francisco and Los Angeles again.

It was there that Syd Chaplin, Charlie Chaplin's brother and manager, came to visit Bruce in his dressing room. Syd wanted to play Old Bill and was interested in the stage rights of *Old Bill MP*. Sadly Bruce had to explain the complicated situation which had resulted in the play's failure in North America but which also prevented it being performed by another company.

Next stop was Denver, and here he received the news of the sale of Waldridge Manor. It had become obvious to Bruce that he would spend more and more time in America where he could make more money and he also realised that he had invested too much in the renovation of Waldridge. He had reluctantly put the house on the market when he left for America. It sold for £3,500, half what he paid for it, not including the thousands he had spent on its repair, furnishings and fittings.

Bruce's next move was to sign a contract with King Features to syndicate a comic strip in newspapers throughout America and Canada. The deal was concluded in Cincinnati, the last stop in his mammoth tour which, starting in London in November 1922, had given him forty weeks of vaudeville work.

Bruce and Ceal took the first of what would be a succession of furnished apartments in New York and he settled down to creating his strips, delighted to be drawing again. He didn't find it easy, and he studied the great American strip artists for inspiration. American cartoonists, because of the vast number of publications which carried their strips, earned up to £450 a week even after giving fifty per cent to their syndication agency. "Mutt and Jeff," "Jiggs and the Gumps," were favourites of his. Bruce wistfully reflected: "Had I been an American instead of an Englishman, and drawn my War drawings with the American Army, with equivalent world-wide success, I would be a millionaire by now." But as he was British, working with the British Army, he had won the fame without the fortune. Now he was working hard, while that fame still lasted, to make the fortune to match.

But Bairnsfather was not forgotten in Britain. On 19 March Strube did a cartoon in the *Daily Express* showing what Old Bill thought about "Conchies" (conscientious objectors) standing for election in the Westminster Constituency ("where the Cenotaph stands"). The film *Old Bill Through the Ages* was released a few days later and it was reviewed on 22 March under the heading "Historical Medley at High Speed". Syd Walker was complimented for his "extraordinary unction and humorous resource" but the cinema correspondent of the *Daily Express* felt that the unconscious dignity of Old Bill was "out of keeping with the buffoonery". He also felt that there was some "pruning required" but that the technical excellence has certainly never been surpassed in any British film.

In May the magazine *Picturegoer* devoted three pages to *The Seven Ages of Old Bill*, an interview with Syd Walker, and a review of the film *Old Bill Through the Ages* – "a film that is going to make the world laugh". It had been the experienced comic's first film – although he had started as a circus clown and went on to revue and the music halls, working with Charlie Chaplin and Fred Karno. The film continued to tour Britain, and in November it reached Nelson, near Liverpool. The enterprising local paper *The Nelson Leader* had done its homework. In the 7 November, 1924 edition the advert for the Grand Cinema credited Bruce with the writing and direction and carried an item headed, "Captain Bairnsfather's local associations", which reminded readers that he had "associations with Nelson, for his mother was a Miss Every Clayton, daughter of Captain Every Clayton of Carr Hall. Special significance, therefore, attaches to his film, which is being produced at the Grand Theatre next week, *Old Bill in Six Ages*. Apart from the merits of the picture the local connection of Captain Bairnsfather with this district should draw

W.A. Darlington's Alf's Button, *which caused such suspicion in BB's mind. Play poster by John Hassall, whose art school Bairnsfather attended.*

crowded houses". And in case any reader had missed the ad or the feature, an enthusiastic review of the film with pictures of Syd Walker also appeared in the same edition. Despite its box office success, there is no record that Bairnsfather actually made much money from *Old Bill Through the Ages*.

It was, therefore, doubly galling to him that in that year of 1924 a production which had long (but groundlessly) given him cause for suspicion, went on to even greater success. It was W.A. Darlington's *Alf's Button*, which now appeared in a stage version at the Prince's Theatre. Bairnsfather's jealousy had started during Darlington's period of contribution to the magazine *Fragments* when he felt that the latter had copied some of his, Bairnsfather's, ideas.

Bruce was working on another stage production of his own and towards the end of the year returned from the States to talk business with his agents. He had written a "revue" and stayed in Britain long

enough to get it produced and launched at the Hippodrome, Birkenhead. The piece was called *Ullo –* Old Bill's opening catchword. The lyrics were by Henry Creamer, Clifford Seyler, Daisy Fisher and Jack Stachey, with music by Hero de Rance, John Holliday and James F. Hanley.

The author (also, unfortunately, the main financial backer) returned to the States to pursue his "pictorial commitments" and the revue continued to tour the provinces. It didn't do very well. In retrospect, Bairnsfather admitted, "in my private, candid opinion, I felt it was rather too pictorial, and lacked sufficient broad comedy. Two faults which I consider very dangerous ones to have in a vaudeville revue. What humour there was leant towards being a wee bit too sophisticated". In fact it was far too long (fifteen scenes), expensive (with a huge cast) and disconnected. Bairnsfather kept in touch with the show's varying fortunes from New York. Eventually, desperate measures seemed to be called for, and he returned home. By this time he had given up the apartment in John Street and used premises at 33 Tedworth Square, SW3 as his base. At a panic conference with his agent and bookers, it was decided that bringing in a big star name might save the show. Billy Bennett, the popular comedian, was engaged to play Old Bill. It was a bad move, as his salary of £100 was not covered by increased takings.

Bruce borrowed £1,000 from "a friend" to keep the show going. He also raised money on the strength of an inheritance he was expecting and managed to get some work from the *Sunday Express*. In September Old Bill was asked to go to Salisbury Plain and cover the Army's manoeuvres for the paper. His impressions were given good exposure, and were profusely illustrated.

In that same month a hint of more financial troubles to come was foreshadowed by a case that came up in the Bloomsbury County Court on 30 September. "William, Bill, and Captain Bruce Bairnsfather", called out the clerk. The case related to a claim against Captain Bairnsfather for £25.19s.6d for goods supplied, but neither party appeared and they were not represented. The Registrar, in ordering the case to be struck out, remarked "the irony of fate". Although this puzzling little case was dropped by a Registrar who appeared to have strong sympathy for the once-famous captain, the persistent non-payment of a similar petty sum was to lead Bruce into serious monetary difficulties in the future.

October brought brighter news. The Oxford – now known as "The New Oxford" – which had been the scene of the triumph of *The Better Ole*, was procured and Cochran produced *Ullo*. Johnny Danvers was engaged to play Old Bill. He had first played him in one of the many *Better 'Ole* companies, and then took

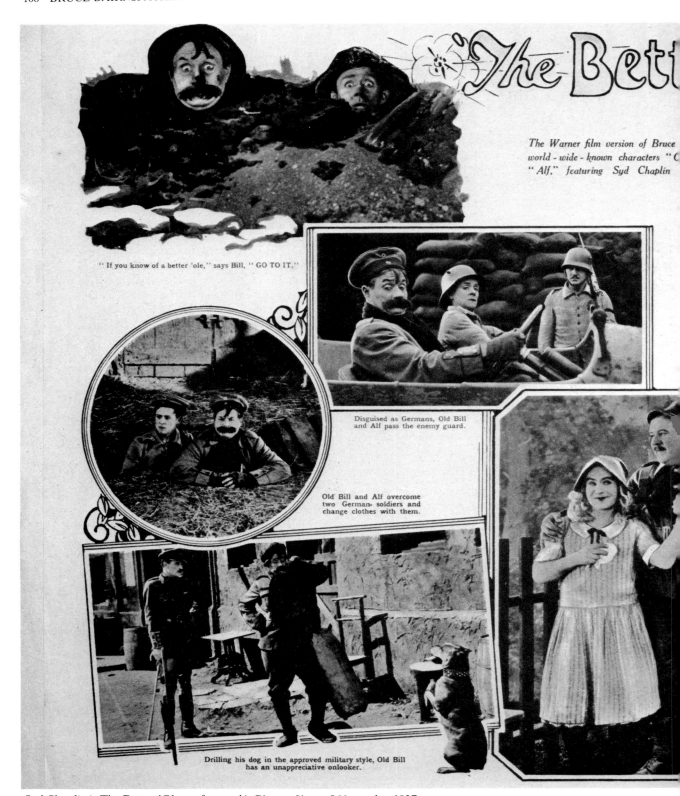

"The Better

The Warner film version of Bruce
world - wide - known characters "C
"Alf," featuring Syd Chaplin

" If you know of a better 'ole," says Bill, " GO TO IT."

Disguised as Germans, Old Bill
and Alf pass the enemy guard.

Old Bill and Alf overcome
two German- soldiers and
change clothes with them.

Drilling his dog in the approved military style, Old Bill
has an unappreciative onlooker.

Syd Chaplin in The Better 'Ole, *as featured in* Picture Show, *5 November 1927.*

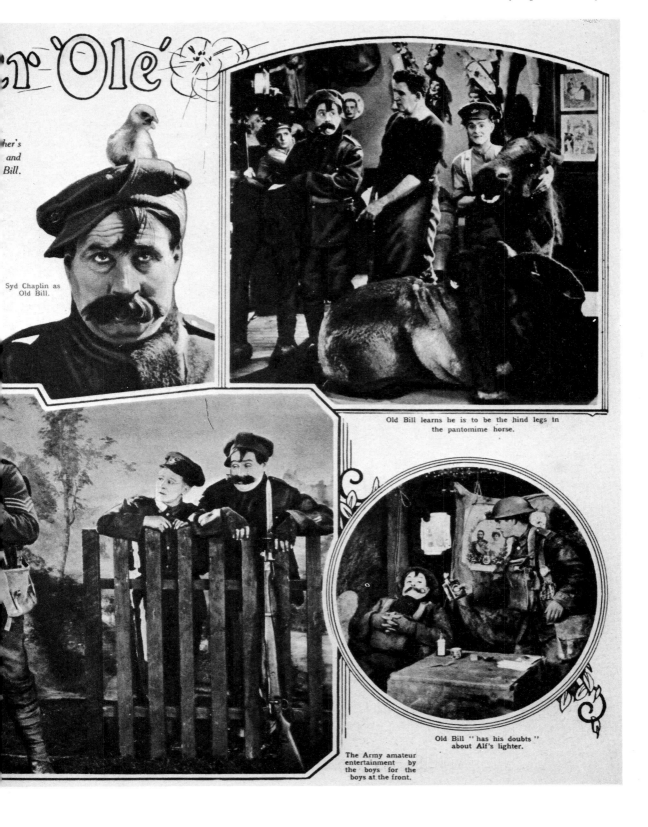

r 'Ole'

her's
and
Bill.

Syd Chaplin as
Old Bill.

Old Bill learns he is to be the hind legs in
the pantomime horse.

Old Bill "has his doubts"
about Alf's lighter.

The Army amateur
entertainment by
the boys for the
boys at the front.

Bairnsfather designing the posters for Warner Bros' The Better 'Ole *in his New York studio. The shelf and pewterware behind him are typical BB* trompe-l'oeil *paintings.*

over the part from Edmund Gwenn in *Old Bill MP* and it was thought that his reputation would do the trick. The revue's name was also changed – to *Carry On, Sergeant* (sometimes even reported as "Carry On, Sergeant-Major") a name that Bairnsfather was to use over and over again. The advance publicity was good, the papers reporting that "Bruce Bairnsfather and his clever wife . . . have worked on the idea that the costumes, scenery and proscenium all belong to each other. They argued it out while on tour in the United States and Canada."

It opened on 28 October. Bruce appeared in the first scene, just as he had done in *Old Bill MP*, as himself, and the papers reported: "The revue is embellished by the musical accompaniment of Jack Hylton's Californian orchestra. Maggie, Old Bill's wife, is played by Miss Joan Lester, and most of the singing is done by Miss Ethel Beard."

The show ran for just over eight weeks, cost its creator £8,000 in all and had financial consequences from which he never recovered. Later it was reported that a "solicitor . . . he had regarded as a partner" put up most of the money and claimed £5,328 was owing

to him. It was probably the long-suffering Champness.

Utterly broken by the failure, Bruce sold his only remaining asset, his car, for £300 and took off with Ceal to the States with only the prospect of the occasional cartoon or strip, and more lecture or vaudeville tours. After the set-backs of 1925, 1926 was to prove far more exciting and rewarding than he could have dared to hope.

Syd Chaplin's desire to play Old Bill resulted in Warner Bros approaching Bairnsfather to sign a contract in which he, Cochran, and Arthur Eliot assigned the rights of *The Better 'Ole* to them to produce as a film. Negotiations started in March. In that same month one of his dearest ambitions was achieved. He was proposed for membership of New York's Players Club and in April was elected. Membership gave him an introduction to a host of theatrical and artistic folk whose company he enjoyed and who were influential contacts for his career. With the help of Charles Coburn and his wife, Bruce and Ceal took an apartment in Grammercy Park, near the National Arts Club, to which he also belonged. Things started to

Syd Chaplin as Old Bill in the 1926 film version of The Better 'Ole.

look up. Contracts were signed with the McClure syndicate to draw a daily comic strip and with Bobbs-Merrill to write an Old Bill book. His wartime friend, Charles Dana Gibson, was now the editor and proprietor of *Life* and no doubt helped to get his contributions published in the magazine.

The Better 'Ole was directed by Charles Reisner and the screenplay was by Darryl Zanuck. It was a silent film, ten reels long, eight of which are preserved in Washington's Library of Congress Motion Picture Section. Joining Syd Chaplin in the cast were Doris Hill as Joan, Harold Goodwin as Bert and Jack Ackroyd as Alf. Bairnsfather was asked to submit designs for half a dozen posters for publicity purposes. He roughed out twelve and was highly gratified when Warner Bros bought the lot for $250 each. It must have seemed like pennies from heaven at this lean time. He also designed and wrote most of the contents of the souvenir book, which sold for twenty-five cents. He wrote "A tribute to Warner Bros", endorsing their treatment of his creation and an article entitled "How Old Bill came to life on Stage and Screen".

Bairnsfather himself admitted that the picture had "scarcely any resemblance to the play that Eliot and I had once written, and no resemblance whatever to the first film that had been made from the play". The story tells how Old Bill, now promoted to sergeant, (something Bruce would never have done to him)

Souvenir programme for the 1926 Warner Bros. film of The Better 'Ole, *designed by Bairnsfather.*

Bairnsfather's World War I idea that Charlie Chaplin borrowed from The Rookie *and which landed him in court.*

discovers that his major is a German spy. His adventures with Bert and Alf involve escapes in a horse costume, capture by the Germans, bombing, poisoning and firing squads.

The film opened in New York on 23 October, 1926 after a première on 7 October which was attended by Condé Nast, Will Hay and Jack Dempsey, "the latter still bearing the marks of Gene Tunney's fists". Bairnsfather covered this meeting of the boxing giants in Philadelphia for the *New York American*. "I have been to many of the biggest fights both in England and America, but never have I had a better view than I had at this one, and never have I seen a more exciting battle", he enthused afterwards. "An uproariously funny but thoroughly farcical conception of *The Better 'Ole*" commented Mordaunt Hall in *The Screen* on 8 October. He went on to say: "There are moments when this comedy drags, but this failing will undoubtedly be remedied for it merely means the curtailing of some of the scenes."

About this time Bruce had a curious episode with Syd Chaplin's famous brother, Charlie, whom he had first met during his days of opulent entertaining at Waldridge. He was called in to help Chaplin in his fight with a writer who was convinced that Charlie had pinched his idea! The idea in question involved a private in the Great War who disguises himself as a tree, and who moves with great comic effect to evade the Germans, stopping dead when they look in his direction. The aggrieved writer had used the situation in *The Rookie* and complained that Chaplin copied it in *Shoulder Arms*. Bruce had used the idea before either of them, drawing it as a *Fragment*! He volunteered to go into the witness box for Chaplin and prove that "in this case all the involved ideas instead of being original inventions were really observations, and as such were common property. In other words, prove that anyone might have thought of, say, a man disguised as a tree, because during the war men were occasionally disguised as trees". His plea was effective, for Chaplin won the case. It is interesting to note that he approached the problem of people using *his* ideas much less philosophically – as he was to demonstrate forcibly the following year.

Back in Britain, the new film was receiving a mixed reception. The *Sunday Express* film critic thought that it "turned out to be, to my surprise, rather a cruel satire on *The Big Parade* and . . . there is little to connect the production with the Bairnsfather legend". Syd Chaplin, he felt, "misses the essential dignity of Old Bill and that 'those who can overlook slipshod construction will probably enjoy *The Better 'Ole*!" Other critics agreed that although the film was "a clever satire", Chaplin failed to grasp that Old Bill was essentially "a dignified character and not a mere buffoon". Chaplin was commended, however, for not forgetting his humble origins and for giving a free performance to 300 boys from the training ship *Exmouth*, where Syd started life as a "poor law boy". To No.151, his old number on the ship, he presented a "suitably inscribed silver watch".

In America the picture continued to play to good audiences both on Broadway and on tour, well into the spring of 1927. It toured Canada too, and it is probable that its success led to the door opening to the next crucial chapter in Bruce's career.

I'll give it about a week

Chapter 10

The Moviemaker Causes a Scandal

(1927–1928)

1927 continued on a high note. Bairnsfather was given the ultimate accolade as a star personality and was chosen as the subject of one of the first talking motion pictures. It was made by the Vitaphone Corporation, New York, and the sound disc was pressed by the Victor Talking Machine Co., New Jersey. It showed Bruce, casually dressed in a zippered cardigan and for once hatless, walking on to a stage to the strains of "It's a long way to Tipperary". He salutes, introduces himself and goes into his Old Bill "chalk and talk" act. He keeps up a continual patter in his soft and pleasant voice, liberally sprinkled with the puns and jokes found in many of his articles. Going back to the "war which ran quite a long time – in fact if I remember it ran nearly as long as Abie's Irish Rose", Bruce went on to describe how "in a fit of temper I commenced to make those sketches, persuaded to start them by some soldier pals of mine". He shows the familiar development of Old Bill and ends to the strains of "Over There" – the Americans' most popular song of the First World War – by drawing "one of those chaps who went 3,000 miles" – a doughboy.

The film was released on 2 April and was shown before *The Better 'Ole* at the Colony Theatre on Broadway. The sound disc is one of only four preserved by the Washington Library of Congress, which also has the one thousand-foot reel of film.

The next milestone was the publication by Bobbs Merrill of *Carry on Sergeant*, a book of reminiscences of Bruce's war. For once the title succeeded for him. He was now able to write a more dispassionate account and had matured from the raw, rather puerile style of *Bullets and Billets* and *From Mud to Mufti*. Of course, he couldn't avoid taking a humorous tone, but through the jokes, some of them slightly fatigued if not yet over-tired, the realism and sincerity managed to shine through. The book, profusely illustrated by some good, often quite original, cartoons,

contains several moving, interesting cameos: the Christmas truce; the sergeant newly promoted to officer who cannot cope with his new relationship to his men and virtually commits suicide in a rashly heroic charge; what it feels like before "going over the top"; the psychology of Old Bill, the perpetual

A typical BB "Doughboy", from the book Carry on, Sergeant!, *1927.*

private who shuns responsibility; the witless, fine physical specimen of "a feudal officer" whose men are conditioned to follow.

The book was written specifically for the American market: few copies found their way to Britain.

Carry On Sergeant added to his star status. He attended the Harvard-Yale Boat Race in June and afterwards was guest of honour at the dinner at the Griswold, Eastern Point, New London. Over the Essence of Tomatoes in Cup, the Noisette of Lamb Argentineuil, the Sour Mixed Pickles and Queen Olives, the Fresh Strawberry Ice Cream and the Petits Fours, he made such an impression on a fellow guest, Mrs Barbara White, that she kept on her dressing table until she died, the dinner menu on

Drawn in 1927 when Bairnsfather was highly involved in making films of The Great War himself.

This man went through Chateau Thierry, the Argonne, St. Mihiel, and Soissons, without a scratch. He was, however, accidentally wounded at Hollywood during the filming of NO MORE WAR

which Bairnsfather drew an "Old Bill" for her dedicated to "Un Esprit Libre". She also christened her son Bruce. In the note accompanying the mementoes, Mrs White wrote: "We had a good time together on a yacht anchored in the river during the race, and afterwards. Both our initials were B.B. and we both were the 'world's worst sailors'!" There was no mention of Ceal.

The next month, Bruce found himself in the courts again. His former collaborator, Seymour Hicks, was suing Bruce and the ever-present W.H. Champness, for the £300 he claimed he had been promised as a minimum payment from the profits of a new play, *Old Bill*, to be produced in America. Bairnsfather was represented by Mr Richard O'Sullivan but the Judge, Mr Justice Acton, refused to take the view which he was invited to take with Sullivan's "customary combination of ingenuity and commonsense" – that as there was no profit there should be no payment. He maintained that Bruce had promised a minimum of £300 and this he was instructed to pay. It was a sour end to what had been an inspirational partnership for Bruce during the days of *Old Bill MP*.

However, he was still being given the celebrity treatment. The magazine, *The Red Book*, showed his picture with the caption, "Bruce Bairnsfather, who made fun of the war. In those days of staggering casualties, his pen made more for *morale* than any other – now *The Better 'Ole* with Old Bill and Alf amuse the millions in the motion-picture theatres".

Bruce then embarked on yet another busy vaudeville tour.

While Bairnsfather was doing his twice-daily vaudeville act at the Palace Theatre, New York, he was approached with a proposition that was to lead him to the climax and the most spectacular failure of his career. During 1927 there was a strong movement in Canadian governmental and big business circles to end the stranglehold that the booming American film industry had on their country. Moving pictures were proving immensely profitable, and Canada wanted a slice of the action at home. From the early days of the new medium the movie had been recognised as a powerful vehicle for propaganda, and films were made showing the glories of Canada in order to encourage immigration. D.W. Griffith, who in 1915 achieved immortality in the annals of the moving picture with his *Birth of a Nation*, made some of these. Before America's entry into the war in 1917, anti-American films were shown throughout Canada, together with stirring recruitment films. But when the appalling horror of trench warfare began to appear in the newsreels, the Canadian Department of the Militia demanded their suppression. During the war national film studios were built at Trenton, Ontario, and in 1917 W.H. Hearst, then Premier of Ontario,

established the Ontario Government Motion Picture Bureau. Three films were shot at Trenton. *The Great Shadow* was the last, in 1919. It starred Tyrone Power – film star father of a more famous son of the same name. Its message was anti-Communist and behind the scenes Canadian Pacific Railways was the sponsor. It was not a great financial success, and the Trenton Studios were forced to close. During the period that followed, many Hollywood successes were achieved with Canadian stories and settings – most notably *Sky Pilot* made by King Vidor and the *The Canadian*, the everyday life of a Canadian homesteader. In the twenties, Hearst's Government Bureau took over the bankrupt Trenton studios and started a programme of expansion. Some excellent documentaries and nature films were made and the Federal Government in Ottawa also set up a Motion Picture Bureau.

At this stage it was realised that to break what was virtually a Hollywood monopoly on commercially viable international feature films, drastic steps would have to be taken to move Canada into the big league. A company known as Canadian International Films Ltd. was founded in October 1927 with the active support of Ontario's Premier, Howard Ferguson. His enthusiasm and energy produced some big name support. Former Canadian Prime Minister Arthur Meaghan and future (1930–35) Prime Minister Richard Bedford Bennett were among the investors. The President was Edward Pardee Johnston and the Vice President William Clarke, a British colonel and a director of Cranfield and Clarke, distributors of short films. A Canadian film magazine *Canadian Moving Pictures Digest* reported on 16 October, 1928 that "on the Board of the Canadian International

The budding director (centre) with Col. William Clarke, Vice President (left) and Major Edward Pardee Johnson, President (right) of Canadian International Films.

Films are several well-known Canadian financiers among which there is Noah Timmin of Hollinger Gold Mine Fame, Alan Ross of the Canadian Wrigley Co., and St Vincent Meredith, President of the Bank of New York".

But the investment target figure of $200,000 (soon to be raised to a more realistic $500,000) had only been half-achieved. There were many promises, and the principals felt that to convert those promises into solid cash, and to make impact on the international scene, a big, world-famous name had to be brought in.

The Board of Canadian Films Ltd. decided to approach Bruce. The significance of this decision as an assessment of Bairnsfather's truly international importance should not be minimised.

A representative of the ambitious, embryonic Canadian film company called on Bruce Bairnsfather in his dressing room at the Palace, New York, with what must have seemed a staggering proposition. Bruce was asked to write the story and make their first all-important film.

Bairnsfather went immediately to the American Play Company, an agency who had handled some of his other deals, and asked their advice. They told him to stick out for a $25,000 fee for the story alone. Weeks followed Bairnsfather's relaying of this offer. Nevertheless he profited by the delay by writing the outline of the screenplay. A grandiose epic was called for, and, as ever, Bruce drew on his own painful experiences to supply him with material. He had been a victim of the first gas attack at Ypres. This had been a great Canadian battle, as the beautiful "Brooding Canadian Soldier" memorial at "Vancouver Corner" in the little village of St Julien near Ypres still bears witness today.

Bruce took this episode as the climax of a story that would follow a sergeant in the Canadian Scottish through enlisting, his arrival on the western front, his martial and amorous adventures and final hero's death in action. He called it *Carry on, Sergeant!*

The synopsis was submitted to the Board, and Bairnsfather was summoned to Toronto to meet the Premier of Ontario, the Attorney General, the Secretary of State and other important dignitaries in the Parliament Buildings. He was then required to show himself before a succession of business tycoons from Toronto and Montreal at a series of formal lunches – the type of function that was sheer anathema to him. However, the magic of his name worked, and Bairnsfather was formally appointed as Director. Soon realising that his allotted budget of $200,000 would not go far if he was to hire experienced personnel both on the production and acting sides, Bairnsfather volunteered to work in a directorial and supervisory capacity for no further remuneration than the $25,000 he was asking for the screenplay. He had not

learned from his expensive lessons. Not surprisingly, the philanthropic offer was accepted with alacrity, and Bruce sublet his New York apartment and moved to Trenton.

Arriving in Canada, he was asked by reporters whether he thought good motion pictures could be made in Canada, and, if so, why hadn't they already been made? Bruce replied that the idea that America was "the sole country suited to such manufacture" was "naturally fostered by American interests". In an epic statement, perfectly suited to the grandiose aims of his venture, he continued: "This huge dominion, great as it may be now, is destined for further greatness . . . Films, whether domestic or foreign in story, can proclaim Canada to the world." There is no doubt that in his own mind he was substituting "Bairnsfather" for "Canada". He saw the film as an opportunity to extend his fame, to add a new skill to his already varied talents, to take his career in a new and exciting direction.

Soon he sent for Ceal, who was in England at this time, and she arrived, complete with little Barbara, then five years old, and her nanny. They took a small wooden house in Trenton, going to the nearby small town of Belleville to the cinema or to have a Chinese meal. Bruce needed the relaxation to take his mind

Cecilia Bairnsfather at Trenton Studios with comic lead, Jimmy Savo. The Old Bill mascot looks over their shoulders.

off the problems which were growing daily.

Production got under way in September 1927, and once Ceal had been installed, technicians on the film remember her over-protective guardianship of Bruce, her intrusion into matters in which she had no knowledge or experience, and that "her hot temper and the fact that she actually had no authority made her well-intentioned but aggressive interference in production matters most unwelcome among cast and crew". It was generally considered that her temperamental and violent outbursts were the result of her over-indulgence in alcohol. Her behaviour at Trenton must have been an important contribution to Bruce's later admittance that Ceal was stifling his creativity, and a straw that broke the camel's back of his patience.

As always these unfortunate episodes alternated with displays of her undeniable charm. Gordon Sparling, third assistant director of the film, recalls: "She was always pleasant and kind to me and to my bride, who at her suggestion played the nurse with Niles Welch in the hospital scene." Others saw Mrs Bairnsfather as "the real villain of the story and the cause of much of the internal dissent that marred the production" . . .

Gordon Sparling had served his apprenticeship under Walter Wanger in New York, and joined Bert Tuey and Clarence J. Elmer on the direction team. It was Sparling's forward thinking that saved the film for posterity, when he rescued the negative from destruction in the 1930s and caused it to be presented to the Canadian public archives in 1951.

Although Bairnsfather tried to employ as much Canadian talent as he could. Hugh Buckler, a British actor, played the sergeant of the title role, and many technicians and much equipment had to be transported from New York and Hollywood. In view of the budget, Bruce looked for little known names. Hugh Buckler, Jimmy Savo (a vaudeville artist who provided the comic relief, playing an Old Bill-type of character, Syd Small) and Munro Ounsley (who played Leonard Sinclair) all had their first film parts in *Carry on, Sergeant!* and Bruce claimed that all three found success in Hollywood later. He also offered a part to George Patton, an ex-major friend, who was then head of the Ontario Government Motion Picture Bureau. His persuasive letter to Patton is reproduced here in full.

Bert Cann, the photographer, was experienced, and Bruce enjoyed working with him, calling him "an artist by temperament, a fine photographer, and a good disciplinarian". Cann, with his team of Charles Levine, Walter McInnes, William J. Kelly and W.H. Graham, did a fine job, despite the ugly disputes and personality clashes, bitterness and rivalries that dogged the production.

started, and Bairnsfather took over the design of the sets until a replacement was found. In the credits of the film, Bert Rothe is listed as under "Art Dept.", but Sam Corso, who also worked on the film, was not credited because of a dispute with Bairnsfather.

A whole Paris street was constructed in a large disused brewery that Bairnsfather had hired. One ingenious scenic prop that was never used was an elaborate working model of Ypres. Gordon Sparling spent three months on its construction. Here is his account: "An example of lost expenditure resulting from lack of pre-planning was the large miniature of the bombed and burning town of Ypres, with its three-foot high ruined Cloth Hall Tower. Instructions were that there should be a 'dead horse' at the edge of the square. It would tie up with some close-up actuality shooting. So there it lay, all two inches of it, very realistic and very dead. But the on-again, off-again miniature with all its wired explosives and tiny bricks piled into walls, was never used – and the mystery of the 'dead horse' was never solved." Conversely, to save money, Bairnsfather used his Army contacts to borrow a large quantity of Black Watch Canadian Highlander uniforms, equipment and rifles – for the cost of transit alone. As the new-born Canadian film industry had as yet no wardrobe department of its own, all the German and French Colonial uniforms had to be hired or bought from New York.

The French Zouaves and Spahis had borne the brunt of the first horrific gas attack of the war in April 1915 – the action in which Bairnsfather himself had been shelled. So he was directing from painful personal experience, and was determined that the scene should be authentic and truly epic. At this time Canada had only a small black population, so with typical ingenuity, he combed Toronto for unemployed Pullman porters and "found a sufficient number of suitable negroes". He was delighted by their realistic performances and "ordered a whole morning's solitary choking and writhing".

Two huge outdoor scenes were filmed. As well as the gas attack, the flight of the terrified Ypres refugees was filmed over soft ground that had been churned up to simulate the fearful topography of the Ypres salient in 1914–15. Bairnsfather and Bert Cann were well satisfied with the results when they saw the rushes. "The illusion was excellent in every detail . . . We knew we had attempted and accomplished something never achieved in Canada before."

As Bairnsfather overspent his budget and cuts in staff had to be made, he gradually assumed more and more responsibility in a variety of areas, taking on the responsibilities of directing, producing, continuity and screenplay. Nobody ever remembers seeing a formal script. Under the thinly veiled pseudonym of "Charles Bruce", Bairnsfather appears in the credits under "Script". Gordon Sparling commented of the script: "Theoretically he had one in his pocket, but my feeling is that beyond the general outline, he made it up more or less from day to day." The reason, Sparling feels, is that Bairnsfather was frightened that people would steal his ideas.

For the general shots of military movement on the western front Bairnsfather went on to Norman Gunn, who had an extensive library of official war films in his Toronto home. Gunn provided him with several movies of war scenes and retains a vivid memory of the visit Bairnsfather paid him, playing the part of the movie mogul, complete with limousine and liveried chauffeur. According to Mr Gunn, Bairnsfather was even dressed in morning attire, bowler hat and cane. He was particularly enthusiastic about a sequence showing a Highland Regiment moving through a destroyed town which he felt admirably conveyed the atmosphere he was trying to portray.

As the budget over-ran by double the allocation, Bairnsfather, with the dedicated but naïve generosity that had impeded him from getting his just financial rewards at so many crucial stages in his career, volunteered to forego his salary until "the Company could better afford it". It never could. But by this time Bruce felt that "by protecting the making of the film, I was protecting my own reputation".

Bairnsfather, with his history of collapses, breakdowns and periods of "being run down" at times of stress, was mentally and physically wrung out by the gruelling, troublesome filming. "Never in my life had I encountered such complications, difficulties and worries," he later commented. As time passed and the picture slowly but surely materialised the troubles seemed to grow in proportion. "A time at last came when I found myself almost standing alone in a sea of difficulties that surged about the whole endeavour. I saw there was at all costs one thing to do for everybody's sake, and that was hold everything together, and pilot the making of the film to the very end until we actually would have the product 'in the can'. Then it would not so much matter what happened. The proof that a good picture could be made in Canada would be there in practical form. To have thrown the towel in would have been disastrous but many and many a time did I long for the end of the fifteenth round."

In fact the situation got so bad in the spring of 1928 that he withdrew from the production, taking with him the only copy of the continuity and the negatives of all the productions stills. According to Canadian film buff Michie Mitchell, the "producers retaliated by having the Sheriff of Hastings County seize the script and stills", and Bruce was prevailed upon to return to production. From that point on, however, there would be two camps – Bruce, Bert Cann and a

few other loyal crew, and, on the other side, William Clarke, Johnston and other members of the Board of Canadian International Films Ltd.

At last, in May 1928, shooting was somehow completed. The actors were paid off and left, the working staff dwindled and, finally, Bairnsfather, Bert Cann and a lab expert were on their own for weeks of painstaking editing and cutting. At last they were satisfied with their labours. "We felt enthusiastic and convinced that the investors and the public at large, when they saw the result, would be amazed at what had been achieved at Trenton, with our limited scope and under such trying conditions."

During this period Bairnsfather was also having to worry about the publicity for the release and première of the film. In July he wrote to George Patton with some of his requirements. Once again his almost pathological fear of people stealing his ideas shows through.

Cutting was completed in August 1928, the fourteen reels (about 140 minutes of film) was considered too long, and for its commercial release, *Carry on, Sergeant!* was reduced by four complete reels to 9,700 feet. Gordon Sparling felt ". . . the film is considerably better than the cruel fate it received. There are many moments of beauty and artistry. But it has been so buggered about, cut and re-cut, from over fourteen to nine reels, to satisfy criticisms, to mollify the military, the prudish, the exhibitor and the renovator, that it is not fair to judge it by the wonky continuity that is left".

Norman Gunn, who provided much of the military footage, looked in vain for the Highlanders' scene that Bairnsfather had so admired when he bought it in 1927, when, for the first time, he saw the final version of *Carry on, Sergeant!* in 1978. It had obviously ended on the cutting room floor, with all but about 50 feet of the film Gunn had provided. Norman was bitterly disappointed and commented: "If the name Bruce Bairnsfather had been left off the credits at the start of the picture, one would never believe that it portrayed any of the characters or humour that Captain Bruce Bairnsfather was so famous for."

On 6 October, 1928, the *Canadian Moving Pictures Digest* was eagerly awaiting a release date. Already it had formed the judgement that, "all conceded that it was not the Great Canadian picture expected . . . Reports were current that about $350,000 was spent on the production, but no corroboration of this sum has been made by its producers". Gordon Sparling estimated the cost at $450,000 – "the biggest and most expensive feature ever produced in Canada . . . It is also our biggest and most spectacular flop". D. John Turner, Archivist at the Canadian National Film Archives, estimates the cost at $500,000 because of

Evidence of Bairnsfather's paranoia manifests itself in his letter to Patton of 27 July 1928.

"excessive salaries and grandiose settings". Whatever the exact figure, there is no disputing the fact that Bairnsfather grossly exceeded his budget. But perhaps more pertinent than accusations of extravagance is the criticism that he was totally inexperienced as a film director, and perhaps "over the peak", with "the wartime glow on the wane".

After a sneak preview at Runnymede, Toronto, in September, which created no interest, the world première was held in the Regent Cinema, Toronto, on Saturday 10 November, 1928. The film had a theme song, an original score by Ernest Dainty and an elaborate programme illustrated by Bairnsfather, who wrote in his introduction: "Let me say briefly that out of the last ten years' experience in the world of entertainment, never have I had a task which has filled me with a greater sense of enthusiasm or responsibility than the creation of this picture. I feel honoured to have been selected to be the maker of Canada's first big feature production. For over a year now a band of capable enthusiasts worked with myself on the very difficult and strenuous task of producing this picture, and I know that I voice their opinion as well as my own when I say that if our work leads to the approbation and affection of Canadian audiences, for their own first great screen presenta-

The programme of the world premiere of Carry on, Sergeant!, *10 November 1928.*

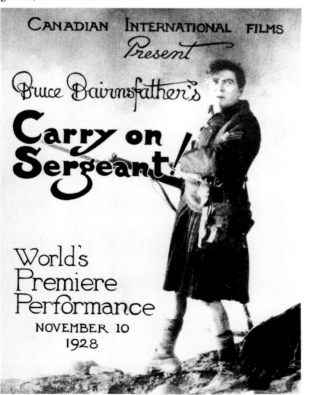

tion, we will have been fully repaid."

Ceal ran true to form at the première, making an ugly scene in the lobby of the Regent with N.L. Nathanson over the way that the film had been handled.

The movie opened to the public the following Monday, the day after Armistice Day.

Apart from criticism of the scene showing the married Sergeant Mackay's lapse in France with "an estaminet girl" – it was not thought seemly that a Canadian soldier should "engage in sexual intercourse out of wedlock, even under the most trying circumstances" – the film had good reviews. By no means explicit by today's standards, the estaminet scene showed Marthe, played by Louise Cardi, inviting Bob Mackay, played by Hugh Buckler, to follow her upstairs. After some conscience-searching he walks up the stairs after her. The controversy certainly gave the film a good deal of publicity. One report stated: "Very little is left to the imagination when a soldier and a French girl 'go the way of all flesh'."

The *Toronto Star* was enthusiastic and reported that the film grossed more than $10,000 in its first week, the third highest in the city that week. The second week was even better – the takings were the highest in Toronto, despite bad weather. It also ran for a week at Brantford, Trenton, Kingston and St Catherine. Bairnsfather made personal appearances at the "road showing" of the picture. He was billed as "The World's Best Known Cartoonist", the movie as "Canada's First Mammoth Motion Picture", that "every theatre-goer in Canada is rarin' to go to see".

But sadly, by the end of December, the film was reported as "failing to carry on". Bruce was not making personal appearances and audiences were walking out. Rumours of behind the scenes rifts in the company were rife and eventually, owing to a major dispute amongst the shareholders, the run was terminated, and by January 1929 Canadian International Films Ltd. was declared bankrupt.

Why was *Carry on, Sergeant!* – a film on which so many hopes had been pinned, so much talent, faith, enthusiasm and persistence expended; so much financial and moral support given from such high places – such a monumental failure?

Current opinion has much to say in its praise and favour. Gordon Sparling believes, after seeing it again in 1979, that it has "many fine moments of beauty and fine artistry". D. John Turner believes it to be "a reasonably good film", comparing favourably with King Vidor's *The Big Parade* and Raoul Walsh's *What Price Glory*. He considers Bert Cann's photography excellent and the acting "acceptable". Bairnsfather and Bert Cann were convinced that, although it had faults, "never before had a picture of this magnitude or proficiency been made in Canada".

Bairnsfather's introduction to the programme for Carry on, Sergeant! *Courtesy of the Canadian National Film Archives.*

Michie Mitchell in an article in *Filmland* in October 1978 describes the photography as "superb", the sets and properties "extremely effective" and the acting "very good", and, ultimately, "definitive proof that feature film production in Canada was possible". He felt that the enforced drastic cutting was as responsible as Bairnsfather's inexperience as a scenarist and director, for the film's final failure.

Certainly the movie views well now. Taking into account the deficiencies of technique that were to be expected from a picture made at that early stage in the development of a nation's film-making industry, the battle scenes have a feeling of reality and excitement. The contentious "estaminet scene" is shot and acted with sincerity and sensivity. The title sequences owe not a little to *Fragments from France*, and some of the scenes in the trenches look suspiciously like animated versions of them. Nevertheless, the general impression is of an entertaining, interesting film which was obviously made from real experience and with sympathy. It deserved to have fared better.

The facile solution for its failure, and the one most generally accepted (and subscribed to by Bairnsfather himself and Bert Cann) is that *Carry on, Sergeant!* was released just as Hollywood and New York companies were launching their exciting novelty, the full length talking feature. "We had made a

silent picture at about the worst moment it was possible to make one," was Bruce's verdict.

Gordon Sparling, however, rejects this theory as being only partially true. He maintains that in those early days the talkies were only suitable for parlour comedies and light fare, while epics like *Carry on, Sergeant!* and the successful *Big Parade* were better served with brief subtitles. D. John Turner has discovered that only two out of Toronto's one hundred cinema theatres were in fact wired for sound in 1928. So if the cinema public were flocking to see other silent films – why not *Carry on, Sergeant!*?

It was expecting too much of the public that they should still be interested in a story set in the First World War ten years after it was all over. People wanted to forget and move on. This seemed to be something that Bairnsfather could not, or would not, do. He seemed to think that by not writing a story about Old Bill he was doing something entirely new and different.

The fact that distribution in Canada was still American-controlled could also have had a great deal to do with the film's lack of success. D. John Turner also feels that a major fault lies in the erratic continuity "and the blend of drama and humour is uneasy, probably both due to Bairnsfather's inexperience and his off-the-cuff shooting methods".

Gordon Sparling recalls how the experience left Bairnsfather "disillusioned and deeply upset". Certainly it left him poor once again. For almost a year he had worked for no salary, and even Barbara, five years old at the time, remembers her father's heartbreak, and the bitter clashes when people came to argue over money with him at the small house in Trenton.

There was worse to come.

Chapter 11

The Threat of Divorce

(1928–1932)

Bruce had been engaged by Canadian International Films not merely to produce one picture but to be their resident "big name". After the blockbuster to end all blockbusters had been completed it had been expected that he would stay on to make many more films, to put Canada on the map in the movie world.

Before the abortive career of *Carry on, Sergeant!* had terminated, and while Bairnsfather was still at Trenton, he was approached by an "emissary of the Attorney-General" who assured him that all the difficulties would be "settled in time" and promised that really big studios would be found for his future projects. Gordon Sparling well remembers that Bruce "was in this thing on a long-term basis, and I know for a fact he was already planning his second picture and acquiring a permanent home near the studio".

Despite the strains and varying fortunes of his first venture into movie production, Bairnsfather was seriously tempted to stay on. For one thing he was beginning to love Canada. From his early Thornbury days, he had been a confirmed country lover. Rural Canada's vast lakes, streams and forests were exerting an attractive influence on his solitary nature. For a complete contrast to the traumas of Trenton he had made relaxing fishing trips into northern Ontario, and had longed to stay at a "small and exceedingly rural inn".

Three considerations forced him to move on again. Firstly, he had not been earning for almost a year and must have been in severe financial hardship. Secondly, Canadian International Films had not proved to be the vehicle that would sweep Bairnsfather and the Canadian film industry into the international fame that he and all its shareholders and employees had hoped. He found himself in an obscure Canadian backwater with only a flop to show for the last twelve months of his artistic career. But the factor that exerted the strongest influence on his decision to leave Canada was the fact that, as he put it in his book, *Wide Canvas* – written much later – "for a whole year now Old Bill had been doing nothing". This was an open admission of his dependence upon

Bruce, after the episode with Constance Collier.

his famous character. He expressed no regret over the realisation, either because he did not see it as a personal capitulation, or because he considered it to be a temporary measure. It is probably that the significance of his action, in wedding himself forever to Old Bill did not occur to him either at the time or later. And so with the "cordial thanks" of the Prime Minister of Ontario and the Attorney-General as his only recompense, he took the train back to New York.

There his first priority was to bring Old Bill out of mothballs. Back in England the Old Codger was in the public eye again – as a waxwork model in Madame Tussaud's, where he remained until 1934. In America Bruce devised a series of drawings charting Old Bill's progress through the strange environment of the United States and Canada, with his young pal, Bert. The drawings were bought by the American magazine *Judge*, and Bairnsfather's six-months' contract for a weekly drawing was extended for another eighteen. The drawings he did for *Judge* and other American publications during this period were later published in book form. As always, he drew from personal experiences to provide settings for the varied adventures of the trouble-prone pair. When one particularly hazardous scrape landed them in prison, their creator visited Tombs Prison, New York.

Though well-received in North America, the transatlantic adventures of Bill and Bert came in for some censure in the British Press. "I always think exiles are the most pathetic creatures," wrote one indignant columnist. "And two of the most pathetic exiles of recent years are Bruce Bairnsfather's Old Bill and his clean-shaven companion, Bert. After having fought so well through the war and symbolised the Tommy's attitude to the whole ghastly conflict, these two creatures of an artist's fancy have now become American citizens . . . They appear each week above the Bairnsfather signature in the New York magazine *Judge* and although they look just the same as they did in the days of 'If you knows of a better 'ole, go to it, their language is now the language of Al Capone and the wisecracking comedians of Broadway.''

The Trenton saga was by no means over, however. During 1929, the *Canadian Moving Picture Digest*, edited by a spirited woman called Ray Lewis, ran a series of post-mortems, enquiries and columns of editorial conjecture and comment. Ray Lewis had been called to a conference by Colonel Clarke when the idea of the syndicate and the film had first been proposed. Now, with the advantage of hindsight and with the failure of the film confirmed, she was able to report on 12 January, 1929 that: "My first instinctive connection with this Canadian project of Col. Clarke's was true. I felt that those who invested their money would lose it, and it looks that way for a

certainty today. The office of the company has closed and the picture is on the shelf. One half of a million dollars is lost – and Canada again besmirched as a country in which someone used Canadian picture production as a means of 'grabbing some money'." The movie had attracted indignant letters from the film-going public where it was showing, objecting to the now infamous "estaminet scene" and the whole Canadian film industry was feeling nervous and jittery about future productions. By 26 January, Canadian International Films had been served with a series of writs by photo-engravers, printers and others for debts totalling around $10,000. In the 2 February edition of the *Digest* Ray Lewis wrote that perhaps the movie could "be salvaged from its unfortunate position, re-cut and re-assembled for public appeal and sent on its money-making way". Ray went on to make a harsh attack on Ceal and her notorious interference: "I am opposed to belittling the efforts of the 'gentler sex' in protecting the interests of their 'weaker half', but, if reports are to be relied on, the woman in the case of *Carry on, Sergeant!* appears to be responsible for many of the unshowmanlike blunders which were made in connection with it."

The same magazine carried a two page article by Gordon Sparling. It pulled no punches and gave a blow-by-blow account of Bairnsfather's total inexperience and lack of qualifications for his various personal appointments, his expensive hiring and firing activities, the factions and frictions and the wild excesses of expenditure. However, Sparling loyally maintained that "the story of Canadian International Films was one of inexperience, bull-headedness and extravagance rather than of money grabbing or financial dishonesty".

These articles unleashed a tidal wave of reaction. Toronto newspapers took up the story and the failure of the film was gone over yet again.

On 13 February, the *Toronto Daily Star* carried a long article featuring an indignant letter from Bairnsfather in New York, protesting that he was being made the scapegoat for the film's failure, maintaining that he would welcome "a full inquiry in court on this question". Bairnsfather said he had "refrained from this exposure through a great period of time due to my honest and loyal desire to prevent a true analysis of events from reaching the public". But now he felt impelled to speak out to reveal the real truth. The letter was aggressively self-defensive and can have done little to re-establish his reputation. Obviously Bruce had not been able to find a North American equivalent of the loyal and protective Champness, who had dealt with his real and imagined grievances in Britain.

The Toronto *Telegram* also ran the story, printing extracts from Bairnsfather's communications object-

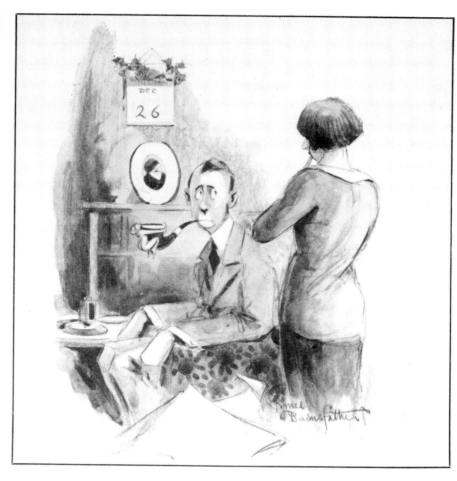

"*You'll have to keep it, darling, till after mother leaves.*"

The Swami says, dear, "Only our souls are real. Our bodies are purely imaginary."

Two untypical Bairnsfather cartoons from The Collected Works of Bruce Bairnsfather, *1931.*

ing to, "the monstrous and untruthful attack made upon me and my work and my reputation". Sparling replied in the same paper, claiming that Bairnsfather had merely "beclouded the very issue I tried to make clear". The indomitable Ray Lewis devoted a large part of her 23 February, 1929 issue to the dispute, giving it a full-page editorial. She also published "Startling and Sensational Revelations of Where Half a Million Dollars Went" in the form of a two page letter "from One Who Knows". It detailed the extraordinary salaries paid during the production.

"LIST OF EXTRAORDINARY SALARIES PAID DURING THE PRODUCTION OF 'CARRY ON, SERGEANT!'

The President's Salary Not Shown As He Was Not President During the Period of This Compilation.

E.P. Johnston – President $1,000 per month
W.F. Clarke – Vice-President .. 1,000 per month
B. Bairnsfather – Director ...500 per week
D. Bartlett – Assoc. Director 350 per week
(Terminated by payment of 2,100)
B.K. Johnston – Secretary ...100 per week
Miss Stahl – Continuity Girl 75 per week
R.H. Young – Private Sec'y 50 per week
 B. Bairnsfather
Jimmie Savo – Comedian 1,100 per week
Hugh Buckler – Sergeant400 per week
Niles Welch – Captain400 per week
Bert Cann – Cameraman300 per week
G. Best – Purchasing Agent .. 75 per week
Gordon Sparling – Art Department 75 per week
H. Hanley – Supt. Elect125 per week
W. Brotherhood – Supt. Laby 125 per week
B. Rothe – Art Director250 per week
J. Stricker – Supt. Carpenter 125 per week
C. Levine – 2nd Cameraman 66 per week
Various actors and actresses 175 to 50 per week
C. Elmer – Ass't Director125 per week
A. Orenbach – Propertyman 125 per week
B. Turey – Wardrobe125 per week
Asst Propertyman 60 per week
Grip 60 per week
Carpenter 66 per week
Negative Man 60 per week
Artist – Scene Painter125 per week
Six or eight Electricians ... 49.50 per week
 (With overtime would average $60 each)"

The salary that created the most comment and resentment was the $1,100 per week paid to Jimmy Savo – whose scenes mostly ended up on the cutting room floor.

Bairnsfather, it was claimed, had received a $90 a month car allowance, $50 for his private secretary whose fare from England had been paid for by the company (and who, after quarrelling with Bairnsfather remained as a clerk to the company) and a $50 per week salary for his chauffeur. The letter detailed a series of disagreements and rows between Bairnsfather, the directors and a succession of employees. It was the most direct attack on his incompetence ever launched. "Legal advice caused by friction between the management and Bairnsfather (Mr and Mrs) cost approximately $500," maintained the author of the anonymous letter, continuing: "How can any picture be a success when one man takes upon himself the following positions, contrary to the wishes of the then executives: Director, Supervising Director, Story Writer, Title Editor, Cutter. And this by a man without any previous experience."

"One Who Knows" goes on to describe the poisoned atmosphere, how Bruce wouldn't trust the company telephone and had his own private line installed and that "suspicion was everywhere, and everybody treated each other as a spy, for either one side (Johnston and Clarke) or for the other (Bairnsfather). Employees who were discharged by the President were immediately re-engaged by Bairnsfather . . . Many employees resented taking orders from a woman not an employee of the company, and it can honestly be stated that had not Mrs Bairnsfather interfered with the management there would have been more harmony, saving of time in the production and, naturally, a great saving of money". Ceal's role as the villain in the piece was becoming more and more apparent.

Nothing if not impartial, the *Digest* also published a two-page letter from Bruce. The letter started by Bruce justifying himself, "in face of the slanderous and untruthful attack that has been made upon me in an article . . . by one Gordon Sparling". It continues by belittling, in scathing terms, Sparling's importance and position on the film. Over and over in the explanation Bruce damns himself as the almost paranoic character that Sparling and "One Who Knows" hinted at in their letters. "During the long path that I had to follow through the subsequent mass of trouble, due to inefficiency and bad management," he claims, "I ceaselessly kept a watch as I had to do, on several people, as to their demeanour and deportment, and always had Mr Sparling under my surveillance, for I long suspected that he had leanings towards the supporting of a faction which was subsequently ejected from control." He had obviously anticipated a back-

lash, "for I luckily took precautions, as I waded through that horrible year, to get signed letters and affidavits from a variety of competent and loyal members of the Staff" – not the action of a confident and competent man in control of his subordinates. Bairnsfather countered each point raised in Sparling's letter, an important one being the question of the chief assistant director who according to Sparling, got "disgusted and left". Bruce's version was different: "The real story happens to be that, due to impertinence he was dismissed . . . and he happened also to be a man whom I had watched for a long time in order to find out which side his affiliations were taking."

The sad and sorry recriminations end with the statement that the company still owed him between six and seven thousand dollars and that "I have lost months of valuable time . . . and have had a great deal of damage done to my career and reputation. Since 1914, during the course of my career, I have never had such an outrageous state of affairs to deal with. I did not think that after my successful career that I had come to Canada in order to suffer as I have done."

There is little doubt that such public displays of self-pity and peevish suspicion by Bairnsfather himself did far more to damage a career that from now on assumed a downward trend, than any criticisms by his detractors.

The whole business, which ended so sordidly, was a tragedy of major proportions for Bairnsfather. It had been the biggest opportunity of his life – the chance to escape from Old Bill's grappling clutches, to make a milestone in film history, to create in a variety of challenging directions. And yet he failed, massively, to fulfil the confidence in him shown by the original enthusiastic backers, or to fulfil his own promise. For the first time people had found the man that so many had loved and admired, to be difficult, moody, suspicious almost to the point of abnormality – even downright impossible. Certainly over the years he had demonstrated an increasing tendency to suspect others and he had frequently rushed into print to accuse others or to defend himself against real or imagined wrongs. But never before had people with whom he had daily contact turned so resolutely against him. One explanation to the riddle could well be Ceal's influence. Never before had she played such an active and intrusive role in Bruce's work. He had credited her publicly before for her contributions, but these displays had stemmed from his remarkable loyalty to her. At Trenton she made a strong, physical impact, putting herself between Bruce and his staff, upsetting people by giving orders on her own nonexistent authority, stirring up suspicion between her husband and his employees and venting the full force of towering rages upon actors and technicians alike.

There is little doubt that she soured his relationships with many with whom he could otherwise have worked smoothly.

Bruce had not, after all, abandoned ambition in the film world. Plans were afoot to form a New York-based motion picture producing company. Bairnsfather prevailed upon Niles Welch, the young actor who had played the juvenile lead in *Carry on, Sergeant!* not to return to Hollywood, where he had notched up an impressive list of money-making films, but to stay and work with him in New York. This Niles did. It says a lot for Bruce's undeniable ability to cast people under the spell of his honest charm, for commonsense, experience and financial considerations must surely have told Niles to speed back on to Hollywood and pick up his acting career. Sadly nothing came of the venture, and Niles' widow later told Gordon Sparling that the decision to stay with Bairnsfather cost them "many more months of loss – after the 'dreadful affair' which had already taken a year of their lives and careers".

After a few weeks living in a hotel Bruce and Ceal took an apartment and studio. Bruce remembers it as being on Thirty-Eighth Street, but newspaper reports list it as at No. 18, East Forty-Eighth Street. He spent many evenings relaxing with congenial fellow members in the Players Club after working all day on his sketches. He was also contributing to *The New Yorker* at this time.

Barbara and her nanny moved with them, and the period at Trenton, when her father was preoccupied with business worries, and the following year in the New York apartment were the only two years she lived constantly with her parents as a child. She remembers frequent and amusing guests at the studio apartment. Sydney Blackmer the actor and Lenore Ulric his wife, star of *Lulu Belle*, *Kiki*, and other stage hits, were regular visitors as were the Coburns. Bruce developed a strong interest in magic and Barbara was often intrigued to see him pack all his magic props into his dinner jacket for club functions. He was "a wonderfully entertaining father". Together he and Barbara devised a levitation act and a snake charming act to amuse their guests. Weekends were spent at house parties in the beautiful Harmon district at the Blackmer's country home. Here the Bairnsfathers met a host of famous names in the film and stage world. One name that began to crop up more and more frequently in the Bairnsfather guest list at the studio was that of the famous English actress Constance Collier.

At the age of fifty, as she then was, Miss Collier was a world-famous actress with a wealth of experience in a career that already spanned forty-six years in the theatre. It is very likely that Bruce first saw her as a chorus girl when he haunted the music halls in Birm-

The actress, Constance Collier.

ingham, and later as they both toured the country – she in plays and he as a travelling salesman for Spencer's. Born in theatrical lodgings in Windsor in 1880, Laura Constance Hardie soon followed her Shakespearian actor parents on the stage, making her debut as a fairy in a production of *Midsummer Night's Dream*. By 1893 she was in the chorus of a light opera and became one of that glamorous breed, a "Gaiety Gal", which gave her experience and stagecraft that stood her in stead throughout her long and distinguished career. She progressed to small dramatic roles and studied in Paris under Coquelin, meeting Sarah Bernhardt. In 1902 she began a seven year association with Beerbohm Tree's company and her first Broadway success was in 1908 in *Samson*.

In 1915 D.W. Griffith brought her to Hollywood to appear in *Intolerance* and from then on, like Bairnsfather, she was equally at home on both sides of the Atlantic. Perhaps her best known American production was in Du Maurier's *Peter Ibbetsen*. She bought the rights to the play and put it on in New York with John and Lionel Barrymore. After *Peter Ibbetsen* she wrote several plays and published her autobiography *Harlequinade, The Story of a Life* in 1930. An extraordinary, versatile and capable woman, she was also gaining a reputation as a Hollywood film producer.

On 16 January, 1930 Constance had sailed into New York on the *Aquitania* with her director, Frank Vernon and her mascot Go-go, a small African monkey. She was to star in *The Matriarch* at the Princess Theatre, Chicago, following its successful nine-months' run at the Royalty Theatre in London. She had a powerful part which she played with strength and conviction. The play was as successful in Chicago as it had been in London, and in March it moved to the Longacre in New York.

Bruce and Constance began seeing a lot of each other when they were collaborating on a play. The work started in April and on 21 May, feeling neglected, Ceal took off for Europe on the understanding that Bruce would follow her in four or five weeks. Barbara was taken back to England to live with the Hon. Frederick and Lady Margaret Hamilton Russell. Eventually she would become their ward and live with them for nine years. Lady Margaret was Ceal's sister-in-law by her first marriage to the Hon. Michael Scott, and the two women had remained close.

According to contemporary newspaper reports, no sooner had Ceal sailed for England, than Bruce and Constance Collier set up home together at 222 West Fifty-Ninth Street, under the none-too-original assumed name of Mr and Mrs Bruce.

These months were a lyrical interlude for Bruce. The troubles at Trenton were behind him, some money was coming in from the *Judge* and *The New Yorker* pictures, and while in Europe he had also set up a contract with the English magazine *The Passing Show* to do regular strips and the occasional article. He earned $2,000 by writing the scenario of a short "talkie" and was approached by George Bye, a successful literary agent, to write two stories at $1,500 each. One was taken by *The American* and the other by the Curtis Press in Philadelphia. And he was without Ceal.

From a short time after their marriage onwards, her drinking habits, tantrums, over-protection and interference in his work had been a constant strain and burden on him, culminating in her performance at Trenton. Yet he had remained intensely loyal to her, trying to disguise the drinking, being patient, affectionate. It cannot have been easy to work under these conditions.

With the relaxed and mature Constance he found calm and inspiration. She was several years his senior but handsome in a dark and almost portly way.

But on 28 August, Ceal filed a suit against Constance Collier in the New York Supreme Court for alienation of her husband's affections. She claimed that Miss Collier had "maliciously enticed Mr Bairnsfather away from her". As she had suffered "great distress of mind and body" she proposed to sue Miss Collier for $100,000 – in those days a considerable fortune.

On Ceal's return to England, Bruce had written to Lady Margaret Hamilton Russell, explaining his conduct. "I have to have my imagination – and complete freedom. Domestic life, beautiful as it may be for those who can do it, is not for me, and poor Cecilia, much as she may try, is unable to understand that inner thing, which is me, and which I have to live by."

He followed this cry from the heart by a cable stating: "I have, after vast patience, come to an unavoidable decision which nothing can alter. The acceptance of the situation is better for all concerned. I regret to cause pain, but it is absolutely unavoidable and final." The decision was to leave Ceal. There is no doubt that the idea of causing pain was totally abhorrent to him, and that such a message could never have been sent lightly.

On 29 August Cecilia followed the alienation suit with a divorce suit, naming Constance Collier as co-respondent. Miss Collier, who had been served with the alienation suit as she was leaving a smart New York restaurant, denied the charges and proclaimed her intention to prove her innocence.

Who knows at this stage, nearly sixty years later, whether the affair was platonic or had been consummated. Unfaithfulness of mind and spirit had certainly occurred, and for the first time for ten years, Bruce felt free and able to create. His next action, however, was to apply to dismiss Ceal's divorce suit in October 1930. His grounds were that as neither he nor Ceal were residents of New York, the local courts had no jurisdiction over them. Ceal countered by giving evidence that his resignation from the London Garrick Club, and his joining of the New York Players' Club proved his New York residency. She claimed that they had both been resident in the United States since 1924 and in New York for the past five years. On 9 October the Supreme Court of Justice in New York ruled in her favour.

On 18 November Bairnsfather agreed to withdraw his appeal and the Supreme Court granted Ceal temporary alimony of £21 per week. This must have put a severe strain on his finances and possibly led to another long and gruelling lecture tour.

Ceal's next move was in December. She requested preference in the legal calendar for her divorce suit against Bruce and was refused. This decision may well have affected the remaining twenty-nine years of Bruce's life and his future artistic output.

1930 was ending on another down note for Bairnsfather. It had also been a traumatic year for another star, with whom he had worked as long ago as 1917, Edmée Dormeuil, who had played the estaminet girl in the stage version of *The Better 'Ole*. Like many attractive young actresses, she had married into the British aristocracy, becoming Lady Owen. By 1930 her businessman husband, Sir Theodore, had died and his attractive widow fell in love with her married doctor, a Monsieur Gastand of Versailles. On 23 July Edmée shot Gastand four times with a little revolver she had concealed in a silk scarf, and then calmly gave herself up to the police.

Bruce's problems were not solved in so dramatic a fashion. His loyalties were torn between his duty to his wife and daughter and his desperate need for the freedom to express his artistry. After a year of no income in Trenton, he had started to earn a respectable amount from his various contracts only to be forced to pay out a large part of what he was earning to Ceal. The lecture circuit took a tremendous toll out of him, both mentally and physically. But he had been offered a fee of $500, half of which went to his agent, Colston Leigh, half of which he kept, for one engagement at the Minneapolis Knife and Fork Club.

Bruce looked upon lecturing as "an ordeal" and had to do a tremendous amount of what we would today call psyching himself into his new role. For the content of the lecture he drew heavily on his vaudeville experience, using a combination of lantern slides, Old Bill stories and "chalk and talk" on a large easel. His old experience at Spencer's helped him to make his own props and gadgets. At his first engagement at the Knife and Fork Club in Minneapolis, he describes walking on stage "feeling like a large bundle of nerves held together by a suit". But the audience of four hundred loved him, and on the strength of his one success, the agency booked him for a season.

It was a very harsh winter, and his schedule was gruelling. The sequence of bookings sometimes caused him to back track on his route and he covered thousands of miles: Detroit – Pittsburg – Montreal – Detroit again – Buffalo – Cleveland; shows at military establishments such as Fort Leavenworth and West Point – always to big audiences (over two thousand in Pittsburgh for instance) and to a good reception. It must have been a tremendous boost to his wounded ego that he could still make people laugh, that they still wanted to see him. He certainly needed all the approval he could get to counteract the battering of the miles in trains and taxis, the lonely routine of solitary hotel rooms, and the nightmare of receptions. And all the while he had to find time to keep his drawings going for *Judge*, the *New Yorker* and the *Passing Show*. Luckily hardship seemed to conjure up his funniest ideas. He evolved a technique for

"Barbie" in a chess championship, 1932.

working in hotel rooms: he pulled out a long drawer from the chest, turned it upside down, then put it halfway back and used it as a drawing board, or desk.

Meanwhile Ceal's divorce proceedings were moving on. On 20 January, 1931 the hearing began in the New York Supreme Court.

Shortly after this the sheer exhaustion of the winter's lecture tour caused Bruce to have another breakdown and this time he went into hospital. Ceal later told the Press that she returned to America to visit him in hospital and "they rushed into each other's arms". In May she filed an application in the Supreme Court to discontinue divorce proceedings and returned to Europe. Had Ceal's request for preference in the legal calendar been granted in December, the divorce might have gone through, and the remainder of the Bairnsfather story might have been entirely different. From now on, a large part of this time and energy had to be devoted to looking after Ceal. It was a heavy burden.

On 21 May, Bruce embarked on the *Mauretania* in New York telling reporters that "his domestic affairs were straightened out and he was going to England to join his wife". His arrival, or rather, non-arrival, at the other end of the voyage caused much fluttering among the newsmen who had been waiting, pads poised, at Portsmouth. Bruce had sailed on to Cherbourg. He met Ceal in Paris and they spent a week together in the city they both loved, sipping their drinks outside their favourite Montparnasse café. Their differences patched up, or swept under the carpet, the question of where to live arose. It was basically a question of where they could afford. Again Lady Margaret Hamilton Russell stepped into the breach.

Lady Margaret was in many ways an exceptional woman. She drove her bright red car with panache, was a competent golfer and delighted in teaching her young ward Barbara the skills of archery. She and her husband spent the summer in residence at the family home in Crowbrough, moving for the season to their town house at Cambridge Gate, Regent's Park. During the summer months, it was Frederick's habit to drive down to Brighton every afternoon to play chess and Lady Margaret would take Barbara with her to her golf club at Piltdown where she had bought a row of four cottages opposite the club house. She built on to the end of the row, making a changing and relaxing room and created a pleasant garden around the cottages. At Piltdown Barbara made a close

friend of Olive Blunden (later Grinstead), the steward's daughter. They were kindred tomboys, preferring presents of Indian head-dresses and blankets to the elaborately dressed dolls created for them by Barbara's French governess. Their fantasies led them into the exciting world of cowboys and Indians and they referred to each other as Jim West and Buck Jones. It was as Buck and Jim that they set up a commercial venture they took very seriously – a market garden run from the cottage shed.

They had their own printed invoices and had to submit their accounts to Lady Margaret for auditing. Soon Buck and Jim, who specialised in lettuce, parsley and mint, had some new customers – Captain and Mrs Bairnsfather.

Lady Margaret put at their disposal one of her four cottages at Piltdown and here they made their base until Lady Margaret's death in 1937. In their garden was an old disused chapel which Bruce converted into a studio. The calm backwater at Piltdown, in lovely Sussex countryside, was like a haven after the turbulent Canadian and New York episodes. Here few people bothered Bruce, he even had a special window constructed in the studio so that he could spot visitors, and if they were not to his liking he could escape out of a rear window. At Piltdown he could unwind,

Jim West and Buck Jones – alias Barbie Bairnsfather (left) and Olive Blunden (right) and friends, early 1930's, at Piltdown.

potter in the cottage garden, secretly observing the golfers on the first green and eighteenth tee, and drawing golf cartoons for Mrs Blunden – one of which still hangs in the club house. And here he could really enjoy being a father, playing boisterous games with Barbara and her friend Olive.

But the interludes of peace at Piltdown were interrupted frequently by forays into the outside world. Bairnsfather was always conscious of the importance of keeping himself in the public eye, lest he and Old Bill should be forgotten and become unwanted.

On 24 July, 1931 Hannen Swaffer, a friend of Bairnsfather's, published in his column in the *Daily Herald*, a description of "Bruce Bairnsfather's new play, written while he was in New York". Perhaps it was the play he wrote in collaboration with Constance Collier. Certainly it would have been a surprising innovation to theatre-goers had it ever reached the stage, for it was a modernised version of the Messiah story – "A Christ-like being arrives in New York, heals the sick, performs miracles, befriends the poor, and finds himself attacked by modern Pharaohs". It was called "The Man in the Square", because the first miracle takes place in Union Square. After restoring sight to a blind woman, helping out in a mansion for down-and-outs, breathing life into a dying actress, The Man "disappears out of the life of the people, remembered only as 'The Man in the Square' ". The play was never performed.

In September the Bairnsfathers were back in New York, and Bruce was getting ready to embark on another lecture tour. On 13 September, the final formality in the dropping of divorce proceedings was reached when the case was removed from the docket of the local court. It was the end of an expensive episode, the details of which were to be revealed all too publicly later. At the Press conference that followed, Bruce posed with his arm round Ceal's shoulders vowing that they would "start all over again".

Another heavy lecture tour schedule awaited him and there would be five more during the thirties. He took breaks from the cold north where the lecture tour industry was mostly centred in those days, and had short holidays in California, Florida and Arizona. He always felt more at home in hotter climates and enjoyed citrus groves, and strange desert scenery, its solitariness appealing to his "loner" nature. One of his most exciting side trips while on tour was to the great observatory on Mount Wilson near Pasadena, where he stayed a whole day and night, studying the sky. The sheer magnitude of the universe he was able to observe so clearly, produced some predictable philosophical impressions about the insignificance of man. But his conclusion that people were "juicy little unfilleted lumps, with all their illnesses, accidents, wars, famines, and some snob-

bish little idea about civilisation" was stated with characteristic wit – as was his summing-up of his brush with astronomy – "It had given me a bad attack of the smalls".

Bairnsfather felt he needed some new experiences and sensations to stimulate his creative ideas. He hit on the idea of a world tour. This would surely provide enough material for a whole series of pictures, articles and lectures. His agent was enthusiastic about the idea, seeing potential for several more tours from this successful client. He helped Bairnsfather to arrange his American schedule so that he finished up in California, ready to sail to the Orient on the first leg of the tour.

The travel arrangements were a triumph of plotting and planning. Ceal was to accompany him, but he could not afford their combined fare around the world. First he negotiated a deal with the N.Y.K. Japanese Line that, in return for the publicity of his voyage and an article with drawings for their magazine *Japan*, they would give him two first-class passages from San Pedro, California, to London. He also agreed to write a book on his experiences for Hutchinson and probably received a substantial amount in advance royalties, which subsidised the trip.

The negotiations had been difficult, the planning, complicated and wearing. Add to this the extra workload he took on in order to earn his way, lecture by lecture, to their port of embarkation and it is no surprise that Bruce arrived in Los Angeles in a state of near collapse. He also had a recurrence of the painful mastoid trouble that was a legacy of his shell shock, and was in no fit state for a strenuous world tour.

However, the California sun was warm and therapeutic and, as always, he flourished in the heat, spending a restful fortnight in Los Angeles.

Bruce was extremely excited about this trip. Despite his fear of sea sickness, he adored travelling. It also promised so much on the personal front – a chance of a "second honeymoon" in first-class berths on the ultimate in cruise ships, the *Chichibu Maru*; relief from the pressure of touring and personal experiences; a chance to forget financial worries and, above all, an opportunity to recharge his creative batteries. Sadly he would return home to a new, even deeper, sea of troubles.

The Bairnsfathers set sail in the spring of 1932. Ceal enjoyed the luxury of their passage and the VIP treatment they received. Bruce probably preferred to chat with the crew. Their first stop was San Francisco, and they were given the "full treatment" of a Press conference on board ship, followed by a Press lunch on shore. Then they set off on their voyage – next stop Hawaii.

Happily it was a gloriously smooth crossing, and

Attempt at a second honeymoon on the Chichibu Maru. *Cecilia Bairnsfather, 1932.*

Bairnsfather actually enjoyed the voyage. With his usual sensitivity, he was conscious of the phoniness and stagey-ness of Honolulu. He intuitively foresaw the over-commercialisation that would develop.

Japan was their next port of call, and the sheer beauty of Yokohama Bay and Fujiyama, which Bairnsfather saw in terms of "a Japanese painting on silk", impressed him a great deal. So, too, did the reception he got in Japan. For many years after, Bairnsfather would recall with pleasure, and even amazement, the enthusiastic and affectionate welcome that he and Old Bill received. He was immediately commissioned to draw a series of Old Bill cartoons for a Japanese newspaper, and was fêted and guided, with Japanese thoroughness and courtesy, through a host of sights and experiences, from

wrestling (which he thoroughly enjoyed) to geishas, and the music of the *samisen* which he grew to love. Japan had been an ally in the First World War and Bruce's work would inevitably have been seen and appreciated by the Japanese – as it was by the French, the Italians and the Americans. The pure and simple lines of Japanese art and the skill of Japanese craftsmanship appealed enormously to Bairnsfather. His own drawings were rapturously received. As he moved on to China, requests from the newspaper *Jiji Shimpo* followed him – "We want twenty more sketches".

At Shanghai Bairnsfather felt compelled to visit the battlefields of the recent Sino-Japanese conflict at Chapei and Woo Sing, whose desolation reminded him of the Ypres Salient. The poverty, squalor and general hopelessness of China touched him deeply – more so than the similar conditions he was soon to see again in India.

In Hong Kong, the humidity and heat proved overwhelming for Ceal and from then till they reached the freshness of the Mediterranean, Bruce embarked on all sightseeing expeditions alone. This let him indulge his curiosity and love of the bizarre to its full extent. The irksome task of a radio interview in Hong Kong soon over with, he explored bazaars, opium and gambling dens, photographed pythons and hamadryads in Macao and Singapore, Johore and Penang, and at last reached the ultimate object of his pilgrimage – India.

Bruce had been longing to revisit India, to hear again the once familiar accents of Hindustani, to watch the fakirs and snake charmers, to see the beautiful temples to Siva and Vishnu. What he saw in 1932 dismayed him: electric fans instead of punkahs, speedways instead of jungle paths and, horror of horrors, guided parties of tourists. "The advent of gasoline", he philosophised, "electricity, excessive

tourists, motion pictures, and so-called 'awakening' has done its best to kick all the stuffing out of Kipling's wonderful India. What was once a country tinted with the glamour of the Arabian Nights, is now in that dull, grey phase brought about by the importation of all the above-mentioned poisons". Or had Bruce merely changed the rose-coloured spectacles of nostalgic childhood recollections for the reality of acute adult observation? Certainly, despite his independence, his flouting of class and family tradition, his championing of the working class, the spirit of the sahib in the heyday of the Raj still had a small place in his make-up, as is evident in the comments he made after his tour. At the end of his long journey through the Orient, he sensed everywhere he had visited, a spirit of changing attitudes and latent unrest: ". . . the coloured people of the East, en masse, have less awe and respect for the white population. It almost seems as if, at last, familiarity had bred contempt. They have heard their leaders and agitators talk and have been annoyed to see them allowed to go on doing so. Nobody can take a yard quicker if you give them an inch, than the natives of India. The question is: 'Have we arrived at the age when everyone *should* have yards?'." He saw change, too, on the other side of the fence. "Good old General Sir Pepperton Chutney V.C., D.C.O. with his bronzed face, tradition,

"Cross Section of the Awakening East".

fever, tiger-shooting, mess kit and, 'when I was in Madras – 'eighty five', vocabulary seems to have become extinct. His place has been taken by a less colourful but possibly more learned officer.''

The oppressive heat and humidity of Aden, Suez and Port Said proved too much even for Bairnsfather. He rechristened their ship (the *Suwa Maru* in which they had sailed from Japan) the SS *Oven*, and was as delighted as Ceal to sail into the Mediterranean. They called at Naples and finally disembarked at Marseilles, travelling to Paris on the night train. Here they stopped off to see their favourite haunts in Montparnesse and to recover from their long voyage.

It was now June. The Bairnsfathers returned to their haven at Piltdown, intending to complete their world trip by going on to New York for the lecture tour Bruce was committed to in the autumn. Bruce spent the next few months working hard on the material he had amassed during the tour, writing his book *Laughing through the Orient*, preparing his forthcoming "show", contributing his strip to the *Passing Show* and articles and sketches to the occasional national newspaper. For relaxation he taught Barbara and Olive the art of Japanese wrestling, and did extensive alterations on the studio. Bairnsfather was always a talented and capable handyman, but he also put his more artistic talents into his homemaking, delighting in *trompe-l'oeil* murals. In the cottage at Piltdown he painted an enormous Willow Pattern plate on an entire wall, the centre of which depicted the view from the cottage window.

On 1 August he published a major article in the *Daily Herald*, entitled "Old Bill Comes Back". It was inspired by the erection of the massive war memorial at Thiepval in France which bore the names of the 73,077 British soldiers with no known graves who

Old Bill, looking like the publicity photographs of Arthur Bourchier in the stage play of The Better 'Ole, *goes on show as a waxwork in Madame Tussaud's, 1930. By courtesy of Madame Tussaud's, London.*

gave their lives on the Somme. It also commemorated the 200,000 soldiers of all nations who had died fighting to gain the hill on which the memorial was built, the site of a heavily fortified château. The Prince of Wales unveiled the gigantic memorial that day, and in the article Old Bill and the Captain discuss, in alternating bitter and sentimental moods, their attitude to war memorials in general. Bairnsfather once again used the device of a dialogue between "the Capting" and Old Bill to give stronger vent to his own opinions than he felt able to do when speaking solely as himself. In many ways Old Bill was an extension of his personality, in much the same way that a dummy often becomes the embodiment of one particular facet of his ventriloquist creator. Between them Old Bill and the Capting were able to say in no uncertain terms that they felt that the true war memorials were the maimed soldiers who still inhabited the many war hospitals throughout Britain. They also felt that if a soldier had known that his reward (if he survived) or compensation (if he died) for enduring the horrors of the Great War, was to be an impressive structure of brick and stone, it would not have been sufficient motivation for joining, or continuing to endure, the fearful conflict.

They were expressing the feelings of the great majority of the war veterans. Industrial unrest, unemployment, a total lack of understanding, gratitude or remembrance by those who had been civilians during the fighting were all adding fuel to the fires of discontent and bitterness. In November of that year of 1931, a veteran of the Boer War and the First World War, named, by extraordinary coincidence, William Busby, made a dramatic gesture in reaction to the country's apathy. He laid his campaign medals on the South African War Memorial in his home town of Leicester, saying: "The country has forgotten me. I have no further use for these." He went on to explain his action. "I feel that my country has not done what it might for ex-Servicemen. I am registering what may be a humble protest." Busby had certainly served his country faithfully. He had joined the Leicestershire Regiment in 1897 served with the Royal Warwicks in South Africa, and then had joined the Royal Welch Fusiliers in 1914, later taking part in the battle of the Somme.

William Busby claimed to have been employed by Bairnsfather as a model, and was generally known as Old Bill. This was a very widely made claim, but Busby's feelings about the attitude of his country to old soldiers like himself mirrored exactly the feelings of Bruce Bairnsfather and Old Bill as published in the *Daily Herald* article of 1 August.

Later that month, as the summer in which Bruce Bairnsfather had enjoyed so many happy hours at Piltdown drew to an end, another huge financial blow hit him.

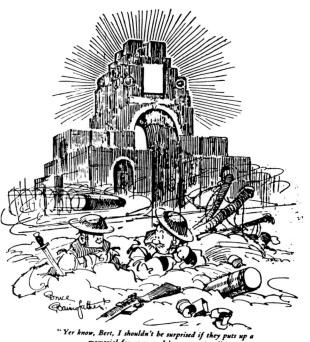

" Yer know, Bert, I shouldn't be surprised if they puts up a memorial for us around 'ere some time "

Chapter 12

Bankruptcy Looms

(1932–1934)

Though pleasurable, the summer months had produced little or no income. Now the cumulative effect of his unbusinesslike ventures, his huge investments and the unfavourable terms of many of his contracts over the last ten years became apparent. The *London Gazette* of 23 August, 1932 carried a small item to the effect that a bankruptcy notice had been issued against Captain Bruce Bairnsfather, described as "a domiciled Englishman of 18 East 48th Street, Manhattan, New York, journalist". The notice was issued "at the instance of William Henry Cork, trustee of the property of Moss Freeman, of East Cheap, E.C., accountant and auditor".

This affair hung over Bairnsfather's head for the next two years. First he was forced, for non-payment of his dues and because of his status as a prospective bankrupt, to give up his membership of the Garrick which he had re-joined on his return from America. The shame must have been hard for Ceal to bear, too, but now she had irrevocably cast in her lot with Bruce as he had with her. Happily, one problem was solved by the generosity of Lady Margaret Hamilton Russell, who continued to house and bring up Barbara. Frederick even set up a trust fund for her.

Bruce reacted in a curious way to the bankruptcy notice. It had been served by Cork for persistent non-payment (over several years) of a small debt. It is quite likely that the notice had been served merely as a device to force payment of a pesky but unimportant nuisance. Payment of it might well have averted the complete financial disaster of bankruptcy. Yet Bruce went to extraordinary lengths to avoid being confronted with Cork's demand for payment. Attempts to find him in London failed, and as a New York address had been given in the *London Gazette*, the search moved across the Atlantic. There, too, no trace could be found of the elusive debtor, and on 27 August his New York club, the Players, announced that it was holding a large bundle of mail for Captain Bairnsfather. It had no idea when he would be returning to New York and stated that it had last heard from him three weeks ago in India! This was either a loyal smokescreen or a blatant inaccuracy, as it was three months since he had been in India. The British Press decided he had gone to Paris. It is more probable that he had gone to ground at Piltdown. Wherever he was, his hiding out had the effect of allowing bankruptcy proceedings to grind on, with all the ensuing unpleasant publicity about his sad financial affairs.

In a couple of months the excitement had died down and Bruce and Ceal sailed for New York. Ceal based herself in New York whilst Bruce embarked on an eight-thousand-mile tour of thirty-five cities, using the new material he had gleaned on his Oriental journey. The long engagement over, he again returned to England with a contract for a further tour in his pocket.

1933 started on an apparently high note. *Laughing through the Orient* was published in March. It received good reviews, with phrases such as "packed with drollery" and "the whole narrative, with details of the trip, is inimitable". The book is a curious mixture of bad and good. The passages which are pure travelogue are extremely well done. They show the author's acute powers of observation and are liberally sprinkled with the entertaining turns of phrase he could often produce. However the sections where he introduced Old Bill into this complex, multi-coloured backcloth in an attempt to maintain his status as a "humorist" seem strained. The book ends with a curious little epilogue in which Bairnsfather describes the incredible lengths to which people will go to avoid looking at others' photograph albums of their travels. Sadly, the public took a similar attitude towards *Laughing through the Orient* and not enough copies sold to give him any royalties.

March also brought a humiliating blow. On 27 March he was dropped from membership of the

Bruce Bairnsfather on stage doing his "Chalk and Talk" act.

The cover of Laughing Through the Orient, *1933.*

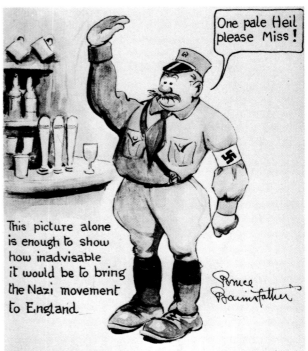

Bairnsfather's comments on Hitler Youth from Old Bill Looks at Europe, *1935. A version of this cartoon also appeared in the* Daily Express *two years previously.*

Players Club in New York. Bruce's membership had given him much pleasure, and made many friends for him. Doubtless the publicity given to his financial affairs was the reason, and the Players was following the Garrick's lead.

Then came an interesting project that involved travel. Bairnsfather was commissioned by his friend Beverley Baxter to do a series of articles for the *Daily Express*. He made a fascinating trip through Germany and on into Russia. In Berlin he was invited to a stag party given by "one of Herr Hitler's closest friends". To his disappointment Hitler, though expected, did not appear. But Bairnsfather was compensated by getting a close look at "the individual who has emerged from obscurity and battled his way up to the proud position of Public Headache No.1", the next day. The sensitive and observant Bairnsfather made "a close and careful survey" of Hitler as he reviewed his Nazi bodyguard outside the Rathaus in Berlin where he ceremoniously signed the city's

"Golden Book". Bruce picked up strong vibrations of "frenzied force" and, to use the 1930s word for sex appeal, "a lot of IT". He saw Hitler as a "male Jeanne d'Arc", a fanatic who, in his own misguided ways, was totally sincere. Bruce sensed the hypnotic power that could develop into a source of evil, while admiring the single-minded drive and ability to achieve. The slanting hair line and paint brush moustache which made Hitler so eminently caricaturable left a strong impression on Bruce, and he was, for many years to come, to draw striking and accurate cartoons of the Fuehrer.

It was another disappointment to Bairnsfather that when in Russia he didn't manage to see Stalin. He was given ample opportunity to study Stalin's face, however, from the omnipresence of posters bearing his distinctive features. Bairnsfather was obsessed with the paradox of the benignity of Stalin's smiling mouth and crinkled, twinkling eyes, and the monstrosity of his power. As with Hitler, Stalin was to become part of Bairnsfather's cartoon repertoire, and a very able and accurate caricaturist he proved to be. On the whole Russia depressed and bored him. The model factories, the co-operative schemes, the modern buildings – all left him cold. He only came alive when he was allowed to wander through the grand palaces of Russia's Imperialist past, imagining

THAT O.G.P.U. FEELING

"That OGPU Feeling", from Old Bill Looks at Europe.

how it would have felt to be the Tsar – or even Rasputin.

The articles he had been commissioned to write for the *Daily Express* reporting on this extensive trip appeared in the paper starting Monday 29 May, 1933. Saturday's *Express* described the "feast of humour, description and philosophy" to come from Old Bill's fact-finding tour and prophesied: "There will be an enormous demand for Monday's Daily Express."

Bruce Bairnsfather did not have the confidence to travel without Old Bill. The concept and style of the six articles were similar to the construction of *Laughing through the Orient* and had similar results. There were patches of strained humour, where Old Bill strove to be the amusing old cove he had been throughout the Great War, interspersed with passages where Bairnsfather's intuitive perception and sincerity were allowed to peep through. There was much homespun philosophising between the Capting and Old Bill. The latter, when asked by the Capting what he thought about the situation in Germany, with Hitler, Nazis, "and all that sort of thing", and the chances of another war, commented: "Wars is like hiccoughs; they sometimes come on again when yer thinks they're over." Together they set out to examine the upsurge of Nazism. They noticed the proliferation of brown shirts, of swastikas, of general love of uniform and militarism spreading everywhere. Though Old Bill is allowed to reminisce with and be sympathetic to a Kamerad he had fought against in the Ypres Salient, name of Muller, Bruce and Bill form the joint impression of rising and organised Nazism, which they instinctively fear and mistrust. Bairnsfather saw the ill feeling expressed towards minority groups, and the Capting warns Old Bill to conform, to learn how to make an impressive Heil Hitler salute, swastika on his armband, lest he be taken "for a Communist". Throughout Germany (as he was also to find throughout Russia) Bairnsfather had the distinct impression that the walls had ears, and that free expression of one's feelings was an extremely dangerous indulgence.

In the sixth and final article in the series, published in Saturday 3 June, 1933, Bairnsfather allows himself to escape from Old Bill's stranglehold and to express his own opinions of "the mess" in summary. He opined that the English should limit themselves to spectating European "rows" from the sidelines as they would any other sporting fixtures; that the French should firmly resist all requests to disarm and that the Germans should feel proud of their progress and growing strength. Simplistic opinions, perhaps, but his assessments of the potential dangers of Hitler and Stalin and rising nationalism were far-seeing and exact. He seemed torn, however, between a grudging admiration for the achievements of the two regimes he had examined and a strong fear that their very success could lead Hitler and Stalin to attempt to impose their dangerous doctrines on their neighbours. While acknowledging the magnetic appeal of the two leaders, their charisma, he sensed in their increasing power the seeds of the Second World War. The articles were well received by *Daily Express* readers. "Captain Bairnsfather's admirable articles recall the glorious days when Old Bill was a power in the land. We could do with more of the Old Bill spirit today," wrote one on 31 May.

Throughout the summer, Bairnsfather continued to contribute to the *Passing Show*. Williamson the editor, and his wife, became personal friends of Ceal and Bruce. Another friend was also a regular contributor to the magazine at this period – Hannen Swaffer. Perhaps with Bruce in mind, Swaffer wrote an article in the 22 July edition in which he discussed the prevailing personal misery of most humorists. "Abysmal gloom seems to be the inevitable accompaniment of all creative humour," he wrote, and even more pertinent to one of Bruce's failings, "I know many humorists . . . often they go round accusing each other of stealing ideas".

Passing Show in the early 1930s was a bright, lively and light-hearted magazine. Its attractive, full-colour cover illustration was drawn by Gilbert Wilkinson. His style was very akin to a British Rockwell – with wholesome, appealing children, young couples and grandparents. Owned by Odhams, and allied to the *Daily Herald*, the magazine carried articles by and about popular figures of the day: Evelyn Waugh, Bunny Austin, Ritchie Calder, Will Scott, Douglas Jardine, Ashley Sterne. It had competitions and special offers, and a large number of cartoons, by Frank Ford, Wilson Fenning, "Dee", Nate Collier, Norman Kay, Stan Terry, Frank Whitburn, George Whitelaw, Seymour Hurley, A.C. Barrett and others. Many of them were staff artists for the Odhams group, and on a Friday night, after they had their weekly pay packets, they would gather for a booze up and gossip in the little pub in Maiden Lane opposite Rules. It was run by Clinton Davies, the actor who had followed Bairnsfather into his hospital bed at Rouen and who later played one of the villains in *Old Bill MP*. So his ears naturally pricked up when he heard the name Bairnsfather discussed. The consensus of opinion was that Bruce could only, when it came down to it, do Old Bill. At that period Bairnsfather's contribution was far removed from his *Fragments* work. It varied from full length illustrated articles to a single drawing. On Bruce's return from the tour through Germany and Russia he again visited the States, and enjoyed the new experience of broadcasting on commercial radio. He wrote an article for *Passing Show* highlighting the difference between the BBC type of

"The Great Teas Industry". Bairnsfather's social comment in The Passing Show, *August 26 1933.*

radio and the commercialism of American broadcasting – where advertising intruded into cultural programmes. Other contributions Bruce made to *Passing Show* gave sincerely felt, sharp social comments on the tea industry, the commercialisation of rural villages, gangsterism, or the pollution of English beauty spots. Looking back, it would appear that the Odhams' artists' pronounced opinion was somewhat harsh. It is interesting, however, that in later *Passing Shows*, Bairnsfather reverted to producing an Old Bill feature again – a strip illustrating the adventures of Old Bill and Bert. Perhaps Williamson agreed with his staff artists' views. Bairnsfather was also writing for *Passing Show's* sister newspaper, the *Daily Herald*. From 14 June, Bruce (in the shape of Old Bill and Bert) was the "very Special Correspondent" at the Economic Conference, and he had a major article published on 4 August, the nineteenth anniversary of Britain's entry into the Great War. Bairnsfather, looking at the world-wide situation, wondered whether he "was listening properly when they blew the whistle in 1918". He feared the imminent outbreak of another world war, and reviewed the general political climate in a fairly serious light. The article then launches disappointingly into a re-hash of an idea already published elsewhere. It was the idea of a blueprint for a future war, first promulgated in *The Bairnsfather Case* in 1920.

The European trip was quickly followed by yet another American tour. As soon as he returned home he plunged into a music hall tour. The only consolation to Bruce was that his act on the halls was only fifteen minutes compared to the hour and fifteen minutes for the average lecture. For the twenty-five weeks of the tour he lived the tough life of a variety artist struggling to earn his billing. No longer did he automatically qualify for star treatment. He did twelve shows a week, travelled on each Sunday and stayed in sleazy theatrical digs: a far cry from the Ritz of 1919. It was a routine he was to follow, as often as he could get bookings, for the next four years. He usually managed second billing, with a fee of £30–£40. The quarter of an hour act consisted of a mixture of comedy patter and sketches and had a fairly good reception from his audience. In different parts of the country, he, like hundreds of professional artistes of the period, was able to do the same act month after month after month. Naturally Bruce did Old Bill over and over again.

In October the results of his irresponsible action in not paying the insignificant debt owed to Moss Freeman, rebounded unpleasantly. The *London Gazette* of 10 October announced that a receiving order had been made on "a creditor's petition against Captain Bruce Bairnsfather". The first meeting was fixed for 19 October at the infamous Bankruptcy Buildings, and the public examination for 6 December in the same place. Bruce was in Carey Street.

He reacted according to the pattern he had set in previous times of stress. He went to ground. The *London Gazette* described him as "late of Piltdown, Sussex, but whose present residence or place of business the petitioning creditor is unable to acertain".

For Ceal and Bruce the parading of Bruce's financial inadequacy in public must have been very hard to bear. Bruce took a fierce but endearing pride in his success. He was always anxious to present the picture of a famous man with more work on his plate than he could cope with.

About this time Bairnsfather loved to relate how he spent about £300 a year (a colossal sum in those days, especially when measured against his income) in answering fan mail and returning autograph books from all parts of the globe. A typical Bairnsfather autograph of this period shows Bruce in distinguished company – George Robey and Billy Bennett and on the next page, Montgomery, Marie Tempest, John Mills – with whom his name would again be linked – and a host of other stars of the stage, sports and arts.

Nowhere in his autobiography of 1939 does Bruce breathe a hint of the bankruptcy proceedings. But the newspapers of 20 October, 1933 made sure that everyone who was at all interested knew and the first meeting of creditors held on the 19th was widely reported. The senior assistant official receiver gave his report on the debtor's statement of affairs. This showed unsecured liabilities of £14,286, which included an income tax claim for £9,380. Against this massive figure were the pitiful assets of, "cash in hand £105, royalties estimated to produce £200, 10 original sketches £50 and a number of other sketches". The saddest statement was that of "10 original sketches

Typical Bairnsfather signature in a 1930's autograph book.

£50''. It was clear proof of his fall from fame, for in 1918 his sketches were fetching 100 guineas, while in 1917 he had hit an all-time high of 225 guineas for his picture of a Canadian at Vimy Ridge. In his autobiography he was to claim having received double that amount for a picture.

The report went on to blow more holes in the myths of Bairnsfather's success and enormous earnings. His name had become such a household word throughout the English-speaking world in the years from 1915 to the mid-twenties that everyone assumed that he was earning a fortune. Now the Receiver revealed that *Old Bill MP* was "a failure from the financial point of view and he (Bairnsfather) lost the money he invested. He was forced to sell his house at a heavy loss and he then went on a music hall tour in England and America earning just sufficient to maintain himself and his family".

As if that wasn't revelation enough, the losses of *Ullo*, otherwise known as *Carry on, Sergeant!* were then explicitly reported: how Bairnsfather bore the brunt of the loss, raising money on a reversion and borrowing £1,000 from friends. Bairnsfather stated that he earned a weekly salary of 21 guineas (which was probably for his weekly contribution to the *Passing Show*) but had no contract for this engagement.

Bairnsfather volunteered to set aside £25 a month for his creditors. Even the solicitor representing them, Mr. J.W. Goldman, of Messrs. Isadore Goldman & Son, regarded this offer as "very honourable and handsome. It reflected the greatest credit on the debtor, who but for the enormous amount of the income tax demand would not have been forced into the Court".

When asked by the court when his earnings had justified such a high tax assessment, Bairnsfather replied that it was during the years 1917–1919, the period of the stage play, *The Better 'Ole*, and that he had not appealed as he was in America for part of the time. It was a typically unbusinesslike statement. The public examination which followed on 6 December showed that Bairnsfather had only earned £3,000 in royalties from *The Better 'Ole* (it was, of course, the promoter, C.B. Cochran who really made the fortune from the play – though Bruce had earlier estimated his earnings at only £2,000). Some very different facts and figures were given at this sitting of the Bankruptcy Court to those reported in October.

Bairnsfather's liabilities were now set at £18,131, with his £155 of assets being absorbed in the preferential claim for taxes. The terms of his 1919 contract with *The Bystander* were described as, "to draw sketches and edit a paper at a salary of £3,000 a year". He actually drew this amount for two years, and as shown above, he earned £3,000 from *The Better 'Ole* at about this time. But £9,000 of earnings would not qualify him for £9,380 of taxes – or even super-taxes – a fact which was not picked up and examined by the Bankruptcy Court. At the 6 December examination it was revealed that he lost £8,000 plus, on *Ullo*. But perhaps the most hurtful revelation was that Bairnsfather had, "long periods without employment". Heavy travelling and advertising costs and expenses, the disputed tax claims, the lack of regular work and the draining losses of *Ullo* were jointly blamed for Bruce's insolvency.

As was his wont, Bairnsfather turned to Old Bill for help.

One's best friends

Chapter 13

New Variations on an Old Theme

(1934–1938)

The next five years were a period of struggle. There were no new exciting projects and Bruce had to work hard to get the assignments he did. There is no doubt that his charm and good humour earned him work from people who knew him personally – as his acquaintance with Beverley Baxter of the *Express* and Mr Williamson of *Passing Show* had worked to his advantage in 1933.

A new way of getting his work before an appreciative public emerged in 1934, but it was one from which he chose to make little, if any, profit. This was the year he started his close liaison with the Royal British Legion, of which he also became a member (a tremendous boost in itself to recruiting).

The British Legion had been formed in 1921 to promote the interests of ex-Servicemen. In February 1934 Old Bill, the most famous ex-Serviceman of the Great War, formally joined the Royal British Legion, and to celebrate the event, Captain Bairnsfather designed a British Legion postcard with the caption, "I've joined the British Legion. Have you?" It was a portrait of Old Bill, plainly sporting a British Legion badge. The postcards sold for one shilling a dozen post free and were printed at the British Legion Village.

The Captain followed up with one of his many "How Old Bill Was Born" articles in the February edition of the journal. To explain his genesis, Bairnsfather took his experienced readers back to the Plugstreet Wood area, to the days of improvisation and ingenuity, "before the war was placed on a business footing" – and even further back – to his days as a wireman's assistant in the Birmingham area.

The same story of Old Bill's birth was reported in the *Sunday Dispatch* that month and Bairnsfather's continuing popularity was demonstrated by the fact that a new snack bar in Edgware was christened "The Better 'Ole". Strube, the *Daily Express* resident cartoonist, did a cartoon on 22 February which showed

Bairnsfather's recruiting poster/postcard for the Royal British Legion.

Old Bill holding a lowered British Legion standard and comforting a soldier. It acknowledged "Captain Bairnsfather's famous war character". The public in general, and Old Bill look-alikes in particular, refused to believe there had been no real model for the most famous soldier in the world. This was demonstrated by an article in the *Morning Post* headed, "Ole Bill, Bairnsfather's Friend Still Hale and Hearty'. It featured an interview with a Mr Merrigan: "Ole Bill". Merrigan, a veteran of three wars, Bengal, South Africa and the Great War, referred to his friend Captain Bairnsfather who "found him on the Norfolk coast". At sixty-eight he was described as not having a grey hair on his head, a hard worker in a foundry, and a keen eater, drinker and dominoes player, and was interviewed in the Wheelwright's Arms in Croydon. Merrigan perpetuated the myth of his kinship to Old Bill until he died.

From March, Bairnsfather started a monthly series of original cartoons for the *British Legion Journal* which he entitled "The New Fragments". The first one, "Leaves from Old Bill's memory book" was set in the trenches – it showed Old Bill and Bert in a trench, water up to their chests, being castigated by a sergeant, "Hey, where's that corrugated iron I told yer to bring up? You're not out 'ere just to 'ave a good time yer know". For the rest of the year the First World War theme continued to dominate, interspersed with the occasional post-war Old Bill, as in July 1934 when he comments to young Cyril, who is watching some guardsmen march by, "No Cyril, I don't really know what soldiers is for now-a-days, except they looks nice around the place". In November, Armistice anniversary month, there is a typical Old Bill and Bert *Fragment*, "How the end came to Old Bill". The old codger, casually toasting some bread skewered on his bayonet over his brazier, remarks, "I 'ear as 'ow peace 'as broken out, Bert".

As well as the monthly cartoons, Bairnsfather contributed more articles to the *British Legion Journal* and also took an active part in Legion recruiting. In April he visited the Weston branch, gave a talk and did some Old Bill sketches which were auctioned for Legion funds.

On 13 April he visited the Northampton branch for a "Dug-out night". There was a grand turn out to meet him – five hundred legionnaires, including Sir

Showcard/poster for Adkins Nutbrown Tobacco. June 1934.

A "rough" for a Payne's tea advertisement.

John Brown, the National Chairman – a very convincing Old Bill, complete with inevitable walrus moustache and rum jar.

The June magazine carried Bairnsfather's ad for Adkin's Empire Nut Brown tobacco. It shows a splendid Old Bill, but with very chunky fingers – proof that Bairnsfather still found hands difficult to draw, as he had back in the Bishopton days when he had to call on parlourmaid Rhoda for help.

July's Journal published a long article by Bairnsfather on "Mental Disarmament" with an original sketch by him on each of three pages. Fears of another war were making the news, and Bairnsfather starts in serious vein, incredulous that after the horrors of the last war another one could be even contemplated so soon. He felt the reason was that "nations and most of the individuals composing them, are not mentally disarmed . . . metaphorically speaking (they) turn up at conferences like a lot of rival gangsters, place empty revolvers on the table as a gesture of peace and good will, but have hands in their pockets fingering the trigger of others loaded in every chamber. Until the world is mentally disarmed this 'no more war' business will really get nowhere. All that will happen is that the most disarmed nation will have to catch up in a hurry when the next row starts".

Bruce took an active interest in current affairs, had strong opinions, and was not afraid of expressing them. There is little doubt that had the magazine *Fragments*, which he edited in 1919 and 1920, continued, he could have developed into a highly competent journalist. Honesty was one of his qualities, and he finishes this particular article with candour. "After all the experiences culled in that last Big Row, the question is, How do I stand now? Am I a total and confirmed pacifist? Am I purified from all forms of bellicosity? The Answer is no, and while things are as they are I don't think I should be. As long as there is the faintest idea that we might be invaded, or any part of our Imperial property attacked, I am sure I shall behave in just the same way, all over again."

On 10 August Bruce gave an illustrated entertainment at the Tunbridge Wells Opera House in aid of the Tunbridge Wells branch. He made £125 for their funds and, reporting the event in September's issue, the editor proclaims: "England owes Bruce Bairnsfather a good deal more than its leaders have yet recognised for the smiles and laughter he raised in the trenches and dugouts of the Great War." The same issue carried a feature on "The Songs We Sang" by W.L. Day, illustrated by Bairnsfather, with Old Bill, Bert and Alf singing their hearts out.

October 1934 brought some relief in Bruce's financial affairs. His bankruptcy was discharged, but not before the newspapers had splashed his inadequacies in their columns once again with slight variations in the sums involved. The heavy costs of Ceal's divorce petition, about £1,200, were, for the first time, added to the list of contributory factors to his insolvency – together with "lack of remunerative employment, heavy costs of income tax and super tax" and the £8,000 loss of *Ullo*. It was also reported that Bruce had proved to be "a gold mine" for the newspapers he worked for during the war. It was a pitiful indictment on his lack of business acumen. As always, however, his sincerity and likable personality impressed officials both on the prosecution and defence sides, Mr J.W. Goldman, appearing for the creditor, Mr Fincham, again repeated his admiration for Bruce's good intentions and integrity and said that owing to the general conduct of Captain Bairnsfather, the trustee would be pleased if only a short suspension of the discharge was imposed. When the receiving order was made the debtor announced his intention of paying as much as possible to his creditors, and through solicitors he entered into an agreement to pay a minimum of £20 a month. That agreement "had been faithfully and honourably carried out".

The Judge summed up, in a phrase that made the headlines, that "Captain Bairnsfather had contributed very largely to the gaiety of nations during the very serious period of the War" and granted an order of discharge subject to a suspension of fourteen days.

Christmas 1934 must have been much more lighthearted for the Bairnsfather family than the grim one of the previous year.

Several regular sources of income, if somewhat modest, continued into 1935. The monthly "New Fragments" still appeared in the *British Legion Journal*. The January contribution extended the theme of disarmament. Old Bill is reading a newspaper with headlines like "War Clowds in the Far East" [sic]. "Tension in Balkans", "Is Germany arriving?", "Air Force increases". Old Bill comments to Bert, "Yes Bert, seems as if the only way to get disarmament is to arm". The rest of the year produced the normal mix of cartoons, with October seeing one of Bairnsfather's frequent workings of "The Better 'Ole" with the shell bursts representing "Pacts", "Talks", "Understandings", "Rearmament" and "Scenes".

In April of 1935 Bairnsfather made a pilgrimage back to the scene of his only real fighting experience – the area of the Ypres Salient. He made the journey on the twentieth anniversary of the shelling that had put him out of all future active service.

The pilgrimage was reported in an article that appeared in June's *British Legion Journal*, entitled "How I came back to Mac". Bairnsfather had an unfortunate compulsion to repeat ideas and drawings. In this otherwise well-written article he felt

The first five miles are the hardest, but nothing matters if you have a great object in view

Bairnsfather's comment on the Labour Party Conference.

obliged to quote from his book *Bullets and Billets* when describing how he had marched with the 10th Brigade from Ypres to the village of St Jean, scene of the first gas attack, and Bairnsfather's shell. The rest of the article describes how he retraced his steps from dusk on 24 April to dawn on the 25th and how he remembers with affection a gallant lieutenant friend (the "Mac" of the title) who was killed, as were very many of Bairnsfather's battalion that day. Bairnsfather movingly describes how he found his friend's name inscribed on the impressive Menin Gate Memorial and how he heard the Last Post sounded beneath its great arch. This ceremony is faithfully carried out every night to this day as a tribute by the Ypres townspeople to the brave British soldiers who gave their lives in the fight for the salient. Bairnsfather also visited many of the British cemeteries that are immaculately kept by the Commonwealth War Graves Commission – and read with sadness the stark inscription on the many graves of unknown soldiers: "A soldier of the Great War known unto God".

Strip cartoon from The Passing Show *magazine of Old Bill and Bert, reproduced in postcard form.*

The music halls provided a tour for Bairnsfather again this year, and his contribution to the *Passing Show* continued. The magazine had gone from strength to strength, attracting top class writers and artists and by 1935 had changed to a larger format. Gilbert Wilkinson's popular drawings still graced the magazine's cover and inside were serialisations of new novels (such as P.G. Wodehouse's *The Luck of the Bodkins*, illustrated by Illingworth), biographies, (such as *Romance and Mr Selfridge* by William Blackwood) as well as complete stories and articles about sport and health. It contained a four-page humour section with cartoons by Tom Cottrell, Way, A.C. Barrett, W.H. Cobb, G.S. Sherwood, Jack Dunkley, Harold Beards, Charles Hyslop, and many other comic artists. Bruce's contribution had also changed – from the large size cartoon and/or article to a four-picture strip cartoon – the first called "Old Bill's Boy". It then settled to a steady and successful formula, "Old Bill and Bert". Bairnsfather's strip appeared on the back of the cartoon section sharing the page with another familiar name, Mabel Lucie Attwell.

By September Raphael Tuck and Sons were reproducing the strip as postcards using a distinctive two-colour (black and orange) presentation. The cards were very popular. Once more Bairnsfather had been dissuaded from trying new and original material – if that's what his editor thought the public wanted, then

Bairnsfather's sympathetic view of the abdication of his fan, Edward VIII, in 1936.

that's what Bruce had to churn out. The strips were well drawn, but tended on the whole to produce a smile rather than the guffaw that the original *Fragments* provoked.

The pleasure produced by these wartime jokes had not been forgotten in the country where he had spent so many months since the war – America. The Service magazine *The Quartermaster Review* published a long article in its May/June 1935 edition by Christy Borth, entitled "A Wise Man in Motley".

The article was triggered by a request from a veteran, still bed-ridden as a result of his wounds in the Great War, who, when visited by Borth, was chuckling over a worn copy of *Fragments from France*. "It's saddening to realise", he is reported as saying, "that a generation has grown up without ever learning of the man whose mirth was perhaps the most potent factor in allied victory in the World War. Why don't you try to tell them about him?" And Borth proceeds to tell the story – in a somewhat melodramatic, occasionally inaccurate, but well-intentioned manner.

Further proof that Bairnsfather was still remembered with respect and affection in the U.S.A. was the publication that year by the Dodge Publishing Company, New York of a book called *Old Bill Looks at Europe*. It re-used material gathered during his tours of Germany and Russia for the *Sunday Express* in 1933, and his pilgrimage to the Ypres Salient in April 1935. The latter had already been written up in the Royal British Legion Journal for June, and would form the basis of Bairnsfather's article in *Twenty Years After* in 1936.

In the 149 pages of the book, Bruce had room to express his reactions to and opinions of what he had seen. But, just as he had in *Laughing Through the Orient*, he first of all had to describe going through the motions of deciding upon, and then locating, a suitable travelling companion. It was an artificial device to justify including Old Bill. Nevertheless, when the inseparable pair arrive in Ypres and ensconce themselves in the congenial Hotel Continental opposite the station (still used by pilgrims today) the sincerity and strength of their reaction to the scenes of Old Bill's birth (in "Plugstreet" Wood) and the Captain's "Blighty one" (at Wieltje, near St. Jean) shine through. Bairnsfather's journalistic expertise, based on his superb powers of observation, compensates for a strained compulsion to be amusing, and produces a vivid picture of Nazi Germany under Adolf Hitler and Russia under Stalin. The chilling message emerges through the cartoons of repressed societies, in which criticism of the regime was extremely dangerous. The author's final message is a philosophical summary of then current attitudes in England (and this despite the fact that the book was an American publication). At times it betrays his upper class origins and advocates a return to the feudal system and a perpetual Conservative government. It ends, however, with the words, ". . . the level keel which England has maintained through all these precarious and impoverished times is mainly due to the patient self sacrifice of the vast mass of the English people of all classes". So speaks the creator of the archetypal working British man – Old Bill.

Another American project must have raised Bairnsfather's hopes that he could climb out of his rut. It was reported on 14 October that Wallace Beery had been asked to take the name part in a film of Old Bill. A script had been sent to Hollywood which attempted to represent the old codger "up-to-date and thoroughly modernised". Wallace Beery was a big name and it would have been interesting to see his portrayal of the thoroughly British old soldier – and to compare it with Sydney Chaplin's interpretation. Unfortunately, nothing more was heard of the project.

The following month brought a compensation. The popular magazine *Answers* started to give away brightly coloured prints of some of the best loved *Fragments*. On 16 November the series started with the most famous of all, "The Better 'Ole". It was followed on 23 November by "Coiffure in the Trenches", on 30 November by "The Fatalist", on 7 December by what had been the very first cartoon accepted by *The Bystander*, "Where did that one go?", on 14 December by the cartoon used by the German army to illustrate its pamphlet on humour, "So Obvious", and finally on 21 December by "No Possible Doubt Whatever".

1936 opened with few prospects in view but the year was also to bring the usual sprinkling of exciting plans that never came to fruition. The first false alarm was on 2 January when the Press reported that "Old Bill is coming back to the London stage". *The Better 'Ole* was reported as having been re-written by Rex Newman, who "writes revues and runs seaside concert parties in the summer". The play was "to make a bid for twice nightly popularity in the West End Theatre with comedian Syd Walker as the lightning successor to the late Arthur Bourchier as Old Bill". It would seem that the bid failed, as no records can be traced of any such production actually reaching the West End.

Bairnsfather did an early lecture tour in the States, returning on 28 March on the White Star Liner *Scythia*. The lecture tour led straight into a four-week music hall tour in England. 1936 saw a trend in "cine-variety", an interesting combination of film and live acts. Bairnsfather was contracted to Union Cinemas and he was engaged for a week at a time with a fifteen-minute act. Mick Harvey, who managed the

Sketch BB did for the Manager of a Union Cinema, Mick Harvey, in 1936.

variety acts for a Union Cinema at this time remembers Bruce's second billing act. It was the usual mix of comic patter and Old Bill sketches and was met with "moderate reception". Mick remembers Bruce, however, for his "cordial and nice" personality and because of the sketch he did for him which took Bruce about five minutes to produce.

Because of his American and British music hall commitments, Bairnsfather's contributions to the *British Legion Journal* dwindled significantly in 1936. Only one original cartoon was published throughout the whole year. It appeared in June, and showed Bill and Bert commenting on the trouble spots that were springing up throughout the world.

A new weekly magazine was started by George Newnes that year. It was edited by Major General Sir Ernest Swinton K.B.E., C.B. and entitled *Twenty Years After*, featuring articles by men who had served in the Great War. The magazine was dedicated "to the memory of those who marched away and returned no more, and to those who survive, in gratitude for all they did and all they suffered" and its stated purpose was "to describe the Great War of 1914–1918". One feature contrasted photographs of famous war landmarks as they were in 1914–1918 and as they appeared in the 1930s. The featureless, shell-pitted landscapes seem miraculously transformed into industriously reconstructed roads and farmsteads of 1936. Contemporary paintings were also published in the magazine which was later issued in bound volume form. The stark drawings of Paul Nash (some of whose work can be seen in the Imperial War Museum today) contrasted with the stylised heroism of Sir William Orpen's paintings and – of course – reproductions of the war's most famous artist's work, Bairnsfather.

In Chapter VIII of *Twenty Years After* an article entitled "Bruce Bairnsfather looks back" appeared. It was illustrated with reproductions of "The Better 'Ole" and "No Possible Doubt Whatever", and also with a new "Fragment" drawn specially for the work.

In the article Bairnsfather confirmed that his most vivid war impressions were those culled in the early months, when he was actually in the thick of things. He recalls experiences already well documented in *Bullets and Billets* and in countless other articles. Bruce reminded his readers of the lighter aspects of the war too: "There were nights of joyous reunion in estaminets, camps and billets. A full and merry life was the lot of those temporarily situated in the back areas in those towns and villages untouched by the sordid horror of the front line." This comradeship was badly understood by those at home who had not shared the horror, and so could not appreciate the kinship. Bairnsfather ends with the surprise he felt when visiting the war museum at Ypres. He saw a

Poster for the Argyle, Birkenhead, September 1936.

huge enlargement of "The Better 'Ole" with the caption, "*Mon vieux, si tu connais un meilleur trou . . . vas-y!*".

A second music hall tour followed in the autumn in traditional theatres. He visited one of his favourite provincial theatres, The Argyle in Birkenhead, the engagement starting on Monday 7 September. Bairnsfather describes The Argyle with critical affection as having "a meagre supply of time-honoured dressing rooms, remarkable for a paucity of plumbing" but ". . . the theatre is almost invariably full", and ". . . here is the real spirit of the halls as they used to be".

Bairnsfather didn't always draw his own posters. George Ratcliff, for many years an active and well-

loved member of the Cartoonists' Club of Great Britain, was a set designer for Stoll Theatres from 1934–1939. His happiest memories were of his days at the Manchester Hippodrome, which George claims was then the largest theatre in Britain. During his time at this great old theatre, Bruce returned three times to do his act. George remembers him as a very warm, friendly man, with "no pretensions, no side", well-loved by all the stage hands. George did the posters for the front of the house for Bairnsfather's act, and conscientiously studied Bruce's style. He was tickled pink when, going to Bruce's dressing room, he showed the artist some of the Old Bill type cartoons he had copied and Bruce was "shook rigid" by the uncanny resemblance to his own style.

One of the most revolutionary events in Bruce's whole career occurred on 1 October. He took part in the first programme in a BBC series of experimental TV transmissions from Alexandra Palace. At first the Baird process broadcasts suffered from extraordinary interference badly distorting the picture. The announcer, Fred Culpritt, appeared to be performing incredible contortions and it was explained that "owing to the failure of a water supply at the television station, there were one or two slight technical hitches". Happily Bruce's cartoons featuring Old Bill were very clear, and to the amazement of the small handful of privileged viewers, were reproduced on a "Marconiphone television receiver . . . in the heart of London".

In a policy reminiscent of today's broadcasting, the BBC decided to play it safe the following day, and announced they would show films instead of the planned ballet and zoo scenes – on account of that technical hitch.

These latter years of the thirties were confusing for Bruce. Many months were spent struggling to survive, fearful of obscurity – and every now and then Bruce would get dramatic proof that he was still beloved and respected. Although television's potential was not yet realised, the fact that Bruce, of all the celebrities available at that time, should have been chosen to open the first programme was surely a unique tribute to the special esteem with which he was still regarded.

Ironically, this new opportunity saw the beginning of his very lean years.

On 13 March it was reported that Bruce would be teaming up with the experienced and popular comic Billy Russell, and that their double act would tour America and Africa. Tour Britain they certainly did – and most successfully – but they never made it to America.

It was a natural pairing. In a curious parallel development, Russell had created his own Old Bill, independent of Bairnsfather. Like Bruce, Billy volunteered in 1914. At this time he was already an experienced actor – his first appearance being as a juvenile at the Theatre Royal, Gloucester in 1900 – and was touring in pantomime. He was not actually called up until March 1915, when he was sent to join the South Staffordshire Regiment. After nine weeks training he was on his way to France – just as Bruce was coming back after his encounter with the shell at St Jean. He served three years in France and again, like Bruce, used his keenly felt experience to create. Knowing his background, his officers asked Billy to do some shows to cheer up the troops. The character he portrayed in his front line act was a "Trench Philosopher", who chewed on his clay pipe and commented with humour on the realities of the existence he shared with his fellow Tommies. Bruce even went to see his act when touring the trenches. "Afterwards," recalls Billy, "he came up and congratulated me on my performance. The characters we had created in our different ways were very similar, but it was entirely coincidental. He was a darling of a man, very charming and good natured."

After the war, Billy developed his character, transferring him to civilian life in a deliberate move to get away from the wartime stories he cannily felt the public had tired of. His character continued to be a success, commenting on life and its difficulties for the working man. His career had reached a high point in 1933, when he performed in a Royal Variety Show.

This partnership gave Bruce's career on the halls a tremendous fillip. Not only was Billy the top of the bill, but he had much to teach Bruce in the art of being a comic. They also got on extremely well and their friendship continued long after their double act broke up.

The act started with the routine that Bruce had been doing for years; the development of Old Bill from a baby to a grown man, to the walrus-like character everyone loved – all done in lightning sketches to the accompaniment of comic patter and incorporating some of the best-loved *Fragments* cartoons.

Then Old Bill in the shape of Billy Russell, came on stage and spoke "on behalf of the working classes". In the finale "Billy and Bairnsfather combine effectively to portray 'Old Bill' on the battlefield, while those popular songs like 'Pack up your troubles' are sung", as the provincial newspaper reported, for which they "were accorded a rousing welcome". The rollicking nature of the act can have done little to win back the approbation of the Bairnsfather family but it certainly helped to pay the bills that always seemed to pile up. Billy Russell usually worked on a percentage of the box office takings and Bruce probably shared the same system with him. As the act was well received, he probably did better than on his normal fixed salary.

The double act of Bairnsfather and Russell.

The month after the Russell/Bairnsfather duo was announced, more work came Bairnsfather's way – with the *Evening Standard*. On 10 April it announced a competition – for the best "Coronation Camp Fire" story. "A famous artist", it announced, "has joined Coronation Camp Fire . . . Every day Captain Bruce Bairnsfather, the creator of Old Bill, will illustrate the feature. His drawings will add immensely to the Camp Fire fun. It may be that your story will be chosen for illustration by Bairnsfather."

The coronation was that of George VI and Queen Elizabeth. It would take place on 12 May, and already visitors from the Dominions (as they still were), the Continent and the United States were gathering for the great event. The "Camp Fire" story had to feature "a man or woman from an overseas country" and the winner each day would earn two guineas.

July opened an interesting chapter for Bairnsfather. Although he had broadcast in the States, the earliest record the BBC have of Bruce on radio is for 27 July. It was in the first of a new series called "The man behind the melodies" and the subject was Herman Darewski, who was musical director of the stage version of *The Better 'Ole* in 1917. To open the programme, which went out at 8.00 p.m., Darewski requested that "Plum and Apple", one of *The Better 'Ole's* first songs, should be played. Bruce and Darewski then reminisced about the play – the disastrous dress rehearsal which made them all want to put up the notices before it even opened, followed by the totally unexpected smash hit, that ran for two and a half years, and had twelve companies touring Australia, India, Africa, Canada and America, as well as Britain.

No more broadcasting offers were made, although Bairnsfather obviously hoped the spot on Darewski's show would have led to more, especially in view of his television work the previous year.

None of Bairnsfather's work appeared in the *Royal British Legion Journal* throughout 1937, but he kept up links with his fellow servicemen by joining the Uckfield branch of the Old Contemptibles Association on 14 August. He was very proud to belong to that exclusive band whose rigid membership requirements were that members had to have served in France between August 5 and November 22, 1914

With the Season's Greetings

and Every Good Wish

for

Christmas and the New Year

from

One thing about it! Never reckoned we'd be 'avin our Christmas dinner indoors this year, did yer Bill?

(Specially drawn for the Old Contemptibles' Association by Captain Bruce Bairnsfather

Christmas card design for The Old Contemptibles Association, which Bairnsfather joined in 1937.

and to be in possession of the 1914 Star and Clasp medal, known as "The Mons Star". The address on his application form is given as Piltdown, but some very sad news was soon to force him to leave the haven and refuge that the cottage had provided in times of trouble and stress over the past five years.

He had put many therapeutic hours into improving the cottage and studio and had enjoyed the rare opportunity to be a father to Barbara. They had gone on painting and fishing expeditions together – a whole day sketching trip to Hurstmonceaux Castle was a particularly memorable outing. At this period Bairnsfather was experimenting in gouache for his landscapes and the rural peace of Piltdown gave him some beautiful scenes to sketch. But Bruce also took Barbara to the zoo and the circus. He was a great story-teller and read aloud from favourite books like the *Green and Blue Fairy Books* of Andrew Lang, *Coral Island, Huckleberry Finn* and F.C. Burnand's *Happy Thoughts*. Bruce was a regular visitor to the Peacock pub at Piltdown until a tactless friend told the landlord who he was. He never went back.

These happy interludes were brought to a sudden end with the tragic and unexpected death of Lady Margaret Hamilton Russell on 27 January, 1938. She died in her bath, the bathroom door locked – a harrowing experience for the family. The complex

she had built up opposite the golf club at Piltdown was no longer used, and Ceal and Bruce had to search for another home. The London studio was to be the answer for a while. Barbara continued to live with her well-loved Uncle Freddie.

Advert for the Empire, York, 1938. "Two World Famous Personalities".

The act with Billy Russell was still going strong in 1938, as shown by the advert in the York newspaper for the act at the Empire. Bairnsfather, "creator of the Immortal Old Bill topped the bill, with Old Bill in person, the Royal Command comedian Billy Russell".

Interviewed by the local Press. Bruce talked of his experiences in vaudeville in the States, recalling an engagement in Chicago during the height of the gangster rule during prohibition. Twice in one week the theatre where Bruce was playing was raided. The first time they "cleaned out" the pay box, and the second time they robbed the artists of their payroll. But Bruce claimed to have received a "tip off" and so escaped with his "dough".

There were no such excitements at the York Empire, but the duo were popular. They did particularly well at the theatres in the Argyle organisation at Birkenhead, Middlesborough and York. The mana- ger of the famous Argyle at Birkenhead where Bairnsfather always loved to play was T.D. Clarke – following in his father's footsteps. He put on bills at these northern theatres called "The Billy Russell and Bruce Bairnsfather show" and had great success. Judging by the photographs of Billy Russell in his Old Bill costume and make-up, he was probably the most convincing Old Bill of all.

It was an otherwise quiet year, though the *Sunday Express* did publish a prophetic Bairnsfather picture on 25 September. It shows Old Bill tapping a saluting Adolf Hitler on the shoulder and, with the words, "Hey, just a minute", trying to make him aware of the Cenotaph behind him. It reflected the nervousness in the air about another war, and was of course drawn while Chamberlain, Daladier and Mussolini were at the meeting with Hitler which resulted in Chamberlain's "Peace in our time" statement.

Bairnsfather knew better.

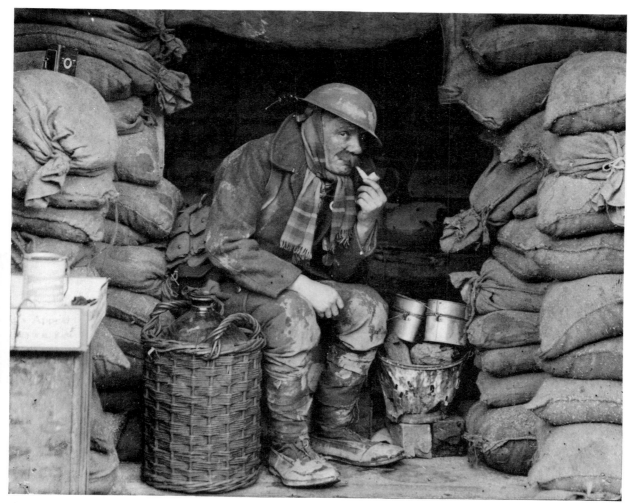

Billy Russell, probably the most authentic of all the Old Bills.

Chapter 14

An Autobiography & The Last Film

(1938–1941)

As the smoke of impending war began to thicken in 1938, Bruce was writing his memoirs. Those who remembered the Bairnsfather of the last war sniffed the air and smelled advantage. *The Bystander* engaged him for a weekly drawing, the War Office asked him to do a recruiting poster, Alexander Korda liked the idea of a film, John Long & Co. prepared to publish his book, while Hutchinson considered two others. Bruce was fifty-one years old and much wiser than he had been in 1915. Now he had London agents to handle his affairs and they were Curtis Brown, one of the best-known firms of artists' agents in the world, whom he first sought out in their American offices in the late 1920s.

The autobiography was called *Wide Canvas*. The title was not typically Bairnsfather. In a *Fragments* mood he would probably have named it "Colourful Canvas" or "Many Memories", using the alliteration of which he was so fond, but the title does give a clue to the book. Bruce made very few attempts to be funny, and set out to tell the story of his life up to 1938. It was well told, but dishonest.

There are no lies in the book, but he simply leaves out all the nasty bits. There is no mention of bankruptcy and no suggestion of any difficulties in his marriage. He makes no direct criticism of others, although he does point out where he might have done better – "Had I been able to have a clever personal agent right from the very start, I would have made many times more money than I did". Then, immediately, as if regretting that hint of acidity he follows with: "However, what I got was enough for one."

In 1938 it looked as if Old Bill might have another lease of life. Thus *Wide Canvas* was written from a positive platform where Bairnsfather could afford to be generous. Yet it is unlikely that, even if the circumstances had been totally otherwise, he would have written in a greatly different tone. He was a gentle yet determined man who could bear no ill will.

On 28 February, 1939, John Long signed a contract through Curtis Brown to publish *Wide Canvas*, and in

"Old Bill" Again: By Capt. Bruce Bairnsfather

"Of course, it's only Vital Industries like this we're protectin', yer know, Mate."

FROM THE BYSTANDER

Postcard published by Valentines. Reproduction of a 1939 Bystander *cartoon.*

Cover of Old Bill Stands By. *April 1939, the second printing which went into 20,000 copies.*

"What d'yer mean, what time do I go up?"

"Gosh, it would be terrible if France lost all this to Italy!"
From Old Bill Stands By.

April *Old Bill Stands By, An Old Friend in a New Emergency*, was published by Hutchinson. It was a thin paperback, thirty-six pages long. Inside were eighteen full-page cartoons with many small sketches, interspersed with captions and brief commentaries. Old Bill was older, he had aged as his creator had done. He had put on a little weight. They both had. Yet the spark of original humour is there, as if the threat of war had rekindled Bairnsfather's genius. The barrage balloon joke, "What d'yer mean, what time do I go up?" and the Sahara one, "Gosh, it would be terrible if France lost all this to Italy", were vintage Bairnsfather.

The earliest and best of his original Fragments were not drawn as a vehicle for Old Bill. Bill just happened to be there. If Bruce could have dropped Bill at this moment he might have gone on to make full use of his acute observation and appealing sense of humour, to establish himself once and for all as the world's greatest cartoonist. The Sahara joke could almost be a parallel to "Who made that 'ole? Mice?" In order to explain the joke to their own soldiers, the German authorities had added "It was not mice. It was a shell". Equally, they might, in similar circumstances, have added to the Sahara joke "He means the sand".

"Let's see....Better
give it another
few seconds"

The rear cover of Old Bill Stands By.

Bairnsfather's "Walls Have Ears" propaganda poster.

But it was too late for Bruce. He was type-cast. Those who employed him saw him only as Old Bill and that was all they wanted. Many of the drawings in *Old Bill Stands By* were drawn originally for *The Bystander* in 1938. The book sold over 20,000 copies and the work was popular enough for Valentines, the postcard publishers, to bring out a postcard series entitled "Old Bill Again" reproducing pictures from it. *Old Bill Stands By* shows some of the last examples of his simplistic genius, one of which is on the rear cover. A falling parachutist is trying to decide when to open his parachute: "Let's see . . . better give it another few seconds."

Bruce had much to contend with at this time. Ceal was becoming increasingly difficult. "Nervous" is how Bruce put it. She was demanding more and more of his attention, which affected his work. Had he been able to harden his feelings with ambition, he might have broken away and gone forward to lasting success; but, seeing a bright future ahead for Old Bill, Bruce finally resigned himself to becoming a chronicler, depicting situations in which his famous character might find himself. It was a tourniquet upon his imagination, and very soon all the old jokes would be dusted off and used again.

To the outside world, however, things looked quite different at first. The War Office asked him to do a poster to encourage recruiting in the Territorial Army and on 11 April, 1939 the *Daily Express* reported: "Old Bill joins up again – to get recruits . . . Old Bill – Bruce Bairnsfather's famous wartime character – is to be brought to life in a new guise this week . . . the War Office are to issue 10,000 posters all over the country. . . ."

On the same day the *Daily Mail* headed its comment, "38 Men (and Old Bill) To Boost Terriers", and announced that thirty-eight public relations officers were to be appointed throughout the country to encourage recruiting, and that ". . . Captain Bruce Bairnsfather has brought his famous character Old Bill to life, to help in the work. On Thursday the ageing face of Old Bill will look down on you from all the London buses . . ."

The *Sunday Graphic* at the end of that same week headlined with "Old Bill is in The Money" and went on: "After 20 years Captain Bruce Bairnsfather, creator of Old Bill is making a come-back . . . Old Bill has made a come-back too on 10,000 posters . . . for twenty years he has been dead, his fat jolly face

Over My Sandbags

By Captain BRUCE BAIRNSFATHER, M.C.

BAIRNSFATHER created that historic character " Old Bill " while serving in the Front Line in the last war. This time he is on the Home Front and will contribute his impressions of the war in his own inimitable style to each fortnightly issue of DEFENCE. This journal presents him to its readers not only in the familiar guise of a famous comic artist, but as a writer whose keen observation of our present-day anxieties is enlivened by that same spirit of cheerfulness which carried us through the dark days of 1914-18.

The title of Bairnsfather's article in Defence *magazine, 1 October 1939, which erroneously credits him with the M.C. Future articles omit the error.*

thrown in the disused attics with the rest of the war relics. He was called the 'greatest inspiration of the last war'. He was equalled in fame only by his creator, once the world's most famous cartoonist."

Old Bill made national headlines for days. By bringing him back after twenty years the War Office admitted just how important a part Old Bill had played during the First World War, yet there was no formal recognition or award for his creator.

April was marred by the death of Johnny Danvers at the age of seventy-eight. Danvers had played Mr Belcher in *Old Bill MP* at the Lyceum and had toured as Old Bill in *Ullo*. In his last fourteen years he had been confined by arthritis to one room in Brixton, surrounded by pictures and mementoes. Apart from those showing him with his nephew, Dan Leno, the largest number were originals by Bairnsfather and pictures of himself as Old Bill. So it was "Old Bill is dead. Long live Old Bill".

The growing new Army responded to Old Bill and his antics. Hyde Park became a tented camp to house the burgeoning numbers of recruits, and as prefabricated huts were set up to replace the tents, the Gunners living in them gave them names. The first four built were called "The Ark", "Cupids Corner", "Turnips" and "The New 'Ole". Old Bill was definitely back.

Alexander Korda Film Productions (AKFP), writing from Denham studios, offered Bruce £2,000 to be paid in weekly instalments of £100 starting in July, for the exclusive rights to film Old Bill. The rights were to last for seven years and in addition AKFP also required an "exclusive option to produce and exploit further motion pictures incorporating the character Old Bill". Bruce agreed, dealing through his agents Curtis Brown. The contract was signed by Bruce Bairnsfather and Alexander Korda.

The *British Legion Journal* began to publish regular full-page drawings of Old Bill amongst the new Army. A company called Dimensional Displays sought permission to make models of Old Bill and to use his image for advertising purposes, and in September the *Sunday Chronicle* engaged Bruce on a Services story competition. "Laugh Again with Bairnsfather", it said, ". . . famous comic artist who . . . saw the funny side of things more brilliantly than anyone . . ."

The Service magazines sought him out too. *Defence – The Fighting Man's Fortnightly* carried the first of a long series of illustrated articles by Bairnsfather on 1 October, 1939. In an extraordinary slip they bylined him as "Captain Bruce Bairnsfather MC". The mistake continued into the following year. The error would have upset Bruce, for while he never

Bairnsfather as caricaturist.

complained about his lack of recognition, it was a slight that he felt very deeply, as he showed clearly in cartoons, such as his "British K-nights Entertainments" and "Those Medals" drawn so many years before.

The *Defence* articles were entitled "Over My Sandbags" and were introduced briefly by the editor – "Bairnsfather created that historic character Old Bill while serving in the Front Line in the last war. This time he is on the Home Front and will contribute his impressions of the war in his own inimitable style to each fortnightly issue of *Defence*. This journal presents him to his readers not only in the familiar guise of a comic artist, but as a writer whose keen observation of our present day anxieties is enlivened by that same spirit of cheerfulness which carried us through the dark days of 1914–1918."

His contributions were indeed prose observations, illustrated by cartoons and caricatures and, unusually, Bairnsfather hardly used Old Bill at all. Many of

the drawings are superb examples of the political cartoonist's art, and capture the essence of a situation – or an anticipated situation. One of many such drawings shows Hitler releasing Stalin from a jack-in-the-box – a comment on the surprise treaty between Germany and Russia.

Wide Canvas was published on 12 October, 1939. Press reactions varied, but most papers acknowledged the book's arrival. "Peterborough" in the *Daily Telegraph* ended his famous column with a piece headed "Old Bill" but gave no judgement. *The Observer* published its review some five months later, after Bairnsfather had been regularly in the news. The reviewer, Howard Gray, expressed surprise at the artist's literary ability. "Everyone knows how Mr Bairnsfather can draw, and how genuine is his sense of humour. But some will be surprised to find that his literary range is not confined to wisecracks, but can extend to a volume of two or three hundred pages . . . he has developed into a pen-man of facility and charm. He has a vein of high spirited commentary

Frontispiece portrait of Bruce Bairnsfather for his autobiography, Wide Canvas *1939.*

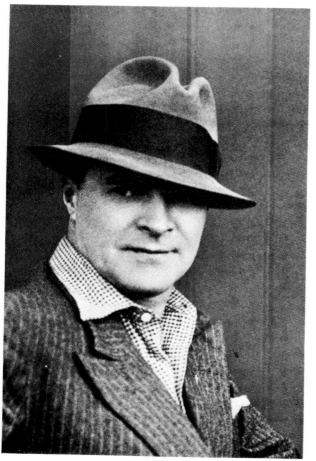

that recalls 'Ian Hay' and from such a jaunty companion the reader does not wish to part until he is obliged."

At the weekend following publication the *Sunday Chronicle* made a bigger splash with a story headlined "Bairnsfather reveals a Wartime Secret. The Amazing Story of How Old Bill was Born". *The Chronicle* showed a picture of a young Bruce Bairnsfather and "Where Did That One Go", the artist's first published "Fragment". The story, built around the forthcoming Alexander Korda picture and the publication of *Wide Canvas*, was the same familiar one of how Old Bill was created. There was nothing new. But BB and OB were very much in the news. *The Daily Mail* mentioned them in connection with "That Same Old Moon" (an original Fragments drawing) and a blackout story, and *The Star*, *The Telegraph* and *The Sunday Graphic* all made conjectures over the next few weeks about the forthcoming film in which it was rumoured that Will Fyffe would play Old Bill, and Bruce was drawing a regular strip, "Young Bill", for *Illustrated* magazine, the successor to *The Passing Show*. The treadmill was beginning to turn again. Across the Atlantic they were remembered too and the *New York Times* ran a large feature on 20 November with pictures of the classic "Better 'Ole" cartoon and insets of Bruce and Old Bill. The title of the piece was "Old Bill finds a Better 'Ole".

That they had found a Better 'Ole was certainly the way things must have looked to Bruce and Ceal as Christmas approached and the "phoney war" period began. To cap it all George VI visited the troops in France and there saw pinned up a poster that Bruce had done for the "Careless Talk Cost Lives" propaganda campaign. *The Daily Express* reported "The King thought it was a good one and (this will interest you Captain Bairnsfather) said you hadn't lost your touch!" So Bruce had it all now. He had the time, the place and the opportunity, but would Old Bill let go?

The film to be made by AKFP was named *Old Bill and Son* and a separate company called Legeran Films was formed by Korda for the purpose. The script was written by Bairnsfather in collaboration with Ian Dalrymple who had worked with Korda as writer and co-producer on a popular and successful film about the Royal Air Force called *The Lion has Wings*. The film required authentic front line scenes, and permission was obtained from the War Office to visit the BEF in France and to film there. Bruce and four others left London on 11 December, 1939 and were the first film company unit to go to the front line. They stayed three weeks, during which time Bairnsfather drove over one thousand miles up and down the line and filled his notebooks with sketches that he used later for his *Defence* contributions, many minor articles and another Hutchinson book.

While he was in France, many admirers recognised him and asked for his autograph. One of those was the Reverend Lawrence Wray, who remembers the episode very clearly. "During the First World War I'd served on the Somme with the South Wales Borderers and I'd got to know Bruce Bairnsfather's cartoons even before I went out in September 1915. Then in the Second War, I was posted to the same area with the Army Chaplain's Department attached to Number 3 Casualty Clearing Station near Arras. It was a few days before Christmas (1939) during the phoney war period and I was having lunch in the Hotel Univers in the town, when I saw Bruce Bairnsfather. He was at the next table with a group of war correspondents including Richard Dimbleby and others. I thought that he looked very ill and not very cheerful. Anyway I went up to him and said, 'I owe a debt to you, Sir, for your cartoons of the First World War and I would value your autograph'. He asked me where I was stationed, and said, 'I'll send it along'. A few days later, on Christmas morning, a despatch rider arrived with a cartoon of Old Bill I've kept ever since."

Bruce wasn't happy about the filming. It might have been memories of the failure of his last joint venture with Eliot reflecting badly upon this co-operation with Dalrymple, or now that this new war looked like bringing him back to fame and fortune, he might once more have begun to think that others

Drawn in Arras, December 1939, for Padre Lawrence Wray, when Bruce was with a party of journalists which included Richard Dimbleby.

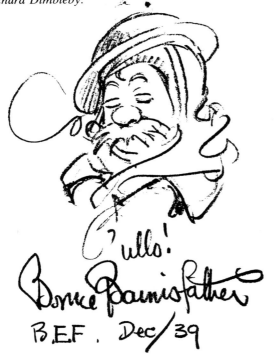

Bairnsfather on the set of Old Bill and Son *at Denham, 1940, with Morland Graham, who played Old Bill.*

would steal his ideas. He could even have deliberately decided to be unhappy about the way things were going, because the last time he had felt so doubtful was the opening of *The Better 'Ole* in 1917, and that show had been a smash success. In his concern with "omens" a legacy from his ayah's stories in India, it would not have been out of character for him to have attempted to manufacture his own, thus ensuring a similar success for *Old Bill and Son.*

He tackled Korda about his fears in January 1940, obviously to some effect, for through Curtis Brown he was offered an additional £500 to be paid from "1st of January last" in ten weekly instalments of £50 each. The money was "for the further services you are rendering on the script and general preparation of the *Old Bill* film . . .". Bairnsfather was still apprehensive. He went to see Korda again and this time Korda put his position in writing. "It is our intention that the screen billing will be based on the following –

General Film Distributors Limited
presents
BRUCE BAIRNSFATHER'S
'OLD BILL'
in 'OLD BILL & SON'
by Captain Bruce Bairnsfather
and Ian Dalrymple
with
MORLAND GRAHAM
JOHNNY MILLS & RENEE HOUSTON

(we) . . . assure Captain Bairnsfather . . . that we have never varied from our original intention of making a first-class film of 'Old Bill'."

That seemed to do the trick and there were soon other things to think about. Back in 1920 the radiator mascots of Old Bill's head were very popular. Louis Lejeune, the mascot manufacturers of Portland Street, which made the original versions, now entered into a contract to ". . . produce and sell Motor

Car and Aeroplane Mascots to be made in metal from designs made and approved by the Artist, and to produce and sell other objects designed by the said Artist only when and if such objects are designed by or approved by the Artist . . .". Bruce was clearly intending to keep a tight rein on Old Bill this time around. The contract, dated 29 February, 1940, guaranteed Bairnsfather a minimum return of half a crown for every model sold and stipulated that the whole arrangement would be cancelled if models were not on sale within six months.

Whether any new models were made by Lejeune has not been definitely established, although there are chromium plated versions of the 1920's bronze heads. The chrome heads are slightly larger than the bronze, suggesting that they may have been made from a casting taken from an earlier bronze. The Bairnsfather signature on the tin hat is also a little different, the crossing line of the "t" in Bairnsfather being much shorter than previously. Even if the chrome heads were produced in 1940, it could be that wartime controls on the use of metal prevented their manufacture in any numbers, and petrol rationing, which had been introduced the previous October, had drastically depleted the number of motor cars on the roads. So despite all his care, Bruce may not have made a penny from Lejeune at all.

Life, however, was pleasant. In 1939 he and Ceal had bought an old forge, with two cottages attached, at North Chapel, near Petworth in Sussex. Handyman that he was, Bruce, with locally recruited assistance, including a carpenter called Bill, had converted the forge itself into a studio, alternating between there and 4 Pembroke Studios, Kensington. At the rear of the forge he built the largest of his miniature theatres, every part of which, from drops to lighting, worked perfectly. He and Barbara, then eighteen,

Bairnsfather's picture, which still hangs in the Half Moon pub opposite The Old Forge, North Chapel.

The Old Forge and Barn Close, North Chapel, near Petworth.

put on shows for visitors in the "North Chapel Hippodrome". Barbara recalled how it worked. "I helped him with its construction and operation. It had a five-foot diameter revolving stage and a very ambitious (for the time) lighting system with dimmers made from drain pipes and copper plates. The scale was one inch to one foot. The orchestra, 'Bert Brazil and his Nuts,' was operated by a series of cams all cut with a hand jig saw. We had a sort of travelogue programme with scenes from China, India etc. The proscenium opening was cut into the garage wall and the audience sat in the garage. He made a beautiful Nativity series for the village church to be shown in this theatre."

Occasionally, Bruce would go across the road to the Half Moon pub where, leaning on the bar, wearing his hat at a jaunty angle over his eyes and a long overcoat, he would take his time over half a pint of bitter. "He didn't have more than a half," said Dave Carter who worked opposite the pub, "and Mrs Bairnsfather never came in." The landlord, Eric Sinclair, had a talent for woodcarving and made a number of ashtrays showing Old Bill. Bruce drew pictures for the pub, the Home Guard and the Working Mens Club, which he would occasionally visit, doubtless seeking the comfort of Old Bills. The pictures still hang in North Chapel and many people there remember him. But Bruce rarely smiled. Dave Carter recalled: "He always seemed sad somehow. It

seemed as if he couldn't let himself go. Of course, his wife was an invalid in a sense."

Carter had an open space beside the Old Forge which he used as a woodyard, a business he ran for himself. Thus Bruce often saw him, and would pass the time of day, inviting Dave to accompany him in his motor car for a drive through the countryside. As they travelled, Bruce talked only about the trees and the fields, or about a cottage here and there that he would like to buy and renovate. Sometimes they drove to Midhurst and had tea in The Old Manor Tea Rooms where, it seems, Bruce was well-known. Meanwhile, across the Atlantic he was making headlines.

As a result of his many years in America Bruce had various agreements with American artists' agencies covering different forms of creative work. His cartoons were handled by the Bell Syndicate, 247 West 43rd Street, New York, and his lecture tours by Colston Leigh of Fifth Avenue, New York. Now that he was back in the news the Bell Syndicate was placing his work again and on 28 January, the Boston *Sunday Globe* carried a feature "How I came to create Old Bill". It was the old story, though it was illustrated by four cartoons set in 1940, and there was an editorial promise, "A cartoon on the lighter side of the war by Bruce Bairnsfather will appear each Sunday". Owing to the American syndication system Bairnsfather cartoons were used many times over in different cities and in different publications. In England Bairnsfather often drew almost identical cartoons for a range of publications and apart from *Illustrated*, was also working for *Tatler* and the *Royal British Legion Journal*.

The making of the AKFP film continued on into the spring, with Bairnsfather spending most of his days on the set at Denham. *Illustrated* on 6 April not only contained the usual Young Bill strip, but also a three page photo feature on the film, by Bruce, with Old Bill on the cover.

In November the pace quickened further. Hutchinson published *Old Bill and Son* by Bruce Bairnsfather and Ian Dalrymple. It was, to quote Bruce's preface: "Ian Dalrymple's interpretation in narrative form of the film scenario of *Old Bill and Son* that we evolved together." The two-hundred page book contained twelve photographs of scenes from the forthcoming film and six Bairnsfather drawings.

Hutchinson also published *Old Bill Does it Again* a book of exactly the same layout and construction as *Old Bill Stands By*. There was a difference, however. Old Bill had regained his stranglehold on his creator, and featured in the majority of the full-page pictures. Whether Bruce was tired, whether he had run out of inspiration or whether he decided to settle for the easiest method of earning money, the light of

Old Bill and Son.

" Look 'ere ! I don't mind yer muckin' around with neutral gals, but yer can't do it with Allies, see ? "

Bulldog Winston: one of the few "Bill-less" drawings in Old Bill Does it Again. *1940.*

originality hadn't survived the year. He'd even used pictures he had drawn for the Great War. The month continued strongly, however. In America the Bell Syndicate offered, and got, a year's contract for exclusive rights to publish weekly newspaper cartoons by Bruce in America and Canada, and the BBC broadcast *The Better 'Ole*.

The transmission was on the Home and Forces

Programme on Monday 25 November, from 8.15 p.m. to 9.00 p.m. . Syd Walker led the cast as Old Bill, Bruce acted as narrator throughout and the BBC Chorus and Revue Orchestra provided the original Darewski music. The studio was in Langham House, immediately opposite the old Langham Hotel, where he had stayed in 1916. The omens looked good and the year was well rounded off by an article by P.V. Bradshaw in *London Opinion*.

Just before the First World War Bradshaw had been the founder of the pioneering Press Art School which offered postal tuition in art, and had engaged many leading cartoonists from time to time to act as staff members to his pupils. Many of his graduates became well known, amongst them Fougasse, whose real name was Kenneth Bird, and in 1940 Reginald Arkell, the editor of *London Opinion*, asked Bradshaw to do a series of tributes to leading humorous artists under the title, "They Make Us Smile". The one on Bairnsfather was published in December 1940.

As had happened so many times before, the story of the creation of Old Bill was re-told, but Bradshaw told it with understanding. He mentioned the occasion on which questions were asked in the House of Commons about Bairnsfather's "vulgar caricatures of our heroes" and dismisses its implications by a simple statement, "The nation – and its heroes – thought otherwise". That article, and others, were collected into a small book *They Make Us Smile* which was published two years later. The roll of artists included provides a fine measure of Bairnsfather's standing at the time when most people were rediscovering him. In alphabetical order Bradshaw's choices were, Bruce Bairnsfather, George Belcher, Walt Disney, Fougasse, Grimes, Horrabin, Illingworth, David Langdon, Lee, Low, Phipps, Frank Reynolds, Strube, Bert Thomas, Tom Webster, George Whitelaw, Gilbert Wilkinson and Lawson Wood.

How wonderful 1940 had been. But in 1941, everything was to fall apart again.

Yes, it was on board a Corvette at an American Naval Base that he was asked to join the Merchant ServiceJust for a while

Old Bill in the company of the creations of Bert Thomas, Illingworth, Grimes et al on the cover of Percy V. Bradshaw's They Make Us Smile.

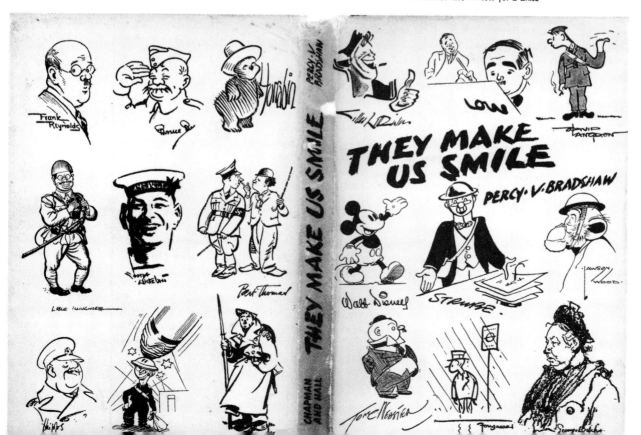

Chapter 15

World War 2 with the Americans

(1941–1945)

On 29 January, 1941 *Old Bill and Son* was shown privately to an invited audience of critics. The *Manchester Guardian* was unenthusiastic the following day. "The plot is a disconnected business, a series of episodes of the sort we usually call picaresque when we really mean stragglesome. It is, in fact, as glaringly unkempt and untidy as Old Bill's famous moustache which that delightful actor Morland Graham wears with conviction and distinction." At least the *Guardian* added that the film has "warmheartedness and optimism".

Disconnectedness was an enduring character of Bairnsfather's work. His fascination and love for music hall conditioned him to the concept of a series of Acts, Fragments or Splinters. The obvious examples are his cartoons, and most of his stage and screen output was fabricated from a collection of individually realised situations. It is highly likely that the "stragglesome" result of *Old Bill and Son* was due to the "further services" he had been "rendering on the script and general preparation of the Old Bill film", for which AKFP had paid him another £500. Perhaps if he had left the whole thing to Korda and Dalrymple the film might have succeeded.

AKFP had had doubts about the film for several months, and in January, even before the public showing, they wrote to Curtis Brown and gave up their options on any further work by Bruce. It must have been a severe blow to his expectations. Bruce was not expecting to receive any percentages on the ticket sales for the picture in addition to the payments he had already received, so his future income depended on new films. Now he knew that AKFP didn't want any more of his scripts.

When the film opened for public performance at the New Gallery Cinema on 9 February it wasn't condemned outright. Most reviews covered the basic story that Old Bill's son, Young Bill, had been lost on patrol while fighting in France and that Old Bill joins up again to find him. Few critics went much further. The *Sunday Express* was probably the most positive: "Chalk up a hit for Morland Graham on this picture as Old Bill . . . it's an amusing highly sentimental affair written in the authentic language of the Front with no attempt to be subtle." It finished: "A pity to see so fine an actor as John Mills in so empty a part." The film was not a success, and it is ironic that Morland Graham's performance had been singled out for praise. Korda had originally wanted a "weightier" Old Bill and would have preferred Roger Livesey. Livesey turned down the role. A further irony is that *Old Bill and Son* did rather better in Canada, where Bairnsfather's intended epic had failed.

Meanwhile Bruce had other worries. The air raids in the Midlands came dangerously close to his parents' home at Bishopton. He wrote to his old friend Billy Russell in July. "My old father had a nasty time. A whole stick of bombs, right round his house. Nearest one, as far off as the dress circle from the foots. Might easily have been done in. I am moving the old folks away from those parts." He moved them to Goffs Farm in North Chapel not far from The Old Forge, as he called his own home there. Barbara, who had been with Bruce and Ceal after leaving the Hamilton Russells, joined the ATS in November as a private. She followed this career, later as a commissioned officer, for the next five years.

The year was a terrible anticlimax to the hopes of 1940. Bruce continued to work for *Illustrated* and a variety of other magazines such as *The Tatler*, but he was forgotten again in Britain as quickly as he had been remembered. Even the Royal British Legion, for which he had been providing a monthly full-page cartoon for over two years, reduced the size of his contribution to make room for other things. No sooner was that done in August than another Old Bill died.

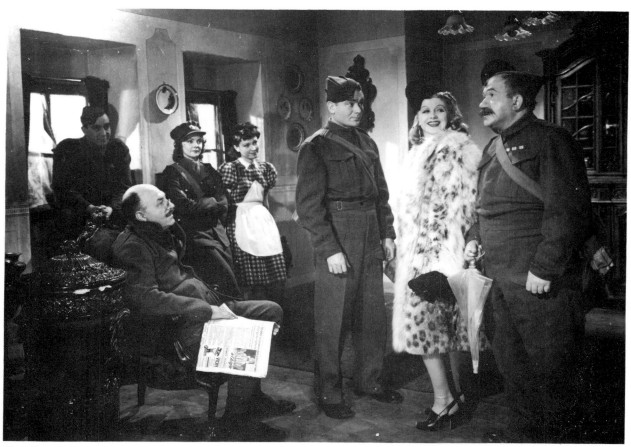

Standing: John Mills as Young Bill, Morland Graham as Old Bill, with the female lead, Renée Houston, from Old Bill and Son.

Merrigan was a Chelsea Pensioner, and had entered the hospital in December 1938 at the age of seventy-two after twenty-three years service in the Middlesex Regiment. He sported a walrus moustache, and his claim to be the original Old Bill was not disputed, and he was known as such in the hospital. Doubtless he, like most of the dozens of other claimants, ended up by believing his own story. In October the Press noted Merrigan's death. "Old Bill is dead", said the *Daily Herald*. Bruce, if he saw it, would have been greatly depressed. It was a sign.

Strangely, however, things were happening in America. Early in 1942 Captain Bruce Bairnsfather was appointed as an official cartoonist to the American Forces in Europe. It is not at all clear now how the appointment came about, but it may have been through the efforts of the Bell Syndicate. Bruce became a contributing cartoonist to the American Forces newspaper, *Stars and Stripes*, and Bell quickly tied up an agreement with Curtis Brown for "the first and exclusive newspaper rights to the new series of cartoons by Captain Bairnsfather of the United States

Army stationed in England and Ireland'. The agreement, dated 4 May, 1942 gave to Curtis Brown "60 per cent of the net receipts of the Bairnsfather sales". Bruce had a great liking for Americans, and gained encouragement from their energy and open mindedness. The contract gave him the right to sell cartoons direct to magazines such as *Life* and *Collier's*, and it appears that Bruce had made a decision to direct his efforts across the Atlantic. He became an American representative in Europe, wearing the American uniform, with the rank of captain and began his duties in Northern Ireland in April 1942.

Drawing on walls without approval had been a habit of his from the time that he had been able to hold a pencil. In 1942 the Americans surprised him by asking him to draw murals on their mess and billet walls to brighten up their surroundings. No doubt he would have been amused by the idea at first, and would have attacked it with vigour, but reflection must have made him sad to recall how his military audience, once measured in millions, was now measured in hundreds. Mrs Roosevelt, the wife of the

29/July/41

The Old Forge
North Chapel
Petworth. Sussex

Dear Bill

A line or two to cheer you on your way! Seeing you were at New Cross (I may be wrong) I thought I'd find out how you are and how the tough road has been of late. I also wanted to know how you and yours are, in these explosive times. I trust your wife and sons are well, also your house intact. So far, all well with us. Weathered a couple of blitzes, but my old father (Badgeworth way) had a nasty time. A whole stick of bombs, right round his house. Nearest one, as far off as the dress circle from the foots. Might easily have been done in. I am moving the old folks away from those parts.

I have often thought how when we were at Middlesbrough etc we were doing an act that was a year, at least, ahead of our time. What a wow that tableau would have been in these days!
I suppose you are still "Home Guarding" in intervals of the show business

All the best
Bruce.
Bairnsfather

Letter to Billy Russell, the comedian, July 1941.

American President, visited an American Red Cross Services Club and, according to *The Star* of 11 November, 1942, "got the biggest laugh of her visit to Northern Ireland from a 30ft. by 40ft. cartoon done on a wall of a lounge . . . the cartoon (was) completed in nine hours by Bruce Bairnsfather".

Bruce moved around a great deal at first from station to station, and from Northern Ireland to England, but early in 1943 became attached to the 305th Bomber Group of the 8th Air Force based at Chelveston near Bedford, so that he was able to go home to the Old Forge at North Chapel on weekends, living on the base during the week in single officer's quarters.

His life at Chelveston was at least secure. He had a small but steady income from his official appointment and continued to draw strips and cartoons for *Illustrated*, as well as contributing to other papers such as *Stars and Stripes* or *Yank* from time to time. His work now was seldom very funny, the humour forced, or even difficult to find. Occasionally he would observe a real situation and turn that to use. He still depended upon personal experience as he had always done, to find inspiration, and now too old at fifty-six to be in the fighting zone, he had to try to observe from the sidelines. He wasn't good at it.

It is an extraordinary thing that, for such a likeable man, Bruce Bairnsfather had few friends. Indeed, apart from just two or three people he seems to have had only acquaintances. Throughout his life he sought the companionship of "Old Bills", this quest polarising in later years into finding specific individuals to fill the role. One of those was Dave Carter at North Chapel, who accompanied him on trips around the countryside. Two of the other people who came nearest to being friends were the painter Barribal, with whom there had been many arty parties shared in the heady days at Waldridge, and an American colonel who was the Commanding Officer at Chelveston when Bruce arrived. The American was called Curtis Le May.

Colonel Curtis E. Le May (later General) was a

One of Bairnsfather's regular war-time strip cartoons in Illustrated *magazine.*

forceful personality, with firm ideas upon how both his own unit, and the war, should be run. His men called him "Iron Ass". The unit, the 305th Heavy Bombardment Group, was part of the American Eighth Air Force and was charged with daytime strategic bombing of German industrial targets. Le May introduced many tactical procedures that became standard in the Eighth Air Force. He often led his own planes in their raids over Germany, won the British DFC and later fought against the Japanese. His most formidable responsibility was for the dropping of atomic bombs on Hiroshima and Nagasaki although he went on to head the Strategic Air Command and to become Air Force Chief of Staff. But in 1943 he was still a unit commander at Chelveston and there he and Bruce Bairnsfather took to each other.

The British Clerk of Works at Chelveston was Jimmy James and Mrs James, Jimmy's widow, remembered Bruce clearly and with great affection thirty-five years later. "I understood that he was commissioned into the American Forces to boost their morale," she said. "He was an extremely nice man, a perfect gentleman. Everyone treated him with respect and there is no doubt that he stood apart – I mean he wasn't a GI. I don't remember him ever talking about Old Bill or his wife and family – he wasn't a man to talk a lot but I think he enjoyed what he was doing."

Father and daughter in uniform; Bruce and Barbie at Chelveston, 1943.

Life at Chelveston, where he could be on his own during the week, and home in North Chapel at weekends, probably suited him.

The Americans were delighted to have Bairnsfather around. He was the only Englishman in uniform on the base, and they looked upon him almost as their mascot. Thus they involved him in everything they could. He drew portraits, pictures and murals for the mess and canteens, cartoons for the camp bulletins and even pin-ups. There was a considerable vogue for nudes amongst the officers and many of them had Bruce draw full length figures on the walls alongside their beds. The major pre-occupation however was "mud". The U.S. Army Air Force's official story of the Eighth Air Force's first year in Britain put it like this – "One enemy the engineers [building and maintaining the airfields] cannot arm themselves against is the weather. And weather – particularly the rain of the English winter – plus farmland plus construction all adds up to mud. Roads of mud, rivers of mud and lakes of mud plague construction crews and operating personnel alike. Fortresses, if they stray from the runways, bog down

The official cartoonist to the American forces in Europe paints a typical mural. Courtesy of the U.S. Air Force.

Capt. Bruce Bairnsfather, famous English cartoonist, draws a picture of Cpl. Edward Elcevich, Shirley, Mass., at an Eighth Air Force Base, somewhere in England. Courtesy of the U.S. Air Force.

in it hub-deep: trucks sink to their axles, small pfc's [American soldiers, Privates First Class] go down to their hip pockets. English mud is infinite in its variety, and ranges from watery slop to a gelatinous mass with all the properties of quick-setting cement. Grizzled veterans swear that they have never seen anything like it – since the last war." One grizzled veteran, Bruce Bairnsfather, 305th Bombardment Group who had learned a great deal about mud in "the last war" captured the feeling in his drawing "Lieutenant Chelveston" which he presented to 305th Bombardment Group.

Mrs James remembered his work in the Officers' Club. "My husband designed a bar for one wall but the end wall was bare. Bruce painted New York [on it] . . . it was the view as you go past the Statue of Liberty. The statue was as high as the wall. He

painted every building and those fellows [the Americans] knew and they could pick them out." Bruce clearly still had his eye for detail. Curtis Le May recalled that painting and others that Bruce had done.

"He painted all over the place. Our Public Relations Officer, Harold Fox, had a little coop of an office and Bruce decorated the wall with an unforgettable shelf. In this case he worked in the style of William Harnett, who drew everything in exaggerated three-dimensional quality . . . That's the way Bruce Bairnsfather did his shelf.

"It had some books on it. I've forgotten the titles, but they were suggestive of various ramifications of a PRO's life. Then he put a few other things on the shelf. There was a bottle of VAT 69 and a carton of Luckies and some loose cigarettes lying around. Also one cigarette, on the edge of the shelf, lighted. It was burning down close to the shelf, and the ash was about to fall off. Strangers would come into that office, and they'd take one look, and either start to grab the bottle of VAT 69 to take a swig, or rush to the rescue of the burning cigarette – you had to be on top of the thing before you realised that it was all a trick of painting."

General Le May continued his description of the excellence of Bairnsfather's *trompe-l'oeil* skills by recounting an episode that occurred after Le May had left Chelveston and which caused a lot of amusement throughout the station at the time as well as a great deal of embarrassment for a visiting VIP. This is how the General told his story:

"The best feat which Bruce performed in the *trompe-l'oeil* line was a decoration he put on the wall of our Officers' Club. That was down at the lower end of the long room, quite some distance from the bar. Bruce painted a big mural.

The artist went to town with a life-sized job which showed an Army Air Force GI standing on the deck of a ship coming into New York harbour. I got to see that picture eventually . . . Course, the GI has his back to the room. He's at the rail, looking out at the skyline . . . big bottle of booze sticking out of one of his hip-pockets. There he is, safely returned from the war in one piece.

But even Bruce Bairnsfather didn't realize quite how far he was carrying his fool-the-eye routine.

. . . I won't say just who the general was. He was a man of importance, very serious by nature, and he wanted everything to go just right and according to the book. He dedicated himself to seeing that it went that way. Probably it was a good idea that he wasn't around in 1942 because things weren't going according to the book and he would have been pretty badly disturbed.

Anyway, he came up to Chelveston for an official visit and look-see; and when duty was done he

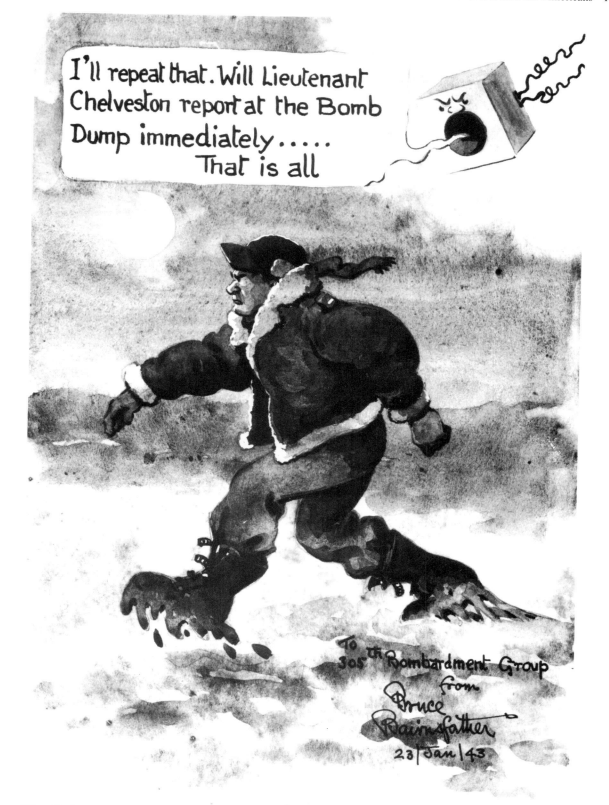

'The Chelveston Mud', reminiscent of Flanders in 1914–18.

(GPR-57 2-305X 15-5-43) (OLD BILL)

Bairnsfather with the damaged "Old Bill" Boeing B–17.

repaired to the Officers' Club, along with the current commander of the 305th (won't say who he was, either) and a few of the select and elect. They were all standing there at the bar, and it was along toward sunset, cloudy and rainy outside, and only a few lights turned on, and not many people around.

The general looked down the room critically. Other people were attempting to keep up a conversation, but he seemed to have something on his mind.

He spoke, sharply and to the point. 'Sergeant!'

The bartender, who was the only sergeant around, came quickly to see what the distinguished visitor wanted. 'Yes, sir?'

General What's-his-name gestured with his glass. 'I don't like to see this sort of thing, Sergeant.'

'Excuse me, sir. I don't quite get –'

'I mean *that* sort of thing,' said the general firmly, gesturing with his glass again. 'I mean that enlisted man down there at the end of the room. He shouldn't be standing there like that. Furthermore, he's not in Class A uniform, and I like to see only Class A in a club. But this is an *officers'* club; he

doesn't belong here. Go down and tell him to go over to his own club where he belongs!'

. . . In due course of time our distinguished general had to walk the length of the room and see for himself just what was a-doing. It has been recorded that he was somewhat embarrassed and annoyed about the whole episode."

Another thing Bairnsfather did was to paint designs on to the noses of the bombers of 305th Group, and the crew of one of those bombers became the most decorated crew in the whole Group. The bomber was named "Old Bill" and Roger Freeman, in his history of the 8th USAF *The Mighty Eighth*, tells the story.

"The 365th Bomb. sqdn., 305th Group, included a B-17F 42–29673 nicknamed 'Old Bill' in honour of the famous cartoon character of World War I trenches created by Bruce Bairnsfather, the British artist who currently contributed cartoons to the US Army newspaper *Stars and Stripes*. This aircraft returned from Heligoland bearing witness to the severest battering a Chelveston aircraft had received and survived. The Luftwaffe had commenced a series of head-on passes at the 305th, as it prepared to unload over Heligoland. In 'Old Bill' oxygen lines were hit and shell fragments entered pilot 1/Lt William Whitson's leg. Co-pilot 2/Lt Harry L. Holt, without oxygen, took over while Whitson went aft to fetch emergency bottles. Holt was almost unconscious when the pilot returned. Revived, he took over the controls again to allow the pilot to have his wounds dressed. Cannon fire from a subsequent attack shattered the plexiglass nose and mortally wounded navigator 2/Lt Douglas Veneable, manning the nose guns, while Bombardier 1/Lt Robert W. Barrall, partly shielded by the bombsight, suffered minor injury. Cannon shells also struck the top turret, leaving gunner Albert Haymon bleeding profusely from a head wound and damaging the operating mechanism. Haymon continued to operate the turret by hand cranking until it jammed. Cannon fire again found its mark in a further head-on fighter pass and Bombardier Barrall, manning the nose cheek guns, was again wounded. Then a 20-mm shell, exploding against the pilot's window grievously wounded Harry Holt. Despite their wounds, Haymon and Barrall took turns at the controls while pilot and co-pilot were given first aid. The rear of the aircraft had also been riddled with bullets and shrapnel, particularly the radio compartment where the operator, Sgt. Fred Bewak, received wounds. Left waist gunner Homer Ramsey had also been hit, but was able to give first aid to the radio man. Only two of the eleven on board (a photographer was present) were unharmed, the tail and right waist gunners.

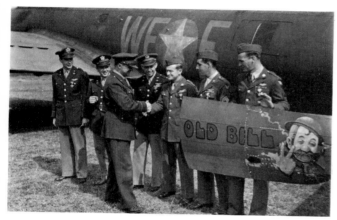

"Bruce Bairnsfather, war correspondent and a famous cartoonist, congratulates crew members of the Boeing B–17 'Old Bill', who have been presented awards during a ceremony at Chelveston, England on 25 July 1943." Courtesy of U.S. Air Force.

With a 200 mph slipstream coming through the open nose, a buckled right wing and defunct hydraulics, 'Old Bill' struggled back to Chelveston where emergency systems enabled the gallant crew to make a successful wheels down landing without brakes or flaps. The crew later became the most decorated in the 305th. Whitson and Barrall collected DSC's for their part; eight Silver Stars and seven Purple Hearts also went to the crew for this action."

The incident, and "Old Bill", attracted a lot of Press attention, including a photograph in *Target Germany*, the official HMSO publication in 1944 of the USAF history which told the story of the 8th Bomber Command's first year in Europe. In the text, however, where much space was devoted to factors affecting morale, there was no mention of Bairnsfather. NAAFI was credited with maintaining canteens, as was the American Red Cross. The chaplain, the doctors, the attitude of the British and the character of the American fliers were all listed as strong planks in the structure of morale. There was little about a sense of humour and nothing about cartoonists.

Bruce's direct contribution to this war's humour was slight, though his ideas from the First War were still being used by others. Bill Mauldin, fellow artist for *Stars and Stripes*, and one of the great American cartoon finds of the Second World War used "The Better 'Ole" situation on several occasions and, of course, so did Bruce. Mauldin began drawing cartoons in 1940 for the *Daily Oklahoman* about the soullessness of Army life. The paper's owner was also publisher of the 45th Division *News*, and used reprints from the *Oklahoman*. Mauldin's biting

observations, often featuring two cartoon characters known as "Willie and Joe", amused the soldiers and infuriated many commanders. While he was serving in the Italy campaign as a sergeant he contributed to both the *News* and to *Stars and Stripes*.

Through cartoons Mauldin spoke for the enlisted soldier against injustice, often so vehemently attacking senior officers that he considered to be unfair or incompetent, that he came close to military censure on many occasions, including a possible court martial. Encyclopaedia Brittanica says that "Bill Mauldin's disenchanted soldiers were proper descendants of Bairnsfather", while Curtis Le May wrote: "It would not be accurate to say that Bruce Bairnsfather was the Bill Mauldin of WWI because he was a lot more than that." Whatever the truth of the matter, Mauldin was not dominated by his creations and went on after the war to become one of the best known and respected social and political cartoonists in America.

However, he and Bruce had an accuracy of observation in common, an ability to capture an atmosphere in their drawings which went far beyond the two dimensions in which they worked. Mauldin

Cover of Jeeps and Jests.

could, and did, speak for himself. Bairnsfather never could. Despite a censure from on high that he always confronted head on, Mauldin won a Pulitzer Prize. If Bruce had been able to counter his Establishment critics in a similar way, bringing their disapproval into the open so that it could be dismissed, he may have then received some official recognition for his work. Mauldin, in the concluding lines of his book, *The Brass Ring* says: "General Patton, home for triumphal parades, had said I was the Bruce Bairnsfather of World War II and that he hadn't liked Bairnsfather either." Bairnsfather could not have written that. He wanted to believe that everyone liked him. That was both his strength as a person and his weakness in his striving for success.

However, in America, magazines and newspapers found space to use his work, though it was almost always presented through Old Bill and written by Bairnsfather as a conversation between himself and "The old warrior". It was a dated and worn-out technique.

Though Bruce continued to draw his cartoons and through Putnams, which had introduced his *Fragments* to America in the last war, published a collection of his drawings made among the American Forces, entitled *Jeeps and Jests*, even his determined spirit was showing signs of accepting the inevitable – that Old Bill would never let go and that it was a dead man's grasp.

One of Bairnsfather's rare portraits, the subject – Major General Russell P. Hartle, who wrote the foreword to Jeeps and Jests.

Bill appears in eighteen of the 103 drawings in the book. Bruce had first joined the American Expeditionary Forces in Northern Ireland, where the Commanding General was Russell P. Hartle, and it is a measure of the American appreciation of his work that Hartle wrote a foreword to the volume:

"Bruce Bairnsfather has an excellent knowledge of his subject since he has studied the American soldier at first hand. During 1942, while I was in command of the American troops in Northern Ireland, Bruce was an honoured guest of our Army there. He hiked through bogs; rode in Jeeps; was tortured in medium tanks; ate in the men's messes and slept in their camps. When he draws a picture of a soldier sleeping in a Nissen hut under a leak in its tin roof, he knows whereof he draws, for he has slept in Nissen huts under those conditions. When he portrays a young soldier puzzling over Irish names like 'Ballymena', 'Ballyclare' and 'Ballycarry', to decide finally that the name of his destination is 'Bally-hooey', he is conveying to the reader with rare and humorous insight an ordeal that many American soldiers – myself included – underwent, and the recollection of which in future days will always draw a chuckle from us."

Bairnsfather could only draw those situations well which he had experienced. In the First War it was that absolute genuineness of his work which made it so funny, but his insistence upon personal experience, upon "sleeping in a Nissen hut under a leak in its tin roof", as General Hartle put it, became the final straw which broke his imagination because he was no longer able to visit the fighting zones to find inspiration. Many cartoons in *Jeep and Jests* are those he drew for *Stars and Stripes*, others are variations on previous themes, and one or two, given an ounce of stardust, could have been equal to *Fragments*. One such shows Old Bill, an American soldier and in the background an old, irate, Irishman.

"What's he mad about buddy? Hitler?" enquiries the American.

"Nao," replies Old Bill, "Cromwell".

The British Press ignored the publication. American reviews were plentiful and generally favourable, as if writing about a favourite son who hadn't quite come up to expectations. The *New Yorker* summed things up concisely with: "Fairly corny by present sedate standards, but a half-dozen of the more satirical pictures are right on the nose," and the more partisan *Weekly Book Review* referred to ". . . Bairnsfather's rare and humorous insight . . ."

During his Chelveston days Bruce found time to paint in watercolour and in oils, primarily for relaxation, but an edge of uncharacteristic cynicism showed through on one occasion when Mrs James went to see him. "He was doing an oil, about three feet by three

feet. It was a haystack. Just a haystack with grass all round. You could see every detail. I asked him who could possibly want a picture of a haystack. He said, 'The picture doesn't matter. All they want is my name on it.' He told me later that he was being paid 100 guineas for that haystack.''

The following year, 1944, he continued his work with the Americans, making the news now and again as a minor celebrity under the permanent shadow of Old Bill. In January he made a trip to Camp Holcomb, a US Marine Corps Base in Northern Ireland. The *Empire News* reported his visit as "Old Bill is Here Again". The copy under the headline both concealed his acceptance of defeat by Old Bill and revealed his longings to break away from cartooning altogether, and to become what Major Tom and Janie would have called "a true artist". The copy read: ". . . the celebrated Bruce Bairnsfather, of Old Bill fame . . . has just arrived . . . to do a series of sketches . . . 'On several occasions I have feebly suggested that Old Bill should get a well earned rest', Bairnsfather told the *Empire News,* 'but the demand continues unabated'. A native of North Chapel, Sussex, Bairnsfather had one ambition: to live quietly in a little ivy-covered cottage amid the quiet smiling English countryside which he loves so much, after this war is over. Meantime, Old Bill and he are still on active service.''

In February he was one of the judges at an exhibition held in Piccadilly, a collection of work by the members of the United States Forces in Europe. *The Star* reported that Captain Bairnsfather had picked out a cartoon drawing that "particularly attracted him". It was entitled "Invasion" and "featured a U.S. Army Officer addressing his men prior to establishing a bridgehead on the beaches across the Channel. His questions to them are: 'Got everything, men? Chewing gum? Chocolate? Peanuts? Spam? OK Let's go' ''. The artist wasn't named, but the drawing was classic Bairnsfather or Mauldin. If Bairnsfather had been capable of envy he would have felt it then. He would have wanted to have drawn that picture. Indeed in his last book, *No Kiddin'*, published a year later in New York, he drew a variation of that exact theme. *The Star's* entry ended sadly ". . . among his other activities, Captain Bairnsfather had been doing decorative murals for Army huts and canteens".

Nevertheless, Bruce Bairnsfather maintained a brave face, the habit of a lifetime. Those around him would not have seen any change in his manner. His underlying character was quiet though he still responded to short bursts of extrovert activity, a trait which the Americans liked in him. In March a "Mock Trial" at Chelveston by 305th Bomber Group, had Bairnsfather accused of painting a "nude". The "nude" in question was a picture of a fish hanging

Bairnsfather's version of a joke which won a U.S. cartoon competition.

over the mantlepiece in the Officer's Club. He was found guilty and sentenced to "continue painting pictures for the Group and to attend the Officers' Club between 5 p.m. and 9 p.m. every evening for the duration of the war and six months afterwards". It was a warming indication of their affection for him and he would have found comfort in it. But there wasn't much war left.

In March he was asked to do a poster for the "Salute the Soldier" savings campaign, using Private John Askham of a Northampton Home Guard unit as a model, and in September *The Star* printed what was probably the last Bairnsfather British war cartoon published. It was titled "The Ghost of Old Bill" and captioned "The foot slogging ghost of the Old Menin Road". A ghostly Old Bill is seen on a typical Belgian tree-lined road. Behind him is a Bren Gun Carrier full of Tommies and a road sign saying "Ypres/Menin". Oddly the cartoon was not new and had been commissioned by *The Star* much earlier when Charles Carrdus, the managing editor, invited Bruce to draw a cartoon which would link Old Bill, (who in Carrdus's words "typified the courage, fortitude and humour of the 1914–1918 Tommy") with the British soldiers fighting Hitler. At that time the drawing wasn't used because of the shortage of space due to paper rationing. Twenty years earlier practically every newspaper in the country would have dropped its leader column in exchange for a Bairnsfather cartoon. Not now. There was still a small hope in America. Putnam's published his last book, *No Kiddin'*, this time introduced by his friend, Major General Curtis E. Le May.

He wrote: "Many of our young fliers had never heard of Old Bill but it was not long before most of them had learned to know him as the modest, genial fellow that "drew that cartoon in yesterday's *Stars and Stripes* . . . Perhaps I fancied it, but just as Old

Bairnsfather was in reality called upon to draw nudes on the walls alongside the beds at Chelveston.

"Hum, Mice Again, Eh?". 1940's version of "Who Made That 'Ole".

Bill had represented the tough backbone of the British Army, so did a new American face of Bairnsfather's – a fighting, flying, face – represent the Eighth Air Force. Maybe this was our contribution."

Le May used the word "genial". Not since World War I had anyone else described Bairnsfather as anything other than "sad" or "reserved". Living on the Chelveston base during the week, away from the restrictions imposed by Ceal's presence at home and amongst young men whose life tempo was quickened by war, Bruce obviously felt himself amongst kindred spirits. It was probably the last time in his life that he was able to shut out reality and to live for his cartooning. He had a clear cut purpose and he makes this obvious in his own brief introduction to the book:

". . . I have had the honour of being attached as an Official War Artist, to the United States Forces in Europe, from the time of their first arrival over here. In this capacity, I have now drawn just on two hundred sketches for that historical American military journal, *Stars and Stripes*.

Many and varied have been my experiences as a roving War Cartoonist, but possibly I value none more than the many long months I have spent with the Eighth Air Force in Flying Fortress Land.

Winter and summer I have shared, as far as it was within my power to do so, the sort of life that these heroic Air Crusaders have had to lead whilst over

on this side carrying out their arduous and hazardous job.

I felt it was the only way to draw pictures, that might in some small measure give relief to the grim and precarious existence of those around me."

The book contains a full quota of Old Bill cartoons, but the collection ranges over some three years, back to the earlier part of the war, and here and there are thumbnail sketches of Churchill, Hitler, and Stalin which originated in the promising days of 1939 when, with the war, opportunity knocked for the second time. There is a hint of the genius of a Phil May behind the likenesses, yet their message is only what might have been.

No Kiddin' also illustrates the essential Englishness of Bairnsfather. Despite the wrongs, real or imagined, that he had suffered from the British authorities, despite the fact that it was the USAF which had employed him, despite his love of things American, despite the fact that the book was being published in New York, not one American personality appears in it other than a photograph of General Le May which appears above his introduction. But Churchill and Monty are there.

It attracted far less attention amongst the American reviewers than *Jeeps and Jests* had done, although *Weekly Book Review* remained a firm fan saying: "Bruce Bairnsfather has lost none of his skill

and his humour is warm and wise and unforced. There are many fine cartoonists depicting military life today, but this artist's work is still something special." However, few people who had taken a view over the total of Bairnsfather's work would have agreed with the reviewer. Certainly he had been special in earlier days, and on a rare number of occasions he could still fire on all cylinders, but there was nothing dramatically new.

There are two drawings in this last 1945 book which are, apart from a change of clothes to suit the later war, the same as two drawings in his first 1915 book of *Fragments*. "Gosh! There must have been some careless talk", is the twin of "They've evidently seen me!" and there is the inevitable Better 'Ole – this time with Old Bill saying to an American soldier, "Don't know what it is but there's somethin' about this war that reminds me of the last 'un!" The wheel had turned its circle.

In 1945 the war ended. Old Bill was out of a job. In 1945 Major Tom died, leaving just over £1,000, not enough to support Janie. Now it was up to Bruce. In 1945 Captain Bruce Bairnsfather submitted to the Royal Academy an oil painting of a country scene by a viaduct in Shropshire.

It was turned down.

The picture that was turned down by the Royal Academy, much to Bruce's disappointment in 1945.

Bairnsfather as caricaturist, proof that he would deserve a place in the prestige exhibition, "English Caricature" in 1984–5.

Belligerent Tourist

Liberation

The Fortress doctor

The Unicyclist

Chapter 16

Popularity on the Wane

(1945–1950)

Barbara Bairnsfather remembers that the rejection of the picture upset her father very much. "He debated submitting the picture under another name so as to get an unprejudiced appraisal," she said. He didn't, though. There can be no doubt that he was seen only as a cartoonist and had been so for thirty years. Very clearly, a picture submitted to the Royal Academy by the cartoonist creator of Old Bill was likely to start at a considerable disadvantage.

Bruce's first concern was for Janie now that Major Tom had died and he brought her over to the Old Forge from Goffs Farm to live with Ceal and himself. It cannot have been an easy existence and Ceal would certainly have been difficult about it. Work was drying up and now, approaching sixty, even Bruce's formidable energy was declining.

Nevertheless, although he concerned himself more and more with landscapes, he continued to submit advertisements or cartoons to British clients that had used him in the past, but few were accepted. His output was still considerable, because it was in his nature to draw continually and his strip cartoon work was still being used by Bell in America.

When Barbara left the ATS and came home in May 1946, finding a job at the local cottage hospital, he roped her in to help out with his amateur theatricals at the "Petworth Hippodrome", and they would invite local friends in for an evening's entertainment. Another Barbara, Barbara Stewart, who lived in Petworth as a girl, went to the Bairnsfathers' several times and recalls the occasions very clearly.

"Now and then we were invited to spend an evening with them. This was usually because he and Barbara had a new show for us to view! They had made a miniature theatre and gave the most beautiful performances. Barbara did all the costumes and sets, but between them they wrote the scripts, worked the puppets and did the various voices, not to mention working the gramophone for the musical numbers. You were shown to your seat in the old barn, given a programme and then watched eight or ten sketches starting with the dancing girls. There was an interval half-way through for them to do costume changes and it was all done most professionally."

Barbara Stewart had also met Major Tom and Janie, and recalled that Janie was still painting her beloved birds, but it is on the intensity of Bruce's work that she is particularly revealing: "Once when we went for an evening's entertainment Bruce didn't appear for about an hour and when he arrived made profuse apologies saying that he'd got rather bogged down with work. My mother asked him how many cartoons he had to do and he replied that that week he had forty to do . . . but normally it was about twenty a week, all for the American market. Can you imagine twenty a week? No wonder he had a breakdown!"

Precisely when Bruce's breakdown happened is not clear, but it was probably just after the end of the war, when the additional burdens of his father's death and mother's dependence, were added to the daily strain of life with Ceal. Despite all the pressures, he still found time to write to the newspapers and attract attention. He hadn't lost his love of being in the news.

At the beginning of 1946 there was considerable comment in the Press about a cartoon character known as "Chad". Chad always appeared as a bald head and a long nose peering over, and from behind, a wall, his head flanked by the fingers by which he was apparently holding on. The caption under a "Chad" joke invariably began "Wot? No . . .?"

On 2 February the *Daily Mirror* carried a story headlined "Now Chad's father turns up". There was a signed drawing by Bruce of both Chad and Old Bill looking over the Chad wall, with underneath the line, "Wot? Yer didn't ask yer Dad?" The story suggests that Chad was descended from Old Bill and that "Mr Bairnsfather claims Chad for son". It was unlikely

that Bruce would have made a serious claim, for Chad's exact origin was at that time as confused as that of the famous "Kilroy". The story goes on and compares Chad to Old Bill.

"He has the same itch to pop up and ask the questions that put the lid on pomposity. Mr Bairnsfather . . . gave the *Daily Mirror* Old Bill's opinions on the Young Pretender, Chad, in the smithy he has turned into a studio at North Chapel, near Petworth, in Sussex.

"Everybody knew Old Bill. When Mr Bairnsfather was in Japan some years ago he was always being asked to draw. 'Old Bill pliss', the Japs wanted. Now that has never happened to Chad yet. Nor has anyone come forward and claimed proudly that he is the original Mr Chad. That's happened to Old Bill lots of times. Mr Chad should feel very small.

"Still, Mr Bairnsfather and a forgiving Old Bill may take Chad with them when they tour the United States . . . the Americans want to see some more Old Bill drawings and they may like to meet Mr Chad."

The true creator of Chad was George E. Chatterton the cartoonist who signed himself as Chat. Chat had first drawn Chad while a recruit at RAF Cardington in 1938, but during the war Chad's "Wot? No . . ." comment on shortages ranging from food to women, caught on, particularly with the RAF in whose weekly newspapers Chad appeared. Oddly, Chat's own most memorable cartoon was one entitled "Burma" Bill which he presented to Field Marshal Viscount Slim of Burma, and later Chat, like so many others, would draw his own version of "The Better 'Ole". Long after the war when shown the *Daily Mirror* story Chat said: "I think this was just a newspaper gimmick! I do not believe that Bruce said half of this."

The Chad incident was probably a Bairnsfather ruse to attract attention. He was getting very little Press notice. But there are sad indications between the lines of the *Mirror* story. Firstly Bruce obviously felt it necessary to "puff" Old Bill. Perhaps he was feeling insecure about the lack of work in Britain, and there is an implied rebuke in the reference to the fact that the Americans, and not the British, wanted to see some more Old Bill drawings. Whatever the substance to the *Mirror's* assertion of Bruce's claim on Chad, the American story was accurate, and he, Ceal and Barbara left in August, renting out the Old Forge to holidaymakers.

In America they based themselves first in Boston and then in Providence, Rhode Island and Bruce set off on lecture tours arranged through his agents Colston Leigh. Barbara found herself a job at the Butler Hospital in Providence, and when her parents re-turned to Britain the next spring she stayed behind.

Janie, now in her late eighties and suffering badly from arthritis, must have posed considerable problems for Bruce and typically he wanted her to stay with him rather than in a nursing home. To make things easier in the limited space at the Old Forge he commissioned a local architect/builder F.J. Hodgson to extend the building. By coincidence, Hodgson's daughter, Monica, had been at school at St. Catherine's, Guildford, with Joy Bairnsfather, the daughter of Bruce's forgotten brother, Duncan, and she remembers what Bruce gave her father when the job was completed in 1947. "Bruce Bairnsfather did an Old Bill drawing and gave it to my father as a gift. I have this here now, framed and hanging in my lounge as my father gave it to me several years before he died . . . it depicts Old Bill standing holding an ornate door knocker in his hand and talking to one of his mates. The caption reads, 'Wonderful old door knocker, ain't it chum? All I wants now is a licence to put an 'ouse round it'. This was a joke because my father had great difficulty I remember . . . in obtaining a licence and permission from the authorities to do the conversion work."

That same winter, 1947, Bruce and Ceal went back to America for another tour. It was a punishing schedule. In December the *Evening Standard* reported "Old Bill on tour" and went on to list celebrities taking part in a lecture tour of America ". . . Bruce Bairnsfather, the cartoonist creator of Old Bill ("still looking for a Better 'Ole"), MP Beverley Baxter, Hector Bolitho, the Dame of Sark. A US lecture tour calls for a leather larynx and unlimited resistance to travel fatigue. Fees run from £8 a night upwards – plus free board, travel and meals. Fifty per cent of the takings go to the agent." The quip about "still looking for a Better 'Ole" must have hurt Bairnsfather because clearly he was not making very much money. The lecture tours would have been a method of paying for life day by day and very little more than that. The next year, when Barbara married Bill Littlejohn whom she had met in Providence, Bruce and Ceal managed to attend the wedding by paying for their Atlantic passage with yet another lecture tour. One stop on that tour was in New York at the McMillin Theatre in Columbia University, and Joy Bairnsfather who had gone to New York in 1941 and married Robert Evans there six months later (she has since remarried and is now Joy Hoban) went along to listen. "His lecture consisted of amusing patter accompanied by lightning cartoons which he passed out after the show. My Aunt Ceal was with him and always stood at the back of the theatre and said she had strong telepathic communication with him. I remember he wore a beret a great deal as he was very conscious of his baldness." Bruce was tiring,

Barbara's wedding picture. Left to right: Bruce Bairnsfather, William F. Littlejohn Jr. (the bridegroom), Barbara Bairns-father, William F. Littlejohn Sr. (father of the bridegroom), and Mrs. Celia Bairnsfather. Providence, R.I., 14 August 1948.

and he was running out of funds. At the end of the tour they went back to North Chapel and Bruce decided to sell the Old Forge.

The expense of the wedding, the increasing difficulty of caring for Janie and his ever-decreasing income, were all factors in the decision. Over the previous three years the Bairnsfathers had let the Old Forge as often as possible when away, using the smaller Barn Close for themselves whenever dates clashed. The decision to sell was hard. They had been at North Chapel for ten years and while they could remain in the village at Barn Close, even when the Old Forge was sold, it could not be the same. It seems likely that the sale of the Old Forge was principally to raise enough money to find Janie a permanent place in the nursing home at Godalming. In any event the house went on the market in July 1949, and the asking price was £7,500.

On 9 April the *Daily Mail* carried a photograph of Morland Graham with tin hat and walrus moustache, "in his best known part". The title of the piece was "Old Bill Dying in a Car". Morland Graham had died the night before, aged fifty-seven. When he had played Old Bill in *Old Bill and Son* in 1940, Bruce had said: "He's Old Bill come to life. It is as if he had

stepped out of one of my own sketches." The death of another Old Bill marked the coming end of one more phase of Captain Bruce Bairnsfather's life. He had only one more US tour to make and this time he set off alone for America early in 1950, and while there he saw his daughter for the last time. They had dinner together at the Mayflower Hotel in Washington, neither realising that it would be their last meeting.

Bruce was sixty-three years old. He had been the most famous cartoonist in the world. He had made and lost a great deal of money, and travelled the globe. Once everyone knew him, now he was only remembered by some. Yet his fundamental character had not changed, he was still a quiet, reserved, honest individual, with a streak of impish humour that could not be repressed for long. Having weathered the corrugations of success and failure, Bruce made his final return trip back across the Atlantic from New York, and on the same voyage was Jean Appleyard, who recalled their meeting.

"I had the pleasure of meeting him on the liner *Caronia*, voyaging from New York to England in 1950. I was seated next to the late Sir Alexander Fleming at the Captain's table, and the Captain arranged a small informal dinner party so that we,

The view from the cottage at North Chapel, looking across the Sussex Weald, that Bruce left in 1950. His watercolour impression.

his table-mates, could meet Bruce Bairnsfather. During conversations Bruce Bairnsfather was quietly making a drawing on the back of a menu card. I asked him if we might all see his handiwork – there in a few moments was a drawing, of an absolute likeness of Sir Alexander Fleming, and yet still 'Old Bill' holding his mug of beer, with the caption 'To the Bloke what did what Pasteur did'. BB (presented) the sketch to Sir Alexander Fleming (who) in his dour Scots manner, also shy and retiring, stuffed the sketch into his pocket with a Humph – but obviously greatly appreciating the gesture."

On 21 April, 1950 the Press was waiting for the last time to greet Bruce on his return. Old Bill was still as popular as ever, according to his creator. "I met him everywhere, and sometimes had to autograph as many as 70 copies of him [sic] a night." Then, slipping nearly twenty years in time, he recalled, "Even in Japan, when I asked what audiences would like me to draw, the answer was generally 'Old Bill'." The memory of his rapturous reception in Japan was one he fell back upon when times were bad. They were bad now for he was returning with no contracts or prospects in view.

The letter home

Chapter 17

The Twilight Years

(1950–1959)

Bruce and Ceal now lived by themselves in Barn Close. Ceal was becoming more and more difficult, still seeking refuge in alcohol. They had had a daily help for some years, since Bruce's Chelveston days in fact, and one of those was Mrs John Carter from nearby Sandrocks Cottages. Her brother-in-law, Dave Carter, remembered that she worked a full day every day, including cooking breakfast for Ceal.

North Chapel is a small village, and gossip had it that Mrs Bruce Bairnsfather was "a bit funny". She was hardly ever seen out and about. There is no doubt that Ceal from time to time still overdid her drinking to the extent of having to be carried to bed. Bruce had always covered up for her and he continued to do so, but it was becoming embarrassing as well as difficult. They had decreasing social contact with those about them – not that they had had a great deal of such contact for some years. Bruce therefore had less and less time in which to draw, as the need to tend to Ceal increased. Whatever he was able to produce he found difficulty placing. Once again they were in need of money, and for that reason put Barn Close up for sale at the end of 1950 and began to look for somewhere else.

When both the Old Forge and Barn Close at North Chapel, their home for longer than anywhere else, were sold, they started a period of wandering and moving, searching for a safe haven, for their own Better 'Ole. The calm English countryside of Hereford, where Bruce had spent his first years in England when Major Tom and Janie first brought him home from India, seemed the obvious choice. While looking for a place, the Bairnsfathers stayed at the picturesque old inn, The Feathers, at Ledbury.

The Captain's incognito image was soon spoilt. He was quickly recognised, sitting quietly at the bar, the cap that had almost become his trade mark pulled jauntily, or defiantly even, over one eye. He was hailed as "Old Bill" and was soon drawn into activities at the local British Legion and police gatherings doing sketches, mostly of Old Bill, of course, which according to a local fan, he'd "give out indiscriminately to those assembled".

The strain of living out of suitcases, of being forced to act the local celebrity but with no work or income to match the title, soon began to take its toll. They decided to move again – nearer Eardisley and the house of his aunt and uncle. Driving over the beautiful Brecon hills, looking for a suitable cottage, they came across a solitary café at Winforton, known as The Old Cross. Its isolation and its solid timbered walls attracted them. On impulse they went in and asked for rooms. The manager and manageress, Mr and Mrs Mutlow, were quiet, kindly and uncurious folk – just what the wanderers needed. Bruce was himself beginning to feel unwell. Ceal was suffering badly from her ever troublesome "nerves". They needed peace and quiet and complete anonymity. The Mutlows were sworn to secrecy about their once famous guests and respected the Bairnsfather's confidence and need for privacy. Bruce told Mr Mutlow that he had moved from The Feathers because he was always recognised and people flocked to see him. Ceal rarely left her room. Mrs Mutlow took her meals up and most days she spent entirely in bed. Bruce soon benefited from the recuperative beauty and peace of his surroundings. He drove round the countryside, often taking Mr Mutlow with him for company, stopping the car to make a sketch when he was particularly taken by the beauty of a scene.

He seemed perpetually sad and desperately worried by Ceal's condition, which didn't improve. Sometimes on his expeditions with Mr Mutlow, they'd stop for a pint and Bruce would relax for a while and chat happily. They once spent a memorable day at a local agricultural show, and the relationship obviously acted as a salve to Bruce, Mr Mutlow playing the familiar comforting role of Old Bill to Bruce's "Capting".

In June of that year the Bairnsfathers became

Bairnsfather's impression of the countryside of his youth, to which he returned in 1950, in search of his "Better 'Ole".

grandparents for the first time. Barbara's boy was named Bruce Every Littlejohn, acknowledging both grandparents. Bruce – not Ceal – wrote a warm and joyful letter on hearing the news and enclosed a typical sketch.

Things looked slightly brighter when Bruce was commissioned by the brewers, Mitchell & Butlers to do some ads for their beer. But Ceal was still constantly ill and Bruce's cover was beginning to be blown. He seemed to be torn between his desperate need for privacy and a yearning for the fame and recognition he used to enjoy. For despite his protestations to the Mutlows that no one should know of his presence at the café, he flaunted the unmistakable Old Bill mascot on his car. One day a party of Welsh miners, driving through, stopped at the café for a meal. Spotting the mascot they rushed in shouting: "Where's Old Bill? There's his badge on the car, go and get him, we're not leaving here till we've seen him." Mr Mutlow discreetly told Bairnsfather and he agreed to come and meet the miners. He shook hands all round and true to form, sketched them an Old Bill on the white café wall. They went away happy.

Again when his car needed repair and Bruce wanted it back in a hurry, the mascot did the trick – the car was repaired immediately. After seven or eight months' stay, the Bairnsfather's moved on in September 1951, back to Colwall, leaving Mrs Mutlow with a Bairnsfather picture on the café wall.

Whilst at The Feathers Bruce had made the acquaintance of a bricklayer, Mr Daniels, who lived with his wife and children in a cottage on Jubilee Drive, Colwall, nestling on the side of the glorious Malvern Hills. As with Alf Mutlow, Bruce felt a strong affinity for Tom Daniels and asked him to find a suitable home for him and Ceal. Tom found just the thing – Dial Cottage, Evendine, Colwall. The cottage, although charming and full of potential, needed a lot of work.

Ceal's illness showed little signs of improvement. Probably the most constant visitor to Dial Cottage was her doctor, Dr Peter Richardson, of North Malvern. Before they consulted the doctor, Bruce went to buy a fireback from the Richardsons to install at Dial Cottage. The doctor was surprised to learn that the stranger who came to pick up the fireback was the

...in the Crown Jewels and were trying to export them. Well, here's to Fewtie and Fill and Forah Every Littlejohn. May everything go bitter well with you all. Love Dad.

we have with us tonight—

BRUCE EVERY LITTLEJOHN

(A new Lecturer is born)

Bruce's comment to his daughter, Barbara, on the birth of his first grandchild.

famous World War I cartoonist. "Good Lord," he said, "I thought you were dead years ago." Bruce was, however, seriously ill. Though everyone who met them was conscious of Mrs Bairnsfather's illness, few people knew that at this time Bruce underwent the first of a series of operations at Worcester Royal Infirmary performed by the surgeon Philip Nicholas. The operation removed what would be a recurring and increasingly serious growth in his bladder, which caused him a great deal of pain. As always, he concerned himself first and foremost with Ceal's troubles and minimised his own. Writing to thank Barbara for a splendid Christmas parcel in 1951 (most of the contents of which were sadly stolen before it was delivered) he commented: "I am much better, but a repair job like I had takes time to absolutely be right. However I astounded both surgeon and doctors at speed of recovery." His relationship with his surgeon became one of friendship too, and Bruce painted a portrait of the Nicholas's daughter Mary. Bairnsfather had never considered himself to be a portrait artist, but he was very taken with the little girl and wanted to see what sort of a job he'd make of it. The family felt it was a fair likeness. Both medical men (Richardson and Nicholas) remembered Bruce as a man who, although virtually a recluse and a very "sad" person, had no self-pity and whose every thought was for his wife. By this time Ceal was labelled "a chronic invalid".

Bruce's main solace was Tom Daniels. They became "great pals" and Tom accompanied Bruce when he did guest "turns" at local functions. He was the ideal Old Bill surrogate, helping Bruce with his props, and acting as his assistant. Bruce's support for and interest in the Royal British Legion was as strong as ever. When the members of the Colwall British Legion discovered that Old Bill's creator was living in their community, they prevailed upon him to draw three cartoons to hang in their club. In February 1952, for the payment of two bottles of whisky that he consumed on the job, he did three splendid drawings on the sliding partition. They have since been framed and over 20 years later still took pride of place in the club.

He also took an interest in the Old Contemptibles organisation. He painted a magnificent pub sign in oils for the Birmingham branch's meeting place, The Albion, on the corner of Livery Street and Edmund Street. In honour of its fine new sign of a World War I soldier warming himself by a coal brazier, the pub changed its name to The Old Contemptible. Bruce occasionally attended the group's meeting, revelling in the company of the dwindling band of Old Bills.

In September the *Hereford Times* published a specially drawn sketch of Old Bill saying "Ullo Hereford", when Bruce spoke at the Hereford Rotary Club.

Another exposure in the Press at about this period,

Programme for Farval and Denco's Annual Christmas Party, 12 December 1952.

this time in a national paper, the *Daily Mail*, was an updated version of "The Better 'Ole". Bruce drew Old Bill in his famous hole with the "Red Dean" of Canterbury as his companion. Bill was exhorting the Dean to go to his better 'ole in Moscow. Again he showed a great caricaturist's talent in his portrayal of the controversial cleric.

Neighbours remember the Bairnsfathers at this time as a couple who were "seeking refuge", and who appreciated being shown a lack of curiosity or interest in their lives. Bruce made a studio on the top floor of the cottage and amidst clouds of cigarette smoke painted delightful oil and watercolour landscapes from the sketches made driving round the Hereford countryside in his battered old Morris. He still found it difficult to get commissions or to sell in Britain, but the landscapes sold well in the United States.

From this time onwards everyone who was remotely close to the lonely couple had the impression that there was a rift between them and their daughter, and that for some reason they disapproved of her marriage. Yet Bruce continued to write affectionate letters to Barbara, signing them by his nickname to her,

"Sam" (from Singapore Sam, because of his love of hot climates) and always referring to Ceal as "Mim", Barbara's baby name for her. To compound family worries, Janie, who now lived permanently in the nursing home at Godalming, enjoyed varying health. She was almost crippled by the arthritis that had become progressively worse since Bishopton days. Joy, Duncan's daughter, who had replaced her favourite younger son in her affections, and whom she had brought up as her daughter, lived in America, as did her other grand-daughter, Barbara. Janie missed both the girls.

It was probably to be nearer her that the Bairnsfathers moved in 1954 to Thames Ditton, to a cottage called Two Rivers, Ember Reach. Bruce's bladder condition was deteriorating, however, and his visits to Worcester for treatment by Philip Nicholas became more frequent. During these visits the Bairnsfathers stayed with the Daniels in Jubilee Drive. The views from the cottage were superb, the Daniels themselves quiet and kindly, and it all helped to soothe Bruce and Ceal. Realising that the Bairnsfathers had little money, the Daniels tactfully fixed an

extremely low rent which they felt their "paying guests" could afford.

In 1954 the only publicity Bruce received from the national Press was in April, when his beer adverts caught some attention. "Will the younger generation know Old Bill?", was the question the article raised.

The whole Daniels family came to love the shy, sad, but once-famous man who derived such obvious comfort from their company. They admired the way he coped with the great amount of pain he frequently suffered, and his devotion to his wife, whom they found "highly strung" and difficult to live with. Sometimes the nervous condition got so out of control that Ceal had to be moved to a hospital or nursing home. "Nerves" was so often a euphemism for illnesses that society finds indelicate to name – and the weakness that plagued their marriage for so many years was never really cured.

To the Daniels' children, Michael and Ann, Bruce was like a favourite uncle. He made models for them as he had done for Barbara, the best remembered being a Nativity scene in a church for Christmas, which lit up.

Christmas greetings to the Daniels family.

When young Michael Daniels was off sick from school, to amuse him Bruce worked up a conjuring act with him – Bruce playing the snake charmer sitting cross-legged on the floor, making oriental music with comb and paper while Michael operated the snake that emerged magically from the waste paper basket. Some of the "business" was so hilarious that Michael would laugh till the tears ran down his face.

Bruce liked to potter in the kitchen, and Mrs Daniels taught him how to make pancakes – which resulted in a sketch. When Michael went to camp in the Forest of Dean Bruce again commented in typical cartoon fashion. At Christmas time even Tim the cat

Visual note to Mrs. Daniels, who taught Bruce how to make pancakes.

Bairnsfather's suggestion for "The Red Dean" of Canterbury in the Daily Mail, 1952.

Hey! If yer knows of a better 'ole, why dont yer go to it?

and Chunky the dog got their own Christmas cards. Bruce spent much time sketching along the Malvern Hills and presented the Daniels with a delightful picture of their cottage.

"Old Bills' deaths" were still being reported. On 5 September, 1955 *The Times* described Harry Thurston, who died in New Jersey at the age of eighty-one, as being selected by Bruce Bairnsfather to play the part of "Ol' Bill" . . . "He joined the Army in 1914 but was invalided out two years later and it was then that his great opportunity came with the production in 1917 of *The Better 'Ole* at the Oxford. King George V and Queen Mary were present at the first performance. It was indeed a remarkable performance, at once whimsical and sardonic, and it was moreover, exactly attuned to the mood of the public at the time, anxious for a few brief moments to turn away from the grim contest across the Channel. By no one was it more appreciated than by troops on leave from the appalling slaughter of the Somme battles. Thurston played it with a verve that was irresistible and there were few, indeed, who did not go to the Oxford to see him at least once." The obituary was, indirectly, a marvellous tribute to Bairnsfather's creation and, of course, to Thurston's interpretation of it, implying that he was the original stage Old Bill.

Miss Clem Humphries protested in a letter to *The Performer* (which carried a similar tribute) that her father, John Humphries, was "the first to bring this character (Old Bill) to life in the sketch 'Bairnsfatherland' in Albert de Courville's revue *Flying Colours* at the London Hippodrome in 1916, and later in another sketch in André Charlot's revue *See Saw* at the Comedy Theatre". She went on to explain that Arthur Bourchier had played Old Bill in *The Better 'Ole* and that, "the morning after the Première one critic suggested that Mr Bourchier should take one night off and go to the Comedy to see how the part should be played. Mr Thurston played the role for the last week of the run of *Flying Colours* while rehearsals were in progress for the next production and he may have toured with *The Better 'Ole* but to claim that he created the role in any sense is untrue." Miss Humphries' assertions were backed by Edwin Ellis, who also wrote to *The Performer*. He confirmed that Thurston took the "Johnson 'Ole" sketch on tour. Ellis had played with John Humphries in the original sketch at the Hippodrome.

Bruce would no doubt have been gratified that Old Bill could still rouse such passionate controversy.

The year had begun with an even sadder event. It was the death in New York of Constance Collier at the age of seventy-five. She had become a revered Shakespearian dramatic coach in the United States and her obituary was a glowing account of her glittering and versatile career. She was described as "the helpful friend of John Barrymore, Noël Coward . . . and Kathleen Hepburn". Sir John Gielgud was amongst many fellow actors to pay loving and admiring tributes. There was no published word from Bruce Bairnsfather.

The stays with the Daniels became more frequent and lengthier. It obviously became too much of a strain to keep up the cottage in Thames Ditton and a more practical proposition was to move nearer Worcester and Bruce's surgeon, Philip Nicholas. The house was sold and the news appeared in *The Star* on 30 May, 1956. The paper reported that "Captain Bruce Bairnsfather . . . is off to America for a three month visit with his wife". The trip could well have been planned and then fallen through, though more likely it was a white lie told by Bairnsfather to cover the real reason for moving.

The Bairnsfathers had found a suitable home in the little village of Norton near Worcester. The cottage needed a great deal of work to make it comfortably habitable. Ignoring his failing health and strength, Bruce, who had managed to make a pound or two on the previous cottages he had "done up" and resold, tackled it with enthusiasm.

While he was busy with Chapel Cottage, Littleworth, Norton, he wrote frequently to the Daniels with progress reports, interspersed with details of Ceal's bouts in hospital and her "nerves", which were "getting out of control".

Barbara, too, was regaled with details of the cottage's improvements and he even drew two pictures for her showing different views of the house. He proudly told her: "All you see is my own lay-out. The two brick pergolas are my own construction . . . I constructed the Lych gate entrance . . . There is a seat I made beneath the windows shown in picture 'A'. When fed up with work inside I come out and sit there and think of inflation and ultimate ruin."

Acquaintances from this last, sad and lonely period

Bairnsfather's painting of Chapel Cottage, Littleworth, Norton, after the renovations. The final 'ole.

of his life recall: "He was a very sincere man, a patriot and he was very sad when he heard people making derogatory remarks about Britain." The man in the street still remembered him and Old Bill. In January 1957 the correspondence columns of the *Daily Telegraph* printed a series of letters on the perennial riddle of the model for Old Bill.

The first letter maintained that Bill, like "the Capting" was in the Royal Warwicks, the second writer always believed that the model of Old Bill was a Birmingham train driver, the third claimed that Private Copestake "had known Capt. Bairnsfather and if he was not Bairnsfather's inspiration he was his twin brother. I was told that when the likeness was first noticed he was not entirely flattered but as Old Bill's popularity grew he began to take some pride in the resemblance, particularly as from time to time it brought forth the odd 'buckshee pint' ". The fourth letter pooh-poohed the Copestake theory. It was written by a Mr Busby (which was indeed Old Bill's surname) who claimed that his brother was presented by Seymour Hicks with a picture captioned "From Bruce Bairnsfather and Bill Busby to another Busby"

and the final letter recalled Bruce doing his "chalk and talk" at an American Army Unit in Bromyard, Hereford to raise funds for War Savings. "He informed his audience that Old Bill was entirely a creation of his own and that no individual had inspired him" – at last the truth was reached and the correspondence finished.

Bruce was very much alone in these last years, but he eventually found another Old Bill to chat to, to help him with the improvements, in the shape of a villager, Bert Knight. "Me and him was pals for a couple of years," Bert remembered and he was delighted to help the Captain build his studio, a new porch, ornamental arches and the well and fish pond. As so often happened, Bruce's quiet charm worked its magic on Bert. "I never met a better man . . . he was as straight as a die . . . he would never show any of his troubles . . . he's the world's finest cartoonist . . . he was as good a soul as ever lived." Bert accompanied Bruce to South Bank Nursing Home when he went for treatment and despite Mrs Bairnsfather's protestations that "it wasn't serious" was one of the first to realise that the new friend he had come

Evening on the Arrow. A chalk and crayon drawing done by Bruce in the last years.

Bert Knight. The final real-life Old Bill.

to love was suffering from cancer.

If Bruce knew at this stage he certainly kept it to himself and made no allowances for his physical condition. As always, his primary concern was for Ceal – "Funny" as he had come to call her. He made plans to build a cottage in the garden for her sister "Bunny" to come from London to be near her, but he was never well enough to see the plans through. His correspondence gave little hint of the seriousness of his own condition. In February 1958 he wrote to Barbara with solicitous concern about her mother: "Mim is very frail and seedy these days, and I have a full-time job looking after her, and the place as well. The base of the trouble is nerves . . . I have to watch her like a cat, and do everything myself to keep her well at all." The situation was not helped by the appalling weather. "We are having synthetic South Pole weather at the moment and I feel like Hilary every time I go out shopping." A fortnight later he reported: "Over here the weather during this last week has hit the jackpot in horror. Snow, ice and blizzard . . . The Severn is 9 feet above its normal level. Over a hundred main roads blocked with snow. Several towns and villages cut off. Just the right weather to be sent out for a lecture tour (as I have been before now!)."

When the thaw came, Worcester and the surrounding villages were hit by torrential floods and Bruce was interviewed on television about the freak conditions round his village of Littleworth. During all this

he was struggling to keep up his visits to his mother. He told Barbara she was "very weak now, and hardly knows me, but she is I am glad to say in a splendid place. She will be ninety-eight before long. The nuns who run the place are excellent and look after her well."

Work was very hard to come by, even when he felt well enough to do it. But he still struggled up to London, looking for new commissions and talking bravely of a "TV job" that was to have been shown coast to coast on 5 November in a programme called *Close Up* on Canadian television. He considered selling the house, but in July withdrew it from the estate agents after only three weeks, despite the fact that he was offered £2,200 which was little short of his asking price of £2,500. He had several reasons for his change of plan – firstly Ceal liked the place: it was now looking most attractive, the garden a riot of colour in the summer sun. Secondly the hassle of a sale, a move, and finding another house all seemed too much. He wrote to the Daniels about it: "As you know I once said 'If yer knows of a better 'ole go to it' (but if you *don't* know of a better, it is advisable to stay in the one you are in)." But the asking price for Chapel Cottage tells a more fundamental story. The Old Forge had fetched three times as much. The Bairnsfather's finances were draining away, and

Letter to the Daniels, with the decision to stay on at Littleworth.

The people who wanted to buy the place said "I wonder you can bear to leave it".
The Bungalow has now been built, where the orchard was, and strange to say it is an improvement. No trouble at all, and looks nice.
As you know I once said "If yer knows of a better 'ole go to it", (but if you don't know of a better, it is advisable to stay in the one you are in).
Anyway, this is where we will be now for some time, and this being so, I have got rid of the car. Not sorry either, as motoring today, is a headache, and not a pleasure.
There is also such a good bus

Bruce was forced to sell his faithful old Morris, maintaining with true grit that "motoring today is a headache, and not a pleasure . . . Driving in Worcester is more like playing polo in a car these days".

In August he was interviewed by the *Birmingham Weekly Post* for their "Midland Portrait". It was headed "Old Bill Bairnsfather" and although describing his cottage in general terms and referring to it as his "Better 'Ole" they would not "divulge its whereabouts. Recently in an unguarded moment, Bairnsfather wrote a letter to a national daily giving his address. An avalanche of fan mail swamped him and, a kindly man, he does not like failing to reply to any letter, but just could not cope with it at all". This referred to a letter he wrote to the *Daily Mirror* on 28 June. A reader had stated that Reginald Smythe, creator of Andy Capp, "was the greatest humorist since Bairnsfather". Bruce wrote: "Seeing Mr Smythe and myself mentioned together in a reader's letter the other day I thought a meeting should take place between Andy and Old Bill. I therefore enclose a drawing which may interest your readers." It showed Andy Capp, saying "If yer knows of a better Capp . . . wear it!" to Old Bill, who replied, "Ullo". The paper reproduced "The Better 'Ole" and gave a brief resumé of Bairnsfather's career. Bruce was described as "a bulky man who carries his seventy years lightly".

The Birmingham profile prefaced a series of articles by Bairnsfather in the *Weekly Post*, the last he was ever to do. They started on 2 January, 1959 with the story of how Old Bill was born – the same old story but with new pictures, which showed that Bruce hadn't lost his touch. The paper reprinted a song of the First War that someone on the staff had recalled:

"Where's Old Bill?
We can't find Bill
Has he got a Blighty one
Or has he got a chill?
Send the enemy word to say,
"Can't play, Bill's away,
There won't be any war today
We can't find Bill"

The following week Old Bill's story continued, "Slithering about in Plugstreet Wood". It was accompanied by a sketch showing that Bairnsfather's observation was as acute as ever. Two Teddy Boys are looking at Bill in a glass case, commenting, "Rum Lookin' Bloke Ain't 'E?"

The third and final article ended with an anecdote describing an episode during his last lecture tour. Bairnsfather arrived at Vancouver from Seattle by train to be greeted by a group of Pressmen. "Draw 'Old Bill', someone shouted, as the cameras started to flash and click. So, there and then, I was backed up alongside a monster diesel and had to put a life-sized 'Old Bill' on the flat steel flank of the engine, whilst the driver looked out of his cab and smiled." It was a memory of a triumphant moment of recognition that he obviously savoured in these lean days. The *Post* articles produced a letter from Bruce's old Company Sergeant, A.E. Rea, then seventy-five. It read:

"It would be impossible to convey what your articles by Captain Bruce Bairnsfather on Old Bill meant to me, having been his Company Sergeant from the time he became Training Instructor in the Isle of Wight until I was gassed on the Somme and invalided home.

I have not seen him since, but by his racy stories of those early days I am delighted that his old free-and-easy style still survives. The memories of many happy days before going overseas and the nightmare experiences of 'Plug Street' are a precious recollection today . . ."

Bruce would have been glad of this comforting reminder that his efforts were still remembered, for he had recently received a sad blow. "Poor very old Granny passed on," he wrote to Barbara on 1 February, 1959. "For a long time, I had of course seen this coming. I sat beside her in silence, and unrecognised towards the end, but she was in no pain. Just slept herself away." He was writing from the Private Ward, Royal Infirmary, Worcester, and continued: "Well all this was grieving. But almost simultaneously I had to come in here for an operation. A major one but non-malignant I'm glad to say."

He had been in hospital for five weeks, mourning for his "mascot mother" whose favourite son he had never been but of whom, at the end, he was proud to say: "All she wanted was to be with me". He was also worried about the effects of all this bad news on Ceal. He worried about Barbara, whose young family was going through a series of childhood ailments which involved heavy medical expenses. All he said of his own plight was "Had a tough time". Ceal's first husband the Hon. Michael Scott, died in the same month on 9 January.

Bruce's stamina was nothing short of incredible. In July he had three weeks in London. "During that period I had to be quite Ritzy. Had to have lunch with Sir Beverley Baxter in the House of Commons as he was writing a story about me for a Canadian magazine . . . Also had an invitation from Field Marshal Montgomery and the Officers of the Royal Warwicks to go to a party at Warwick this weekend. (Private information) Don't want to go (still more private) not going to. Chucked in with all this grandeur. I was asked to draw a picture for Mr McMillan." [sic].

At last his fellow officer from the 1st Btn, The Royal Warwicks (Monty) was acknowledging him, as was the Prime Minister.

Macmillan's catchphrase, "You've never had it so

The last photograph of Bruce Bairnsfather. June 1959.

good", hardly applied to Bruce. Soon after he came out of hospital Ceal had what he considered to be a serious bout of 'flu. He had to admit that looking after her in his own weakened condition made him feel "like a piece of saturated flannel". As far as the cooking was concerned "I specialise on real Indian curries," he wrote, "and am quite a crack shot at them now." The previous harsh winter had depressed him. "If I could afford it I would spend every winter in Ceylon," he maintained. He was immensely cheered by an unexpected batch of mail. "In a fortnight I have got this, that and the other (fan stuff) from Kenya, Malaya, Canada, Sarawak," he wrote to Barbara. He failed, however, to say when that exciting fortnight was. Like his constant recounting to the Press of the popularity and fantastic welcome Old Bill had in Japan, it could have happened several years before.

At last a commission had come through from Canada – illustrations for a story in *McLean's* magazine. But by the end of July, after three major operations and eighteen examinations, he had to go back to see Philip Nicholas. Before he went into hospital for the last time, he performed a ritual that was, tragically, an all too regular occurrence when he moved house, or reached a crisis point. He had a bonfire and burned "a lot of old cartoons". This disregard for the value of his work is one of the reasons for the scarcity of surviving examples, despite his long and prolific artistic career. Obviously the lack of recognition he had received during his last years had made him feel that his work was worthless and did not merit preserving. He had always, with characteristic generosity, given away the cartoons that he dashed off so facilely. His last few weeks were no exception. The sketches he gave the nursing staff at the Royal Infirmary in Worcester during his final visit are still treasured by their owners, who felt real affection for the man who bore his pain so stoically and who remained so cheerful.

At last, on 29 September, 1959 he died. The growth in his bladder was indeed by now malignant, the bladder had to be removed and the cause of death was acute renal failure.

Next day many newspapers carried a new version of the heading "Old Bill dies". They produced "The Better 'Ole" and a variety of "Old Bills": in *Fragments* and strip cartoons; in his balaclava, his trilby, his tin helmet, his cloth cap; on stage . . . they mostly concerned themselves with his World War I and immediately post war work – the *Fragments*, and Old Bill. *The Times*, never his greatest fan, said he "was fortunate in possessing a talent, limited but very real, which suited almost to the point of genius one particular moment and one particular set of circumstances; and he was unfortunate in that he was never able to adapt, at all happily, his talent to new times and new

circumstances . . . Bruce Bairnsfather did an immense number of things – journalism and illustrations, but he never repeated the success of that one outstanding comic 'moment of truth' ". The *Daily Telegraph*, the *Daily Mail*, the *Daily Express*, the *Belfast Telegraph*, the Birmingham and Worcester papers and many others, carried warm tributes, detailing his long career. The *New York Times* and *Life* magazine were amongst the American journals to pay homage to "the artist-soldier who made all England laugh" who "kept his fame but lost his fortune" (referring to the bankruptcy). Old Bill was described as the "cartoon predecessor of Bill Mauldin's Joe and Willie of World War II".

Barbara was shocked to hear the news on the radio and Bruce's wartime friend, now General, Curtis Le May, helped to get her back to England in time for the funeral. It was a very quiet affair for such a world-famous personality.

Captain Bairnsfather was cremated at Cheltenham Crematorium. Present at the funeral were Barbara Littlejohn, Angela Ashley (Ceal's sister), the Daniels, Mr B. Knight, Mr A. Jones, another villager from Littleworth, and representatives from the Royal Warwicks, the Gloucesters, and Westward Ho! Ceal was unable to attend.

"While Capt. Bruce Bairnsfather the man is no longer with us," reported the local paper, "his merry drawings, with all their humour and pathos, remain – an everlasting memorial to an era of heroism and gaiety so bespattered with the blood of war."

His memorial plaque in the Gardens of Remembrance reads:

"In loving memory of
Capt. Bruce Bairnsfather
1st Royal Wark. Regt.
Creator of Old Bill.
29th Sept. 1959. Aged 71."
(He was, in fact, 72).

Chapter 18

Post Mortem

After Bruce's death it was almost impossible for Ceal to find a bolthole. None of the people who had been happy to look after both of them were prepared to take her on alone, without Bruce's patience and protection. The shattering effect of his death is not hard to imagine. Immediately after the funeral she went to London with her sister, but they couldn't live together for long. Her "nervous condition" deteriorated and she returned to Worcestershire, where she was forced to spend some time in hospital in Malvern and in Worcester. Then, with no home to go to, with no one to look after her to keep her company, she went into the Rashwood Nursing Home at Droitwich. It specialised in looking after distressed gentlefolk and the fees were tailored to the residents' means.

Chapel Cottage had been sold by Ceal's Worcester solicitors in order to boost her funds, but in the period between Bruce's death and the sale, much of the contents, including paintings and mementos disappeared. Barbara was only able to take a few pictures with her when she returned to the States after the funeral and Bruce's last Old Bill, Bert Knight, to whom Bruce had promised one or two things, received nothing.

The Daniels at Colwall were expressly forbidden by Ceal to let Barbara have any of "the books and other old papers" that had been stored in their shed by Bruce, and eventually the mice got to them and they were burned. On Ceal's authority "the best things" – mostly paintings – went to Sotheby's. What happened to Bairnsfather's Norton effects remain a mystery, with local hints of a mysterious character to whom Ceal entrusted many of her treasured objects while she was in hospital and who was never seen again.

During her six years at Rashwood, Mrs Bairnsfather always wore a bundle of Bruce's letters pinned to her nightdress which no one was allowed to touch. She was remembered as a determined lady who liked to have her own way and it was that independence that led to her death. In addition to her general invalidism, she had also developed a heart complaint and was confined to bed overnight. The sides of her cot were pulled up before she went to sleep.

One night at the end of January 1966, she tried to get out of bed by climbing over the cot sides and fell. She was examined and helped back to bed, but died ten days later. It was then discovered that she had broken her neck in the fall. The *Droitwich Guardian* carried the full story of the inquest and a resumé on the life of her husband. In addition, the Mayor of Droitwich, Alderman E. Shirley Jones added a tribute. "At Rashwood Nursing Home there has died a very gracious lady . . . –[her husband]was the man who introduced the British soldier to the public at home in the early days of the 1914 war. Hitherto the public had not known its own soldiers . . . Captain Bairnsfather's work will live so long as the British public is interested in the reaction of its Servicemen to danger, exhaustion and discomfort." It certainly has lived on – though very often without being recognised as such.

In 1948 a native of Kings Langley near Hemel Hempstead, called Bill Mead, died. Bill, a plumber, had fought in the First World War and afterwards he grew a walrus moustache, so that he became known as Old Bill – as so many other soldiers did. Bill was a keen darts player and his wife, Emma, would sit by and watch while he played at The Red Lion. Emma died just one month after Bill, and in their memory the family raised £100 to buy a silver cup, and founded the Old Bill Darts League to compete for it. Nearly forty years later the League continues. The present secretary of the league, Bill Evans, a member for many years, had known nothing about the origins of his charity.

There are many examples of Bairnsfather's work becoming such a part of history that its creator has

become synonymous with an attitude or state of mind. A perfect example of such a situation can be found in the story of the MOTHS – the Memorable Order of Tin Hats.

The organisation was founded by Charles A. Evenden in South Africa in 1927 with the aim of helping veterans to rediscover the comradeship of the trenches. It was exactly what the ex-soldiers were looking for.

Evenden's ideas caught like a bush fire. Branches sprang up throughout South Africa. They were called Shellholes. Each Shellhole had its own name and its voluntary unpaid officials. They were known as Old Bills, and Bruce Bairnsfather's Old Bill was the Order's mascot. The movement became international three months later when the Windy Corner Shellhole was founded in Reading, England, and when Field Marshal Jan Smuts was appointed as an Old Bill, he was the one hundred thousandth member.

The Moths knew Bruce's contribution, as the soldiers and ordinary people of Britain had known it during World War I. RSM J.A. Thornton DCM, MSM of the Highland Light Infantry, a veteran of the First War, was emphatic: "The stories of Old Bill were always with us and, incidentally, kept us going." Mrs M. Scott, a schoolgirl during the war recalled her soldier father: "I remember the days as children with my brothers when my dad, who lost a leg in the Battle of Ypres, would read the cartoons to us and believe me some of them he couldn't read for laughing. He laughed till tears came down his cheeks." The Windy Corner Shellhole at Reading remembered on its golden jubilee in 1978. Guest of honour was Viscount Montgomery of Alamein, and he it was who proposed the Toast to the Memorable Order while, on the cover of the programme, was a picture drawn for the Reading Moths some years earlier by that other man from the Royal Warwickshire Regiment – Charles Bruce Bairnsfather.

In 1972, the then Senior Old Bill of England, Paddy Padwick, had bid at auction in Phillips of New Bond Street for a bronze head of Bairnsfather's Old Bill. In the same sale was a bust of Adolf Hitler. Paddy paid £90 for Bill, while Adolf Hitler fetched only £45.

Gradually, since the 1970's, the demand for Old Bill items has grown. Paddy's bronze had originally been a car mascot and the same item began to appear in salerooms in chrome and brass. A very small head, apparently designed for motor-cycles, also turned up

The Windy Corner Shell Hole, Reading, use their Bairnsfather picture on the cover of their golden jubilee dinner menu. Bairnsfather's fellow officer from the 1st Bn., the Royal Warwickshire Regt., then Viscount Montgomery of Alamein, C.B., was the guest of honour.

Charles Evenden's 1927 cartoon, which inspired the founding of the Memorable Order of Tin Hats.

"Paddy" Padwick, England's well-loved Senior Old Bill of the MOTHS until his death in January 1980, with his Old Bill head. Courtesy of the Evening Post, Reading.

and the authors received an anonymous parcel containing a lightweight aluminium copy of the car mascot. The note enclosed with it said, "My husband was so fond of Old Bill before the war (World War II) that he made a few of these for the family."

Enthusiastic collectors have uncovered an extraordinary variety of Old Bill items ranging from dolls to Wilkinson Royal Staffordshire heads, through Grimwades Bairnsfatherware pottery to full length Carlton figures. Ephemeral cameos of Bairnsfather's work include cigarette cards, postcards, playing cards, jigsaws and the more obvious books and magazines. Now and again an original drawing comes up for sale and a major article on Bairnsfather memorabilia was published in the August 1974 issue of *Antiques Weekly*. It seems as though collectors are beginning to appreciate Bairnsfather's work. Cartoonists always have done, have understood its "attitude of mind", as Bruce would have said, and have kept it alive. In 1977, Mac the cartoonist, alias Captain G.D. Machin DFC, a veteran of the First World War, said: "Bairnsfather's brilliance, in that Old Bill series anyway, helped to win the war."

Jigsaw puzzle version of a "Fragment from France". The Bystander.

"Chat's" version of The Better 'Ole, *drawn for* Dekho Magazine *in 1968. Courtesy of George E. Chatterton.*

Illingworth put Wilson in the 'ole with Heath in 1975 in The News of the World. *Courtesy of the Newspaper.*

In 1968 Chat drew his version of the Better 'Ole for *Dekho Magazine*; in 1970 the National Gallery Exhibition "Drawn and Quartered: Cartoonists from 1720–1970" included Old Bill; in 1975 in the *News of the World*, Illingworth put Messrs. Heath and Wilson in the 'Ole; in 1978 Hector Breeze in *Punch* and Nicholas Garland in the *Daily Telegraph* used the idea, and in 1979 so did Austen in *The Spectator*, and the Editor of *Private Eye*. In May 1982, Cummings had a new version published in the *Daily Express*, and John Jensen re-drew it for the cover of *Punch* in December 1983, a year when Peter Brooke had done his version in *The Times*.

The soldiers of yesteryear, the Birmingham Old Contemptibles, used to meet in the Crown Hotel in the city, under the painting originally done by Bruce for Mitchell & Butler's Old Contemptible Inn, until their very last gathering. The painting still hangs there, although, in true Bairnsfather fashion, it may be one of several versions he drew of the same design. In December 1981, art dealer Nicholas Bagshawe had in his possession a virtually identical picture, done in oil on board, measuring the same as the Crown Hotel version – 56½ in. by 64 in. His valuation was £1,000. The differences between the two versions are minimal, e.g. the number of holes in the fire bucket.

The soldiers of today still use the Better 'Ole Restaurant in Kwanlin, on the Hong Kong–China border, and the Whitbread Old Bill pub sign still hangs outside the Regina Hotel in Ypres. So, despite

Establishment indifference, Bairnsfather's work and legacy live on. The first official recognition of his importance came in 1980, when the Greater London Council erected a Blue Memorial Plaque on the wall of one of his London studios, No. 1 Stirling Street in Knightsbridge. The plaque was instigated by the authors and unveiled by Bairnsfather's daughter, Mrs. Barbara Littlejohn.

The year before, in December 1979, Terry Holmes, the Managing Director of the Stafford Hotel in St. James's, London, decided to form an exclusive club for his regular clients. Being an aficionado of the First World War, and a fan of Bruce Bairnsfather, he called the club "The Better 'Ole". In the hotel's cellars, which date back to Nell Gwynn's times, an authentic-looking First War dugout was constructed, decorated with Bairnsfather memorabilia: plates, prints, and car mascots. Members of the club have plastic membership cards, depicting the "Better 'Ole" cartoon, and their club notepaper. Membership is by invitation only. The Better 'Ole Club has been the scene of many lively gatherings – the opening of the club itself, the receptions after the unveiling of the G.L.C. Blue Plaque and the launch of the second edition of the authors' "Best of Fragments" collection in 1983.

In 1981, General Curtis le May told the authors that the pilot of the "Old Bill" B17 Flying Fortress, William Whitson, whose crew were so highly decorated when it was wrecked in 1943, salvaged the Old

"Hey! Look out! Don't yer know it's dangerous to point a shell at anyone?" One of Bruce Bairnsfather's many WW2 cartoons.

A Bairnsfather pub sign for the Old Contemptible in Birmingham, in oil, on board.

Bill painting on the nose cone and still had it proudly displayed in his Texas home.

In January of that year, Gordon Sparling, who had worked with BB in Trenton on the controversial film, *Carry on, Sergeant!*, reported to the authors on the showing of the film that month on Canadian TV. It was sympathetically received by the public, but film critic Peter Roffman, writing in the Times-Colonist's *Today* magazine, described it as "a tragi-comedy of errors." Sparling disagreed with this assessment. "I fail to see the comic aspect of those errors," he wrote, and maintained: "The public comments I heard were quite favourable, and my own impression was that the picture stood up after all these years as better than generally credited."

Plastic membership card for the exclusive Better 'Ole Club in the Stafford Hotel, St. James's, London.

Headed notepaper for The Better 'Ole Club.

Later in 1981, the Reith Lectures were given by Professor Laurence Martin, Vice-Chancellor of the University of Newcastle upon Tyne. He took as his theme the problem of averting all-out nuclear war. *The Listener* of 12 November published the text of the Lectures under the title, "If you knows of a better 'ole . . ." The article was illustrated by Bairnsfather's perennial cartoon of the same name. Professor Martin ended his talk with this acknowledgement of the enduring validity of Bairnsfather's situation comedy piece,

" I often exasperate people by expressing issues in terms of cartoons I remember. Many of you must have seen some of the drawings of the most famous cartoonist of the Great War: Bruce Bairnsfather. Bairnsfather's cartoons, you may recall, usually depicted a lugubrious veteran, Old Bill, and a raw and nervous recruit. In the most famous cartoon of all, Bill and the recruit are cowering in a waterlogged shell-hole in no man's land under a fearsome barrage with shell bursts all round. The recruit complains about their plight and Old Bill replies, 'Well, if you know of a better 'ole, go to it.' That, I fear, sums up my view of our strategic situation. It is a miserably dangerous one. But, after some years of surveying the no man's land of strategic theory, I have yet to find a better hole than our present balance of power. Moreover, the metaphor holds even when you contemplate the dangers of actually abandoning one system and moving to another. I fear the best we can do is to tidy up the hole and shore up its sides. That task alone is enough to bear further discussion."

On 28 January 1983, the authors wrote to the Editor of the Oldham Evening Chronicle, appealing for information about Samuel Birkenshaw of that town. Birkenshaw was the winner of the "Old Bill Doubles" competition run by Bairnsfather in his magazine, *Fragments* in 1919. Several of Sam's descendents responded to the request. They remember him as a typical old soldier (he had served in India before the Great War), a large man, very upright and smartly turned out. When he died in 1948 he didn't have a single grey hair. A portrait of Birkenshaw as Old Bill used to hang in the Cranberry public house in Oldham (where, it is said, most of his £5 per week Old Bill prize money was spent) until it was destroyed by a flying bomb in 1943. Sam spent some time in London with Bruce Bairnsfather, and made several appearances with him around the country at cinemas and theatres. Although £5 per week was considered a substantial sum of money in the 20's, none of the family remember him sending any money home to his wife. His grandchildren have the suspicion that he never told her about the fee. "A bit of a lad", is how they describe him!

In September 1984, to mark the 25th anniversary of Bruce Bairnsfather's death, Ron Griffiths, Editor of the *British Postcard Collectors Magazine*, produced a limited edition commemorative postcard, acknowledging the enthusiasm with which BB's postcard work is collected by followers of what is claimed to be Europe's second largest collecting hobby after stamps.

The most recent, and perhaps most considerable, tribute to Bairnsfather was the inclusion of the origin-

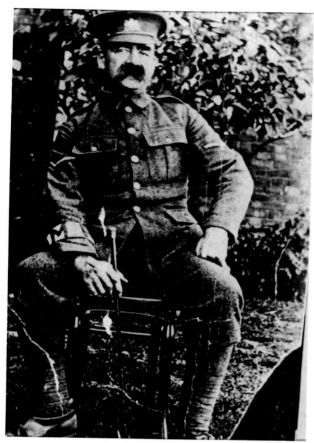

Samuel Birkenshaw, winner of the Old Bill Doubles Competition in Fragments *magazine, 1919.*

Commemorative postcard to mark the 25th anniversary of Bairnsfather's death. A limited edition, published by Ron Griffiths.

al of the "Better 'Ole" in a prestige exhibition entitled "English Caricature. 1620 to the Present" and sub-titled "Caricaturists and Satirists, their art, their purpose and influence." Mounted in 1984 by the Victoria and Albert Museum, London, the collection was first shown in the Yale Center for British Art. It then moved on to the Library of Congress, Washington, DC, the National Gallery of Canada, Ottawa, finally returning to the Victoria and Albert in June 1985. At last Bairnsfather is offered a place beside acknowledged masters such as Rowlandson, Hogarth, Gillray, Sir John Tenniel and Sir Leslie Ward. The exhibition catalogue, discussing the cartoons of the 1914–1918 war, says: "Bruce Bairnsfather's 'Well if you know of a better 'ole' concentrates on the predicament of the British soldier at the Front, and its direct humour and inspired caption found an instant response amongst both soldiers and public . . . his famous creation 'Old Bill' gained international popularity, although his scruffy Tommies, grumbling but enduring, did not always gain official approval."

Although the exhibition is a major step towards a proper appreciation of the importance of Bairnsfather's work, he deserves much more. For a brief period of genius, he allowed the nation to laugh when laughter was about all that stood between the country and despair.

The authors have, on several occasions, suggested to the Imperial War Museum that it should mount an exhibition of Bairnsfather's works, and offered to loan their private collection of Bairnsfatherware, memorabilia and originals. In September 1981, Miss Angela Weight, Keeper of the Art Department at the Museum, replied: "Our exhibition programme is planned two to three years in advance, but in any case I do not feel that Bairnsfather's work merits an exhibition on the scale you are suggesting. If, as *the Guardian* states, 'Critics have subsequently honoured him with faint praise', the reason is, in my view, because his work is of sentimental interest but dubious artistic value."

In the authors' view, this response shows that the Keeper of the Arts Department is, firstly, totally out of touch with what wars are all about and what matters to soldiers and civilians alike in wartime. Secondly, it shows total ignorance of the value of Bairnsfather's work, taken in the context of the First World War when his "artistic" merit is of secondary importance. If the museum was the Imperial ART Museum, then the authors would agree with Miss Weight's judgement. But the I.W.M. is a WAR museum. "Artistic value", which is subjective, dependent upon current fashion and upon artificial academic criteria, should be a minor consideration when choosing exhibits for it. Indeed, as far as those whose morale was uplifted by Bairnsfather's work during the years 1915–1918 were concerned, "artistic value" was quite irrelevant. It should remain so to anyone who truly understands the value of laughter in warfare. The Art Department of the I.W.M. should re-examine its objectives and judge less from the viewpoint of an ivory tower and more from a water-logged trench.

There is no doubt that one of the main reasons for the fact that Bruce's success had such a limited nature is that Bairnsfather never really broke the stranglehold of Old Bill. He went on drawing Bill Busby through the decades, until his final appearance in the Birmingham paper a few months before his creator's death. Bruce always maintained that his fans would never let him get away from Old Bill, that they were always asking for him.

Two questions remain: was he capable of doing anything other than Old Bill? Would the public have accepted anything else? Certainly his one major attempt to do something different at Trenton in 1927 ended in dismal failure. But despite all the controversy it engendered, *Carry on, Sergeant!* was a monumental achievement and current qualified opinion rates it highly. The landscapes he sold in the States during the Fifties were well drawn and attractive. Bruce saw the rejection of one of them by the Royal Academy as an indication that the art world was only prepared to accept him as the cartoonist who drew Old Bill. It could be that he merely needed to submit more pictures before he could earn acceptance. Bruce took both these rebuffs as final and didn't "try again".

As far as the public was concerned, the separate beings of Old Bill and Bruce Bairnsfather progressively merged over the years until they finally became one.

Bairnsfather didn't complain. He was an archetypal Edwardian. Appearances mattered enormously to him and his concern for what others might think dictate many of his activities. He had, too, a sense of duty inherited from the British Raj, his long family traditions and his days at Westward Ho!

Sometimes during our research we felt that Bairnsfather was almost too good to be true. We have no private notes to judge him by, he kept no diaries for posterity and, apart from the last two or three years of his life, there are few letters. The books he wrote all reflect his determination to make light of, or even to ignore, personal difficulties. We received hundreds of letters about him and talked to almost as many people. None considered him as anything but "a lovely man", "a real gentleman", "a very nice person", "charming" . . . It puzzled us that such an attractive and talented person should have no real friends – and apart from the brief episode with Constance Collier, which could have been platonic, no lovers. It is just possible that he led two lives and covered his tracks, as he did in all his writing. Perhaps he gambled, drank and womanised . . . but we don't think so. Certainly he was a very private person. All those who met him in later life talk of him as "withdrawn", "introverted", "shy", "reserved", "lonely", and above all, "sad". Yet beneath the sadness bubbled an unquenchable sense of humour, and occasional flashes of brilliance which manifested themselves in his artistic interpretations or in original turns of phrase. He was on the one hand a simple personality – on the other, a series of paradoxes; the shy man who hated the limelight but who was impelled to seek it out as the moth is drawn to the flame; the sad man who in his moments of deepest depression produced jokes that made the world laugh; the trusting man who at times suspected everyone around him; the dyed-in-the-wool Englishman who could communicate perfectly with the brasher American public; the observer who could admire the self confidence of Hitler's Germany of the 1930s, yet who hated the inhumanities of the Nazi doctrines. He had a talent for drawing, writing and speaking, which was driven by ambition, yet restricted by an inherited sense of values. For a brief spell he was hailed as a genius, the "man who won the war", "the world's most famous cartoonist". It hurt him deeply that his country never officially acknowledged its debt to him: it was one of the reasons for his perpetual sadness in his twilight years.

It is time that Britain said "thank you".

"In the 1914–18 war one had to rely on the very simple things in life and many hardships came our way and when a young Captain in the Army called Bruce Bairnsfather came known to young and all by his Old Bill, bewhiskered, down to earth, dear little fat soldier at war we all began to smile – laugh and cheer. My father said that he should have received the V.C. for services rendered to all of us," Mrs Evelyn Phillips, 1979, aged 70, daughter of an Old Contemptible.

The last published cartoon of Old Bill, in the Birmingham Weekly Post and Midland Pictorial, *16 January 1959. Courtesy of the newspaper.*

Index

The Collectables

A priced catalogue listing of Bairnsfather-related collectables

Preface

List of Categories

This is the first catalogue to be compiled of the collectables associated with the World War I cartoonist, Bruce Bairnsfather. It is based on the authors' 15 years of research and collecting but will inevitably have some omissions. The authors and publishers will appreciate any information on new items for insertion in future up-dated editions of the catalogue.

They fall into nine main categories:

A. *Original* paintings, drawings, sketches, letters by Bairnsfather – dating from c.1908 to the artist's death in 1959.

B. "*Bairnsfatherware*": the pottery items, bearing 'Fragments' cartoons produced during and shortly after the '14–'18 war (mainly by Grimwades)

C. *Other pottery and china items*, such as 'Old Bill' head mugs, jugs and 'Toby jugs', figures of Old Bill etc.

D. *Bystander products*: these include the original *Fragments from France* cartoons which first appeared weekly in the *Bystander* magazine and were then published as eight collections of *Fragments*. The cartoons were reproduced as prints, postcards, jigsaws etc.

E. *Metal ware*: Car mascots of Old Bill's head, in brass, bronze and nickel plate, ash trays etc.

F. *Theatre/cinema ephemera*: Programmes, posters, advertising postcards, magazines, photographs of productions and stars etc., from the various plays and films made about Old Bill, or by Bairnsfather etc.

G. *Books* a. About Bairnsfather

b. Written and/or illustrated by Bairnsfather

c. Illustrated only by Bairnsfather

H. *Magazines* containing articles or cartoons by or about Bairnsfather

I. *Miscellaneous*: Dolls, hankies, badges, glass slides etc., postcards other than in the above categories etc.

Trade Marks: An illustrated listing of the various trademarks on Grimwade's, Carlton, Wilkinson and other china and pottery ware is also included.

As with all collectable items, the prices of those catalogued here are subject to three main factors:
a) Supply and Demand; b) Rarity and c) Condition

a) *Supply and Demand*

As interest in, and knowledge about, Bruce Bairnsfather and his extraordinary career increase, so demand for collectables associated with him continues to grow apace. This interest has been fanned by several recent phenomena. Firstly, there has been a marked renewal of awareness of the 1914–18 war.

Films such as *Gallipoli*, the re-made version of *All Quiet on the Western Front*, *Oh What A Lovely War* and so on have reminded the British populace that practically every family in the land was touched by that horrendous conflict. The First World War is now "history" – on the syllabus of CSE, 'O' and 'A' Levels and degree courses. Young people are researching their ancestors' involvement. There is a boom in the battlefield tours

business, not only by the sadly dwindling band of veterans, but by students, military buffs, and relatives.

Sooner or later, anyone who is interested in the Great War in general, and related collectables in particular, will discover Bruce Bairnsfather, Old Bill and *Fragments from France*. They will find them represented in the war museums (such as the Imperial War Museum, with its Old Bill bus complete with brass Old Bill head mascot), in the Ypres Salient, (such as the Bairnsfather pub sign on the Regina Hotel in the main square) at collectors' fairs (such as the *Fragments* magazines), in the crested china catalogues (such as the Carlton Old Bill figures), in street markets (such as the Portobello Road, with several stalls which stock Grimwade's "Bairnsfatherware" pieces), and in the auction catalogues (such as original Bairnsfather drawings).

Aviation buffs will find accounts of Bairnsfather's connection with the 8th USAF in books about World War II aeroplanes. Theatre and cinema enthusiasts, too, will inevitably become aware of Bairnsfather material. They will find examples of it in National Film Archives in Britain, Canada and the U.S.A.; in museums (such as the Victoria and Albert Theatre departments and the Library of Congress in Washington D.C.); at ephemera fairs (such as play programmes, and cinema stills).

Collectors of humorous art will find Bairnsfather originals and prints in art galleries and art auction catalogues.

Specialist collectors of postcards, car mascots, posters, toys and many other narrow, but fascinating fields, will

eventually discover Bairnsfather-related items in their own specialist outlets.

Interest has also been stimulated by the publicity resulting from the authors' publication in 1978, and second edition in 1982, of their collection of *The Best of Fragments from France*; from the erection of a GLC commemorative Blue Plaque on one of Bairnsfather's London studios in 1980; from the inclusion of Bairnsfather's most famous cartoon, "The Better Ole", in the prestige exhibition of "English Caricature", mounted by the Victoria and Albert and which travelled to the U.S.A. (Yale University) and Canada (National Gallery) in 1984 and 1985.

Ultimately, collectors cannot collect that about which they have no knowledge. The publication of this first catalogue of Bairnsfather-related collectables will reveal the variety of items which are available to the persevering enthusiast. It will stimulate the market by encouraging possessors of these items, perhaps not previously aware of the value of, or interest in, them, to make them available to would-be purchasers.

The authors and publishers also hope that it will attract current collectors to send in details of items not described in the catalogue, or variations on items that are noted. Future editions of the catalogue section of this book will include any information so obtained, and will up-date prices as appropriate to current market trends.

b) *Rarity*
Throughout the many and diverse sections of Bairnsfather-related collectables, availability varies enormously. Most common are some of the *Bystander* products. Copies of the original *Fragments* collections are still relatively frequently found, as are the postcard reproductions of them. Grimwade's "Bairnsfatherware" pottery items are also easily found, but some examples (e.g. plates) are more common than others (e.g. shaving mugs). As described in the appropriate section, variations of transfer and border can add to the value of the potteryware.

In the area of books, some are always cropping up (e.g. *Bullets and Billets* 1916), while others are extremely difficult to track down (e.g. *The Collected Drawings of Bruce Bairnsfather* 1931).

Bairnsfather ephemera, such as theatre programmes and movie magazines, are, because of the very fragility and vulnerabilty of paper, difficult to find in collectable condition. The salvage collection drives of World War II also depleted supplies, as patriotic citizens donated paper items to be recycled for the war effort. The rarity factors will be indicated throughout this catalogue thus:

"*C*" = *Common*. Examples can frequently be found in the stocks of specialist dealers, at collector's fairs, in auction, in present private collections. Items in this category were probably produced in large quantities, (e.g. Grimswade's "Bairnsfatherware", *Fragments from France* magazines etc.)

"*A*" = *Available*. Examples occur from time to time through the above sources. Items in this category were probably produced in significant numbers (e.g. Green Old Bill's head mugs, *Bystander* prints of *Fragments* etc.)

"*R*" = *Rare*. Examples only occasionally occur through the above sources. Examples were either originally produced in small numbers (e.g. Old Bill Car Mascots) or were not considered collectable or valuable at the time of issue and were often discarded (e.g. movie magazines, theatre programmes etc.)

"*RR*" = *Extremely Rare*. (e.g. original *Fragments* cartoons, miniature Old Bill's head motor-bike mascots).

"*U*" = *Unique*. Unique. Only one example known (or thought) to have been made, though similar items may be found (e.g. Bairnsfather's original watercolours, hand-made models of Old Bill etc.)

c) *Condition*
When deciding upon the appropriate selling price for Bairnsfather – related collectables, condition – as in every other collecting field – is of prime importance. Chips and cracks, imperfect transfers, coats of arms or inscriptions, patchy gilding, very obvious hazing, uneven glazing – all will reduce the value of a pottery or china item by 50 per cent or even 75 per cent.

Over-polishing, which smooths away important features, will reduce the value of brass items by 30 per cent. Foxing, broken spines, tears, bent-corners and stains will reduce the value of books, magazines, postcards, prints, programmes and other ephemera by anything from 25 per cent to 75 per cent depending upon the seriousness of the blemish.

Buyers should be sensitive to this criteria when adding to their collection, particularly if they wish their purchase to have any re-sale value. Reputable dealers will normally pay between half and one third of the prices in this catalogue, which are the general purchase prices currently obtained. Keen collectors are often tempted to buy rare items, or items not in their own collection, or which will complete a set (e.g. a postcard series) in less than perfect condition. Should they do so, they must bear in mind the advice given above and not let their eagerness colour their judgement by paying too much. The publication of this catalogue will increase the chances of a perfect duplicate turning up!

The Collectables

Contents of Catalogue Section

Category A.

Bairnsfather Originals

Of all the areas of Bairnsfather collectables, this is probably the most difficult in which to give definitive valuations. Bairnsfather's waxing and waning popularity; the renewed interest in his work; the medium in which the original is executed; the artistic merits of the work; the time it took to complete; the period it was done – all these factors influence the current market price. Undoubtedly Bairnsfather achieved his artistic and humorous peak of genius with the *Fragments from France* series. These are, therefore, the most highly sought after and valued originals, and Bairnsfather's other work is divided into pre- and post-*Fragments* sections.

A range of prices, rather than one precise price is normally given in this category. Bairnsfather's work was immensely varied, comprising simple lightning brush, pencil or pen and ink sketches (in autograph books, on walls, or on any other readily available medium); carefully drafted pen and ink or chalk studies (often highlighted with white) in black and white or sepia; attractively composed and competently executed watercolours or oils – even hand-written letters in his pleasing and distinctive script, often embellished with amusing sketches. The subject matter is equally diverse: landscapes of the English countryside he loved; cartoons of World War I and post-World War I civilian situations, always meticulously observed from actual experience; serious and accurate sketches of trench life; clever caricatures and even the occasional portrait; the commercial work for which he trained at the John Hassall Art School – both roughs and finished, coloured art work for advertisements; World War II cartoons for the British and American market; designs for cinema and theatrical programmes and posters; illustrations for the many books he illustrated.

I. Pre-Fragments

1. c. 1900-1907. Sketches made during BB's schooldays or militia period, in text or exercise books etc. (Illus. Page 18)
RR£5-£35

2. c. 1904-1914. Watercolour landscapes painted during BB's residence at Bishopton. (Illus. Page 23) *RR£35-£60*

3. c. 1908-1914. Commercial designs for Player's tobacco, Lipton's tea, Keen's mustard, Beecham's pills, Flower's beer, Shakespeare Festival posters, local amateur dramatics posters (Illus. Page 29)
Roughs RR£15-£30
Finished art work RR£30-£150

II. Fragments from France 1915-1919

Originals for the cartoons reproduced in *The Bystander* and *Fragments from France* magazines. BB often re-drew the same design.
1. Positively identified first originals
a. 'The Better 'Ole' (Illus Page 44)
U 'Prix d'Amateur'
b. 1915- Nov. 1918 Fragments (Illus. A1)
RR£150-£300
c. Dec. 1918-1919 Fragments
RR£100-£200

2. Re-drawn original Fragments
a. 'The Better 'Ole'
R£100-£250
b. 1915- Nov. 1918 Fragments *R£80-£175*
c. Dec. 1918-1919 Fragments *R£40-£125*

III. Other 1915-1918 World War I Designs

1. Book illustrations for *Bullets & Billets*, *From Mud to Mufti*, *Bairnsfather – Fragments from his Life*, *Somme Stories*, *Back to Blighty*, *For France* and others
Full page illustrations R£60-£175
Black and white line sketches R£25-£100

2. World War I drawings and paintings for charity

7 Aug. 1916 Red Cross, Kineton, near Stratford. Designs auctioned for funds *R£15-£35*
19 June 1918 Red Cross, Surrey Branch. Old Bill in wounded Tommy's uniform *U£175*
11 May 1917 St. Dunstan's. Picture of Canadian at Vimy Ridge auctioned at His Majesty's Theatre *U£300*
Feb. 1918 Chevrons Club Opening Programme design, called "Carry on, Sergeant!" *U£175*

3. Others
a. Sketches done as "thank-you's" or presents *A£10-£30*
b. Serious character studies in chalk etc. (Illus. A2) *R£30-£75*
c. Serious studies of trench life *R£50-£100*
d. Non-*Fragments* cartoons *A£80-£175*
e. Hand-written letters/autographs
Without sketches R£10-£15
With sketches (Illus. 53) RR£15-£25

IV. Post-Fragments

A. Inter-war Years: 1919-1939

1. Book illustrations for *Carry on, Sergeant!* 1927; *Collected Drawings* 1931; *Laughing Through the Orient* 1933; *Old Bill Looks at Europe* 1935; *Wide Canvas* 1939
Full page illustrations R£50-£150
Black and white line drawings R£10-£30

2. Commercial Designs
a. Payne's tea (Illus. A3), Adkins Nutbrown Tobacco (Illus Page 143),
Others Roughs R£15-£30
Coloured finished Art work R£80-£175
b. Cinema and theatrical posters/ programmes *Black and white RR£50-£125*
Coloured RR£80-£175

3. Newspaper/magazine designs
a. Black and white drawings (Illus Page 145)
small cartoons *R£15-£30*
Four picture strip cartoons *R£20-£50*
full page cartoons *A£50-£100*
caricatures *R£20-£50*
b. Chalk or watercolour *R£60-£120*

B. World War II: 1939-1945

a. 1939 propaganda posters *RR£75-£125*
b. 1939-1945 Old Bill/Young Bill/general wartime cartoons, including newspaper and magazine designs *R£20-£100*
c. 1942-1945 cartoons for *Stars and Stripes* *RR£30-£75*
Cartoons of USAAF personnel (Illus. A4) *R£40-£85*
d. 1939-1945 book illustrations for *Old Bill*

Stands By 1939; *Old Bill & Son* 1940; *Old Bill Does It Again* 1940; *Jeeps and Jests* 1943; *No Kiddin'* 1945
Full Page *RR £40-£85*
Black and white line drawings *RR £10-£20*

C. Post World War II: 1945-1959

1. Newspaper and magazine designs *R£20-£60*

2. Commercial designs (Illus. Page 183) *R£30-£75*
3. Sketches done as "thank-you's" or presents (Illus. Page 184) *A£5-£25*
4. Watercolour, chalk and crayon landscapes (Illus. Pages 175, 179, 181, 185) *R£35-£80*
5. Handwritten letters/autographs (Illus. Pages 182, 187) *Without sketches A£5-£10*
 With sketches R£10-£15

A1

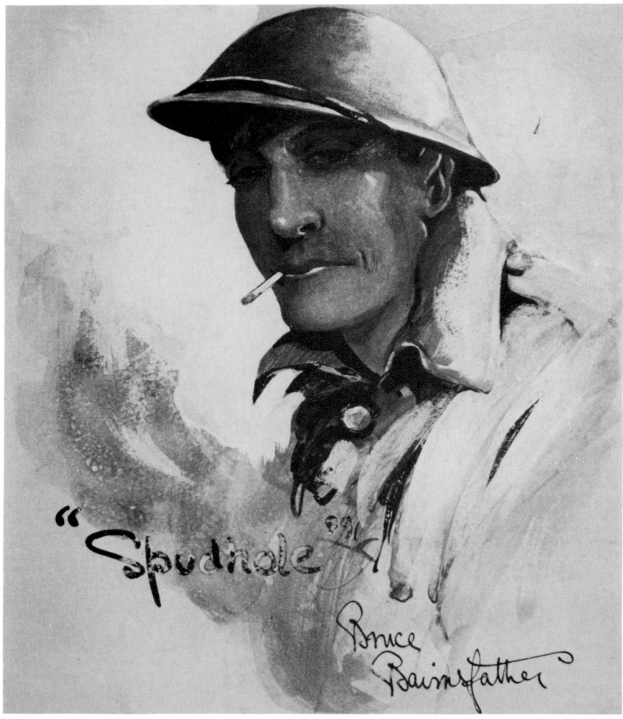

A2

A3 ▶

Geo Payne's
G.P.
TEA

G.P.

Bruce Bairnsfather
Rough

here's Tea for yer!

A4

Category B.

Grimwade's "Bairnsfatherware"

Category B. Grimwade's 'Bairnsfatherware".

Grimwade's was the Midlands factory which from 1917, mass-produced a range of cheap pottery items which were given the generic term "Bairnsfatherware". The cream coloured pottery was printed with transfers of the *Fragments from France* cartoons. The transfers were produced by the Chromo Transfer and Potters Supply Company Ltd., of Stoke-on-Trent. Each was reproduced from a separate lithographic stone. Production continued until well into the '20's.

A basic price is given below for each type of item. The following premiums apply for extra features:

a. Elaborate border in Bairnsfather's style of aeroplanes, tins, helmets, barbed wire etc. £15
b. Smaller version of (a) £10
c. A second transfer £5
d. Unusual shape (e.g. octagonal) small/large items £5/£10
e. Unusual edge (e.g. scalloped) small/large items £5/£10
These premiums are specified in the descriptions and included in the valuations.

The quality of transfer printing, gilding and glazing varies considerably, some glaze being very noticeable hazed. The prices quoted below are for perfect specimens. Distinct flaws and damage will lower the price considerably, as described in the introduction.
Many of the pieces were obviously made for ornamental rather than practical use. Even every day items were designed to hang on walls, sit on mantelshelves or be displayed in glass cabinets. Plates can often be described as wall plaques, with holes bored in the back for hanging string, and a very flat shape. Bairnsfatherware is primarily of interest to BB collectors because of the *Fragments* cartoon transfers. Many pieces are also of interest to crested china collectors, as they bear a town or exhibition crest or coat of arms.
Many items occur in pairs, for which a small premium may apply.

Grimwade's Trademarks/ legends.

a. "Made by the Girls of Staffordshire during the winter of 1917 when the boys were in the trenches fighting for liberty and civilisation". (Illus. B1)
b. "The War-Time Butter Dish for a Family of Ten". (Illus. B1)
c. "A Souvenir of the Great War. Commenced Aug. 4th 1914, Armistice Nov. 11th 1918. Peace signed, June 28th 1919. 'Bairnsfatherware'." (Illus. B2)
d. As above, but with line drawings of Old Bill's head. (Illus. B3)
e. Brown line drawing of Old Bill's head alone. (Illus. B4)
f. Circular green "Grimwades, England". Red "M" (Illus. B5)
g. Green "Atlas china, Stoke on Trent. Grimwade's England". (Illus. B6)
h. As c above, but "memento" instead of "souvenir".

Cheap, Cream Pottery Items.

Plates/Wall Plaques

i. Circular, flat, 16.5cms. diameter. Gold rim, black circle near edge. Plain 3.5cms. dark cream border. Black circle round transfer.
Hanging holes on back.
Transfer: 9cms. diameter, "Out since Mons".
(Illus. B7, Top left hand).
Trademarks: Black and Green as Illus. B1, without butter dish legend.
Basic small plate price. C.£30

ii. As i above, but 19.5cms. diameter.
Transfer: 13cms. diameter, "Where did that one go to?"
(Illus. B8, Centre).
Trademark: Green, as Illus. B9 C.£30

iii. Circular, deep. 19cms. diameter. Gold and black circles as i and ii. Plain 2.5cms. dark cream border.
Transfer: 14cms. diameter, "Here with a loaf of bread".
(Illus. B8, Left).
Trademark: Green, as Illus. B9 C.£30

iv. Circular, flat. 19.5cms. diameter. 4cms. border of trench war paraphernalia (£15 premium). Highly ornamented. Hanging holes.
Transfer: 12cms. diameter, "Where did that one go to?"
(Illus. B11, Left).
Trademark: Black as Illus. B10 A.£45

v. As iv but with
Transfer: "Give it a good 'ard 'un Bert."
(Illus. B11, Right).
Trademark: As Illus. B10 A.£45

vi. Hexagonal (£5 premium). 15.5cms. from edge to edge. Gold rim. Tan circle at edge of 2.5cms. ornate border. (£10 premium).
Transfer: 5cms wide, "Dear . . . At present we are staying"
Crest: Skegness coat of arms.
(Illus. B7, Centre right).
Trademark: Brown, as Illus. B3 R.£45

vii. Circular, 23cms. diameter, deep, ornate black raised 1cm. edge (£10 premium) Black circle round plain dark cream 2.5cms. border.
Transfer: 16.5cms. diameter, "Where did that one go?"
(Illus. B12).
Trademark: Black, as Illus. B10 R.£40

viii. Circular. 25cms. diameter. Ornate 4cms. brown border. No transfer. No trademark. Hanging holes.
(Illus. B13) R.£30

ix. Circular. 25cms. diameter. Ornate 4cms. brown border. (£15 premium).
Transfer: 17cms. diameter, "When the 'ell is it going to be strawberry?"
(Illus. B13, Left).
Trademark: As "h" above. A. £50

Bowls.

x. Circular. 7.5cms. diameter at rim. 5cms. high. Gold rim.
Transfers: (2: £5premium) 6cms. wide, 1. "Better 'Ole". 2. "What time do they feed . . .?"
(Illus. B14, Bottom left).
Trademark: As Illus. B5 £25

xi. Circular. 12cms. diameter at rim. 5.5cms. high. Gold rim. Ornate 1.5cms border. (£5 premium).
Transfers: (2: £5 premium) 6cms. wide, 1. "What time do they feed . . .?" 2. Barbed wire/tree stumps.
(Illus. B14, Top right).
Trademark: As Illus. B2, plus Illus. B15, plus green Grimwade's globe sign (minus crown) as bottom design of B9 £35

xii. Circular cereal or dessert bowl. 13cms. diameter at rim. 2.5cms. high. Fluted 1cm. gold rimmed edge. (£5 premium).
Transfer: 8.5cms. diameter, "Gott Strafe This Barbed Wire".
(Illus. B16, Top right).
Trademark: As Illus. B2 A.£30

xiii. As xii, but
Transfer: "The Better 'Ole".
Trademark: As Illus. B1, without butter dish legend. A.£30

xiv. Circular cereal or dessert bowl. 14cms. diameter at rim. 2.5cms. high. Gold edge. Ornate 2cms. border (£10 premium).
Transfer: 8cms. diameter, "When the 'ell . . ."
(Illus. B16, Bottom left).
Trademark: As Illus. B2 plus green Grimwade's globe sign (minus crown)A.£35

xv. As xiv. but with "Moustache" border.
Transfer: "Here with a loaf of bread"
Trademark: As Illus. B2 R.£35

xvi. Circular bowl, 21.5cms. diameter at rim. 4.5cms. high. Gold rim.
Transfer: 11cms. diameter, "I likes me drop o' rum".
(Illus. B17, Centre).
Trademark: As "h" above, plus green star Grimwade's sign, as in Illus. B9 A.£30

xvii. Circular fruit bowl 25cms. diameter at rim. Gold edge. Raised wavy pattern, outlined in black round rim (£5 premium).
Transfer: 15cms. diameter, "Coiffure in the trenches".
(Illus. B18, Right).
Trademark: As Illus. B2, but with brown, crowned Grimwade's/Winton globe A.£40

xviii. As xvii, but without fancy rim.
Transfer: 16cms. diameter, "The Better 'Ole".
Trademark: as xvi above. A.£35

xix. Fluted, octagonal (£10 premium) fruit bowl. 25cms. edge to edge at rim. 6cms. high. Gold rim, ornate border design in each side. (£5 premium).

Transfer: 16cms. diameter, "Coiffure in the trenches".
Crest: Margate coat of arms.
(Illus. B17, Left).
Trademark: As Illus. B3 R.£45

xx. Fluted, square (£10 premium) fruit bowl. 29cms. corner to corner at rim. 5cms. high. Gold rim. Ornate border design (£10 premium).
Transfer: 16.5cms. diameter, "Dear . . . At present we are staying"
(Illus. B17, Right).
Trademark: As Illus. B2, plus blue-green Grimwade's globe sign. R.£50

Jugs

xxi. 4.5cms. diameter at rim, 7cms. at base, 7cms. high. Gold edge, straight sides.
Transfer: 5.5cms. diameter, "When the 'ell . . .?"
Trademark: As Illus. B15 A.£20

xxii. 6cms. diameter at rim, 7cms. at base, 10cms. high. (Gold edge, straight sides.
Transfers: (2: £5 premium) 6cms. wide, 1. "Where did that one go to?". 2. "What time do they feed . . .?".
(Illus. B19, Right).
Trademark: As Illus. B2 C.£25

xxiii. 7 cms. diameter at rim, 8cms. at base, 14cms. high. Gold edge, straight sides. Ornate 2cms. border round rim (£5 premium)
Transfers: (2: £5 premium) 1. 8cms. diameter, "Coiffure in the Trenches" 2. 6cms. diameter, "What time do they feed . . .?"
(Illus. B19, 2nd from Right).
Trademark: As Illus. B2 A.£30

xxiv. 8 cms. diameter at rim, 9cms. at base. 16cms. high. Gold edge, straight sides.
Transfer: 11cms. diameter, "I likes me drop of rum".
Crest: No caption. Coat of arms.
(Illus. B19, 2nd from Left).
Trademark: As Illus. B10 C.£30

xxv. 9cms. diameter at rim, 7cms. at base. 15.5cms. high. Gold edge, curved sides.
Transfers: (2: £5 premium) 1. 8cms. diameter, "I likes me drop of rum". 2. 5.5cms. diameter, "Where did that one go to?"
(Illus. B19, Left).
Trademark: As Illus. B20 C.£35

Vases/"Pots"

xxvi. 5cms. diameter at rim, 6cms at base. 12cms. high. Gold edge, straight sides.
Transfer: 9cms. diameter, "What time do they feed . . .?"
Crest: No caption. Coat of arms.
Trademark: Green as Illus. B20 A.£25

xxvii. As xxvi, but
Transfer: "The Better 'Ole". A. £25
(Illus. B21, Left).

xxviii. Narrow neck vase, 3cms. diameter at rim, 26cms. circumference at widest part (near base) 5.6cms. at base. 19cms high. Gold edge.
Transfer: 9cms. diameter, "Where did that one go to?"
Crest: No caption. Coat of arms.
(Illus. B21, Right).
Trademark: Black as Illus. B20 A.£30

xxix. 6cms. at rim. 28cms. circumference at widest part (just below border). 5cms. at base, 16cms. high. Gold edge. Ornate 3cms. border (premium £5)
Transfers: (2: £5 premium) 1. 10cms. diameter, "Dear . . . At present we are staying . . ." 2. 6cms. diameter, "Where did that one go to?"
(Illus. B21, 2nd from Left).
Trademark: As illus. A.£40

xxx. As xxix, but
Transfers: 1. 8cms. diameter, "The Historical Touch". 2. 5cms. diameter, "When the 'ell . . .:" A.£40

xxxi. 6.5cms. diameter at rim, 33cms. circumference at widest part (at the shoulder), 8cms. at base, 33cms. high. Gold edge. Black art deco bas relief floral and leaf design around neck and between the transfers (premium £15)
Transfers: (2: £5 premium) 1. 10cms. diameter, "Dear . . . At present we are staying . . ." 2. 8cms. diameter, "Where did that one go to?"
(Illus. B21, Centre).
Trademark: As Illus. B4 RR.£55

xxxii. Urn shaped. 10cms. diameter at rim, 43cms. circumference at widest part (just below border) 10.5cms. at base. 19cms. high. Gold edge. Ornate 2.5cms. border (£10 premium)
Transfers: (4: £15 premium)
1. 10cms. diameter, "The Better 'Ole".
2. 10cms. diameter, "The Historical Touch".
3. 6cms. diameter, "The Better 'Ole",
4. 6cms. diameter, "Dear . . . At present we are staying . . ."
(Illus. B21, 2nd from Right).
Trademark: As Illus. B2 RR.£55

Tea Sets etc.

xxxiii. Tea pot. 6cms. diameter at rim. 36cms. circumference at widest point. 7cms. diameter at base. 12cms high. Gold rim and edge of spout. Ornate 2cms. border (£10 premium)
Transfers: (2: £5 premium)
1. 9cms. diameter, "The Better 'Ole".
2. 5cms. diameter, "The Better 'Ole".
(Illus. B22, Top right).
Trademark: As Illus. B2 R.£50

xxxiv. Tea Pot Stand. 18cms. diameter. Flat, 2 hanging holes. Gold edge.
Transfer: 16.5cms. diameter, "Here with a loaf of bread . . ."
(Illus. B8, Right).

Trademark: As Illus. B9, without Grimwade's star sign. R.£50

xxxv. Sugar basin. Oval. 2 handles. 11cms. from handle to handle, 37cms. circumference at widest point (below border). 8cms. high, gold edge. Ornate 1.5cms border (£10 premium) Transfers: (2: £5 premium) 1. 5cms. diameter, "When the 'ell . . .:" 2. 5cms. diameter, "Where did that one go to?" (Illus. B22, Top left).
Trademark: As Illus. B2 R.£40

xxxvi. Cup. 7cms. diameter at rim. 7cms. high. Ornate border (£5 premium) Transfers: (2: £5 premium) 1. 6cms. diameter, "Where did that one go to?" 2. 4cms. diameter, barbed wire/tree stumps. (Illus. B22, Bottom centre).
Trademark: As Illus. B15 R.£30

xxxvii. Saucer. 14cms. diameter. Gold edge. Ornate border (£5 premium) Transfer: 4 designs repeated from border (Illus. B22, Centre).
Trademark: Green Grimwade's globe R.£20

xxxvi and xxxvii together RR.£55

xxxviii. Butter dish with lid. Diameter 11.5cms. at rim, 15cms. at base. 5cms. high. Ornate border round base (£5 premium). Transfers: 1 On lid. 6cms. diameter, "Dear . . . At present we are staying . . ." 2. Round dish, 3 designs from repeated border. Crest: On lid. Margate coat of arms. (Illus. B22, Bottom right).
Trademark: As Illus. B3 R.£40

xxxix. Cheese dish with lid. Trapezoidal. Longest side 15cms. 7cms. high. Gold edge to base, ornate border round top of lid (£5 premium). Transfers: (2: £5 premium) 1. 6cms. diameter, "The Better 'Ole". 2. 6cms. diameter, "Where did that one go to?" (Illus. B22, Bottom left).
Trademark: (inside top) as Illus. B3 R. £45

xxxx. Flat butter dish. 10.5cms. diameter. 1.5cms. deep. Gold edge. Black circles round transfer. Transfer: 9cms. diameter, "Give it a good 'ard 'un, Bert . . ." (Illus. B7, Top right).
Trademark: As Illus. B1 (£5 premium) R.£25

xxxxi. As xxxx, but black striped border (£5 premium) Transfer: "When the 'ell . . .?" Trademark: None R.£25

xxxxii. As xxxx, but "moustache" border (£5 premium) Transfer: "What time do they feed . . .?" Trademark: As Illus. B3 R.£25

Miscellaneous

xxxxiii. Shaving mug. 8cms. diameter top. Gold edge. 11cms. high. Ornate borders round top and spout (£10 premium Transfers: (2: £5 premium) 1. 6cms. diameter, "Where did that one go to?" 2. 4cms. diameter, barbed wire/tree stumps.

(Illus B14, Bottom centre) Crest: Margate Coat of Arms. Trademark: Impressed initials 'G.E.M.' RR.£50

xxxxiv. Oval bon-bon dish. 23cms. from side to side, longest side. Gold edge. "Basket weave" raised effect on outside. Ornate border on inside (5 premium) Transfers: (2: £5 premium) 1. 6cms. diameter, "Dear . . . At present we are staying . . ." 2. 6cms. "Where did that one go to?" (Illus. B14, Top left).
Trademark: As Illus. B2 R.£30

xxxxv. Miniature ash tray. 7cms. diameter. Gold edge. Dark cream 1cm. border. Black circle round transfer. Transfer: 5cms. diameter, "The Better 'Ole". (Illus. B7, Bottom right).
Trademark: Grey as Illus B20 R.£15

xxxxvi. Jardinière. 18cms. diameter at rim. 69cms. circumference at widest point. 19cms. high. Gold edge. Transfers: (4: £15 premium) 1. 20cms. diameter, "Give 'er a good 'ard 'un Bert . . ." 2. 20cms. diameter, "Dear . . . At present we are staying . . ." 3. 7cms. diameter, "The Better 'Ole". 4. 7cms. diameter, "The Better 'Ole". (Illus. B23).
Trademark: Black. As Illus. B9 RR£100

B1

B2

B3

B4

B5

B6

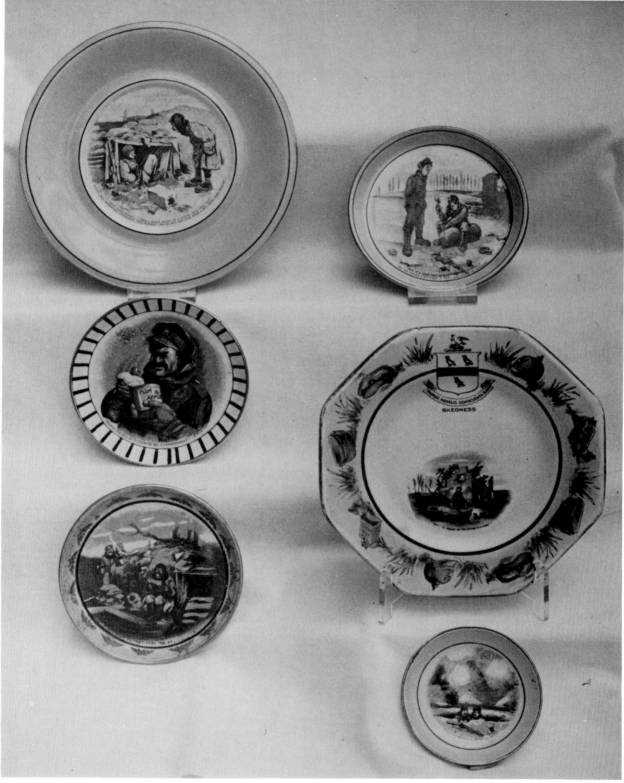

B7

B8

B9

B10

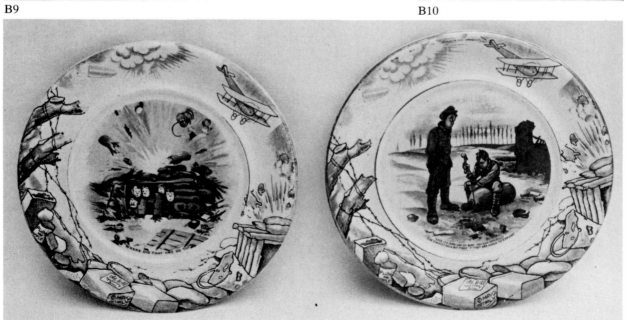

B11

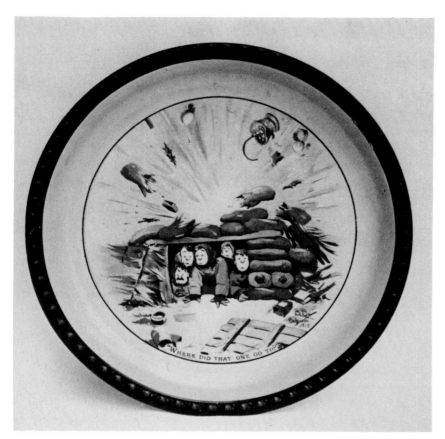

B12

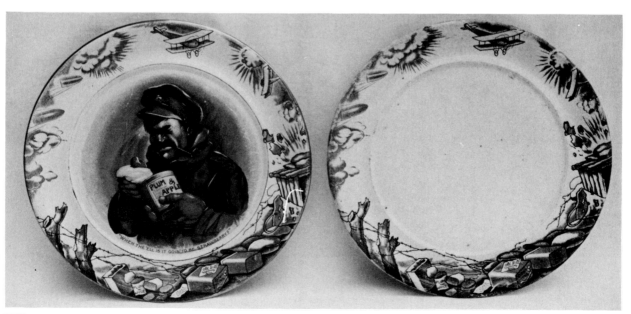

B13

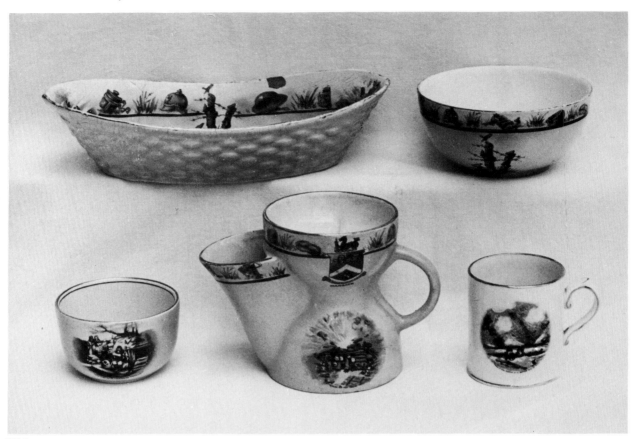

B14

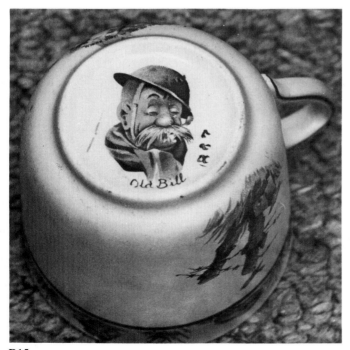

B15

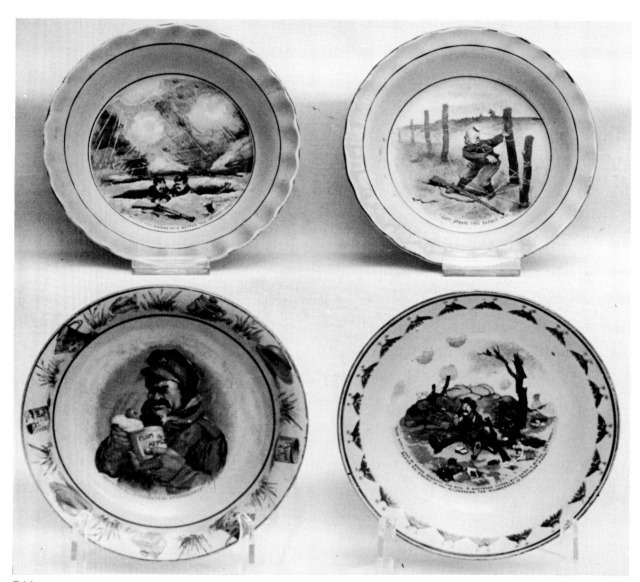

B16

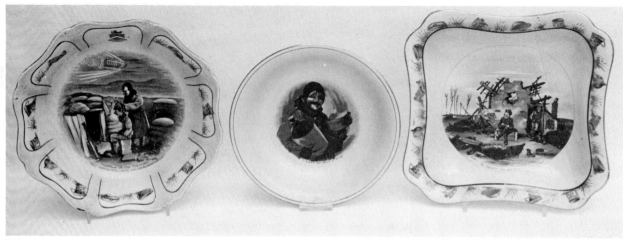

B17

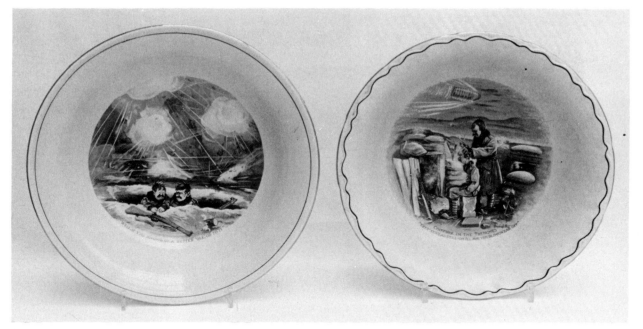

B18

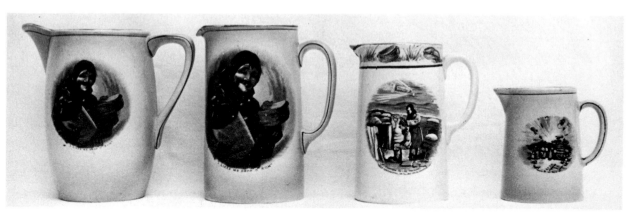

B19

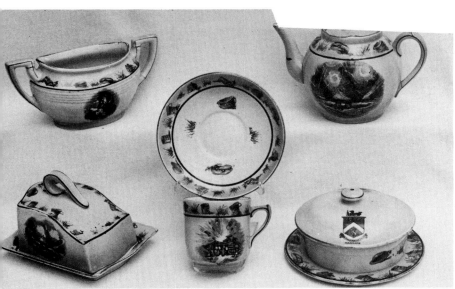

B22

B20

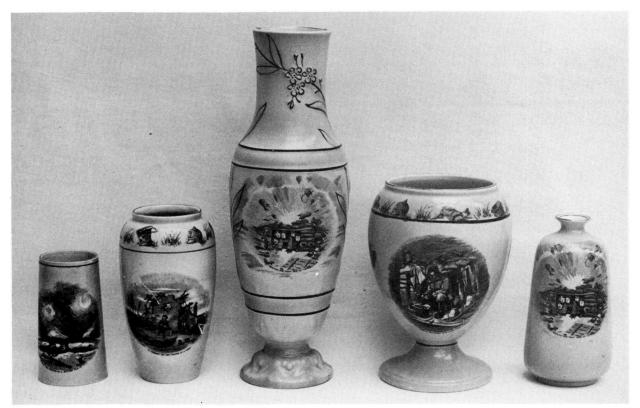

B21

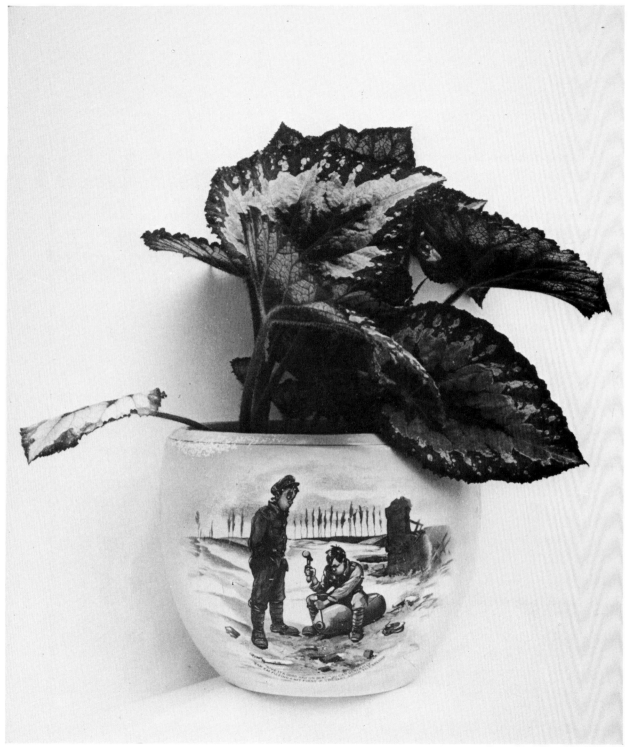

B23

Category C.

Other Pottery and China Items

Carlton China (Illus. C2)

See *Crested China*, by Sandy Andrews, (Milestone) for background to crested china.

Glazed Parian models.

Old Bill standing figure 138mm.
a) Plain white with town crest. *A.£57.50*
b) Inscribed "Yours to a Cinder Old Bill" with coloured balaclava and features, gilding. *R.£75.00*
c) Coloured with British Empire Exhibition (1924) Crest. *R.£80.00*
N.B. The rifle on this figure is very vulnerable. Watch out for repairs.
Shrapnel Villa 83mm. long model. Captioned "Tommies Dugout Somewhere in France." Col. brazier, red and gilding on figure. Reg. No. 660613 *A.£30.00*

Old Bill Heads/Jugs

(Illus. C3)

Factory Anon

Lime green mugs, handle from back of head. (Illus C3, Top left). Black eyes. Walrus moustache *C.£25*
Coloured mug flesh tones, brown cap, moustache, hair, eyelashes, black eyes. (Illus. C3, Bottom left) Handle from back of head. Walrus moustache *R.£30*
Bright pink jug, handle from right ear, slight lip for pouring on left. Black eyes. Walrus moustache. (Illus C3 Top Right) *A.£30*

Beswick (Illus. C3, Bottom right hand). Coloured mug, Flesh tones, brown cap, hair, moustache and eyebrows. Handle from right ear.
Toothbrush moustache. No. 735 *R.£40*

Wilkinson Ltd. (Illus. C4, C5)

Royal Staffordshire Potteries, Burslem. 12.5cms. high heads of Old Bill, complete with helmet with bullet hole, tip of rifle, pipe peeping from under the walrus moustache. Hand painted signature by Bruce Bairnsfather on base and green Royal Staffordshire potteries trade mark. Limited edition. Distribution "controlled exclusively by Soane and Smith Ltd." Some pieces are marked "Reserved to Soane and Smith, 462 Oxford Street, London W".
a) Hand painted. Flesh tones, grey tin helmet, brown hair, moustache, muffler. *R.£100*
b) White, with black hand-painted caption by Bairnsfather, "Who told ye that one?" *R.£85.*

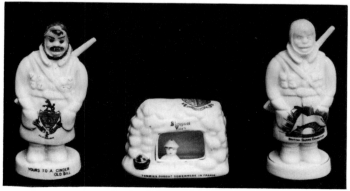

C2

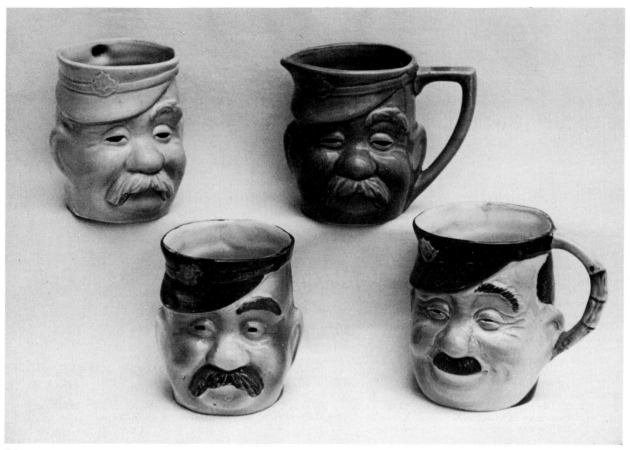

C3

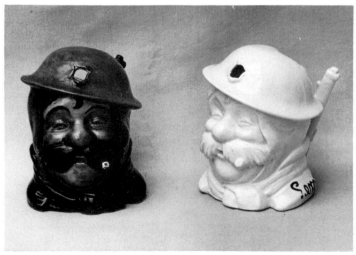

C4

C5

Category D.

Bystander and Bystander-Related Items

It was the editorial staff of the popular magazine, *The Bystander*, who launched Captain Bruce Bairnsfather as a star. By popularising his cartoons, to which they gave the brilliant title *Fragments from France*, by publishing related products, the *Bystander* staff created a world-famous artist – in Bairnsfather – and cartoon character – in Old Bill.

The first cartoon was published in the *Bystander* in January 1915. It was "Where did that one go to?" – He got £2 for it. From then on the cartoons appeared regularly in the magazine (vastly increasing its circulation). After six months, the artist was paid £4 for each weekly sketch. In November 1915, the most famous and enduring cartoon of all, "The Better 'Ole", was published in the Christmas edition. On 26 January, 1916, a collection of the weekly cartoons was published as *Fragments from France*. The *Bystander's* imaginative marketing, and proliferation of products promoting their valuable asset, can be followed in the items listed below.

Bystander Magazine

(Illus. D1)

Examples of editions with Bairnsfather contributions and mentions of him are quoted below. Such copies can be found dating from January 1915 to 1919. Isolated copies thereafter have Bairnsfather contributions.

January, 1915.
Cartoon "Where did that one go to?" *R.£25*

April 1915.
Cartoon "They've Evidently Seen Me" *R.£22*

21 June, 1915.
Cartoon "What it really feels like" *R.£22*

Christmas 1915
Cartoon "The Better 'Ole" *R.£25*

19 July, 1916. (Illus. D1)
Cover Illus. by BB. Two cartoons, "Urgent Warning" not to miss BB exhibition at 190 The Strand. *R.£18*

26 July, 1916.
Cover Illus. by BB. One cartoon, Ad. for "de luxe Fragments" *R.£15*

8 Nov, 1916 (Illus. D3)
Cover Illus. by BB. One cartoon. Photograph of BB returning to France from leave *R.£18*

14 March, 1917
Special "Naval" edition. BB Shipboard cartoon. Ad. for "Ideal Present" of various BB products *R.£15*

4 April, 1917
One cartoon. Ad. for various BB products *R.£18*

23 Jan, 1918
One cartoon. Ad. for *Better 'Ole* play at Oxford *R.£15*

12 June, 1918 (Illus. D4)
One cartoon. Cartoon of BB in Paris by Marcel Poncin (Illus. D4) Ad. for *Bystander* summer edition with Old Bill Ad. for *Better 'Ole* play at Oxford. *R.£18*

25 Dec, 1918
Cover Illus by BB. Col. centre double spread by BB of Old Bill in civvies *R.£18*

Dec. 1918
Bystander Annual. Full page col. cover cartoon by BB of American Doughboys in snowy trench. Two full page cartoons by BB. Ad. for Old Bill Royal Staffordshire heads. Theme of issue – "If the Germans Had Won". 82pp. 2/-. (Illus. Page 76) *R.£25*

12 Nov. 1941
Old Bill cartoon by BB. *R.£15*

"Fragments From France" Anthologies (Illus. D2)

Fragments From France

20.5cms. × 30cms. (Illus. D2)
1st Edition Feb. 1916. Green cover with "Better 'Ole" cartoon 48pp. 43 cartoons. *A.£15*
Photo of BB and foreword about him by Editor Editions 2–11. Different colour covers (e.g. Ed. 8 is brown) ¼ million copies sold. 1/-. net. *A.£5*

More Fragments From France (Vol.II)

(Illus. D2)
1916. Sand or olive green cover (slight variations exist in shade) with "What Time do They Feed the Sea Lions, Alf?" cartoon on cover. 44pp. Photo of BB and foreword about him by Editor. Ads. for other Fragments products. 1/-. net. *A.£12*

Still More Fragments From France (Vol.III)

(Illus. D2)
1917 Bluish-green cover with "Let's 'ave this pin of yours a minute" cartoon on cover. 42pp. Photo of BB and foreword about him by Editor. Ads. for more "Fragment Products". 1/- net. *A.£12*

Fragments From France No. Four

(Illus. D2)
Aug. 1917. Grey cover with "Keep Away from the 'Ive, Bert" cartoon on cover. 36pp. Photo of BB and foreword about him by Editor. Ends with words, "This issue completes a volume. Binding cases 2/4d". 1/- net. *A.£10*

Fragments No. Five

(Illus. D2)
1917. Grey cover. Large figure '5' with Old Bill's head smiling through it. 32pp. Photo of BB, but no foreword. 1/6 net. *A.£10*

Fragments No. Five

1918. American edition. Pub. Putman's (the first volume to be published in USA) *RR.£15*

Fragments From All The Fronts. Number Six

(Illus. D2)
1918. Fawn cover, No Illus. 32pp. Photo of BB with the Americans. The cartoon results of BB's visits to the Belgian, French, Italian and American Fronts. 1/6 net. *A.£10*

Fragments From France. Part six

Sept. 1918. American version of number six, published by Putman's, and by William Brigs in Canada. Introduction by George Haven Putman. Green cover with re-drawn "Better 'Ole" showing Old Bill in the 'Ole with an American doughboy and caption "Both in the same 'Ole now". R.£15

Fragments From France Number Seven

Pre-Versailles Peace Treaty (Illus. D2) 1919. Post-Armistice. Dark brown cover with "How Old Bill Escaped Being Shot" cartoon. 32pp. Foreword by Editor 1/- net. R.£10

Fragments Away From France. Number Eight

(Illus. D2) 1919. Grey cover. Stone "Colossus" Old Bill cartoon on cover. 32pp. 'The Evolution of Old Bill through the Ages' 1/- The last volume R.£12

Fragments From France. Bound Volumes

Vols I–IV in *Bystander* Binding Case with green cover and "Better 'Ole" on cover. R.£45

Vols I–VII Bound in fine leather RR.£75 The authors and publishers would appreciate details of examples of bound Vols. I–VIII.

"Fragments" Magazine

(Illus. D6) 1919, 1920. Weekly magazine, published by the *Bystander* organisation and edited, illustrated by, and generally contributed to, by Bruce Bairnsfather. On cheap paper, selling for 2d., it appealed to the working class ex-Servicemen. Other contributors were popular artists and writers of the day, such as Victor Hicks, A.K. McDonald, Barribal, Will Owen, W. Darlington. Competitions (such as the "Old Bill Double Competition") were a popular feature.

1st issue: 16 July 1919	R.£12
Issues from 23 July 1919–1920	R.£10
Last issue: (probably) 16 October, 1920	R.£12

Christmas 1919 Edition. Coloured cover. 72pp. (Illus. D5) R.£12 Bound volumes, in two parts, including each issue from 16 July, 1919 – 10 October, 1920. Green cloth cover.

Per volume	RR.£75
Per pair volumes	RR.£150

Bystander 'Fragments' Prints

Coloured Reproductions 1916

1/3 each or set of 12, 13/- post free.
1. "No possible doubt whatever".
2. "I'm sure they'll 'ear this damn thing squeakin' ".
3. "A Maxim Maxim".
4. "Keeping his hand in".
5. "That evening star shell".
6. "Where did that one go to?".
7. "The thirst for reprisals".
8. "The things that matter".
9. "So obvious".
10. "The innocent abroad".
11. "Well, if you knows of a better 'ole, go to it".
12. "Coiffure in the trenches".

Each	A.£2.50
Complete set	R.£35

De-Luxe Edition. 1916

"A selection of favourite 'Fragments', specially printed, suitable for framing. 32 pictures in handsome cover. 5/6 post free". Good quality prints on expensive paper. The set presented in a brown folio.

Each	R.£6
Complete set	RR.£200

Bystander 'Fragments' Postcards, 1916

(Illus D7, D8, D9) Nine series of six postcards, produced one set per month from mid 1916, in illustrated presentation envelope, 8d.

Series 1

a) The fatalist
b) "Well, if you knows of a better 'ole, go to it"
c) So obvious
d) Keeping his hand in
e) There goes our blinkin' parapet again.
f) The things that matter.

Series 2

a) That evening star shell
b) The Eternal question
c) Coiffure in the Trenches.
d) The thirst for reprisals.
e) No possible doubt whatever.
f) The innocent abroad.

Series 3

a) Our democratic Army
b) "They've evidently seen me".
c) The tactless Teuton
d) Directing the way at the Front.
e) That Sword.
f) "Where did that one go to?"

Series 4

a) A Maxim Maxim
b) "The Push"
c) Situation shortly vacant.
d) A.D. 1950
e) My Dug-Out: A lay of the trenches
f) "Gott strafe this barbed wire".

Series 5

a) The ideal and the real.
b) In and Out (1)
c) In and Out (2)
d) "Dear . . ., at present we are staying at a farm."
e) " . . . these . . . rations".
f) "Watch me make a fire bucket of 'is 'elmet".

Series 6

a) What it really feels like.
b) "That 16 inch sensation".
c) Frustrated Ingenuity
d) The Soldier's Dream.
e) "The same old moon".
f) Our adaptable Armies.

Series 7

a) "My dream for years to come"
b) The dud shell – or the Fuse-top collector.
c) The Historical touch.
d) Springtime in Flanders.
e) When one would like to start an offensive of one's own.
f) The Conscientious Exhilarator.

Series 8

a) Happy memories of the Zoo.
b) The Nest.
c) A Proposal in Flanders.
d) Thoroughness.
e) The Professional touch.
f) Trouble with one of the souvenirs.

Series 9

a) Observation.
b) The Intelligence Department.
c) His Dual Obsession.
d) The Communication Trench.
e) His Secret Sorrow.
f) Nobbled.

Per card	C.£1.50
Per set of six	A.£10.00
Per set in original envelope	R.£12.50
Empty envelope (Illus. D9)	R.£1.50
Per complete nine sets of six	RR.£100

D1

D2

To France for "Fragments". The newly appointed "Officer Cartoonist" returns to the Western Front to draw cartoons for the French. November 1916.

D3

Was this the real Captain Bairnsfather? B.B. as seen by fellow artist, Frenchman M. Marcel Poncin, in June 1918. Bairnsfather (with his usual suede gloves and cigarette) chooses some naughty French lingerie for a lady friend. As always, Old Bill cramps his style.

D5

D6

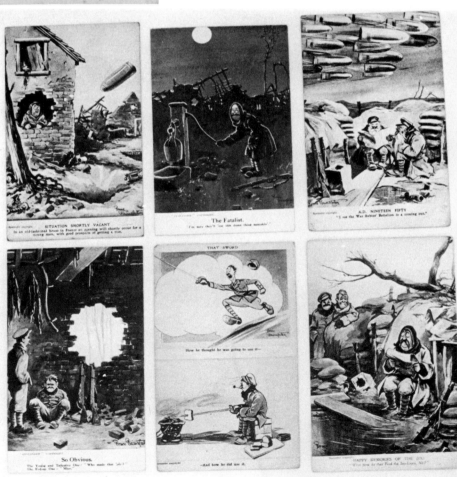

D7

D8

D9

Category E.

Metal Ware

Car Mascots From 8 May, 1919

(Illus E1)
Old Bill's head, with tin helmet, walrus moustache and long muffler. Bruce Bairnsfather's signature inscribed around helmet. 11cms. high. Produced by Messrs. Louis Lejeune (Mascots) Ltd. "Price 2½ guineas, the most popular on the market". Copyright no. 669204 under muffler.
The mascots have a long screw for fitting them on to car or motor bike. They are usually found today on a metal base.
N.B. Many "pirate" copies were made. Because their moulds were made from the original mascots, the copies are usually slightly larger.

a) Bronze *R.£100*
b) Chrome or nickel plated *R.£100*
c) Brass *RR.£110*

Motor Bike Mascots

(Illus. E1)
Miniature of the above, 7cms. high.
Copyright No. 985204
Chrome plated *RR.£175*

Mascots Mounted on Shell Cases Etc.

(Illus. E1)
"Home made" artefacts, often showing imagination and craftsmanship, no two being quite the same but using genuine mascot *U.£130*

"Pirate" Copies of Car Mascot

Usually found with chrome plated finish made in the 1920's *R.£35*

Ashtrays

(Illus. E2)
Brass, circular, 14cms. in diameter. Raised Old Bill head with tin helmet, pipe, walrus moustache and muffler. Inscribed Bruce Bairnsfather signature *R.£40*

St. Dunstan's Collecting Box

(Illus. E3)
Tin 20cms. × 14cms. × 7cms. Painted turquoise with black and cream picture of "Three Happy Men of St. Dunstan's" and "Old Bill's Appeal". Nodding Old Bill head to balance coin on (which is then tipped into the tin) *RR.£45*

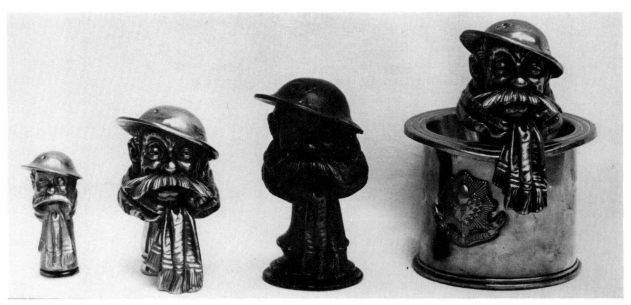

E1

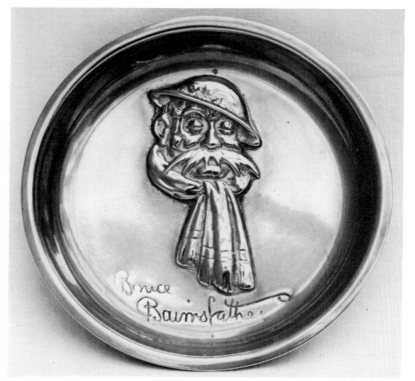

E2

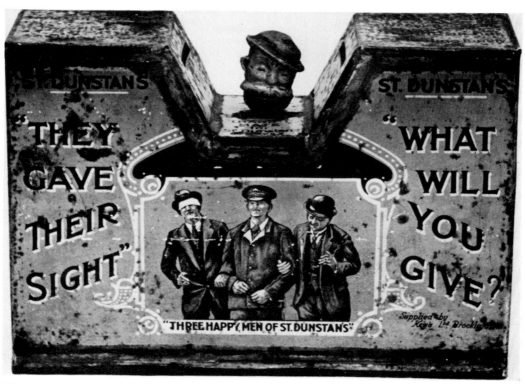

E3

Category F.

Theatre/Cinema Ephemera

These items are listed under the production to which they relate, which in turn is listed in chronological order.

Flying Colours. Sept. 1916

Revue at London Hippodrome, produced by Albert de Courville, starring "Little Titch" and Gabrielle Ray.
Five minute sketch called 'Bairnsfatherland or The Johnson 'Ole", with Old Bill (played by John Humphries), Bert and Alf.

Programme

(Illus. Page 50, 51, 52)
Art Deco col. cover by Palmer-Jones. 'Bairnsfatherland or the Johnson 'Ole' double page spread designed by Bairnsfather. 21.5cms × 28cms. Includes an advert for the Columbia Record of "all the songs and musical numbers" and a warning from the Commissioner of Police of the Metropolis about air raids R.£25

Postcard

(Illus. Page 51)
Pub. Waddington. Artist Bruce Bairnsfather R.£20

Posters

Col. Theatre advert RR.£35

Gramaphone record

Colombia Records 12in. wax record of 'Bairnsfatherland: The Johnson 'Ol' (from *Flying Colours* by Bruce Bairnsfather and B. Macdonald Hastings. London Hippodrome Company, including John Humphries, Chas. Berkeley and E. Ellis (Old Bill, Bert and Alf) No.L1129 RR.£50

The authors would appreciate details of any theatrical posters for this production.

The Better 'Ole. 1917–1919

Musical play at first put on at The Oxford Theatre, produced by Charles B. Cochran, written by Bruce Bairnsfather and Arthur Eliot with music by Herman Darewski.

Programmes

(Illus. Page 61)
a. Designed by Bairnsfather for the original Oxford Theatre production. 36cms. × 25.6cms. folded in three with insert showing cast list. Arthur Bourchier plays Old Bill A.£10
b. As above, but with insert including Poulbot sketch, "Kiddies in the ruins" sketch, starring Sybil Thorndike June 1918. (Illus. Page 68) R.£15
c. Programmes for touring companies of the above in the UK, USA, (with Chas. Coburn as Old Bill) Canada, e.g. 8 July, 1918, Pleasure Gardens, Folkestone 15 July, 1918, Theatre Royal, Canterbury. R.£10–£20

Posters

Pub. David Allen & Sons Ltd. Artist Bruce Bairnsfather. Col. Space in left hand corner for printing names of different theatres R.£30

Postcard

(Illus. Page 60)
Postcard sized reproduction of poster above R.£20

Song Sheet

26cms. × 36cms. Cover designed by Bairnsfather. Separate song sheet available for each song in the show R.£15

Song Annual

Herman Darewski song annual. 22cms. × 28cms. Photographs of Darewski, Arthur Bourchier as Old Bill, Captain Bruce Bairnsfather and Captain Arthur Eliot on cover. 16 songs, including "Plum and Apple" from *The Better 'Ole* R.£15

Play Pictorial Magazine No.191

(Illus. Page 62)
Edition devoted to the Oxford Theatre production of *The Better 'Ole*. Many photographs R.£15

Seesaw: March 1917

Revue produced by André Charlot at the Comedy Theatre, including Bairnsfather sketch "Where did that one go?" with John Humphries as Old Bill.

Programmes/Posters

(details of which the authors would appreciate) RR.£10–£30

The Better 'Ole. July 1918

Seven reel silent film produced by new British Company, Welsh-Pearson, based on the Cochrane stage version. Charles Rock as Old Bill, Arthur Cleave as Bert, Hugh Wright as Alf.

Still Photographs

(Illus. Pages 69, 70)
Of cast, individual stars. R.£5–£15
The authors would appreciate information about programmes, posters etc. for this film, from British or American showings.

Old Bill MP. 1922

Extravagant musical play (with a cast of 100) with strong propaganda message. Written by Bairnsfather, put on by a syndicate (the O.B. Syndicate) he formed and invested in, and with the help of Seymour Hicks.
a. Pre-West End "tryout" production at Golder's Green Hippodrome, Mon 17 April. Edmund Gwen as Old Bill

Posters RR.£50
Programmes R.£10
b. Pre-West End tour: Hammersmith, Portsmouth, Birmingham, Manchester, Newcastle etc.
Posters RR.£50
Programmes R.£10
c. West End production, Lyceum, 12 July
Posters R.£35
Postcards R.£20
Programmes (Illus. Page 99) A.£10

d. Tour of Moss Empire Group Theatres. Johnny Danvers as Old Bill

Posters	RR.£45
Programmes (Illus. F2)	R.£10

Bairnsfather in Music Hall Act. 1922, 1923

Twenty two week tour of Moss and Stoll theatres, starting at Victoria Palace, Nov. 22 and then the London Coliseum

Posters	RR.£45
Programmes	RR.£12

Old Bill Through the Ages. 1924

Film made by Ideal Films, script by Bairnsfather. Syd Walker as Old Bill.

Posters	RR.£50
Stills	RR.£5–£15
Picturegoer Magazine, May, with feature on the film	R.£25

" 'Ullo" (also known as 'Carry On Sergeant") 1925. Revue written and financed by Bairnsfather
a. Pre-West End Production, Birkenhead Hippodrome, then on tour. Billy Bennett played Old Bill for a short time.

Posters	RR.£45
Programmes	R.£12

b. Run at New Oxford Theatre from 28 October. Johnny Danvers as Old Bill.

Posters	R.£35
Programmes	R.£10

Special Performance for Variety Artists Benevolent Fund. 28 March 1926

Programme. Cover by Bairnsfather for show at London Coliseum. Artists include Gracie Fields, Will Fyffe, Lupino Lane (Illus. F3) R.£15

The Better 'Ole 1926 (4 Sept.)

Silent ten reel Warner Bros. film. Directed by Charles Reisner. Script by Bairnsfather, screenplay by Darryl Zanuck. Syd Chaplin (Charlie's brother) as Old Bill

Souvenir booklet

Designed and illustrated by Bairnsfather with Introduction by him. Photos of stars. Article by and about Syd Chaplin etc. (Illus. Page 109) RR.£20

Posters

Twelve different designs by Bairnsfather (Illus. Page 108) RR.£50

Still Photographs

(Illus. Page 109)
Of cast and individual stars R.£10–£20

Cigarette Cards

Wills cigarettes. "Cinema stars". Syd Chaplin as Old Bill A.£5

Picture Show Magazine

Nov. 5. Two page centrefold feature	R.£10
Dec. 17. Review	R.£5

Vitaphone Film 1927 (2 April)

One reel sound film of Bairnsfather sketching (and talking) in his studio
Publicity material of any kind RR.£15–£40
Vitaphone 50th Anniversary Commemorative Booklet, 1976

Carry On, Sergeant 1928 (10 Nov.)

Ill-fated attempt by Bairnsfather to make Canada's first (silent) epic film for the newly-formed Canadian International Films Ltd. Scripted, directed, designed etc. by Bairnsfather in Trenton, Ontario. Originally fourteen reels long, it vastly exceeded its budget. Hugh Buckler played the Sergeant, Jimmy Savo the comic lead.
Posters R£55

Still Photographs

(Illus. Pages 113, 114, 116)
Of Bairnsfather and other technicians with members of the cast on the set R.£10–£25

Souvenir Programme

(Illus. Pages 119, 120).
Designed and introduced by Bairnsfather. Photographs of cast, features about them, words and music of theme song, etc. R.£30

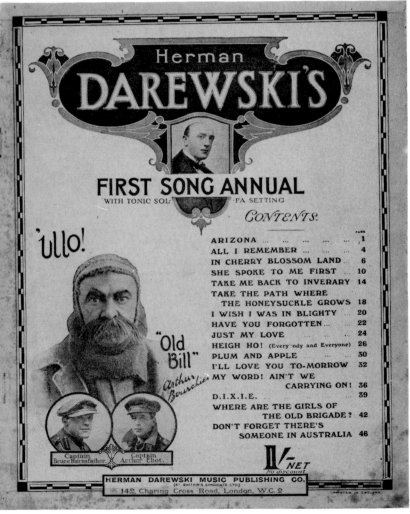

F1

F2

F3

Bairnsfather In Music Hall Act 1936

Posters for Argyle Theatre, Birkenhead and similar. (Illus. Page 149) *R.£45*

Bairnsfather Music Hall Act with Billy Russell 1937/1938

Posters (Illus. Page 152) *R.£45*
Publicity Photographs (Illus. Pages 151, 153) of Billy Russell and Bruce Bairnsfather *R.£10-£15*

Old Bill & Son: Feb. 1941

Bairnsfather's last film, for Alexander Korda and Legeran Films. Script by Bairnsfather and Ian Dalrymple. Old Bill played by Morland Graham, Young Bill by John Mills.

Illustrated Magazine 6 April, 1940

Cover picture and feature about the filming of *Old Bill & Son* *R.£15*

Still Photographs

(Illus. Pages 160, 165)
Of cast, including Morland Graham, John Mills, Renée Houston, and of BB on set *R.£10–£15*

Book of Film

See"Books".

Category G.

Books

Within the subdivision, books are listed in chronological order of publication.

i. By Bruce Bairnsfather

Bullets and Billets

Pub. December 1916 by Grant Richards Ltd. London. 12.5cms. × 19cms., red cloth cover, 304 pp. 19 full page illustrations, (including two photographs of the author), many in-text line drawings. Bairnsfather's light-hearted account of his experiences as an "Old Contemptible" in the Great War. From arrival in France in 1914, life in the trenches in "Plugstreet Wood" including the Christmas Truce, and the birth of "Old Bill" and "Fragments", to his blighty one received during the first gas attack in the Second Battle of Ypres, April 1915. Dedicated to "Bill", "Bert" and "Alf" C.£15

Bullets and Billets

(Illus. G1) Description as above. Special print of 100 copies in 1917 RR.£55

From Mud To Mufti

(Illus. G1) Pub. 1919 by Grant Richards Ltd., London 12.5cms. × 19cms., red cloth cover, 249 pp., 20 full page illustrations, many in-text line drawings. Bairnsfather's account of his experiences from convalescence in Britain in 1915, his association with the *Bystander*, postings to Salisbury Plain and the Somme, promotion to Captain/Officer Cartoonist, visits to the Belgian, French, American and Italian fronts, to the U.S.A. and finally the Armistice. Dedicated to "My Mascot Mother" A.£15

The Bairnsfather Case

Sub-titled "as tried before Mr. Justice Busby. Defence by Bruce Bairnsfather. Prosecution by W.A. Mutch". (Illus. G1) Pub. September 1920 by G.P. Putnam's Sons, London and New York. 12.5cms. × 19cms., orange cloth cover. 236 pp., 11 full

page illustrations, many in-text line drawings. Jointly written by Bairnsfather and William A. Mutch, in alternative chapters. Bairnsfather describes his life from birth to his new post-war career as playwright, lecturer and general celebrity. Mutch, who was on the editorial staff of the *Bystander*, examines the obstacles to his success, the man himself, and his success. Dedicated to "Ceal", his future wife A.£15

Carry On Sergeant!

Pub. 1927 by Bobbs-Merrill Co. Indianapolis. Yellow cloth cover. 16cms. × 22cms. 164pp. A serious "Prologue", followed by a mixture of "Old Bill, Bert and Alf" fiction, and wry Bairnsfather philosophy mixed with some real World War I experience, by Bairnsfather. Full page cartoons and illustrations, some totally original, some redrawn R.£20

The Collected Drawings of Bruce Bairnsfather

Pub. 1931 by W. Colston Leight Inc., New York. Blue cloth cover, with paper jacket illustrated by Bairnsfather (the "Better 'Ole" cartoon). 20.5cms. × 29cms. 88 full page illustrations with captions on plain left hand page. Reproductions from the *Bystander*, *Judge*, *Life*, *The New Yorker* and *College Humour*. Frontispiece photograph of Bairnsfather. Introduction by him. On superb quality paper R.£30

The Collected Drawings of Bruce Bairnsfather

Description as above, but limited deluxe edition with original pencil sketch by Bairnsfather on frontispiece and red cloth cover with black spine RR.£50

Laughing Through the Orient

(Illus. Page 136). Pub. 1933 by Hutchinson & Co. Loose cover designed by Bainsfather over stone colour cloth cover with Bairnsfather sketch. 13cms. × 19cms. 155pp. The result of Bairnsfather's world

cruise – part travelogue, part humour. 18 full page plates, many in-text line drawings R.£25

Old Bill Looks at Europe

(Illus. Pages 136, 137). Pub. 1935 by the Dodge Pub. Co. Orange cloth cover. 16.5cms. × 22cms. 148 pages. The results of Bairnsfather's tour (with Old Bill) of the Ypres Salient, Paris, Germany and Russia, with his semi-serious impressions of the contrasting régimes. Many original full page cartoons R.£15

Wide Canvas

Pub. October 1939 by John Long Ltd., London. 14cms × 22cms. Grey "canvas" cover 252pp. 24 full page illustrations, including photographs of the author and his family. Bairnsfather's serious attempt at an autobiography. Dedicated to "Old Bill" A.£30

Old Bill Stands By

(Illus. Pages 155, 156). Pub. April 1939 by Hutchinson & Co. 22.5cms. × 28.5cms. Paper back, with cover illustration by Bairnsfather. 36pp. Old Bill reacts to the new crisis. Alternate full page cartoons and text with black and white line drawings R.£15

Old Bill & Son

Pub. 1940 by Hutchinson & Co. 13cms. × 19cms. 200pp. with 12 stills from the film and six Bairnsfather drawings. The story of the film of the same name by Bruce Bairnsfather with Ian Dalrymple R.£15

Old Bill Does It Again

(Illus. Page 162). Pub. 1940 by Hutchinson & Co. 22.5cms. × 28.5 cms. Paperback, with cover illustration by Bairnsfather. 36pp. Old Bill reacts to the new war. Bairnsfather's text and illustrations, which include some brilliant caricatures of Hitler and Stalin R.£15

G1

G2

G3

Jeeps and Jests

(Illus. Page 171). Pub. 1943 by Putmans, New York. 15.5cms. × 23cms. paper jacket designed by Bairnsfather over stone colour cloth cover. 106pp. Foreword by Maj. Gen. R.P. Hartle, of whom the frontispiece is rare, serious Bairnsfather portrait. On the right hand side of each spread is a full page cartoon with caption, on left hand side a line drawing. Old Bill mingles with USAAF types RR.£25

No Kiddin'

Pub. 1945 by Putmans, New York. 15.5cms. × 23cms. Col. paper jacket designed by Bairnsfather over grey cloth cover. 94pp. Foreword by Maj. Gen. Curtis Le May. Frontispiece photo of Bruce, with the "Old Bill" B17, now "official War Artist to the United States Forces in Europe". On the right hand side of each spread is a full page cartoon with caption, on left hand side a line drawing. Rarer appearances of Old Bill. Some brilliant caricatures of US airmen, Hitler, Stalin, Churchill RR.£25

ii. About Bruce Bairnsfather

Bairnsfather: A Few Fragments From His Life

Pub. 1918 by Hodder and Stoughton for the *Bystander*. Grey cloth cover sometimes with red border. 18cms. × 25cms. 96pp. By Vivian Carter, Editor of the *Bystander*. A serious, but somewhat biased biography, illustrated by Bairnsfather with black and white line drawings and sepia plates. Photograph of Bairnsfather on frontispiece A.£15

The Bairnsfather Case – i. above.

They Make Us Smile

Pub. 1942 by Chapman & Hall Ltd. A collection of articles by Percy Bradshaw about the best humorous artists of the day. First published in *London Opinion* (see section F above) and other magazines. The first article is about BB R.£10

iii. Illustrated by Bruce Bairnsfather

A Temporary Gentleman In France

(Illus. G2). Pub. Nov. 1916 by Cassell & Co. 12.5cms. × 19cms. 190pp. Col. Bairnsfather illustration on cardboard cover. Anonymous letters from a subaltern. Foreword by Capt. A.J. Dawson R.£10

Somme Battle Stories

(Illus. G1). Pub. 1916 by Hodder & Stoughton for the *Bystander* 12.5cms. × 19cms. Red cloth cover. 240pp. By Capt. A.J. Dawson. Illustrated by Bairnsfather. Col. frontispiece and seven full page plates. Serious pictures of men in the Somme battle R.£10

Back To Blighty

(Illus. G1). Pub. 1917 by Hodder & Stoughton for the *Bystander*. 12.5cms. × 19cms. Blue cloth cover. 232pp. By Capt. A.J. Dawson. Illustrated by Bairnsfather. Frontispiece and seven full page plates and four black and white line sketches, both humorous and realistic trench scenes R.£10

For France (C'est Pour La France)

(Illus. G1). Pub. 1917 by Hodder & Stoughton. 14cms. × 22cms. Brown cloth cover. 176pp. By Capt. A.J. Dawson. Illustrated by Bairnsfather. Frontispiece and thirteen full page sepia drawings, some serious, some humorous (some "Fragments") about the life of the 'Poilu' in the French sector R.£10

Sea Pie

(Illus G3). Pub. 1917 in aid of naval prisoners of war. Contributions from many major artists of the day, including Old Bill cartoon by Bairnsfather. R.£5

Gallant Adventure

1928 TOC H Annual. 18.5cms. × 25cms. Paperback with col. cover. Contributions from many major authors and artists, including three full page sketches of a 1914, 1915 and 1916 Tommy by Bairnsfather R.£15

Category H.

Magazines

Containing articles and/or illustrations by or about Bairnsfather

For *Bystander*, *Fragments from France* and *Fragments* magazine entries, see section D above.

For cinema, theatre, magazine entries, see section F above.

The following is a selection, in chronological order, of the scores of publications to which BB contributed or which featured him. The authors would appreciate details of others.

1915 Sept. Pearson's Magazine

BB cartoon entitled "A Hopeless Dawn" *R.£10*

1923. Pictorial Magazine

(Illus. H1). "The only twopenny magazine with the one shilling magazine features". Series of "Old Bill Looks Back" articles written and illustrated by BB *R.£10*

1923 May. Ideal Home

(Illus. H2). Seven page illustrated article featuring Waldridge Manor. BB's home, with sepia photographs *R.£20*

1927 Sept. The Red Book

U.S. magazine. Photo and caption of BB *RR.£15*

1928–present day. Home Front

(Illus. H3)
Magazine of the Memorable Order of Tin Hats (MOTHS), published in Durban, S.A. Various editions feature BB cartoons, either on the cover or inside. Value increases with age of edition *C.50p–£3*

1933 April onwards. The Passing Show

(Illus. Page 139). Published by Odhams. Varying issues contain full page articles written and illustrated by BB, or half page cartoons *R.£5*

1935 onwards. The Passing Show

(Illus. Page 146). Now appearing in a larger format. "Old Bill's Boy" strip cartoon in four pictures by BB, in orange, black and white *R.£5*

1934 Feb. – 1942. Royal British Legion Journal

Contributions by Bairnsfather in many issues, ranging from two page articles (e.g. Feb/July 1934), a series of cartoons called "Leaves from Old Bill's Memory Book" (Mar. 1934) which then changed its title to "The New Fragments" and continued to the end of 1935. The full page cartoons became spasmodic until the outbreak of war in Sept. 1939 when they became regular again, gradually becoming irregular (and smaller) until they ceased in 1942. The Nov. 1959 issue carried an obituary to BB. Value increases with age of edition *A.£2–£4*

1935 May/June. The Quartermaster Review

U.S. Service Magazine. Long, highly illustrated article (with photos of BB and cartoons by him) by Christy Borth, entitled "The Wise Man in Motley" *RR.£15*

1935. Nov. onwards. Answers

Magazine which inserted a colour print of a Fragments cartoon. The valuation is for a magazine complete with print.
16 Nov. "The Better 'Ole"
23 Nov. "Coiffure in the Trenches"
30 Nov. "The Fatalist"
7 Dec. "Where did that one go to?"
14 Dec. "So Obvious"
21 Dec. "No Possible Doubt Whatever" *R.£10*
The six prints, without magazines *A.£20*

1936 Twenty Years After. The Battlefields of 1914–*1918. Then and Now.*

Published by George Newnes. Magazine in weekly parts, produced twenty years after the end of the Great War and then

published in three bound volumes (Nos. 1, 2 and Supplementary, 1937). Several issues include reproductions of Fragments. Bairnsfather contributed an article in the eighth issue, "Bruce Bairnsfather Looks Back", complete with photos, reproductions of "Fragments" and a new cartoon.
Single issue *C.£2*
Complete set three bound volumes *A.£50*

1938 onwards 'I Was There'

Published by Hammerton. Weekly illustrated magazine to mark the 20th Anniversary of the Armistice, later published in four bound volumes. On page 806, vol. II article by BB "How I Drew Fragments from France", with photo of BB and three cartoons.
Single issue *C.£20*
Complete set four bound volumes *A.£75*

1939/1943. Illustrated

Published by Odhams. Weekly illustrated magazine, the successor to The Passing Show and rival to Picture Post. Strip cartoon by BB of "Young Bill" in four black and white pictures, which finally became a single cartoon. April 6, 1940 edition (featuring 'Old Bill and Son' film) see Category F above *A.£5*

1939/1940. Defence. The Fighting Man's Fortnightly

Magazine. (Illus Page 157) Oct 1, 1939 onwards. Fairly serious articles by BB (at first wrongly credited with an M.C. in the by-line) illustrated by him with some superb cartoons of Hitler, Stalin & Co., entitled "Over my Sandbags" *R.£5*

1940 *London Opinion*

Vol. 1. No. 14. Article by Percy Bradshaw on BB, illustrated by BB (see also Category G above) *R.£10*

1942/1945 Stars And Stripes and Yank

US Forces papers. By 1944 Bairnsfather had contributed 200 sketches to Stars & Stripes *R.£5*

c 1925 to BB's death in 1959. US Magazines

e.g. *College Life, Collier's, Judge, Life, The New Yorker*. Variety of series and isolated contributions by BB; strips, cartoons, articles. Very difficult to find in UK *RR.£5–£25*

1974 Aug. 3. Antiques and Arts Weekly

Article by Peter Johnson about Bairnsfather collectables *A£5*

1978 Nov. 18. Antiques and Art Weekly

Article by George Mell about War Illustrators, including BB *A.£5*

1978 Oct. Postcard Collectors Gazette

Article by Tonie & Valmai Holt on BB postcards *A.£5*

1978 Nov. Kent Life

Article by Lucy Eaton about Tonie & Valmai Holt's BB collection *A.£5*

Old Bill Looks Back

What He Thinks of the Somme To-day,
By CAPTAIN BRUCE BAIRNSFATHER.

NOTE—Continuing his tour of the battlefields with the "capting," Old Bill revisits Albert and the Somme, and has a silent moment when he contemplates his old billet. Somewhere, deep down, he has a soft spot for the old days where he lived in a land of mud, peopled by a great brotherhood of khaki-clad men who entered the turmoil of war with a jest and a cheery smile, and as he looks on at what used to be, Old Bill thinks many things. Some thoughts he would not tell for gold, but such as may be made known he gives below.

"THE Somme was a bit off, but it weren't quite like Wipers."

Old Bill let this announcement off at me as we stood in Albert, having just beaten off a sale of postcards, depicting spots that we prefer to think about, and not see.

"What do you mean, Bill? Do you say that Ypres was worse?" I asked.

"Well, not exactly that, capting; but by the time this 'ere Somme was on the menu the war was bein' run up-to-date, as it were—there was corrugated iron, and plenty of sandbags, and all that tackle—a real, comfortable war, as it were. You could ring the bell for anythin'."

"Yes, but it was a rotten battle, though, Bill—in fact, a fearful one! Think of Thiepval, Gommecourt, Delville Wood, Peronne!"

I said this with vigour, and watched him closely.

"Yus, it was a rotten outfit, I know, capting, but some'ow, somethin' 'ad left the war by then. I think p'r'aps it was the chance of losin'. It was serious, and all that; but when we was stuck up at Wipers in them early times it was not only serious but a blinkin' disaster for ever if we 'ad got pushed back. Finish—napoo!"

"Yes, I see your meaning, Bill; but look at this place—look at poor old Albert!"

He looked round at it all sadly.

"Yes, it makes ye think, don't it? You've only got to look at all that rusty barbed wire, what we saw comin' along, to give you an idea of what it was like."

Bill was right. Along those flat, desolate roads it seemed incredible that so much wire could have been used, and incredible that it was still lying there, rusty. One somehow imagined that no war traces could remain after all these years. It was possible to find shell fuse-tops almost as easily as during the war itself.

Souvenirs of all kinds still litter the ground. And this after all those countless tourists! I found myself thinking what a fortune in metal lay between the North Sea and Switzerland! Think of the tons of metal in all its forms that was shot out to France during those dread years! Matter is indestructible, so the metal must be there—somewhere.

Bill was now wandering about amongst some house remnants, obviously impatient.

"Where would you like to go first, Bill?" I asked.

"Well, capting, before I goes to 'ave a look at Delville Wood, and all that, I just wants to drive around the back part. There's something about all them old billetin' villages that gets me. I just want to see them old barns and estaminets we used to know—just want to see them places where the boys used to sit around and 'ave a sing-song, to see them cribs where we lay among the straw and waited for the sergeant to tell us to "fall in on the road!"

I knew what he meant.

"Come on, Bill, let's get along in the car. We'll go straight from here to Doullens, then along again through Candas,

On Other Pages.

ARTICLES.

	Page
V.C.'s of Industry	332
400 Miles with a Dog Team	340
Britain's Biggest Larder	348
Is Finance Killing Football?	359

FICTION.

The Way of 100 Swords	325
The Misfit	335
Homeward Bound!	343
The White Man's Way	351
A New Leaf	356

COMPETITIONS.

Picture Pars	331
£500 Must be Won	Cover iv.

No. 1232. 321 P.M. January 6, 1923.

H1

An interesting feature is an old barn which has been converted into a studio, with a model theatre.

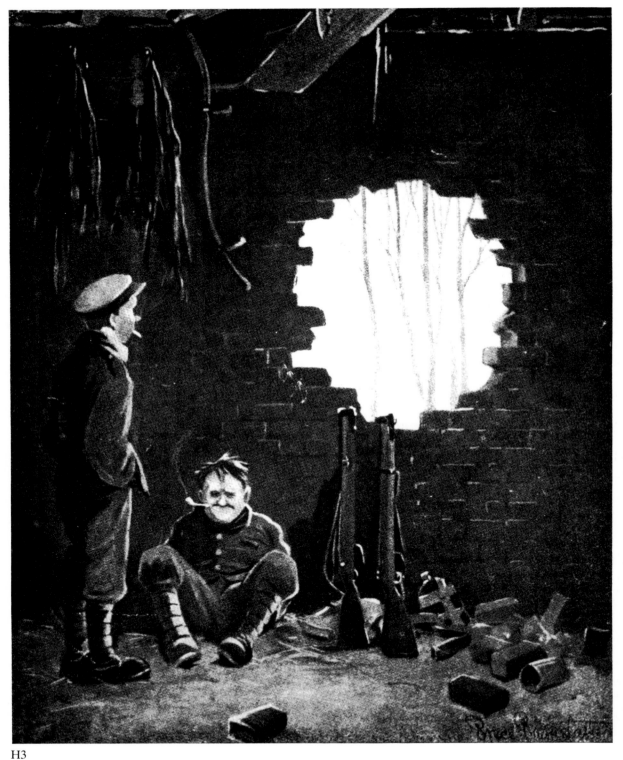

H3

SO OBVIOUS. The Young and Talkative One: "Who made that 'ole?" The Fed-Up One: "Mice". This famous 'Fragment' appeared on the front cover of HOME FRONT *The Memorable Order of Tin Hats Magazine in February 1978.*

Category I.

Miscellaneous

Dolls

(Illus. I1). Old Bill cloth doll on wire frame. 13cms. high. Velvet face. Khaki uniform, balaclava, wool moustache/muffler. Used by the Red Cross as a fund raiser during the war, and by actresses to throw to the audience from the stage of several West End productions – even as a gift from the Prince of Wales. (see chap. 8) *R.£40*

Old Bill 'humpty dumpty' shape cloth doll with no arms. 18cms. high. Khaki material, wool moustache. Label on back "Vaudeville Theatre. Cheep! With Lee White's compliments". Used by the star in the 1919 show, and as her own mascot (see chap. 8) *RR.£50*

Model of Old Bill

(Illus. I2) Designed and created by Charlotte Zeepvat 1982. 28cms. high terracotta figure clothed in khaki uniform with tin helmet and rifle, correct in every minute detail. Standing on base of 'mud', barbed wire, tins, tree stump *U£200*

Glass Slides

(Illus. I3). 8cms. square glass slides for projection in an epidiascope, each with a different 'Fragments' cartoon. Above the caption is the wording "Copyright. Reproduced by permission, from "The Bystander" ". Each *R.£5*

Postcards

Other than 'Bystander' produced and theatrical poster adverts (see Categories B and F). Standard postcard size unless otherwise stated and in chronological order of publications.

4th Div. Follies

(Illus. I4). B & w design of German soldier dancing to Pierrot's mandolin. Caption, "Will stop anyone hating anything" *R.£10*

Bairnsfather Portrait

Pub. Beagles. Photographic portrait of Capt, Bruce Bairnsfather *RR.£15*

Surrey Red Cross

(Illus. I5). Fund raising card, produced for "British Red Cross Society, Surrey Branch. Registered under the War Charities Act, 1916". Col. picture of Old Bill with arm in sling, in blue wounded Tommy's uniform and "Old Bills made like new! If you help the Surrey Red Cross" caption *R.£12*

Red Letter Midget Messages

7cms × 9cms. Inserted in 'Red Letter' magazine, Miniatures of the 'Fragments' cartoons *R.£5*

"Better 'Ole" Series

Pub. Tuck Oilette. No. 3189 *A.£2*

Bairnsfather Copies

Series of anonymously published WWI period copies of 'Fragments' cartoons, with captions slightly changed *A.£1*

Mabel Lucie Atwell

Pub. Valentine. Typical Atwell child 'Mother' holding baby out to khaki-clad soldier. Caption, "Mother to 'Bairn's Father': Well, if you know a better 'ome – go to it!" *R.£5*

Old Bill Bus

Photo card of HM the King inspecting 'Old Bill' bus at Buckingham Palace. 14.2.1920. The bus, complete with brass Old Bill Mascot, is now in the Imperial War Museum *A.£5*

British Legion

(Illus. Page 142). Fund raising card, showing Old Bill wearing BL badge, with the caption "I've joined the British Legion. Have you?" 1934. "One shilling per dozen" *R.£5*

Old Bill and Bert Series

Pub. Tuck . "Humorous Postcard Nos. 5070–5091. Reproductions of Bairnsfather's weekly comic strip in the magazine 'The Passing Show' of the adventures of Old Bill and Bert, with an acknowledgement to the magazine. B & w and orange. 1935 *A.£3*

Old Bill Again

Pub. Valentine. Reproductions of Old Bill early WWII cartoons from the 'Bystander' *R.£3.*

I1

I2

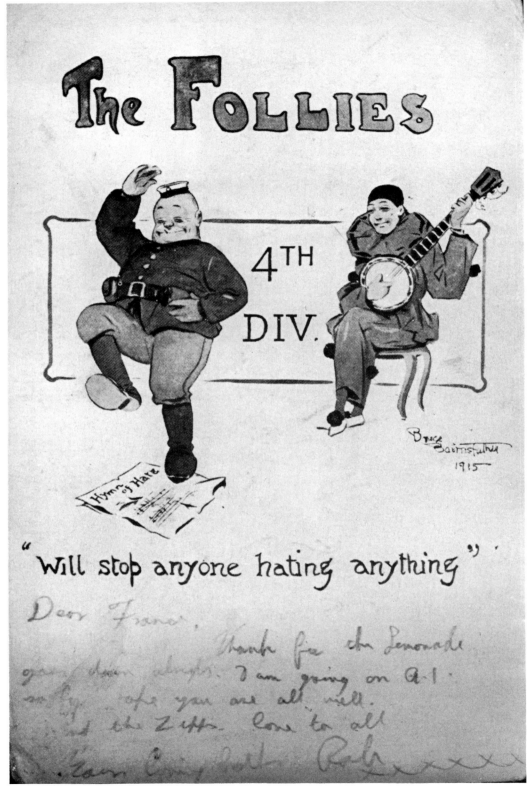

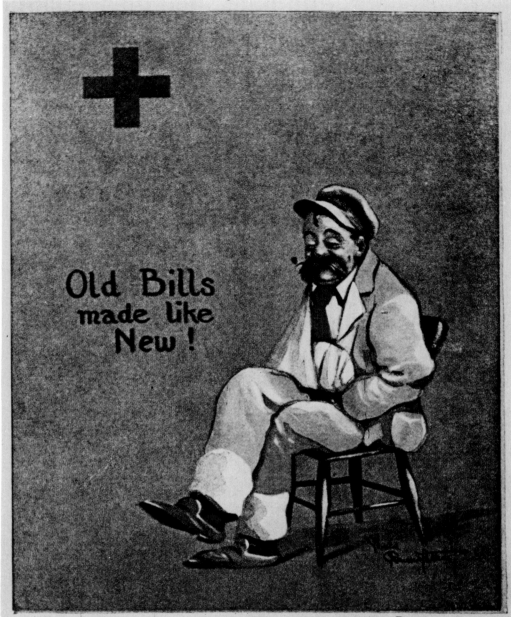

15

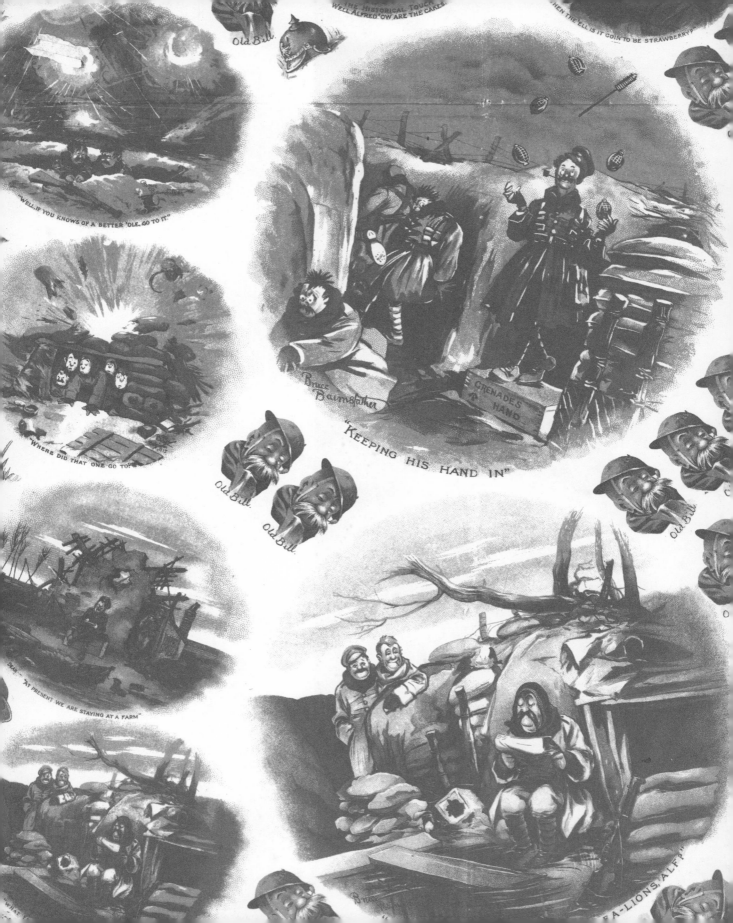